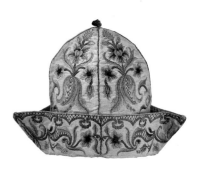

WHAT

CLOTHES

REVEAL

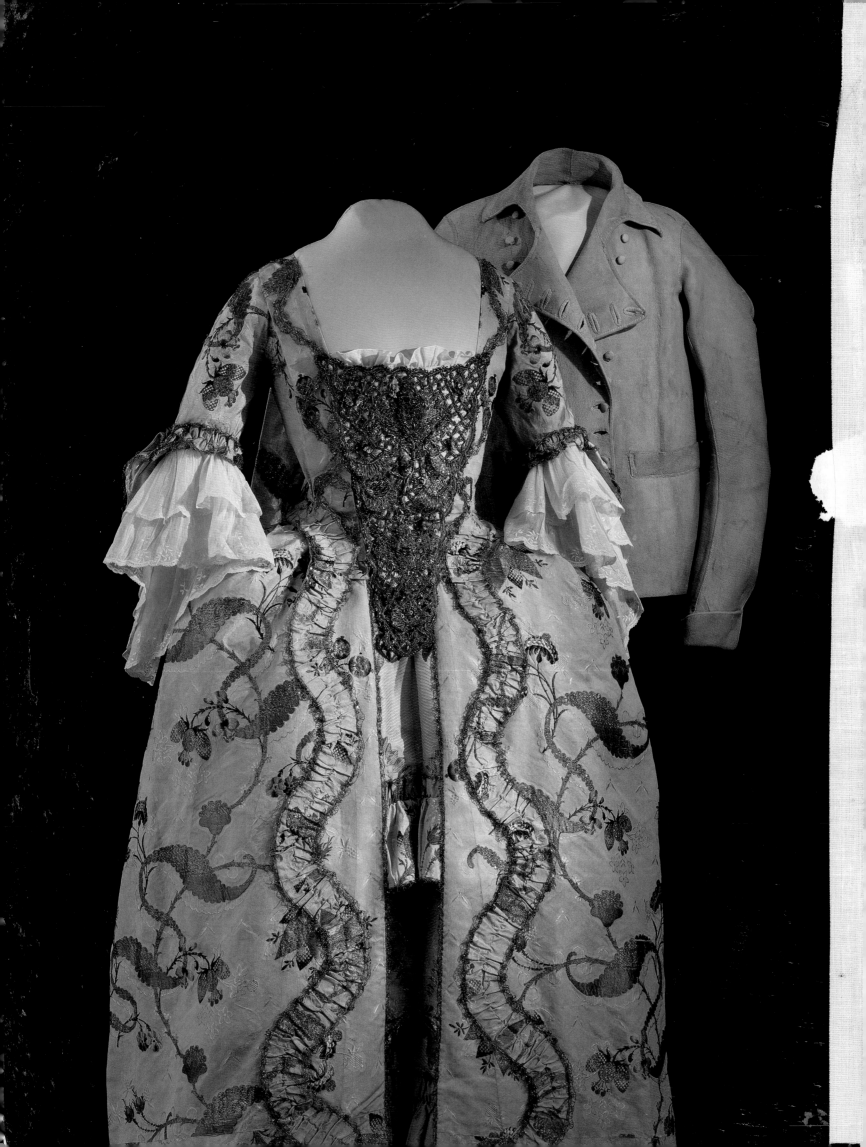

WHAT CLOTHES REVEAL

The Language of Clothing
in Colonial and Federal America

THE COLONIAL WILLIAMSBURG COLLECTION

By Linda Baumgarten

The Colonial Williamsburg Foundation
Williamsburg, Virginia

IN ASSOCIATION WITH

Yale University Press NEW HAVEN & LONDON

Williamsburg Decorative Arts Series

American Coverlets and Their Weavers
Coverlets from the Collection of Foster and Muriel McCarl
Including a Dictionary of More Than 700 Weavers
by Clarita S. Anderson

Degrees of Latitude
Mapping Colonial America
by Margaret Beck Pritchard and Henry G. Taliaferro

Furnishing Williamsburg's Historic Buildings
by Jan Kirsten Gilliam and Betty Crowe Leviner

The Governor's Palace in Williamsburg
A Cultural Study
by Graham Hood

Southern Furniture 1680–1830
The Colonial Williamsburg Collection
by Ronald L. Hurst and Jonathan Prown

What Clothes Reveal
The Language of Clothing in Colonial and Federal America
The Colonial Williamsburg Collection
by Linda Baumgarten

© 2002 by The Colonial Williamsburg Foundation

Library of Congress Cataloging-in-Publication Data
Baumgarten, Linda.
 What clothes reveal : the language of clothing in colonial and
federal America : the Colonial Williamsburg Collection /
Linda Baumgarten.
 p. cm.
Includes bibliographical references and index.
 ISBN 0-87935-216-7 (hardcover : alk. paper)—ISBN 0-300-09580-5
(hardcover : alk. paper)
 1. Costume—Social aspects—United States—History. 2. United
States—Social life and customs—To 1775. 3. United States—Social
conditions—To 1865. 4. Colonial Williamsburg Foundation.
I. Colonial Williamsburg Foundation. II. Title.
GT607 .B38 2002
391'.00973—dc21 2002007297

Photography by Hans Lorenz
Design by Greer Allen and Jo Ellen Ackerman
Printed and bound in Singapore

Published in 2002 by The Colonial Williamsburg Foundation
in association with Yale University Press

www.colonialwilliamsburg.org

Frontispiece. Fig. 1. Brocaded silk gown, stomacher, and petticoat, Britain, 1745–1750, remodeled ca. 1770, 1968-646, 1–3; Deerskin leather jacket, United States, 1800–1825, 1993-13A. See figs. 21–22 and 106–107.

CONTENTS

PRESIDENT'S MESSAGE

Polonius, as crafted by Shakespeare at the beginning of the seventeenth century, may have been somewhat pretentious, but he spoke for his time when he said,

Costly thy habit as thy purse can buy,
But not express'd in fancy, rich, not gaudy,
For the apparel oft proclaims the man.

That was an era when conclusions would be drawn from appearances—an era not unlike our own, in that respect. Indeed, clothes have always revealed much about attitudes and aspirations.

Colonial Williamsburg collects and studies a wide variety of eighteenth-century objects, not as curiosities from another time, but as three-dimensional artifacts that teach us about people, places, and events. They frequently serve as a source of insights different from those provided by the written word.

For instance, the idiosyncrasies of a cabinetmaker's joinery may divulge his ethnic background; an enslaved man's use of a broken spoon as a talisman may open a window to his religious beliefs; or, perhaps the choice of a bonnet or the fabric of a dress will tell us something about textile trade patterns and personal preferences.

Pursuing new knowledge through objects—cultural markers, if you will—has been a centerpiece of Colonial Williamsburg's research and exhibition programs for more than seventy-five years. Our collections number more than sixty thousand British and American antiques and objets d'art, not to mention a few million archaeological artifacts.

This treasure trove of materials is integral to the work of our interpreters, curators, and historians who enrich the experience of the nearly one million visitors that come here each year. What better way to help our visitors understand the culture and lifestyle of our nation's founders. That is our mission at Colonial Williamsburg—that the future may learn from the past.

Colin G. Campbell
Colonial Williamsburg Foundation

FOREWORD

Few categories of antiques offer more in-depth views of past people and events than antique clothing. What other objects could be more directly tied to human beliefs, social behaviors, and cultural values than the garments that people wore? Just as the bell-bottomed jeans of the 1960s speak to the shifting mores of that time, so does Ann Van Rensselaer's Indian cotton dress reflect European trade law and America's sense of informality in the 1790s (figs. 112–114). Historic clothing is layered with such insights. We need only ask the questions. And in *What Clothes Reveal, The Language of Clothing in Colonial and Federal America, The Colonial Williamsburg Collection*, author Linda Baumgarten has done precisely that. Focusing on Colonial Williamsburg's extensive holdings in historic clothing and costume accessories, she has skillfully married the fields of curatorial research and historical inquiry. Her astute assessment of everything from court gowns to tradesmen's work aprons has brought much new information to the surface and sets a new standard for such work.

The Colonial Williamsburg collections are well suited to research of this kind. While many costume collections center exclusively on the apparel of the elite, Colonial Williamsburg's holdings cut across the social and hierarchical scales of the past. That is the case, in part, because of the assiduous and wide-ranging collecting habits of curator Baumgarten over the course of twenty years. Much credit is also due to the efforts of past chief curators James Cogar (1931–1949), John Graham (1950–1970), and Graham Hood (1972–1997), each of whom nourished an interest in antique clothing and acquired important examples for the collection. Mildred B. Lanier played an equally significant role. As the talented and dedicated steward of the Foundation's textiles

from 1953 to 1979, she shaped the costume collection for nearly three decades and devoted much of her energy and thought to its makeup.

Generous donors have also built the collection in ways large and small. Three of them deserve special mention. Grace Hartshorn Westerfield bequeathed her substantial assemblage of antique textiles and costumes to Colonial Williamsburg in 1974. Tasha Tudor, the respected author and illustrator of children's books, has given much of her notable costume collection to the Foundation in recent years. Cora Ginsburg, for many years the country's leading dealer in antique textiles, gave a sizable portion of her personal costume collection to Colonial Williamsburg in 1991. To these and to many other generous donors we are deeply grateful.

The production of *What Clothes Reveal* was a complex undertaking that involved the time and talents of many people at Colonial Williamsburg. Kimberly Smith Ivey, associate curator of textiles, shouldered numerous additional responsibilities while the author researched and wrote the book. Textile conservator Loreen Finkelstein and her team treated most of the objects here illustrated. Joseph N. Rountree, Erin Michaela Bendiner, and Helen M. Olds skillfully managed the publication process. These colleagues deserve sincere thanks.

Finally, we acknowledge with gratitude the support of the DeWitt Wallace Fund for Colonial Williamsburg, established by the founders of *Reader's Digest*, for making possible the conservation of so many objects in this book, and for enabling us to exhibit them at Colonial Williamsburg's DeWitt Wallace Decorative Arts Museum in 2002–2003.

Ronald L. Hurst
Carlisle Humelsine Chief Curator
Colonial Williamsburg Foundation

PREFACE

This book explores what clothing reveals about people in America and Britain during the eighteenth and early nineteenth centuries. This period was a formative one that included the colonial era, the war for American independence, and the early years of the new United States. The volume examines the clothing of poor and rich, infant and adult, slave and free. Some of the garments are functional and mundane; others, glamorous (fig. 2).

Clothing provides a remarkable picture of the daily lives, beliefs, expectations, and hopes of those who lived in the past. People of all eras (including those living today), use clothing not only to meet functional needs, but also to communicate. The language of clothing speaks of status, occupation, aesthetics, social cohesiveness, propriety, and a host of other meanings, subtle and overt. By considering the realities and myths about eighteenth- and early nineteenth-century clothes, people today may discover something about themselves, their historical roots, and their own relationship to wearing apparel.

The study was based on the antique artifacts and archives at the Colonial Williamsburg Foundation in Williamsburg, Virginia. Many fine books and museum exhibition catalogs describe and identify beautiful costumes in considerable detail. The goal here is to put the garments, including ordinary ones, into the context of the human beings who made, purchased, wore, and saved their clothing. Colonial Williamsburg has long held the interpretive goal of making history relevant and meaningful for its visitors. What better ways to do this than to col-lect, display, and describe artifacts that were part of the intimate, daily lives of their ancestors: clothing that touched and that was, in turn, shaped by their bodies?

The Colonial Williamsburg costume collection is a particularly rich resource. Begun during the 1920s, the collection today numbers more than ninety women's gowns, some of which still retain their matching stomachers and petticoats. About fifty-two of the gowns date from the eighteenth century and another ten gowns were restyled in the nineteenth century from eighteenth-century materials. Thirty-four petticoats, many quilted in elaborate designs, and numerous decorated stomachers demonstrate how women mixed and matched garments to add variety to their wardrobes. The collection of men's clothing includes twelve three-piece suits, an additional nine suits that are missing either breeches or waistcoat, and twenty-seven suit coats. Many pairs of breeches, waistcoats, and shirts round out the men's holdings. Children's costumes number more than fifty dresses or frocks, seven of which date from the eighteenth century, and five boy's suits. Thousands of accessories and individual garments, such as caps, shoes, aprons, purses, handkerchiefs, fans, and underwear, add variety and depth. The story is incomplete to the extent that collections, resources, and knowledge continue to be developed.

Most of the garments illustrated here have been part of an exhibition held at the DeWitt Wallace Decorative Arts Museum in Williamsburg, Virginia, from October 26, 2002, through October 26, 2003.

Fig. 2. Gown and petticoat, France, 1780–1790, silk embroidered with silk, trimmed with silk edging and lace, bodice lined with linen, G1991-470, gift of Mrs. Cora Ginsburg.

Exquisite embroidered iris flowers are shaded in subtle tones from purple to lavender accented with yellow and salmon colors. The lustrous striped silk textile adds texture and interest to the unembroidered areas. Past artistic works sometimes held significance that is lost today. Flowers, for example, often had symbolic meanings. Eighteenth-century floral emblem books stated that the lily or iris meant beauty or bashfulness. Did the original wearer of this gown consider the embroidered flowers symbolic or just another pleasing motif?

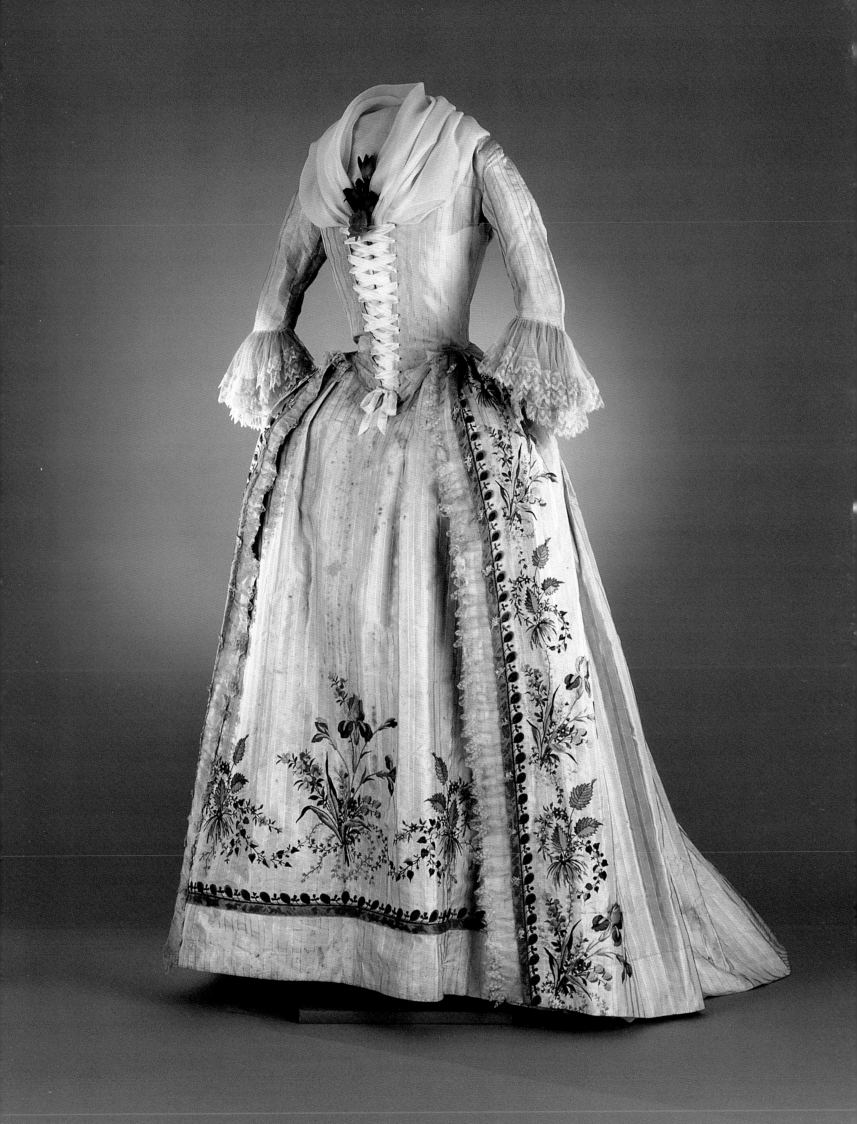

ACKNOWLEDGMENTS

Many generous individuals have shared and supported my goal to publish a major portion of Colonial Williamsburg's exceptional costume collection. I am especially grateful to Pleasant Rowland for providing important seed money for the research and writing phases of the project. The DeWitt Wallace Fund for Colonial Williamsburg provided further support for the curatorial and conservation activities conducted at Colonial Williamsburg, including conservation of costumes for photography and exhibition. Many generous individuals and corporations underwrote printing costs. I acknowledge with deep gratitude the contributions of The Bernstein Family Foundation, Dr. J. Paul and Betsy Bullock, Dr. William A. Chantry, Peter D. Deen, Dynamic Air Engineering Company, Dorothy S. and Charles T. Freeman, Mary T. and Clinton R. Gilliland, Dorothy L. and Andrew R. Haramis, and Kathryn Krotseng.

Numerous other individuals donated important works of art during the more than seventy-five years of Colonial Williamsburg's existence. The important contributions by donors to the museum are discussed and illustrated in the Introduction, and their names are listed in the photo captions. I know that readers who experience the joy of seeing an important or beautiful costume add their thanks for the munificence of countless museum benefactors.

Every museum curator stands on the shoulders of earlier staff members who collected and researched the artifacts we now enjoy studying, exhibiting, and sharing with the public. I especially acknowledge the contributions of former curator Mildred B. Lanier, a respected textile specialist and scholar. Mildred not only added wonderful costumes to the collections, she also shared with me many of the skills she had learned during her long tenure with the Colonial Williamsburg Foundation.

During my past twenty-four years as associate curator and later curator of textiles and costumes at Colonial Williamsburg, my fellow staff members have given unequaled support and encouragement. Although busy with their own duties, they always took the time to help others and freely shared historical references and insights. I am especially fortunate to have the assistance of associate curator Kimberly Smith Ivey, who combines scholarly expertise and research skills with outstanding organizational ability, a willingness to get difficult jobs done on time and with good cheer, and a charming personality. While doing her own research on samplers, needlework, and other aspects of textiles, Kim took on the numerous day-to-day duties while I was researching and writing about costumes; this book could not have been published without her help. Both Kim and I appreciate very much the help of two talented volunteers, Carol Harrison and Julie Stanton, who willingly assist with many important projects and daily activities.

Early in this project, former vice president and chief curator Graham Hood was instrumental in shaping the direction this publication would take. Graham gave me stacks of articles to read and asked difficult questions about the meaning of clothing in the eighteenth century. He always encouraged his staff to do their best research, to dig a little deeper, and to reach their highest potential in whatever project they undertook. I thank Graham for his input and support during the important formative stages of this book.

Ronald Hurst, current vice president and Carlisle Humelsine Chief Curator, has continued to encourage important artifact studies and publications on the part of his employees. I thank Ron for the innumerable ways he facilitated the research, writing, and publication of *What Clothes Reveal*. Having just completed his own book and exhibition, Ron knew what was involved and was able to guide me through periods of discouragement and long hours, as well as to share the exhilarating times.

Photographs and illustrations are as important to decorative arts books as words are. Museum photographer Hans Lorenz is credited with the stunning photography of all Colonial Williamsburg artifacts illustrated in this volume. I very much appreciate and admire Hans's skill and patience with a Herculean task. Craig McDougal ably assisted in many aspects of the photography and film processing. Tracey Stecklein, Eunice Glosson, Anne Motley, Marianne Martin, Laura Arnette, and volunteer Barbara Bilderback performed essential tasks with regard

to photography, including scheduling; cataloging, labeling, and filing photographs and slides; and making images available for publication in a timely manner. John R. Watson photographed the microscopic views of four textile fibers on page 43. Natalie Larson did the excellent drawing of the altered waistcoat on page 195. Other drawings are those of the author.

Greer Allen and Jo Ellen Ackerman created a book that is a visual masterpiece in its own right. It was a joy to watch such talent at work.

Talented conservators rose to the challenge of treating and mounting hundreds of pieces for photography and exhibition. Textile conservator Loreen Finkelstein displayed outstanding ability in planning, overseeing, and coordinating the work of a small army of assistants, interns, and volunteers. For their hard work and talented contributions in the textile laboratory, I thank Kathie Ballentine, Karen Cummins, Kiliaen Parks, Judy Randazzo, Emily Wilson Roberts, Sarah Taylor, Rebecca Tinkham, Doreen Ungate, Renee Walker, and Gladys Zhoroff. David Blanchfield, conservator of metals, Valinda Carroll, Marshall Steel intern, Emily Williams, conservator of archaeological artifacts, and Pamela Young, conservator of paper, treated jewelry, fans, leather artifacts, and works on paper expertly and sensitively.

Florine Carr, my friend and colleague from Houston, Texas, spent many hours helping to analyze and catalog the costumes. We shared wonderful discoveries as we peered at seams, selvages, fibers, and weave structures. Florine played a coequal role in our discovery that an unusual costume was, in fact, a rare maternity ensemble. She also helped to detect many of the alterations to objects in the collections.

Without the efforts of my colleagues in the Publications Department, under the dedicated direction of Joseph N. Rountree, there would be no book. They worked long hours behind the scenes writing contracts, communicating with designers and copublisher, editing, checking color, proofreading, photocopying, and mailing galleys. Special thanks go to my hard-working editor, Erin Michaela Bendiner, who displayed the admirable qualities of being organized, meticulous, thorough, and careful in all phases of the manuscript. Erin's creative ideas shaped the book in many positive ways. Helen M. Olds's talent for design and color assured that the color separations were as accurate as possible. Volunteer John B. Ogden worked many hours helping to check footnotes and

extracts and doing proofreading. Volunteer Catherine C. Swormstedt also did careful proofreading. I acknowledge with deep appreciation the assistance of Donna Sheppard, whose perspective and experience proved invaluable to me, and Julie A. Watson, who cheerfully prepared materials for mailing and performed many other tasks in the office.

I am especially gratified for assistance from my friends and colleagues in the Costume Design Center, directed by Richard Hill, and the Historic Trade Shops, directed by Jay Gaynor. Brenda Rosseau of the Costume Design Center was generous with her time and talents as she designed and sewed reproduction ruffles, underpinnings, and accessories for the mannequins. Nancy Glass assisted in many ways with this project. Janea Whitacre, milliner-mantua maker, provided beautiful handmade reproduction accessories for some of the mannequins.

Colleen Callahan, curator of textiles and costumes at the Valentine Museum, made many excellent suggestions that considerably strengthened the manuscript. I have long respected Colleen's knowledge, collegiality, and curatorial expertise, and am honored that she was willing to invest the time to be my reader. Jocelyn Sheppard and Joan Sweeney read the Leatherstocking discussion in chapter 2 and made excellent suggestions.

Jan K. Gilliam did a thorough and useful index for the book. She also served an essential role in helping to organize and mount the exhibition, reviewing label copy, and serving as liaison between Museums and the Collections Department to ensure that the exhibition stayed on schedule.

Many other people assisted in various ways during the time spent researching and writing the book and mounting the associated exhibition. I thank the following individuals for their help over the years: Olivia Alison, Charles D. Anderson, Janet Arnold, Trish Bare, Laura Pass Barry, Lynne Bassett, Bob Becker, Leslie Bellais, Regina Blizzard, Clare Browne, Mary Ann Cappiello, Cary Carson, Deborah Chapman, Stanley Chapman, Stephanie Conforti, Mary Cottrill, John D. Davis, Linda Eaton, Patricia Gibbs, Nancy Gibson, Harold Gill, Margie Gill, Maureen Graney, Wallace Gusler, Gail Greve, Cathy Grosfils, Rick Guthrie, Rick Hadley, Titi Halle, Carol Harrison, Sophia Hart, Pat Hearn, Wendy Hefford, Jan Hiester, Velva Henegar, Sarah Houghland, Brenda Howard, Martha Katz-Hyman, Stevie Kauffman, Claudia Brush Kidwell, Brenda LaClair, Betty Leviner,

Ann M. Lucas, Barbara Luck, Terry Lyons, Jane Mackley, Gloria McFadden, David Mellors, Philip D. Morgan, Betty Myers, Trudy Moyles, Susan North, Alden O'Brien, Chris Paulocik, Margaret Pritchard, Phyllis Putnam, Clare Rose, Natalie Rothstein, Al Saguto, Joan Severa, Susan Shames, Patricia Silence, Janine Skerry, Kay Staniland, Julie Stanton, Lucinda Stanton, Susan Stein, Henry G. Taliaferro, Naomi Tarrant, Donald Thomas, Gayle Trautman, Jessica Tyree, Nancy Ward, Carl West, Christina Westenberger, Joan Winder, and George Yetter.

Portions of the text of *What Clothes Reveal* were adapted from work published previously. I am grateful to the editors of the following for permission to reprint or adapt sections of my articles: *Dress*, the journal of the Costume Society of America, for "Altered Historical Clothing," "Under Waistcoats and Drawers," and "Dressing for Pregnancy"; *The Magazine Antiques* for "Dolls and Doll Clothing at Colonial Williamsburg"; *Journal of Early Southern Decorative Arts* for "'Clothes for the People,' Slave Clothing in Early Virginia"; *American Material Culture, The Shape of the Field* and the Henry Francis du Pont Winterthur Museum for "Leather Stockings and Hunting Shirts." For full citations, please refer to the Selected Bibliography.

Finally, my deepest gratitude goes to my husband, John R. Watson. His creative and philosophical ideas about artifacts as primary documents and their importance to our study of history have greatly influenced my own thinking and writing. John made many excellent suggestions for improvements to the manuscript. His attentive listening, his belief in me, and his constant love have given me strength and confidence.

(OPPOSITE) *Brocaded silk dress textile, France, 1730-1740. See fig. 334.*

INTRODUCTION
Collecting Costumes at Colonial Williamsburg

The very first garment purchased by Colonial Williamsburg in 1930, an antique dress made of crisp silk, came from the collection of a Richmond, Virginia, woman (fig. 4).[1] Brocaded on the loom in a pattern of flowers and unusual flying insects, the gown must have made a striking statement when it was first worn. The long, full skirt sets off a trim waistline, topped by a wide neckline intended to display elegant shoulders. At the time of purchase, the silk of the gown was dated to the 1780s, although staff noted that the garment was "recut and altered." In fact, the dress was altered in the 1840s from much earlier fabric dating around 1750.[2] Although the gown's full history—who first wore it, when and why the dress was set aside, and who brought it out of storage to wear almost a hundred years later—is not known, the garment may have a Virginia history.

Survival of this or any artifact for hundreds of years usually favors the beautiful and the unusual. People treasure objects that have significance, such as baby's first shoes, wedding dresses, handmade items, and clothes worn by famous ancestors (see figs. 30–32). Further selection occurs when each generation decides what to save from all that has survived. The collecting policy of a historical society or regional museum may focus on clothing worn in the local community. An art museum's holdings may be limited to high style and designer examples. Colonial Williamsburg emphasizes collections that relate to the Anglo-American community of the eighteenth century, yet also extending back into the seventeenth century and ahead into the nineteenth century. Although the Colonial Williamsburg collections include masterpieces, curators have not sought to collect costumes solely as fine art, but rather to preserve examples of what Americans might have worn, what fashion-conscious colonials knew, and what they aspired to (see sidebar, p. 5). Many costumes serve as documentation and patterns for reproduction clothing worn by interpreters in the Historic Area, a program that began in the 1930s.

Throughout the history of the institution, important gifts and purchases lent richness and variety to the Colonial Williamsburg collections. Countless individuals donated or sold one or two family pieces, perhaps found in trunks or dresser drawers, to ensure their preservation and availability for future generations (fig. 5). Similarly, costume and textile collectors chose Colonial Williamsburg as a home for their lovingly assembled artifacts. Curators scoured auction catalogs and visited dealer's shops to round out Colonial Williamsburg's holdings and to expand its capacity to interpret the past. The costumes in the collections are an archive of designs, techniques, and stories, available for study today and far into the future.

Fig. 3. Men's waistcoats from the collection of Doris Langley Moore, left to right, Pink waistcoat, Britain, 1770–1780, silk and silver tissue edged with sequins, lined with silk and linen, 1960-710; Cream waistcoat, Britain, 1770–1780, silk embroidered with silk, metal purl, sequins, and paste, lined with silk and linen, linen back, 1960-711; Pink waistcoat, Britain, 1775–1785, silk trimmed with silk and metallic embroidery and sequins, lined with linen, 1960-707.

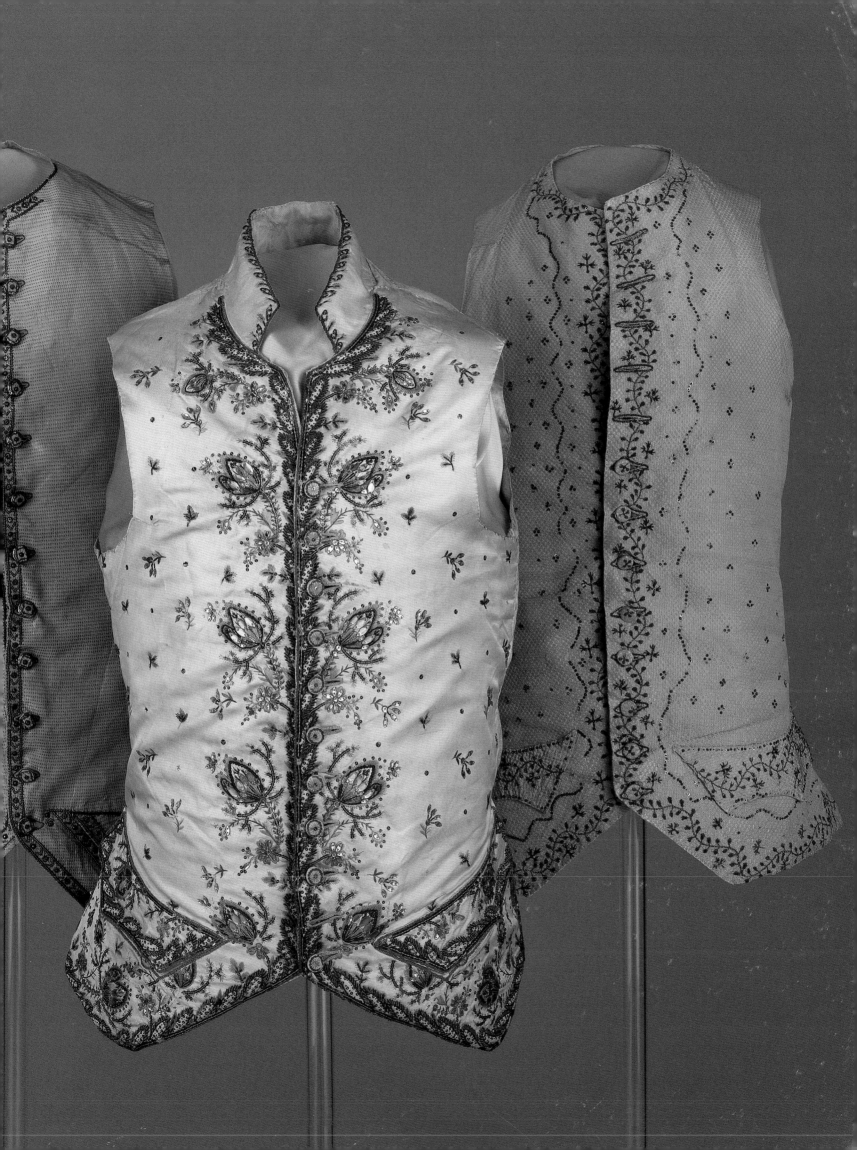

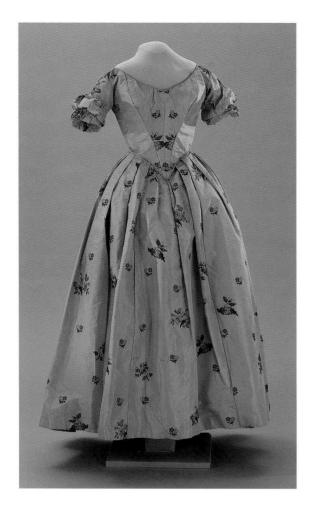

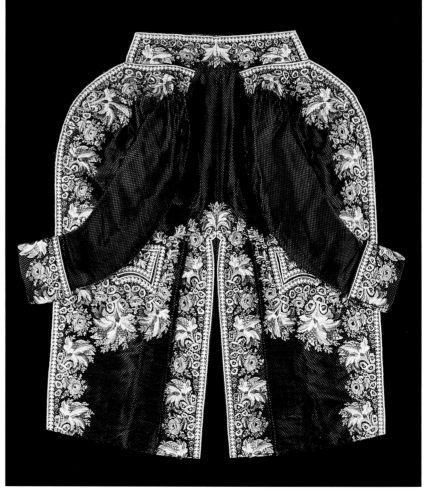

Fig. 4. (LEFT) Dress, English textile, probably worn in Virginia, silk textile ca. 1750, remodeled 1840s, brocaded silk lined with linen and cotton, metal boning, 1930-367.

Many eighteenth-century clothes lasted for decades. This brocaded textile, woven in a design of insects and flowers, was remodeled to wear more than ninety years after the material was first made into a garment. Colonial Williamsburg added the dress to the collections in 1930.

Fig. 5. (BELOW) Formal or court suit coat, France, 1790–1820, silk velvet embroidered with silk, lined with silk, interlined and padded with wool and cotton batting, cotton pockets, G1971-433, gift of Mark A. Clark.

Eighteenth-century formal suits were often masterpieces of the embroiderer's art. This suit coat of rich blue cut and voided silk velvet is strewn with colorful flowers that are beautifully designed and worked with great skill. The donor recalls that his grandmother kept a collection of clothing, purchased from local Dayton, Ohio, auctions, in the attic for her grandchildren to use when dressing up in costume. The breeches to this suit were ruined during a Halloween foray into a nearby farmer's melon field. The farmer shot rock salt into the seat of the retreating twelve-year-old grandson.

Accessioning is the lengthy process of bringing an object into a museum's collections. Artifacts may come from many sources, including auctions, antique shops and dealers, Internet auction sites, and private individuals, many of whom donate important family possessions to ensure their preservation. Take, for example, a man's waistcoat recently added to the Colonial Williamsburg collections (figs. 6–7). A staff member, in this case the textile curator, locates the waistcoat in a costume dealer's inventory and begins the research process. The waistcoat is brought to Colonial Williamsburg for detailed examination, at which time the registrar records its presence and gives the owner a receipt. Working with colleagues in conservation and historical archives, the curator researches the waistcoat to determine its authenticity, provenance (origins and history), and suitability to the collecting policy and goals of the Colonial Williamsburg Foundation, as set by the board of trustees. Once satisfied that the waistcoat meets all requirements, the curator presents it to the accessions committee. Committee members must consult with those overseeing the budget to make certain Colonial Williamsburg can afford the expenditure. Often, generous donors make the purchase possible. After a favorable vote, the curator fills out an accession form for the permanent record, recording the waistcoat's description, condition, and measurements and the reason for bringing it into the collections. The registrar then assigns the waistcoat accession number 1994-152, creates a permanent file that contains all documents pertaining to its acquisition, enters the bibliographic, location, and valuation information into a computer database, and schedules photography. The accession number remains with the waistcoat permanently to allow Colonial Williamsburg to track the garment's location and condition at all times. After accessioning, the waistcoat goes to conservation for a condition survey, then into storage until it is exhibited. The fragility of a textile necessitates rotation to storage, where it remains an important archival document of historic styles and techniques.

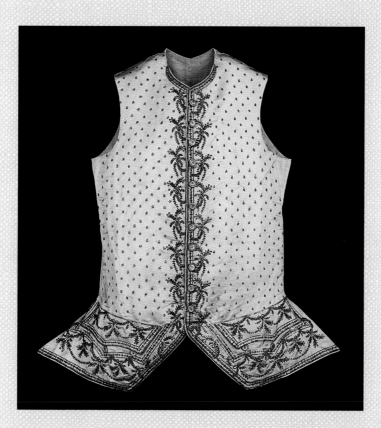

Figs. 6–7. Waistcoat, overall and detail of embroidery, Europe, 1770–1780, silk satin embroidered with metallic threads, sequins, and paste, lined with linen-cotton, 1994-152.

The beauty and intricacy of the embroidered design and the superb condition of this waistcoat made it an excellent candidate for inclusion in Colonial Williamsburg's costume collections.

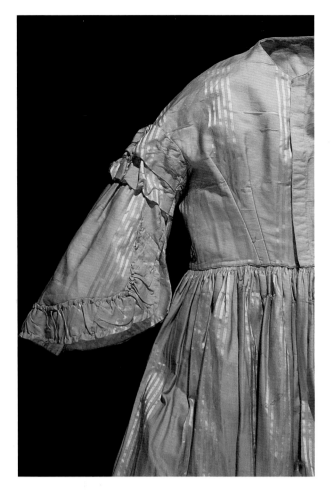

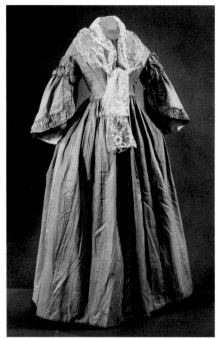

Figs. 8–9. Dress, overall and detail of sleeve, United States, ca. 1860, wool and silk challis lined with cotton and silk, boning, linen bobbin lace scarf, 1935-370.

Although the initial goal of Colonial Williamsburg was to restore the eighteenth-century Virginia town and assemble artifacts from that period, this early addition to the collections (the second dress accessioned) dates to around 1860. The wide sleeves are trimmed with self-fabric strips and piping. The lace scarf was not originally worn with the dress.

At the time the first dress was purchased in 1930, the "Williamsburg Restoration," as it was then known, was in its infancy. Four years earlier, philanthropist John D. Rockefeller, Jr., at the urging of Reverend William A. R. Goodwin, had purchased the first of many eighteenth-century buildings that would culminate in the reconstruction of an entire colonial town. Rockefeller also supported the acquisition of an exceptional collection of decorative arts. By the 1930s, the small southern town of Williamsburg was already on its way to becoming a tourist destination, an arbiter of Colonial Revival taste in home furnishings, and a world-class museum. The town was blessed with not only many original eighteenth- and nineteenth-century buildings, but also an important legacy as the eighteenth-century capital of the Virginia colony, a vast area that included present-day Virginia, West Virginia, Kentucky, Ohio, Indiana, Illinois, Michigan, and Wisconsin. George Washington, Thomas Jefferson, and Patrick Henry walked the

streets, debated politics in the taverns, and developed many of the ideas that later defined the new United States.

Despite an early emphasis on eighteenth-century history and artifacts, the second dress added to the collection five years later was from the nineteenth century (figs. 8–9). The beige challis woman's gown has a high neckline, hourglass shape, and wide pagoda sleeves characteristic of the style around 1860.[3]

One of the most important early clothing accessions was a woman's three-piece ensemble purchased in 1936. The original dealer's invoice described it as "a quilted costume of early eighteenth century in three pieces."[4] Curators quickly realized that the outfit dated later than the early eighteenth century, but it took sixty years to discover that the costume was an exceptionally important maternity gown (see sidebar, p. 153). So few maternity

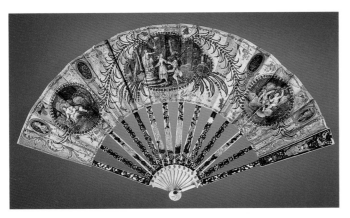

Fig. 10. (*ABOVE*) *Fan, France or Holland, 1770–1780, ivory, silk, paint, metallic threads, sequins, mica, and paste, 1936-599. This fan is painted and embroidered with scenes emblematic of love and marriage.*

Figs. 11–12. (*RIGHT*) *Gown and petticoat, overall and detail of skirt and petticoat, Gown, Britain, silk textile 1745–1750, remodeled ca. 1780, silk brocaded with silk, bodice lined with linen and linen-cotton, boning, reproduction kerchief, 1941-211, 1; Petticoat, Britain, 1750–1775, silk quilted to wool backing and batting, 1941-211, 2. The brocaded pattern of this silk textile has scattered flowers typical of the late 1740s, although the cut of the gown indicates later remodeling. In the brocading process, a design is woven into the ground using extra bobbins of colored silk or metallic threads. The reverse of a brocaded textile reveals that the supplementary threads are limited to the pattern area, not carried across from edge to edge.*

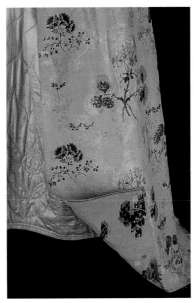

gowns survive that curators did not easily recognize the eccentric construction of the ensemble.

During the first ten years, Colonial Williamsburg collected small costume items such as pocketbooks, gloves, razors, shoe buckles, spectacles, and fans to accessorize the buildings (fig. 10). Early in the 1940s, James Cogar, the general curator of decorative arts, began to purchase larger clothing items from dealers such as Alice B. Beer of New York and Mary Allis of Connecticut. Cogar's efforts added significant costumes to the collection, including men's suits, a man's brocaded silk banyan with a matching waistcoat, and women's silk gowns and petticoats (figs. 11–12 and see figs. 158 and 283–284). Although many early accessions had been altered prior to purchase by Colonial Williamsburg, they remain in the collections as valuable tools to study the evolution of construction and for their glorious period textiles.

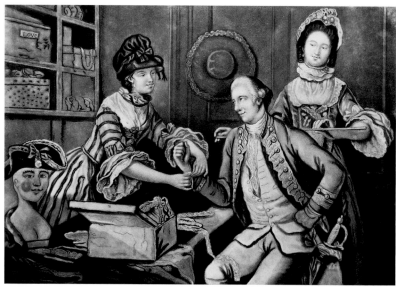

Figs. 13–14. (*BELOW AND LEFT*) *Wedding gown, overall and detail of skirt and petticoat trim, London, England, ca. 1778, silk taffeta trimmed with silk bobbin lace, bodice lined with linen, lace scarf, and eighteenth-century sleeve ruffles, G1946-133, gift of George B. Baylor.*

According to family history, Frances Norton wore this gown when she married John Baylor in London in 1778. The couple moved to Caroline County, Virginia, where the dress descended in the family.

Fig. 15. (*ABOVE*) *THE RIVAL MILLINERS, engraved by Robert Laurie after a painting by John Collet, printed for Robert Sayer, London, England, 1772, mezzotint engraving on paper, 1955-125.*

A fashionable milliner measuring her customer's wrist for a ruffle wears a black hat similar to that in fig. 16. The other milliner measures the man's shoulder width using an ellwand, a type of marked measuring stick.

During the 1940s, the first firmly documented Virginia gown came into the collections (figs. 13–14). Donated by descendants of Frances Norton, the gown may have been her wedding dress when she married Colonel John Baylor. Although too fragile to exhibit, pieces such as this silk gown can reveal answers about textile availability, clothing construction methods, and colonial style preferences.

The 1950s brought another burst of costume collecting. Museum staff purchased clothing, accessories, and prints for the Margaret Hunter Millinery Shop, scheduled to open as an exhibition site (figs. 15–16). Across the street at the Wigmaker, the public could watch as trained craftspeople made wigs by hand. Colonial Williamsburg purchased a rare barber's shaving apron, prints of shop interiors, and wig accessories to lend authenticity to the interior (figs. 17–18).

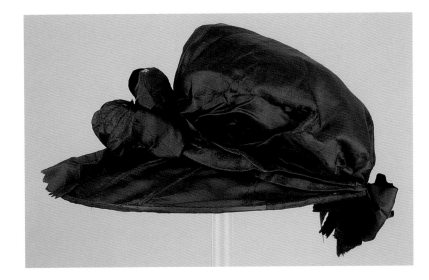

Fig. 16. (LEFT) Hat, Britain, 1770–1780, silk, whalebone, 1993-335.

This rare survival has a puffed crown and bill stiffened with whalebone stays. Although hats of this style were known from prints of the 1770s and 1780s, it was not until the 1990s that Colonial Williamsburg located an example for the collections (see fig. 15).

Fig. 17. (BELOW) Shaving or dressing apron, probably France, 1750–1775, cotton block printed and mordant painted with pencil blue and overprint green, marked with silk cross-stitches, 1951-482.

Gentlemen wore aprons to protect their clothing while getting shaved or having their wigs powdered, as in fig. 18. The block-printed textile in this example imitates more expensive Indian chintz textiles. The initials L. H., probably indicating the printing firm, were incorporated in two places during the printing. Meticulous cross-stitched initials and the number 3 are worked into one corner to help identify the owner after the apron was sent out for laundering.

Fig. 18. THE ENGLISHMAN IN PARIS, engraved by James Caldwell after a painting by John Collet, printed for John Smith and Robert Sayer, London, England, 1770, hand-colored line engraving on paper, 1940-174.

In this scene that satirizes the British response to French fashions, a sturdy Englishman is enduring the torture of having his wig powdered by a dandified French barber-hairdresser. An apron similar to that in fig. 17 protects the customer's clothing from stray powder.

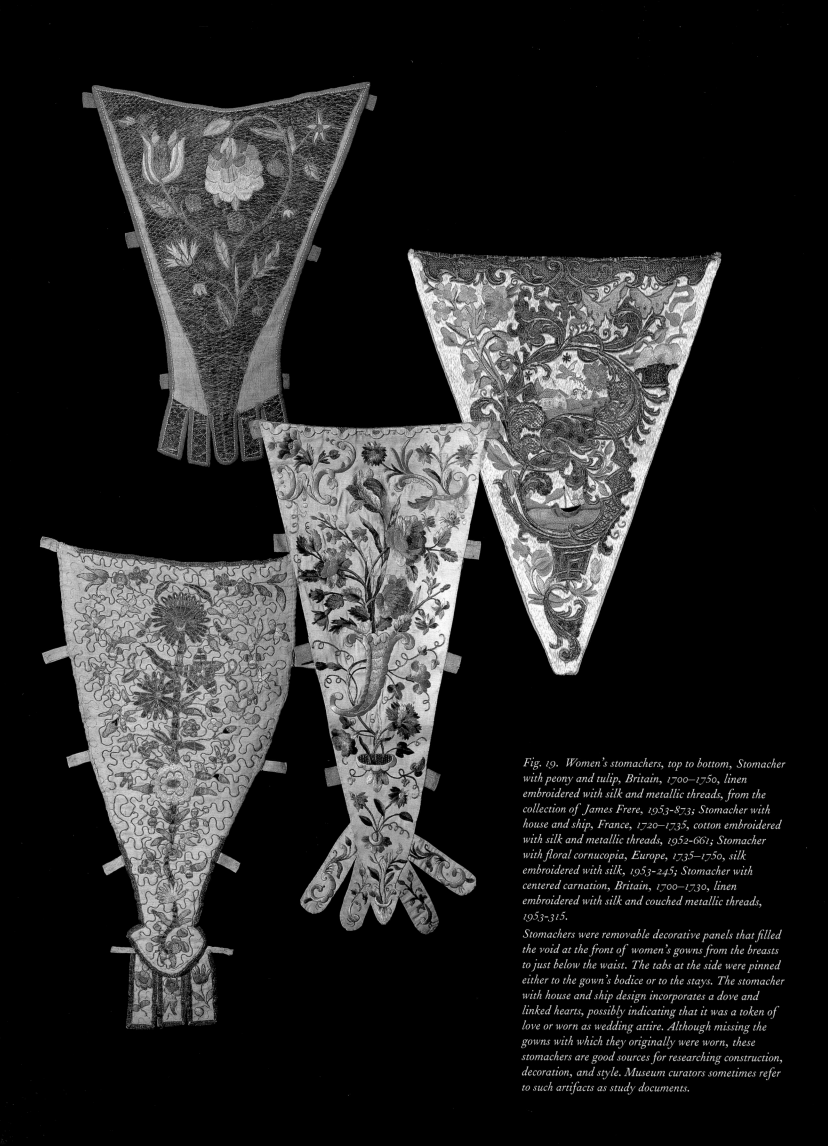

Fig. 19. Women's stomachers, top to bottom, Stomacher with peony and tulip, Britain, 1700–1750, linen embroidered with silk and metallic threads, from the collection of James Frere, 1953-873; Stomacher with house and ship, France, 1720–1735, cotton embroidered with silk and metallic threads, 1952-661; Stomacher with floral cornucopia, Europe, 1735–1750, silk embroidered with silk, 1953-245; Stomacher with centered carnation, Britain, 1700–1730, linen embroidered with silk and couched metallic threads, 1953-315.

Stomachers were removable decorative panels that filled the void at the front of women's gowns from the breasts to just below the waist. The tabs at the side were pinned either to the gown's bodice or to the stays. The stomacher with house and ship design incorporates a dove and linked hearts, possibly indicating that it was a token of love or worn as wedding attire. Although missing the gowns with which they originally were worn, these stomachers are good sources for researching construction, decoration, and style. Museum curators sometimes refer to such artifacts as study documents.

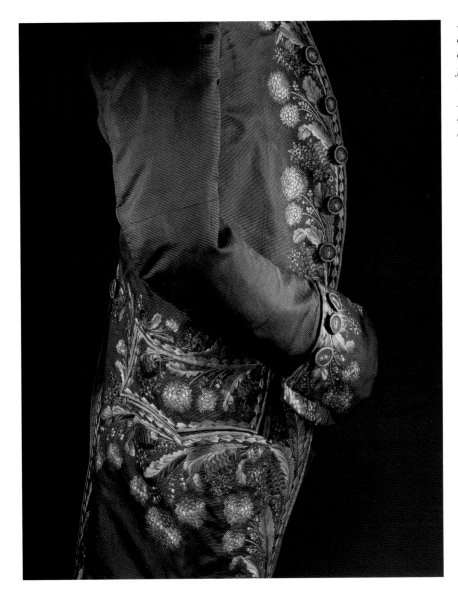

John Graham, curator in the 1950s, enhanced the collections in all areas. He sought additional pieces with American histories and enthusiastically bought overseas, which brought Colonial Williamsburg to the attention of foreign dealers and collectors. Under Graham's leadership, the holdings at Colonial Williamsburg expanded to include more women's gowns, men's clothing, underwear, work clothing, unmade study documents such as waistcoat pieces, and the important Bennett collection (see chap. 1 and figs. 37 and 180). Colonial Williamsburg also added numerous smaller articles and accessories, including pocketbooks, shoes, headwear, and stomachers to the collections (fig. 19).

In 1953, Michael Harvard of London offered to sell to Colonial Williamsburg a clothing collection that James Frere of the British College of Heralds had amassed. Harvard wrote that he had "a collection of mid-eighteenth century costumes. . . . It was got together some years ago by a private collector and just before the war [World War II] the costumes were all on loan to the London Museum at Lancaster House. Now, as you know, the London Museum is housed in much smaller accommodation at Kensington Palace and they have not room to exhibit them."[5] Curator John Graham purchased thirty-eight pieces from the Frere collection for Colonial Williamsburg, including clothing accessories, a little boy's rare linen suit, women's silk gowns and jackets, and men's velvet and embroidered silk suits (fig. 20 and see fig. 248).

In the early 1960s, curators continued the trend of adding individual study documents to the Colonial

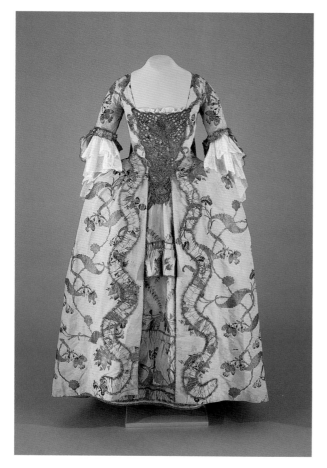 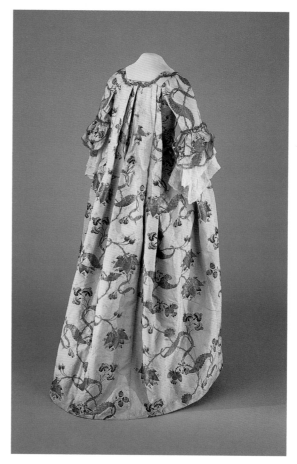

Figs. 21–22. Gown, stomacher, and petticoat, front and back, Britain, silk textiles 1745–1750, remodeled ca. 1770, silk brocaded with silk and silver gilt threads, stomacher trimmed with silver-gilt lace and silk flowers, bodice lined with linen, sleeves lined with silk, reproduction neck ruffle, 1968-646, 1–3; Sleeve ruffles, Britain or Continental Europe, 1770–1785, cotton embroidered with linen, 1985-128.

Despite remodeling that is especially evident in the piecing of the sack back, this gown has superlative beauty. The heavily embellished gold stomacher and gilt brocading threads glitter in the light. Wavy lines of applied trim add extra pattern to the already lavish skirt front. The petticoat, or skirt worn beneath the outer gown, is made of a different silk textile, possibly because the original petticoat was cut up for the remodeling.

Williamsburg clothing collections. Especially beautiful examples include ten men's waistcoats, most embellished with needlework, which are excellent studies in decorative techniques and style evolution. They display great variety in their embroidery and encompass several stylistic periods (see fig. 3).

Many items acquired in the 1960s and 1970s had American histories. Josiah Bartlett of New Hampshire, signer of the Declaration of Independence, wore the black felt cocked hat that was purchased in 1960 (see fig. 30). The Foundation purchased a large collection of furniture, paintings, and other decorative arts from the Glen and Sanders families that included costume items such as women's shoes, a man's waistcoat, an apron, and chil-

dren's clothing worn in New York during the eighteenth and early nineteenth centuries (see figs. 228, 237, and 359).[6] Some new acquisitions had Virginia histories. Made during the American Revolution, a homespun wool-and-cotton coat and a pair of cotton breeches had descended from the Pruden or Askew family of Goochland or Isle of Wight County, Virginia (see sidebar, p. 101).

In the late 1960s, curator Mildred B. Lanier recommended several masterpieces for the Colonial Williamsburg collections, including a spectacular formal gown (figs. 21–22). Brocaded with silver gilt on a cream silk ground and further embellished with an elaborate metallic lace stomacher, the gown has self-fabric ruchings that

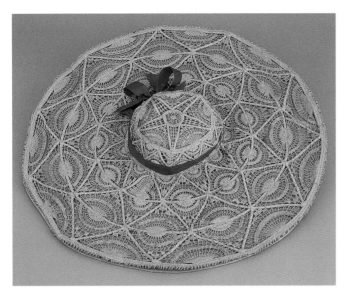

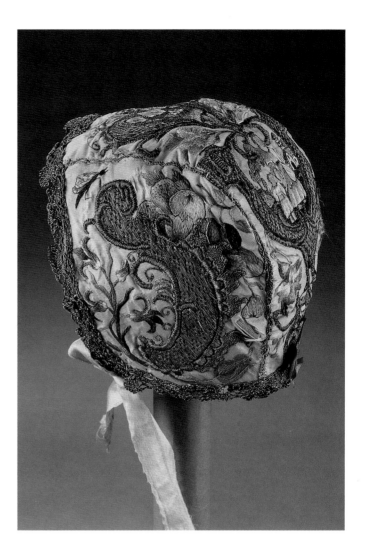

Fig. 23. (ABOVE) Hat, possibly Southeast Asia, worn in Kent, England, 1675–1725, unidentified plant fiber, later ribbon, 1969-265, 1.

This hat descended in the Kennet family, Sellindge, Kent, England. Several other hats of similar design have histories of being owned by British royalty. The origin of such ladies' hats is still a mystery; scholars have suggested Spain, the Canary Islands, Italy, or Bantam in Southeast Asia as possible sources.

Figs. 24–25. (RIGHT) Child's cap, overall and detail of needlework, France, 1710–1730, silk embroidered with silk and silver gilt threads, trimmed with metallic bobbin lace, lined with silk, from the collections of Madam S. E. Rigaud and Mrs. DeWitt Clinton Cohen, G1971-1386, anonymous gift.

The embroidered design on the back of this exquisite cap shows a child attended by a guardian angel. A cap such as this example would be worn for special occasions or for a christening.

undulate down the front of the skirt, echoing the serpentine lines of the rococo silk. A rare hat, acquired in 1969, is made of strawlike fibers woven into a delicate lacy pattern (fig. 23).

A large anonymous gift to the collections in 1971 added numerous needlework tools, study documents of flat textiles, and wonderful costumes, many embroidered or decorated with lace. The gift has an especially strong emphasis in the area of children's garments, including caps, shirts, and a tiny silk suit worn by Dudley Cotton of Massachusetts (figs. 24–25 and see fig. 34). Adults' clothing in the gift includes women's accessories such as stomachers, pocketbooks, and aprons, and men's caps and waistcoats (see figs. 265, 273, and 280).

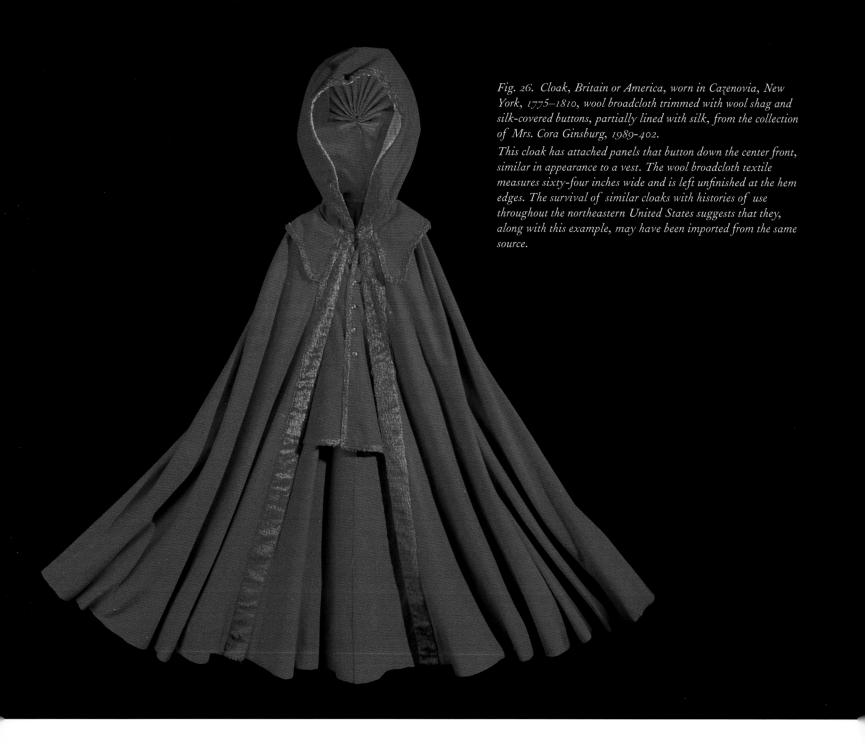

Fig. 26. Cloak, Britain or America, worn in Cazenovia, New York, 1775–1810, wool broadcloth trimmed with wool shag and silk-covered buttons, partially lined with silk, from the collection of Mrs. Cora Ginsburg, 1989-402.

This cloak has attached panels that button down the center front, similar in appearance to a vest. The wool broadcloth textile measures sixty-four inches wide and is left unfinished at the hem edges. The survival of similar cloaks with histories of use throughout the northeastern United States suggests that they, along with this example, may have been imported from the same source.

In the 1980s and early 1990s, Colonial Williamsburg acquired masterpiece costumes and brocaded silks from the private collection of Cora Ginsburg of New York. The Ginsburg collection includes eleven women's eighteenth-century gowns, women's shifts, a hoop petti-coat, men's waistcoats and caps, an American cloak, and incomparable children's garments that are in superb condition and elegantly constructed and trimmed (figs. 26–27 and see figs. 2, 239, 264, and 287–289).[7]

With the accessioning of Tasha Tudor's impressive group of nineteenth-century antique clothing beginning in the late 1990s, the Colonial Williamsburg collections came full circle (see figs. 95, 220, and 388). In addition to some superb eighteenth-century garments, the Tasha Tudor collection is remarkable for its printed cotton dresses from the 1820s through the 1840s. Such garments seldom survived because they were worn, washed, worked in, and worn out. Clothing from the 1800s informs eighteenth-century

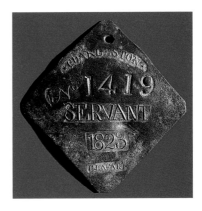

Fig. 27. (LEFT) Waistcoat, France, ca. 1790, silk satin embroidered with silk and chenille, cotton linings, linen-cotton back, G1990-13, gift of Mrs. Cora Ginsburg.

Waistcoats with pictorial subjects of animals, insects, or pastoral scenes became fashionable in the 1780s. This extraordinary waistcoat features cheetahs biting each other in mortal combat. Such waistcoats were the products of professional needleworkers.

Fig. 28. (ABOVE) Slave tax badge, made by John Joseph Lafar, Charleston, South Carolina, 1823, stamped copper, 1990-226.

Periodically during the eighteenth and nineteenth centuries, slaves in Charleston and some other southern cities were required to wear badges when they were hired out for wages. In some cases, the master allowed the slave to keep a small portion of the money earned. Similar to licenses, the badges were sold by the city treasurer and regulated by law. Attempts to control slaves' labor in this manner proved largely unsuccessful.

examples through comparison and contrast. The garments also allow Colonial Williamsburg staff to better interpret folk art portraits exhibited at the Abby Aldrich Rockefeller Folk Art Museum. The costumes gain added significance because the artist used them as inspiration and models for her well-known illustrations.[8]

Colonial Williamsburg's collections are not complete. The Foundation seeks to expand the holdings of artifacts and pictorial sources to include more American examples, especially items from the Southeast, where Williamsburg is located. Curators also want to strengthen the collections in objects used and worn by working people, slaves, Native Americans, children—indeed, all whose clothing seldom survives (fig. 28).

CHAPTER I
COSTUME
Old and New Connoisseurship

People collect many different things for a variety of reasons. Goods change hands at shopping centers, discount outlets, and thrift stores; at booths in antique malls and exclusive antique shops; and at live and on-line auctions. Many who do not consider themselves collectors may still buy more clothing than they need to conform to peers, keep up with new styles, or just because they cannot get enough shoes or hats. Consumers themselves, children accumulate stuffed animals, dolls, action figures, or rocks. Adults reconnect with their own pasts and often discover a window on history through dolls, teddy bears, old toys, or vintage cars. Commemorative plates, coins, stamps, or Christmas ornaments may be an investment, but they also give collectors a sense of completion and accomplishment from assembling a whole series. Those who collect antiques are aware of investment value, yet they also enjoy studying an artifact's history, learning more about the maker and his or her milieu, and viewing the beauty and quality of what has come down from the past. Others are pragmatic, collecting costumes or other historic objects as study documents to learn about technology and design, and to use them as prototypes for accurate reproductions. Collecting often goes hand in hand with connoisseurship, a word that means to be an expert, "one who enjoys with discrimination and appreciation of subtleties," whether it is a stamp collection, fine food, or an antique artifact (see sidebar, p. 22).[1]

Collecting antique costumes is nothing new. Horace Walpole, the great English eighteenth-century antiquarian and correspondent, understood the lure that old clothing had as a connection to the past. An avid collector of costumes and memorabilia, his holdings included Cardinal Wolsey's hat, embroidered gloves that once belonged to King James I, and various suits of armor.[2] Referring to a new acquisition, Walpole called the spurs of King William III "the most precious relics in the world," adding that he had "kissed each spur devoutly." Collectors today understand the special feeling that comes with being the custodian of a rare artifact that brings the past into the present. In the words of Walpole, "who is not rich, who possesses what the world cannot buy?"[3]

Walpole occasionally dressed up in his treasures. In 1769, he received a group of French, Spanish, and Portuguese visitors to his home, Strawberry Hill, "dressed in the cravat of Gibbons's carving, and a pair of gloves embroidered up to the elbows that had belonged to James I." He reported gleefully, "the French servants stared, and firmly believed this was the dress of English country gentlemen."[4] Clearly, the servants could not accurately interpret Walpole's unusual dress.

Fig. 29. Detail of pocket flap from formal suit coat, France, 1770–1800, silk embroidery and appliquéd silk net on striped silk, 1956-306, 1. For overall view, see fig. 76.

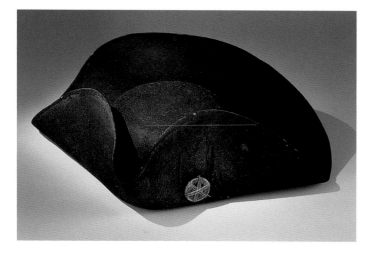

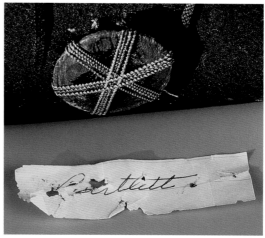

Figs. 30–31. (ABOVE) Man's hat, overall and detail of button, Britain, worn in New Hampshire, 1750–1790, felted fur trimmed with silk, lined with linen, 1960-911.
Josiah Bartlett, one of the men who signed the Declaration of Independence and the first governor of New Hampshire, wore this cocked hat. A nineteenth-century descendant attached the handwritten paper label on which Bartlett's name is written.

Fig. 32. (LEFT) Textile fragment, probably Britain, eighteenth century, early twentieth-century frame, silk stitched to paper, G1970-175, gift of Mrs. Cazenove G. Lee.
According to the inscription, this fragment comes from one of Martha Washington's ball gowns.

Interest in costume history and collecting was in its early stages when Walpole began collecting, and gained momentum at the end of the eighteenth century. Americans, too, saved and cherished their ancestors' clothing, especially notable ancestors. Colonial Williamsburg has many artifacts with histories of use in early America, from the cocked hat of Josiah Bartlett, signer of the Declaration of Independence, to pieces of Martha Washington's dresses; from shoes worn by a woman who danced with George Washington, to the three-piece silk suit worn by the great-grandson of Massachusetts Governor Joseph Dudley (figs. 30–34).

In Britain and America, the vogue for collecting increased with a "patriotic interest in history."[5] The rage for costume dress in historic styles also fueled the desire for information about old clothes. Americans who traveled abroad, such as Virginian Robert Carter, readily participated in the fashion. Carter was painted in his masquerade dress, based on the popular Van Dyck style from the first half of the seventeenth century, during a

visit to London (fig. 35).[6] Other Americans learned about historical styles from imported prints.[7]

The popularity of history painting that depicted subjects from the past peopled with characters dressed appropriately contributed to costume collecting. American history painters wanted to portray their subjects in authentic clothing and occasionally consulted surviving antique garments. When American expatriate painter Benjamin West contemplated a series on the American Revolution in 1783, he wrote to another artist, Charles Willson Peale, for help with researching the uniforms. West asked for "drawings or small paintings of the dresses of the American Army."[8] Perhaps because Peale was something of a collector himself (he opened his own museum in 1784), he included some actual garments borrowed from an acquaintance. Peale sent an old hunting shirt and leggings to West in London, adding, "such our Rifflemen usted [sic] to wear with Powder horn & shot pouch of the Indian fashion, with Wampum Belts, small Round hats & bucks tail and some times Feathers NB: A bit of

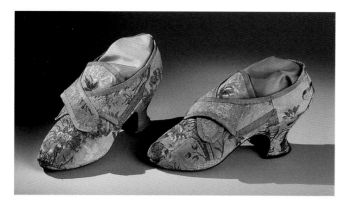

Fig. 33. *Shoes, made by John Hose, London, England, worn in America, ca. 1760, brocaded silk lined with linen, leather soles, 1953-106.*

A handwritten note accompanying these shoes states that they were "Grandmother Bowen's slippers worn by her mother at a ball where she danced with Gen. George Washington." It is not known where the dance took place.

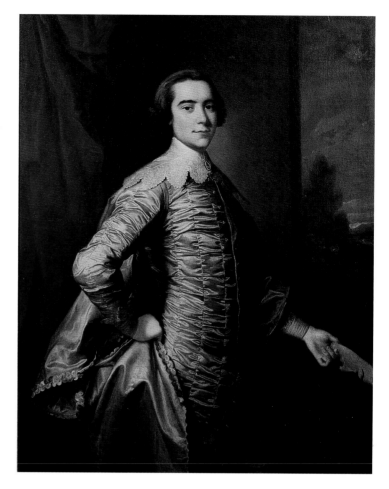

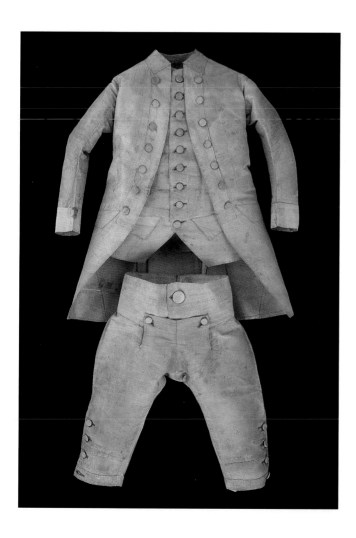

Fig. 34. *(LEFT) Three-piece suit, British textile, worn in Massachusetts, ca. 1776, ribbed silk partially lined with linen, from the collection of Mabel C. Osborne, G1971-1564, anonymous gift.*

According to family history, this tiny suit (the coat measures only twenty-four inches long) belonged to Dudley Cotton, whose great-grandfather was the Massachusetts royal governor between 1702 and 1715. The suit was exhibited in 1876 and again in 1895 as a Revolutionary-era relic. The suit is impeccably tailored of peach-colored silk that has faded to beige.

Fig. 35. *(ABOVE) ROBERT CARTER, by Thomas Hudson, England, ca. 1753–1754, oil on canvas, Courtesy, Virginia Historical Society, bequest of Louise (Anderson) Patten (Mrs. Clarence Wesley Patten).*

Clothing in paintings does not necessarily reflect actual garments worn by the sitters or their everyday dress. Many eighteenth-century portrait artists and sitters chose clothing for its timeless qualities and avoided fashionable garments that would become outdated quickly. When he sat for British portrait painter Thomas Hudson, Virginian Robert Carter posed in a masquerade costume with details borrowed from the styles worn in Anthony Van Dyck's paintings of the seventeenth century.

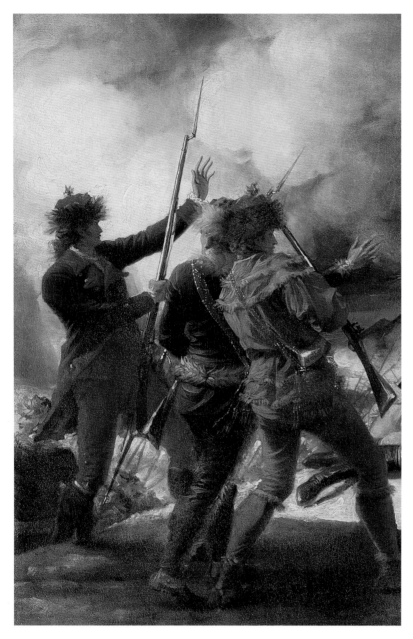

Fig. 36. Detail from THE DEATH OF GENERAL MONTGOMERY IN THE ATTACK ON QUEBEC, 31 DECEMBER 1775, *by John Trumbull, London, England, 1786, oil on canvas, Courtesy, Yale University Art Gallery, Trumbull Collection.*

To achieve accuracy in their work, history painters often researched clothing worn during the events they illustrated. John Trumbull may have based the costumes of these American riflemen on an extant hunting shirt and other Revolutionary War relics collected by his teacher, Benjamin West. Painted more than ten years after the event, this scene commemorates a battle to take Quebec from the British during the Revolutionary War.

fringe instead of the Ruffles on the shirt would be better."[9] Although West never completed his intended work, John Trumbull probably saw the shirt and leggings when he was studying art in West's London studio. One wonders whether Trumbull used them as models for the outfits of three riflemen portrayed in his battle scene, *The Death of General Montgomery in the Attack on Quebec, 31 December 1775* (fig. 36).[10]

One of the early large groups of clothing acquired by Colonial Williamsburg was part of a history painter's personal study collection. Frank Moss Bennett, who lived in Britain from 1874 to 1953, was known for genre and historical subjects, many of which were reproduced on calendars and in other forms of popular art. According to his daughter, who dispersed her father's collection on his death in 1953, Bennett got some of his costumes from another history painter, the Frenchman Jean-Louis-Ernest Meissonier.[11] Colonial Williamsburg purchased more than thirty items from Bennett's collection in 1954, almost exclusively men's apparel, probably because men were the primary subjects of his (and most other) history paintings.[12] The collection includes rarities such as items of servants' livery and eighteenth-century silk suit coats (fig. 37).

The Bennett collection also includes some excellent copies of clothing in the eighteenth-century style. The copies are so well designed that only subtleties of material, condition, interior construction, or cut indicate they are late nineteenth- or early twentieth-century reproductions, not genuine eighteenth-century artifacts. A red coat, for example, shows few signs of wear. The coat is cut too square across the shoulders for the eighteenth-century posture, and the sleeves hang nearly straight, lacking the typical curving over the elbows. Although this coat masqueraded in a museum collection as genuine for forty years, one would not call it a fake because it was almost certainly made to clothe an artist's model, not fabricated to intentionally deceive.

The vogue for painting historical subjects gave impetus to the earliest English published studies of costume. A minor history painter named Joseph Strutt conducted costume research during the 1770s, leading to the publication of the first important English-language history of clothing in 1796. Strutt gleaned information from illustrated manuscripts, not from extant garments. Quoting from various ancient sources, including Herodotus, Homer, Ovid, and the Old Testament of the Bible, Strutt approached clothing from the ethnocentric, somewhat judgmental mind-set of his own day. For example, he believed that men who

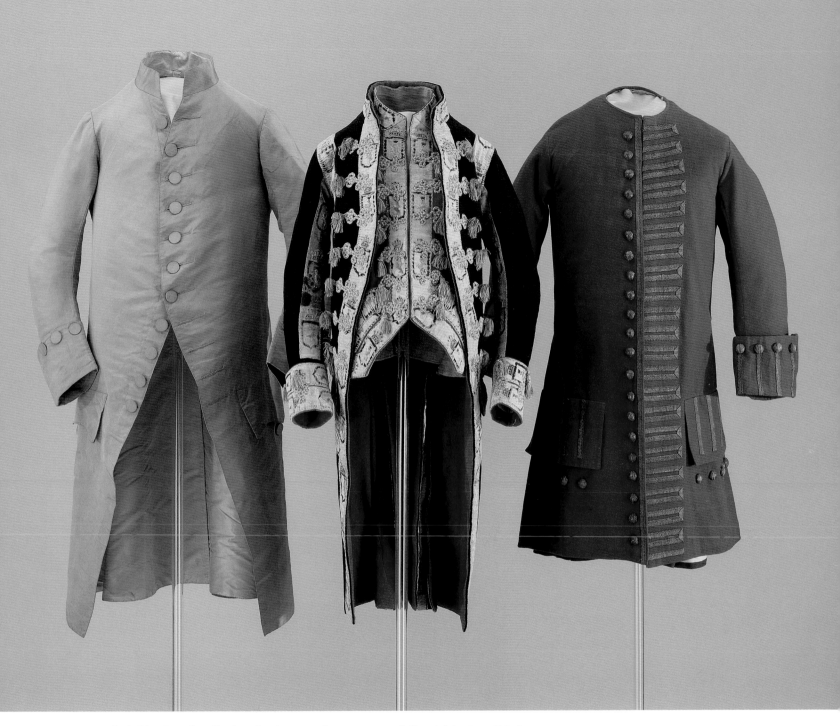

Fig. 37. Men's clothing from the collection of painter Frank Moss Bennett (left to right), Coat, Britain, 1775–1790, ribbed silk lined with silk, linen, and linen-cotton, 1954-1057; Livery coat and waistcoat, Britain, 1810–1850, wool broadcloth trimmed with wool livery lace, lined with wool and linen, 1954-1030, 1–2; Coat, Britain, 1910–1950, wool trimmed with metallic buttons and galloon, lined with linen, 1954-1054.

Twentieth-century history painter Frank Moss Bennett used his collection of antique and reproduction costumes as a visual resource for dressing the characters in his artworks. The coat at the left is sized for a large man with a chest of fifty inches. Although roughly based on an eighteenth-century example, the coat at the right is machine sewn and dates to the twentieth century.

did not wear shirts to bed were indecent. He asserted that, while the pre-eighth-century Anglo-Saxons wore shirts to bed, later medieval men did not. Referring to the latter, Strutt lamented, "one might have expected . . . mankind improved, and decency, at least, established upon a broader foundation."[13] During his own time in the eighteenth century, men slept in generously cut linen or cotton shirts, scarcely distinguishable from, and in some cases the same garment as, their daytime shirts.

James Robinson Planché wrote two influential costume histories published in 1842 and 1876. Like that of Strutt, Planché's books were aimed primarily at artists, actors, and authors who increasingly turned to period sources to achieve a greater degree of authenticity in their historical work. High-minded and serious about the study of history, Planché wrote with some passion that "the sole object of this work is truth as near as it can be arrived at, and the only merit it pretends to is that the pursuit of truth has been assiduously and conscientiously maintained throughout it."[14]

Strutt and Planché studied clothes through secondary sources, those depicted in sculpture, illuminated manuscripts, and paintings. Few, if any, public costume collections existed. This led to misunderstandings in interpreting garments from two-dimensional sources. An inevitable natural selection limited research to the outfits of those most likely to be the subject of paintings or sculpture, famous upper-status men (and a few women) dressed in their best or in clerical garb.

Paintings can, of course, be excellent sources for understanding how people actually wore garments that seldom survive with their complete set of accessories and underwear intact. Paintings show posture and fashionable body shape. A dated painting can help identify the garment that has survived with no history. Nevertheless, modern scholars are quick to point out that the study of dress in paintings must be accompanied by a thorough understanding of genuine period clothing to differentiate between painterly convention and actual clothing.[15] Similarly, knowledge of period clothing can inform art historians who wish to know subtle nuances in paintings (see fig. 35).

People in the twenty-first century see limitations in the work of early costume collectors, historians, and authors, in their methodology and in their self-confidence that

BECOMING A CONNOISSEUR

Connoisseurship, derived from the Latin root *cognoscere*, "to know thoroughly," can apply to professionally trained curators and amateur collectors alike. For instance, Susan, a fictional fan collector, may have begun in a modest way when she inherited her grandmother's fan. The object carries fond associations and helps to keep grandmother's memory alive, yet the intricacy of the fan's decoration and construction also fascinates Susan. She compares it with other fans pictured in books and those displayed in the local museum to learn when and where it was made. Soon, she sees another fan very much like grandmother's in a shop and decides to buy it as a comparison. Then a friend, noticing Susan's fascination with the topic, gives her another fan for her birthday. As a fledgling fan collector, Susan seeks out examples from various periods to give historical context and to represent different materials or styles of decoration. She sees the opportunity to purchase some unmounted fan leaves, perhaps paying a little more than she had planned, but knowing they are rare and wonderful comparisons to her other fans of similar design (fig. 38). Somewhere along the way, Susan has become a fan connoisseur, knowledgeable about the technology, the history, and what makes for a rare survival.

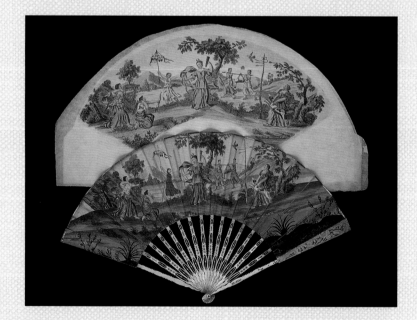

Fig. 38. Fan leaf, Britain, ca. 1760, line engraving, etching, watercolor on paper, 1995-39; Fan, Britain, ca. 1760, ivory, line engraving, etching, watercolor on paper, 1995-38. Both fan and matching unmounted leaf depict the mythological goddess Diana the Huntress.

sometimes bordered on arrogance. If surviving antique garments were consulted at all, they were used in service to activities such as painting or fancy dress. Costumes were routinely worn and often altered to fit the new wearer whose body shape may have been modified by the gentle (and not so gentle) persuasion of fashion, nutrition, and corsets in the later age. Alternatively, costumes, like those in Walpole's collection, were valued as surviving ancient relics of important men and past times, usually considered better or more heroic than the present times. Veneration of age and notoriety for their own sakes blinded collectors to other aspects of an object's history.

Early collectors and authors might be called antiquarians, a title with several meanings. Some sources define the antiquary simply as a student or collector of antiquities, often implying a certain lack of gravity. David Lowenthal, historian and author of *The Past is a Foreign Country*, has defined the "antiquarian disposition" as an "enjoyment of antiques and historical sites, preference for traditional form and design, an appreciation of the cultural creations of the past and a tendency to collect them." Antiquarians have been known to venerate and preserve objects as relics merely because they are old, yet collections of artifacts serve an important function. Lowenthal points out that surviving artifacts or "relics" are "essential bridges between then and now"; he continues that people may respond to them "as objects of interest or beauty, as evidence of past events, and as talismans of continuity."[16]

Traditional connoisseurship had meant identifying the artist or school responsible for a work, discerning originals from copies, and determining good from bad.[17] As early as 1719, an art critic and collector named Jonathan Richardson outlined a method for assessing art objects, primarily as it related to paintings. Richardson discussed concepts such as grace and greatness, invention, expression, composition, coloring, drawing, and handling.[18]

Twentieth-century scholars continued to refine connoisseurship methodology. Charles Montgomery, for many years a teacher in the Winterthur Program in Early American Culture in Delaware, developed a fourteen-step plan that included some of Richardson's original categories. Montgomery's fourteen-step plan urged connoisseurs to analyze the following:

1. Over-All Appearance
2. Form
3. Ornament
4. Color
5. Analysis of Materials
6. Techniques Employed by the Craftsman
7. Trade Practices
8. Function
9. Style
10. Date
11. Attribution
12. History of the Object and Its Ownership
13. Condition
14. Appraisal or Evaluation[19]

Morrison H. Heckscher, an American decorative arts curator and furniture historian, distilled connoisseurship into four essential questions: attribution, authenticity, condition, and quality.[20]

Although, or perhaps *because*, eighteenth-century scholars took the practice of connoisseurship seriously, they limited their study to works of fine art. In the twentieth century, students began to apply connoisseurship to objects with no pretensions of being fine art. People began analyzing decorative arts such as chairs, clothing, and other useful items, asking what the objects themselves could reveal. The artifact became a primary document, as important in its own right as a manuscript in a collection of rare books. By the mid-twentieth century, the field was ready for new methods of decorative arts connoisseurship, and classes began in museum settings such as Winterthur in Delaware, Cooperstown in New York, and Colonial Williamsburg in Virginia. Museum training gave students hands-on experience with antiques.

Contemporary students of decorative arts may specialize in specific aspects of connoisseurship, such as craft technique or trade practice. One such avenue for studying textiles and costume is consumerism, which examines sources of supply, customer demand, how objects are made and distributed, and period trade practices.[21] Because the eighteenth century predates large-scale industrialization and the use of laborsaving devices such as sewing machines, some would conclude that all clothing was custom-made. Others reason that elaborate clothing such as embroidered waistcoats or quilted petticoats must have been bespoke for a particular individual or perhaps made by hand at home. Some clothing *was* custom-made, of course, but countless ready-made items were for sale in shops and warehouses in London and other cities. Armies of quilters, seamstresses, and embroiderers, many of them women, worked long, anonymous hours hand-fashioning clothing for the retail market. Ready-made goods were also imported to America.

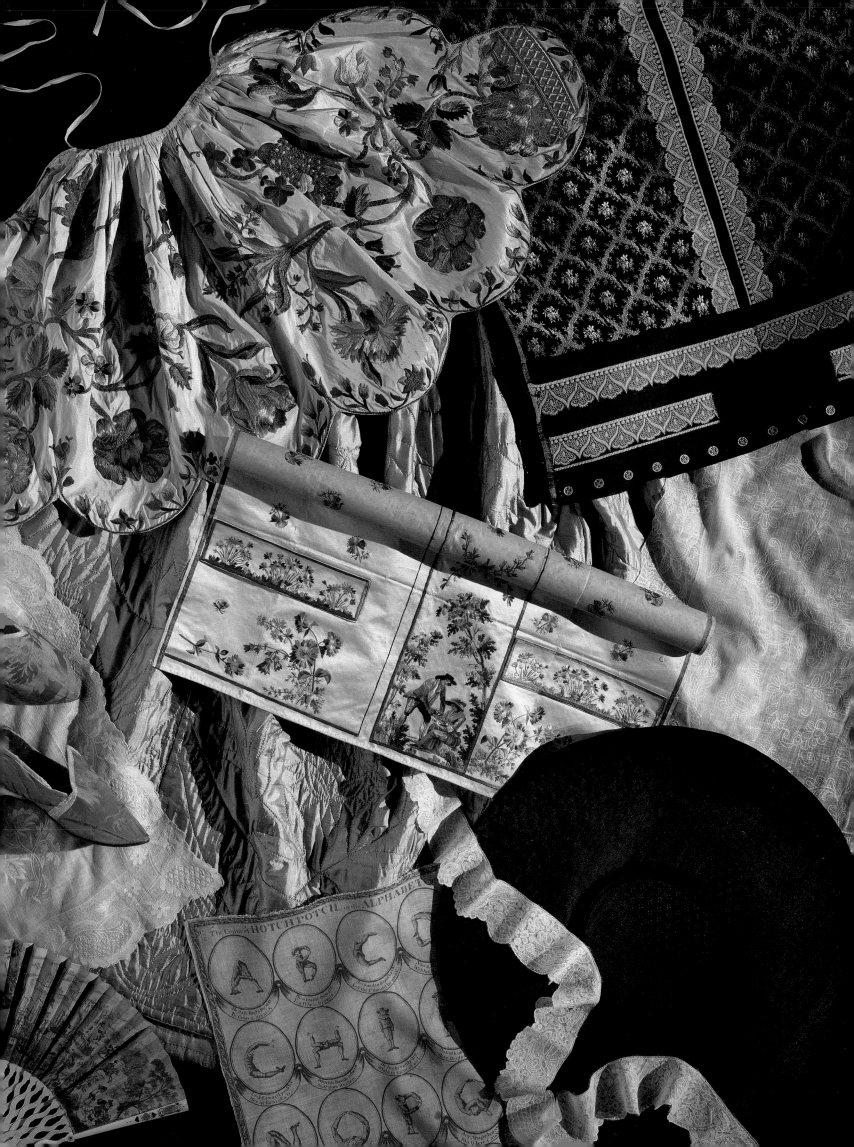

LES MODES PARISIENNES.

Fig. 39. (OPPOSITE) *Ready-made clothing and accessories (clockwise from top left), Apron, Britain, 1725–1750, silk embroidered with silk, silver, and silver-gilt threads, G1991-504, gift of Mrs. Cora Ginsburg; Unmade waistcoat, France, 1780–1795, silk woven with supplementary-weft design, 1954-283; Apron, Britain, ca. 1780, cotton embroidered with linen, possibly remodeled from earlier materials, G1991-523, gift of Mrs. Cora Ginsburg; Unmade waistcoat, France, 1785–1800, silk embroidered with silk, 1987-719; Woman's hat, Britain, 1750–1775, horsehair woven with bast fiber, from the collection of James Frere, 1953-868; Lace edging, England or Flanders, ca. 1750, linen bobbin lace, 1985-134; "The Hotch-Potch Alphabet" handkerchief, Britain, ca. 1780, plate-printed cotton, 1995-113; Fan, signed by M. Gamble, London, England, 1740, ivory, mother of pearl, brass, watercolor on printed paper, 1981-195; Quilted petticoat, Britain, 1760–1780, silk quilted to wool batting and backing, 1960-715; Apron, Britain, 1760–1780, cotton embroidery on cotton, 1953-857; Shoes, Britain, 1780-1785, silk lined with linen, leather soles, 1990-2.*

Milliners and other shopkeepers sold a broad assortment of ready-made textiles, clothing, and accessories. Some items, such as flat, unmade waistcoats, had to be cut apart and tailored to fit a customer's measurements.

Fig. 40. (LEFT) *"The Proposal,"* PETERSON'S MAGAZINE, *May 1855. By the 1850s, men's fashionable daytime suits had lapelled coats and long trousers. This shorter coat became the basic model for men's suit coats over the next 150 years.*

A vast array of finished goods stocked the shelves of merchants and milliners, including men's shirts, greatcoats, cloaks, waistcoat pieces, caps, aprons, ruffles, gloves, quilted petticoats, and women's stays (fig. 39). Although all clothing was handmade in the eighteenth century, garments did not necessarily require weeks or months to construct. Wealthy people who commissioned clothing made to their own measurements did not have to wait long for the finished product. In 1787, a tailor advertised that he would make a man's suit in six hours, although that was not the norm. A 1745 journeyman's price list suggests that a man's velvet suit customarily took seven-and-a-half working days to construct. A lady's fancy gown could be made in a day, if necessary.[22] The preceding examples demonstrate the dexterity and hard work of professionals who sewed for a living, likely working from sunup to sundown. But nonprofessionals could display similar speed and efficiency. For instance, Frances Baylor Hill of Hillsborough plantation in Virginia hand sewed a pair of man's breeches in a week, while performing other domestic tasks during that period and taking time out for socializing.[23]

A basic element of connoisseurship is the ability to date objects by stylistic features such as skirt length, sleeve shape, waist position, and trimmings. Because clothing responds readily to fashion, it is an excellent barometer of evolution in style and taste.[24] The eighteenth and early nineteenth centuries saw many changes in silhouette, some of them radical (see time line, pp. 216–239).

The overall progression of men's suits during the eighteenth century was one of a full, almost feminine, silhouette that evolved into an elongated, slender shape. Early suits had generous sleeves with wide cuffs, slim waistlines, and full skirts. The coat covered most of the waistcoat and knee breeches worn beneath. During the eighteenth century, the coat became slimmer, with fronts cut away to reveal waistcoat and breeches, and sleeves became tighter with smaller cuffs. By the end of the century, long, fitted pants began to replace knee-length breeches to further attenuate the figure. Coinciding with the change in silhouette was an evolution toward plain, dark colors and less embroidery, lace, and trim. By the mid-nineteenth century, fashionable daytime suits had many of the characteristics they would take into the twentieth century: short, boxy coats worn with vests and long trousers (fig. 40).

Although details and trimmings changed, the silhouette of most women's clothing prior to 1790 was a cone-shaped,

fitted top on a wide, full-skirted bottom. The skirt width and shape changed, but it remained full. The bodice varied in its emphasis or lack of emphasis on the chest, but the contrast of a narrow top with a wide skirt continued. The revolutionary change occurred with the neoclassic style at the end of the century, when skirts became slim columns atop bodices with high waistlines, and textiles got softer and lighter (see time line, pp. 234–235).

After enduring years of tight corseting that compressed their breasts and torsos, women living around 1800 finally gained the freedom of comfortable clothing. Or so it seemed at the time. A few daring, fashionable women even shed their underwear, but not without some criticism from more modest or conservative women such as Rosalie Calvert, a wealthy matron who lived near Washington, D. C. In spring 1804, Calvert wrote, "there is a ball every Tuesday, alternately at Georgetown and on Capitol Hill. The clothes they wear are extremely becoming, [although] some display a little too much— among others, Madame Bonaparte who wears dresses so transparent and tight that you can see her skin through them, no chemise at all. Mrs. Merry, the new English Ambassadress, is very fat and covers only with fine lace two objects which could fill a fourth of a bushel!"[25]

Custom, modesty, and the necessity to keep warm before the development of efficient central heating meant that most women continued to wear shifts and stays, as they had in the eighteenth century. The nineteenth-century equivalents were called different names, chemise and corset, and followed the new fashion for natural bustlines and high waistlines (fig. 41).

Later in the nineteenth century, women returned to restricting corsets and lower, natural waistlines, but the new female body shape was fundamentally different from what it had been before the upheaval of the neoclassic style. Eighteenth-century stays reshaped the body into a cone, compressed the bust, and pushed its fullness high. In contrast, nineteenth-century corsets restricted the waist more than before, allowed for a natural fullness of the bust, and created less erect posture, with the back slightly rounded and the head carried more forward (fig. 42).

Many eighteenth-century gowns were altered in the nineteenth century, particularly when fashion returned to natural waists and full skirts after the 1830s. Gowns of the 1770s, 1780s, or 1790s, although not well suited to alterations into the soft drapery of the neoclassic mode, did lend themselves to refashioning into later styles.

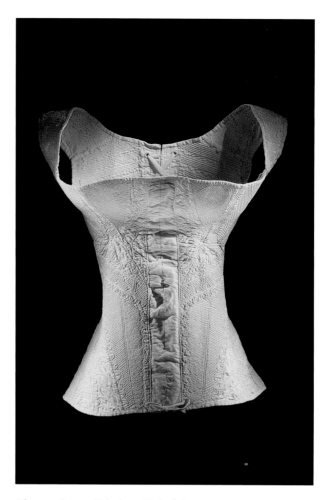

Fig. 41. Corset, Britain or United States, 1820–1830, cotton embroidered with silk, cotton cording, bone eyelets, G1991-511, gift of Mrs. Cora Ginsburg.
In contrast to cone-shaped stays of the eighteenth century, nineteenth-century corsets molded the body into an hourglass shape. Gussets accommodated the fullness of the breasts. This corset has a pocket at center front for a strip of wood or metal, called a busk, that helped mold the figure and flatten the stomach. For eighteenth-century stays, see figs. 47, 63–64, 208, and 309–310.

Construction clues such as darts, hourglass shaping, and bodice boning bespeak nineteenth-century reconstruction (see chap. 6).

Knowing the evolution of fashionable clothing is an important aspect of connoisseurship, but it is only part of the question, "What did they wear back then?" Connoisseurship requires study beyond the surface aspects of the subject, because clothing functions on many levels in addition to fashion. For practical reasons, people choose clothing to suit a particular activity, the time of day, or the

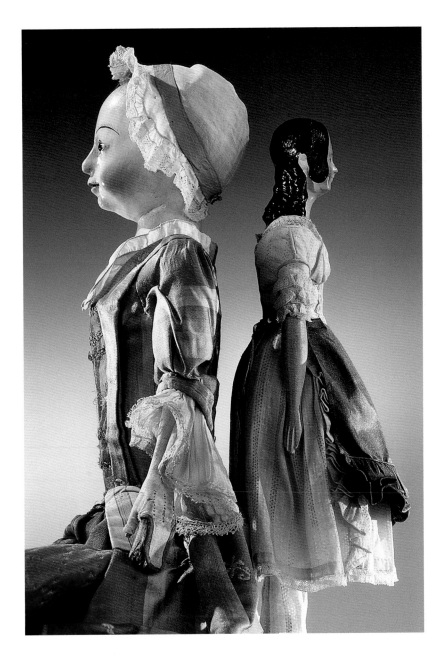

Fig. 42. Dolls dressed in original clothing, Larger doll, Britain or Continental Europe, 1740–1760, gessoed and painted wood, glass eyes, flax hair, silk gown, linen cap trimmed with silk, leather mitts, linen, cotton, and linen-cotton underwear, G1971-1738, anonymous gift; Smaller doll, Europe, 1848–1850, painted wood and papier-mâché, cotton frock, pantaloons, and apron, G1971-1726, anonymous gift. Separated by almost a hundred years, these dolls reflect changes in fashionable body shape and posture. Eighteenth-century stays molded a woman's torso into a cone with flattened front, breasts pushed high, and flat back. By the nineteenth century, fashionable posture was less erect, with the back more naturally rounded. Corsets allowed for the fullness of the breasts but continued to compress the waist.

weather. To fit into a social group, people take into account the expectations of others and the place in which they live. People select clothing based on personality, age, health, and mood.

Costume connoisseurs today investigate how bodies and garments were shaped, and what people wore under fashionable exteriors. Take, for example, men's underwear (figs. 43–44). (Women's underwear is discussed in the sidebar on p. 29.) Then, as now, few people went to the trouble to save plain, intimate, and utilitarian apparel.

Some men did not wear any drawers under their breeches. Instead, they relied on the long tails of shirts and on linings sewn into the breeches to serve the function of drawers. Because of these factors, only a few examples of men's underwear of the eighteenth century have survived.

Far from being part of the fashion mainstream, men's underwear demonstrates how people addressed practical concerns. Thomas Jefferson was among the men who routinely wore drawers and under waistcoats beneath shirts for extra warmth.[26] Jefferson suffered from cold all his life

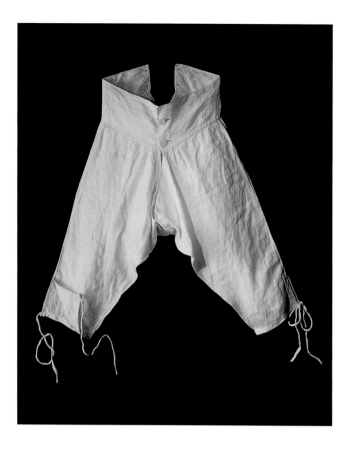

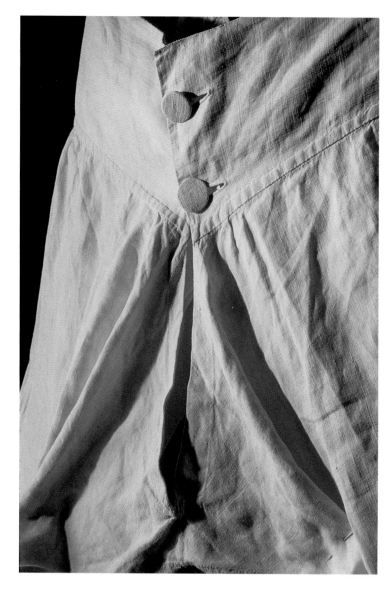

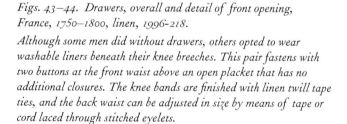

Figs. 43–44. Drawers, overall and detail of front opening, France, 1750–1800, linen, 1996-218.

Although some men did without drawers, others opted to wear washable liners beneath their knee breeches. This pair fastens with two buttons at the front waist above an open placket that has no additional closures. The knee bands are finished with linen twill tape ties, and the back waist can be adjusted in size by means of tape or cord laced through stitched eyelets.

and his wearing underwear was in part an accommodation to physical discomfort. "I have no doubt but that cold is the source of more sufferance to all animal nature than hunger, thirst, sickness, and all the other pains of life and death itself . . . when I recollect on one hand all the sufferings I have had from cold, and on the other all other pains, the former preponderate greatly. What then must be the sum of that evil if we take in the vast proportion of men who are obliged to be out in all weather, by land and sea."[27] Jefferson's sensitivity to cold was exacerbated as he grew older and suffered from rheumatism that had already begun when he was vice president.[28] In 1822, seventy-nine-year-old Jefferson wrote to John Adams that his

strength had declined during the past winter and, even though it was June, "I shudder at the approach of winter, and wish I could sleep through it with the dormouse, and only wake with him in spring, if ever."[29] A year later, with another winter approaching, he again wrote to Adams that his crippled wrists and fingers made writing slow and laborious, as he faced "the hoary winter of age, when we can think of nothing but how to keep ourselves warm, and how to get rid of our heavy hours until the friendly hand of death shall rid us of all at once."[30]

Several of Jefferson's linen and woolen undergarments are extant at Monticello, Jefferson's Virginia home, now

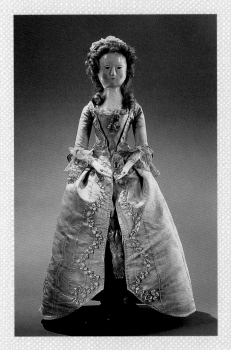

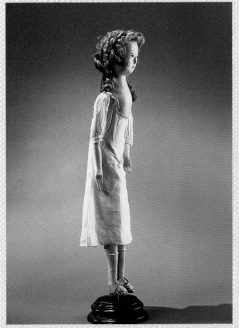

UNDERPINNINGS

This painted wooden doll in original clothing from the 1770s gives evidence of the many layers fashionable women wore beneath their gowns (figs. 45–47). The doll's underclothes are styled, cut, and sewn in the same meticulous manner used for adult women's wear. Beneath the open skirt of the blue silk sack-back gown, a white satin quilted petticoat trimmed with ruffled scallops and blue gauze ribbons is visible. The petticoat has a full lining of white polished linen and a thin batting, or filling, that stops short of the pleated waistband to eliminate extra bulk at the waist. It fastens with ties on the right side. Two additional under petticoats give graceful fullness to the skirt. The first, worn immediately beneath the satin one, is made of white cotton loom quilted in tiny diamonds. Constructed in a slightly A-shape with a center-front dip, the garment has pleats at the waist and also ties on the right side. The second under petticoat, made of white linen-cotton, is A-shaped and pleated toward the center-back opening.

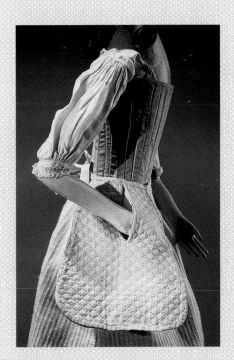

The doll's pocket, or bag, ties around her waist with linen tape over the bottom petticoat. Because the other petticoats have pocket slit openings lined up on the right, the pocket is accessible through the top three layers (see fig. 47). A wooden doll hardly needs stays to mold her body into the fashionable cone shape or to urge her to stand with shoulders drawn back and down. Nevertheless, this doll wears the traditional undergarment, made of cotton twill and boned with a dark material, probably baleen.

A white shift, worn closest to the body, has a deep scoop neckline trimmed with linen bobbin lace (see fig. 46). The three-quarter-length shift sleeves and underarm gussets are made of finer linen to eliminate bulk under the gown's tight sleeves. Brocaded silk shoes and later pattern-knit stockings complete the ensemble. (The absence of drawers is not accidental, but testimony to the fact that women did not wear them at this time.)

Fig. 48. *The Right Hon.*^{ble} *Norborne Berkeley, Baron de Bottetourt, late Governor of Virginia*, printed by H. Ashby, London, England, 1774, mezzotint engraving on paper, 1954-130.

Virginia's Royal Governor Botetourt died in office in Williamsburg, Virginia, leaving a large wardrobe of fine clothing ranging from elegant silk and broadcloth suits to numerous pairs of drawers to wear under his breeches.

a museum open to the public. That these garments survived at all is due in part to Jefferson's fame. Every scrap worn by the famous man was cherished as a relic by descendants; in contrast, the plain linen undergarments of most ordinary men were recycled into rags.

Young, healthy men suffered from the cold, too, and layered their clothing to keep warm. Monday, July 25, 1774, was an unusually cold day in Tidewater Virginia, and the tutor to the young Carter children wrote that, despite "having added a Waistcoat," he still felt "disagreeably Cold" in the schoolroom.[31] He developed a bad cold later that week.

Other men also wore drawers. George Washington's 1760 and 1772 orders for London-made clothes specified that the breeches were intended to be worn over drawers and that the measurements he sent were taken accordingly.[32] The inventory of Virginia's governor, Lord Botetourt, who died at age fifty-three in 1770 following an illness, had twenty-two pairs of drawers made of linen, cotton, and flannel, in addition to ten under waistcoats (fig. 48).[33]

Underwear is outside the fashion mainstream and survives in disproportionately small numbers. Formal and court presentation clothing is also outside the fashionable norm, yet it survives in disproportionately *large* numbers. Highly elaborate and expensive, formal clothing was not worn frequently enough to wear out. Further, it was the dress of memorable occasions, which prompted the owner to save the formal attire as a memento.

But how is it that an elegant brocaded silk gown with distinctively wide hoops and a man's beautifully embroidered suit are deemed outside the fashion mainstream? Consider a young bride of today who normally dresses in the most up-to-date, even avant-garde, clothing. She might still don a wedding dress with long, full hoopskirts based on fashions of a century earlier. The inherent conservatism, including the retention of old-fashioned design features in formal clothing such as a bridal gown, is often called fossilization.

A cream-colored silk and silver gown is an excellent example of stylistic fossilization (see sidebar, next page). Made around the 1780s for a formal occasion or an appearance at court when protocol demanded a conservative style, the gown displays lavish use of trimmings and outmoded side hoops. In the early nineteenth century, fashion called for raised waistlines, yet dresses worn at

FOSSILIZED FASHION

This silk and silver gown shows decided stylistic anomalies. The overall silhouette of the skirt with wide side hoops was fashionable in the 1740s (fig. 49). While the skirt suggests the 1740s, details of the bodice date at least forty years later. The wide, low neckline indicates a date in the 1780s when most women wore puffy, sheer kerchiefs to give the appearance of a prominent chest. The edge-to-edge front closure without a separate stomacher and the graduated sleeve ruffles are features too late for the apparent 1740s date of the skirt. The gown also reveals its true age in its interior construction (fig. 50). The linen bodice lining dips to a deep point at the center back, another construction feature of the 1780s. Finally, the small repeated spot design of the textile is much more typical of the late eighteenth century than the mid century; a patterned dress of the 1740s would have large-scale, realistic floral and scroll designs, not small-scale spots.

Costume connoisseurs date clothing from its most recent feature, which places this gown in the 1780s or later. What, then, accounts for the old-fashioned elements? Made to wear at a formal occasion, such as a wedding or court appearance, the wide hoops of the skirt connoted conservatism, dignity, and formality. This choice is part of the process called fossilization, deliberate retention of old-fashioned design elements for symbolic reasons.

Figs. 49–50. Formal or court gown, overall and detail of bodice inside waist, Britain, 1780–1790, silk woven with silver-gilt threads, trimmed with silver-gilt lace, sequins, gimp, and tassels, bodice lined with linen, from the collection of James Frere, 1953-849.

Formal clothing retains conservative design features long after they have gone out of style. Although the wide skirt was typical of mid-eighteenth-century styles, the deep point at this gown's back waist suggests a date in the 1780s. The crisp silk textile is dotted with metallic silver threads woven from selvage to selvage, a type of fabric called silver tissue.

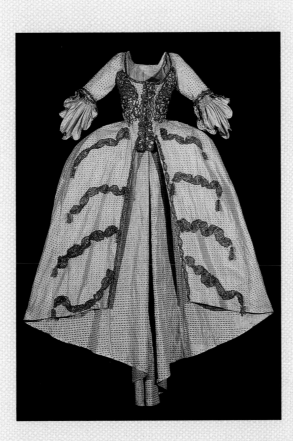

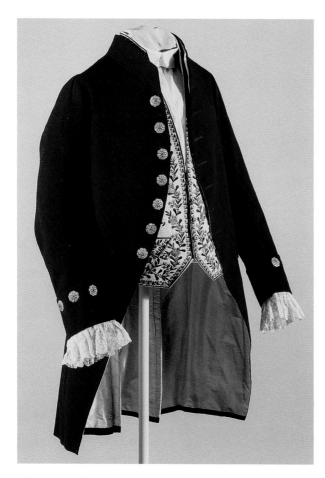
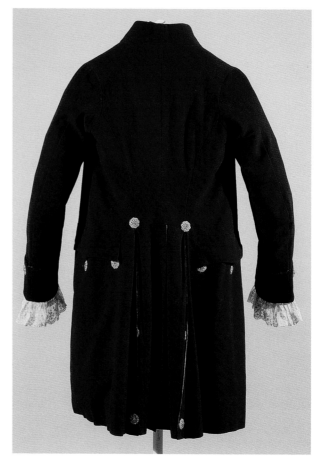

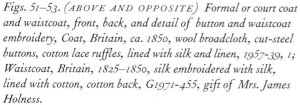

Figs. 51–53. (ABOVE AND OPPOSITE) Formal or court coat and waistcoat, front, back, and detail of button and waistcoat embroidery, Coat, Britain, ca. 1850, wool broadcloth, cut-steel buttons, cotton lace ruffles, lined with silk and linen, 1957-39, 1; Waistcoat, Britain, 1825–1850, silk embroidered with silk, lined with cotton, cotton back, G1971-455, gift of Mrs. James Holness.

By the middle of the nineteenth century, men's court suits followed a formula: dark wool cloth trimmed with shiny buttons, such as these cut-steel examples, and embroidered waistcoats. Styled like a fashionable suit of eighty years earlier, this coat has a center-back vent and pleats trimmed with buttons at the top and peeking out from inside the folds.

British court still retained the older style of wide hoops. Instead of being positioned at hip level, the full skirts of court dresses emerged from beneath the wearer's armpits, an uncomfortable and impractical style that combined two incompatible time periods.

Men's court and formal clothing exhibited a similar lag in styles. A suit coat of purple wool looks at first glance like an example from the 1780s (figs. 51–52). It has a standing collar, fronts that curve over a prominent chest, long knee-length skirts, and shaped pocket flaps. And, in fact, the coat was cataloged as dating between 1785 and 1795 when Colonial Williamsburg purchased it in the 1950s. Comparison with known examples reveals that the coat is almost identical to one at the Museum of London, with a history of having been worn at British court in 1866.[34] This formal style contrasts with men's daytime fashionable clothing of the 1850s and 1860s, the actual date of the Colonial Williamsburg and Museum of London suits. During the same time, men's fashionable suit coats had turned-down collars with lapels, and were either cut full and skirted or shortened to jacket length. Nearly all men were wearing

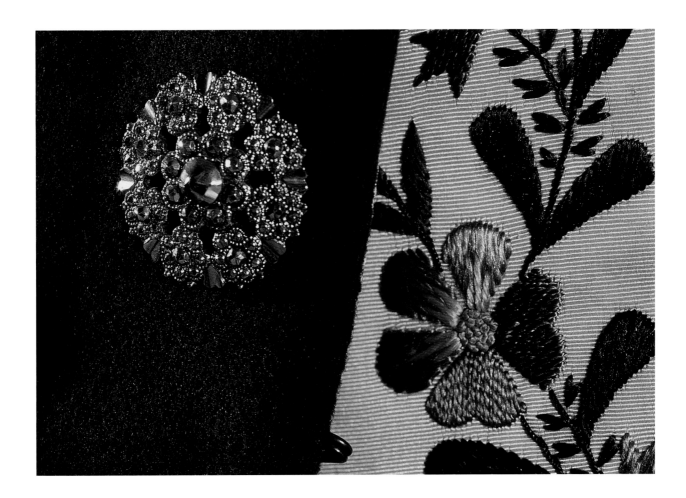

long trousers. Nineteenth-century court suits, however, rejected mainstream fashion and retained the conservative eighteenth-century shape, including knee-length breeches. They were made of plain but expensive wool cloth and trimmed with cut-steel buttons. The relatively unadorned suit coat was worn with an embroidered waistcoat made in eighteenth-century style (fig. 53).

Before men adopted the plain broadcloth court suit of the mid-nineteenth century, they had a last fling with silks and elaborate embroidery for formal dress. The Colonial Williamsburg collection has several spectacular examples of men's embroidered formal suits, including a dark-colored wool broadcloth suit that is conservative in cut, but lavished with brilliant silk needlework (fig. 54). A Spanish coat of orange cut velvet from around 1820 is encrusted with silver threads, bullion, sequins, and beads. It was worn with white silk knee breeches and a waistcoat of silk woven with silver and further embroidered with silver (figs. 55–56). A splendid European court coat of rich blue silk velvet is embroidered with colorful silk floss in a floral pattern that flows from the high collar,

down the chest, around the pockets, across the cuffs, and continues around the back to border the center vent (see fig. 5). As if the fabric were not enough to enhance any man's appearance, the coat is padded on the interior to give the wearer the prominent chest fashionable during the period.

Elaborate costumes made of precious materials, such as the previous examples, have often been considered masterpieces of decorative art. But the definition of quality is sometimes elusive; poets, writers, and philosophers have expended many words to define beauty. So, too, have decorative arts students struggled with how to assess quality in historical objects. In 1950, a book written by Israel Sack called *Fine Points of Furniture: Early American* grouped objects into categories of good, better, and best, and maintained that these quality standards were more important than an object's rarity, age, history, or documentary aspects.[35]

Although Charles Montgomery stressed the importance of knowing an object's history and construction details,

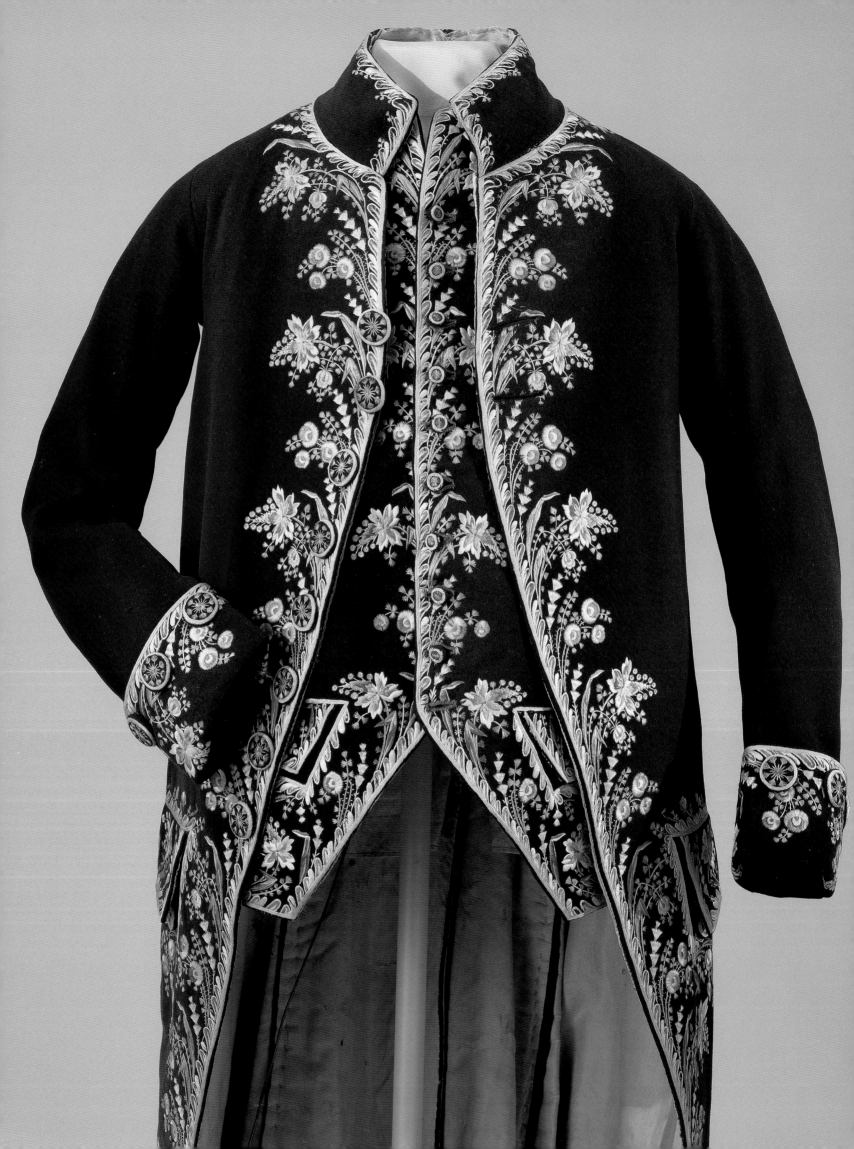

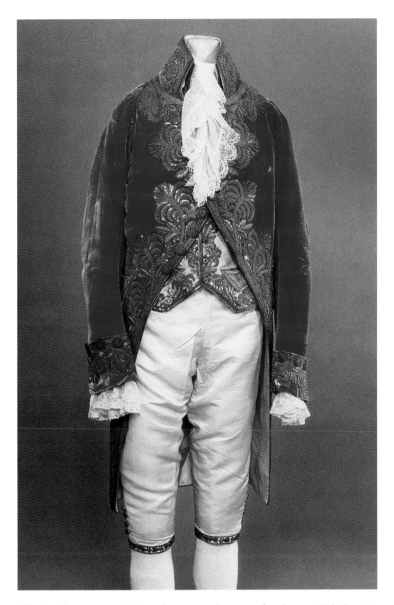

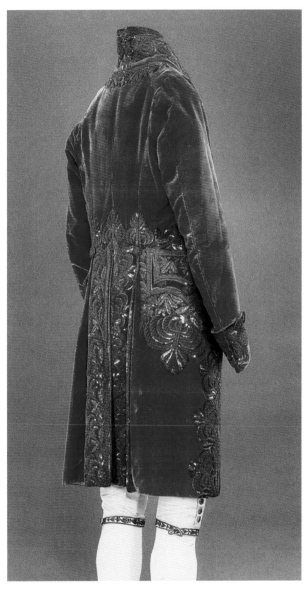

Fig. 54. (OPPOSITE) Formal or court suit coat and waistcoat, Britain, 1800–1840, wool broadcloth embroidered with silk, lined with silk and linen, 1960-650, 651.

This formal suit is modeled on men's fashionable clothing from about fifty years earlier. The colorful silk embroidery stands out against the dark purple-brown of the wool cloth.

Figs. 55–56. (ABOVE) Formal or court suit, front and back, Spain, 1800–1820, silk velvet, silk woven with silver threads, and silk twill, all embroidered with silver gilt, sequins, and beads, lined with silk and linen-cotton, reproduction ruffles, 1941-215, 1–3.

Combining brilliant color, elegant materials, and heavy metallic embroidery, this suit epitomizes the richness of men's European court wear in the early nineteenth century. The silhouette is attenuated, with slim skirts and a high collar that reaches almost to the ears. In contrast to earlier suits of the mid-eighteenth century, shoulders are square and broad. The shape of the coat, which curves away from the body, hints at the cutaway coat that becomes the standard for men's formal wear into the twenty-first century.

he did not negate the importance of design. He urged students to evaluate the success of the overall appearance, form, ornament, and color. While old-style connoisseurship stressed artistic success, modern-day students may wonder whether beauty has any place in decorative arts connoisseurship.

David Pye, a twentieth-century architect and industrial designer, wrote about the process of design and the energy invested in an object's appearance, as opposed to its functional qualities. Speaking with considerable eloquence, Pye pointed out that while work done for appearance's sake may be called "useless," it is not worthless. "There is a difference between useless and ineffectual, no matter what the dictionary says. All the things which can give ordinary life a turn for the better are useless: affection, laughter, flowers, song, seas, mountains, play, poetry, art, and all. But they are not valueless and not ineffectual either."[36] Pye believed that modern people usually relate to an object's overall shape, rather than to details on the surface, yet he believed that "the most noticeable mark of good workmanship is a good surface whether rough or highly finished." Surface is "the frontier of something invisible."[37]

Surface quality and fine detail are especially evident in eighteenth-century costumes and textiles. A gown from the 1770s is made of English silk brocaded in silver, with a white-on-white or self-colored secondary pattern playing across the surface (fig. 57). The full, wide skirt and sack-back pleats that fall freely past the waist to the floor are excellent palettes to display the dancing design of scattered leafy sprigs. Modern lighting can only hint at the surface beauty of a textile that was designed to be seen in flickering candles at an evening ball. The shiny cream-colored silk, combined with mirrorlike silvery brocading, would catch all the available light and reflect it back to the viewer as the wearer moved.

Another gown of similar design and background color achieves its brilliance from Chinese export silk exquisitely hand painted with an intricate floral design (figs. 58–59). From a distance, the gown is like many others of the 1760s and 1770s. It has an overall triangular form with narrow shoulders, ruffled sleeves, and a full skirt. On closer inspection, the hand-painted textile captivates the eye with intricately scrolling flowers and leaves in unfaded colors. The original effect would have been even richer, with many flowers outlined in light-catching silver, now tarnished to dark outlines (fig. 60).

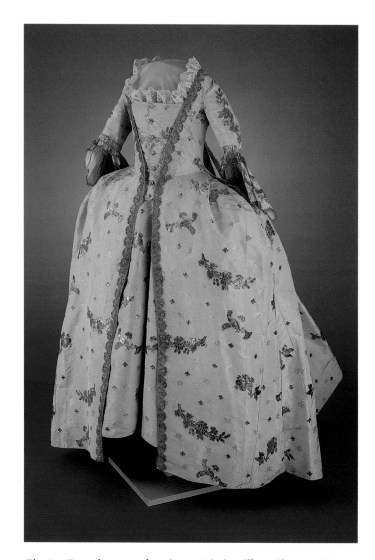

Fig. 57. Formal gown and petticoat, Britain, silk textile ca. 1755, remodeled ca. 1770, silk brocaded with silver and silver gilt, bodice lined with linen, hem faced with silk, trimmed with later silver lace, G1990-12, gift of Mrs. Cora Ginsburg.

This sumptuous gown is fashioned from stiff silk brocaded with glittering metallic silver to reflect the available light. The rich textile and wide hoops mark it as formal wear in an era when fashionable daytime clothing no longer had significant side fullness. Unlike many other dresses that had removable triangular stomachers, this gown has panels stitched in place to the bodice and closed with buttons and buttonholes down the center front. Button-front mock stomachers such as this example came into fashion during the mid-1760s.

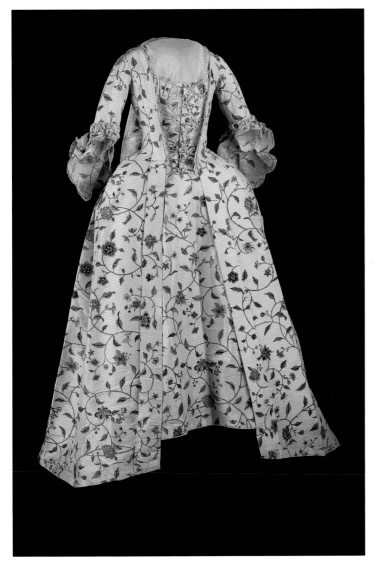

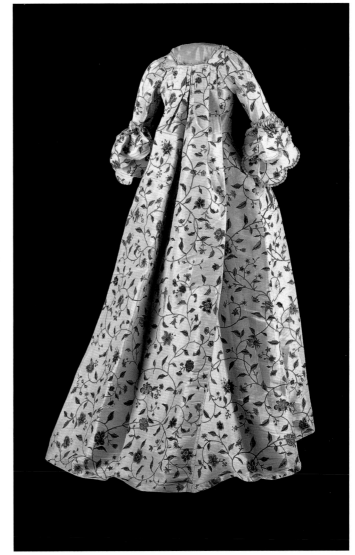

Figs. 58–60. *Gown and petticoat, front, back, and detail of painted silk, Chinese textile, made in France, ca. 1770, ribbed silk hand painted with pigments and silver, trimmed with silk lace, bodice lined with linen, 1993-330.*

Chinese artisans made textiles specifically for export to Europe and America. With its intricate hand-painted floral design and silver outlines, this textile would have been a luxury item. Despite its elegance and expense, this gown shows evidence of remodeling. The skirt and petticoat once had applied ruffles or flounces. Styled as a ROBE À LA FRANÇAISE (in England, known as a sack), the back has pleats at the shoulders that release into a graceful train. The mock stomacher buttons down the front.

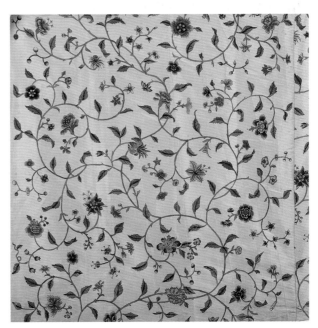

Figs. 61–62. (OPPOSITE AND ABOVE) Waistcoat, overall and detail of armhole, Britain, ca. 1780, silk embroidered with silk, lined with silk and cotton, wool back, from the collection of Doris Langley Moore, 1960-706.
Like most decorated waistcoats, the embroidery is concentrated where it would be seen beneath a suit coat, down the center fronts and surrounding the pocket flaps. The back is plain wool fabric. The armholes have a series of deliberate slashes to enlarge the opening for a heavier man or one with less-erect posture. The cuts have been repaired and supported with modern sheer silk binding.

A man's waistcoat made from embroidered ivory silk is another artifact of exquisite beauty that becomes more lovely the closer one looks (fig. 61). The deep pastel colors of the delicate silk embroidery, worked with consummate skill, glow against the shine of the satin surface. Besides being beautiful, the waistcoat's embroidery is in excellent condition.

What is a masterpiece today? Deborah Kraak, textile curator and consultant, defines a masterpiece as an object with "dynamism, individuality, imagination," materials appropriate to the medium, and the appearance of being a graceful whole. All these factors combine to exceed the viewer's expectations. The masterwork, according to Kraak, speaks "with such uniqueness and clarity that it enables the viewer to feel the artist's joy in its creation." Yet a textile must also exhibit technical and functional achievement, for the designer's imagination "is at the service of the consumer."[38] If clothing does not fit correctly or is uncomfortable, the wearer would hardly consider it a masterpiece, regardless of beauty. At some point, the armholes of the waistcoat were deliberately slit, apparently to enlarge them to fit the posture of the wearer (fig. 62). Perhaps the garment survives in pristine condition only because it was not functional.

Traditionally, people think of a masterpiece as something of greatness and importance. But a minor, rather plain artifact can display masterly technique. A tiny pair of silk and whalebone stays in Colonial Williamsburg's collections, intended to corset a little girl with a waistline of only eighteen-and-a-half inches, are much like the stays made for grown women (figs. 63–64). The girl's stays not only survive in exceptional condition, but also exhibit a perfection of stitching that far exceeds the functional needs of the object. Even rows of identical stitches form channels for whalebone that give the required stiffness to the garment. The stays have a tradition of belonging to one of the daughters of King George III, and their technical excellence certainly reflects the high status of the young wearer.

Is technical excellence required in a masterpiece? Must every part of the artifact display a thoroughgoing and unvarying technical mastery? On the most basic level, a masterpiece is something made by a master, "an artist, performer, or player of consummate skill."[39] To know how people of the past defined a masterpiece, scholars need to know how eighteenth-century masters viewed their work. Masters of any trade had to make a living, and the most successful of them knew where to place the

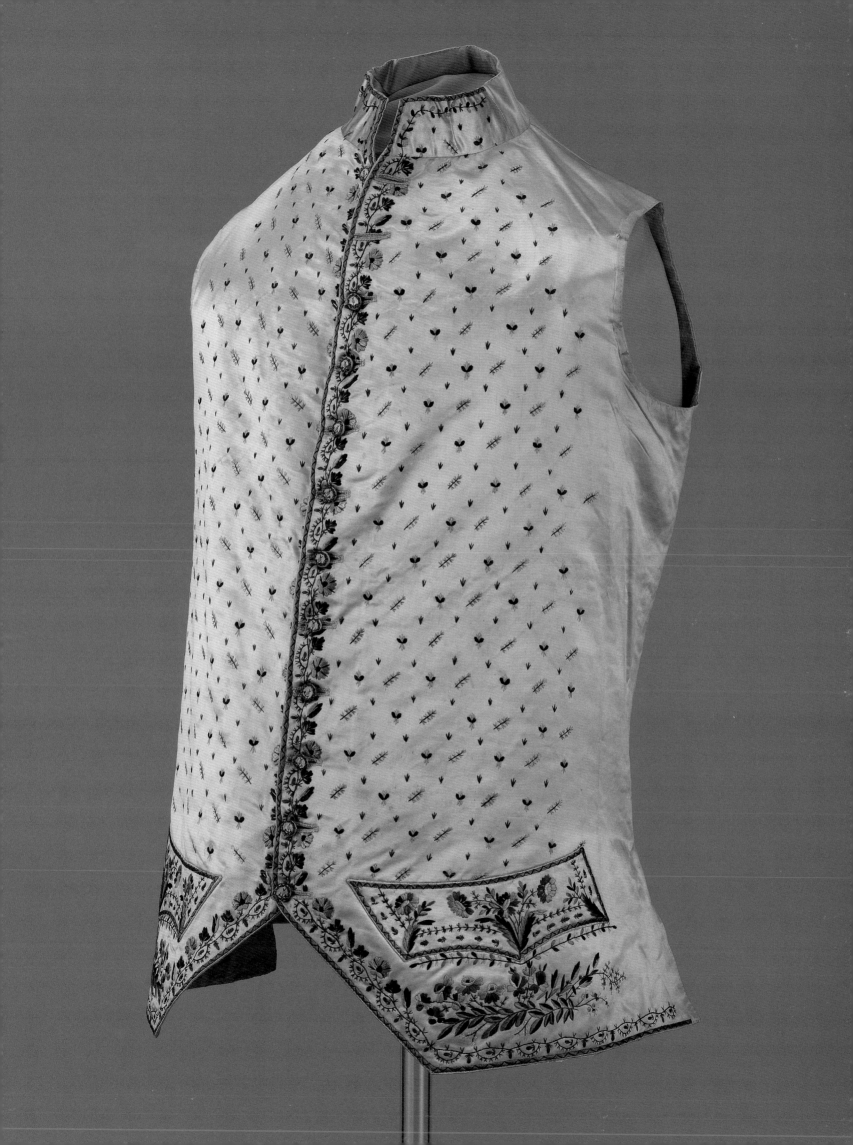

Figs. 63–64. Stays, Child's stays, overall and detail of stitching, Britain, ca. 1775, silk lined with silk, interlined with linen, probably boned with baleen, 1994-27; Woman's stays, Britain, 1770–1785, silk, probably interlined with linen and boned with baleen, lined with later cotton, from the collection of Doris Langley Moore, 1960-729.

Children wore stays shaped much like those of their adult counterparts. These child's stays are said to be from the collection of Anna Maria Dacres Adams, dresser and later wet nurse to the daughters of Britain's King George III. Seen in detail at right, they are beautifully constructed and preserved. The chest measures twenty-one-and-a-half inches and the waist eighteen-and-a-half inches. These woman's stays, which have a waist measurement of thirty-four-and-a-half inches, demonstrate that not all eighteenth-century women were tiny.

emphasis. Time constraints meant that true masters did not waste effort on unimportant details. Can one assume that an elaborate lady's gown will necessarily be finished beautifully on the inside? Will it be stitched more carefully than a functional, plain shift made at home? Modern conventional wisdom deems the eighteenth century as a period of superb craftsmanship seen in every facet of a costume's production. With eighteenth-century costumes, however, conventional wisdom is wrong. Fancy silk gowns frequently display rather long stitches, and the interior construction is not exceptionally neat, particularly before the last quarter of the century (fig. 65).[40] In contrast, women's plain shifts, men's shirts, and even baby clothes are almost universally sewn with small, tight stitches, and all raw edges of the fabric turned inside (figs. 66–67).

There are pragmatic reasons for differences in sewing technique among garment types. Body linens such as shirts, shifts, and baby clothes were worn next to the skin, and their construction had to withstand the boiling, scrubbing,

and pounding inherent in frequent washing (fig. 68). Silk gowns were not subjected to such stresses, either in wearing or in cleaning. They did not need great strength in the stitched seams because stays worn underneath took most of the strain. Gowns did not actually touch the wearer's bare skin. Under the gown, a woman wore an elbow-length shift, an under petticoat, and stockings, all of which kept the outer gown clean by absorbing perspiration and body oils (see sidebar, p. 29). If a silk gown required cleaning, it was sent to the professional silk scourer or dyer who used naturally occurring substances to remove stains and grime. Sometimes the gown was taken apart and dyed a new color, if necessary, to achieve the desired results.[41] Because fine silks were expensive, women expected to remodel their gowns at least once or twice, and unnecessarily fine stitching would only make the task more difficult. Further, most silks were woven so tightly that close stitching was highly impractical. Despite its outward beauty, the interior of the yellow silk gown is stitched with eight stitches per inch (see figs. 65 and 342). One can therefore conclude that a genuine eighteenth-century costume, even a masterpiece,

Fig. 65. (LEFT) *Detail of bodice interior and left armhole from woman's gown, Britain, 1740–1750, ribbed silk lined with linen, 1994-87.*

With future remodeling in mind, most gowns were sewn with easily removable stitches. Even in the richest dresses, interior construction was not particularly fine because effort was not wasted where stitches would be hidden. Buttonholes worked into front flaps of the lining were intended for lacings that fastened the bodice closed. For overall view, see fig. 342.

Fig. 66. (RIGHT) *Detail of neck opening from woman's shift, Britain, ca. 1750, remodeled 1790–1820, linen, marked E. P. with silk cross-stitches, with later cotton sleeve ruffles, 1984-79.*

Except for the ruffles peeking out at the neck and sleeves, shifts were hidden from view. Nevertheless, women sewed them with close, fine stitches and neatly finished off all raw edges. This sewing technique enabled shifts to withstand frequent laundering and prevented chafing. The end of the front placket of this shift is reinforced with needle-made lace called Hollie point. For overall view, see fig. 218.

Fig. 67. *Sampler, Denmark, Netherlands, Germany, or Britain, 1788, linen embroidered with linen and silk, 1997-3.*

The slits cut into this practice sampler were finished and reinforced with needle lace techniques such as those found at the bottom edges of garment plackets.

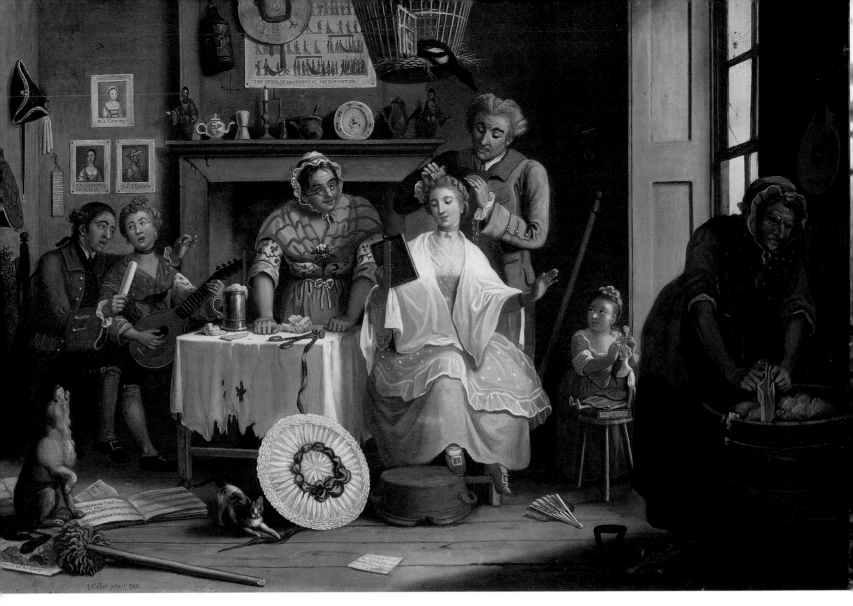

Fig. 68. *High Life Below Stairs*, by John Collet, London, England, *1763*, *oil on canvas*, *G1991-175*,
gift of Mrs. Cora Ginsburg.

*Set in the working quarters of a large house, this scene shows the varied ranks of household servants in clothing
and hairstyles suited to their stations. In the shadows at far right, a laundress bends over an open tub of sudsy
water to scrub clothing or linens, while the rest of the servants socialize. The laundress and two other female
servants wear dark-colored kerchiefs around their shoulders and loose gowns with short skirts, called bed gowns
or short gowns. In contrast, the finely dressed and coiffed lady's maid apes the fashions of her mistress. A white
cloth protects her fine clothes from powder while a male servant in two-color livery styles her hair.*

need not be consistently superior in its technique. Makers
and their customers often considered other factors more
important than finished technique, especially where it did
not show (see sidebar, p. 47).

Modern connoisseurship includes a careful study of the
actual object, often with the aid of scientific devices. Accu-
rate identification of fiber content is basic to any textile
analysis. Fibers of antique clothing, most often cotton,
linen, silk, or wool, have different appearances under the
microscope (fig. 69). Trained conservators and technicians

remove one or two tiny fibers from a seam or knot and
examine the material under a microscope. Untreated cotton
resembles flattened, twisted ribbons. Mercerized cotton, not
available until the middle of the nineteenth century, looks
plumper, with many of the twists straightened. Linen has
cross-hatching or nodes, similar in appearance to bamboo.
Wool has scales. Silk resembles a translucent glass rod.
More sophisticated equipment can determine the breed of
sheep or variety of cotton plant, often an indicator of
region or date of the textile. Although an experienced cura-
tor, conservator, or student can usually identify the basic

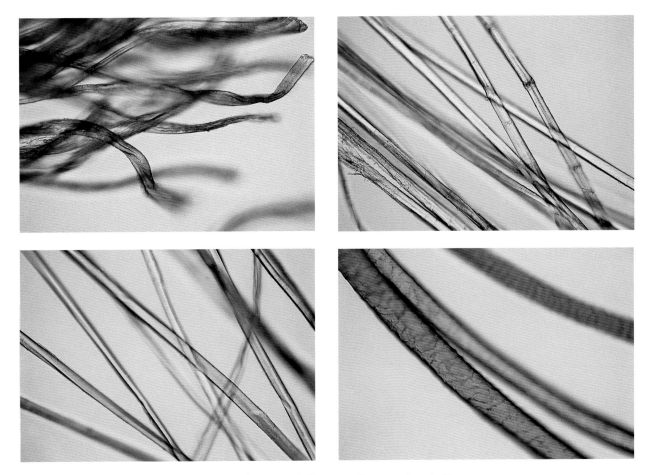

Fig. 69. Fibers under the microscope (clockwise from upper left), cotton, linen, wool, and silk. Under magnification, individual textile fibers have different characteristics that allow precise identification. Cotton looks like twisted ribbons; linen or flax resembles bamboo with cross-hatching and nodes at intervals along the fibers; wool shows scales on the surface of the fibers; silk appears as translucent rods.

materials in a costume by eye and feel, microscopic examination is the only way to absolutely confirm the results.

Accurate fiber identification, combined with other observations and historical information, fills in the complete story of an object's significance. A gown of about 1750– 1765 from England is made of glossy fabric that looks like expensive brocaded silk damask (fig. 70). Microscopic examination, however, proves that it is made of wool, a clue to where the fabric was made. It was not produced in the Spitalfields area near London, where most English silks originated, but rather in or near Norwich, the center for production of Norwich stuff. Stuff was a broad class of fine worsted textile used for upholstery and for less-expensive clothing. Warmer and more durable than silk, stuff had some of the shine and visual appeal of silk. (See p. 114 and fig. 161 for more about stuff.) The gown

has horizontal creases, most obvious in the skirt (see fig. 70). At first glance, the lines are visibly distracting, leading to a temptation to steam them out to give the gown an unwrinkled appearance. The creases, however, document the textile's manufacturing process, which took advantage of an important property of wool, becoming glossy when subjected to sufficient heat and pressure, a technique sometimes called glazing. To impart the shine of silk, the original finishers folded the wool textile and placed it under a press, which gave the desired surface finish, but also created the by-product of horizontal fold lines. Although glazed worsted was less expensive than silk, it still represented considerable financial outlay. No attempt was made to cut around the folds, which would have wasted precious fabric. Instead, the maker and wearer of the gown accepted the creases as inherent in the material chosen.

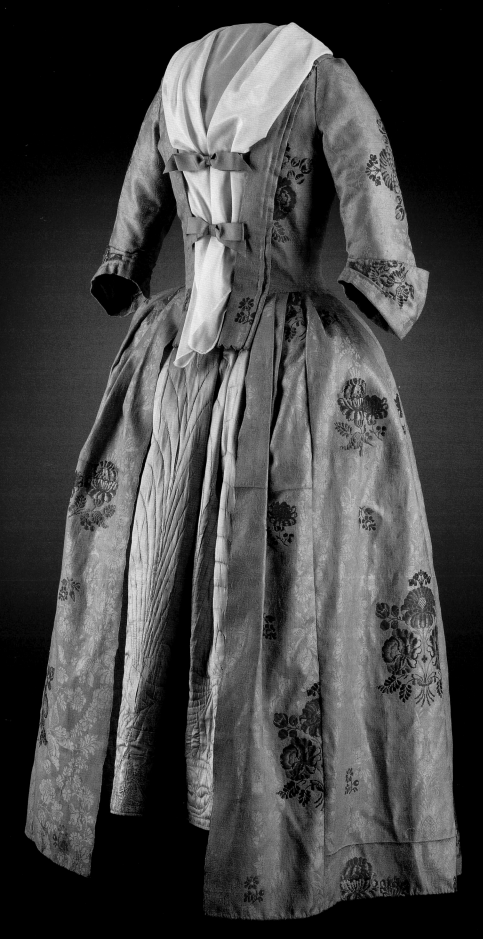

Fig. 70. Gown, Norwich, England, textile, made in Britain, 1750–1765, wool damask brocaded with wool, bodice lined with linen, reproduction kerchief and ribbons, 1988-223; Petticoat, Britain, 1760–1775, silk quilted to wool batting and backing, 1947-507.

Wool gowns such as this rare example survive in fewer numbers than more expensive silk ones. Worn by workingwomen and others for everyday occasions, wool gowns either wore out or were not considered elegant enough to save. The skirt of this gown shows the sharp horizontal creases characteristic of pressed, or glazed, wool materials.

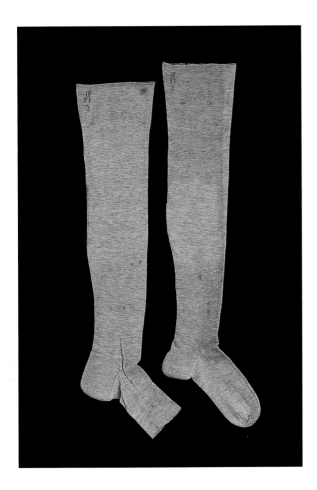

Figs. 71–72. Stockings, overall and detail of markings, made by Pagets, Warner, and Allsopp, Britain, worn in Virginia or Washington, D. C., by Thomas Jefferson, 1800–1820, frame-knitted wool marked with silk cross-stitches, Courtesy, Monticello/Thomas Jefferson Foundation, Inc.
Although almost invisible to the naked eye, the manufacturer's stamp appears under infrared light.

Science helps scholars detect hidden features in a costume. The Thomas Jefferson Memorial Foundation at Monticello preserves a pair of Jefferson's wool stockings, marked with his cross-stitched initials, *TI*. Under normal light one can see indecipherable smudges of ink that resemble letters at the top of each stocking (fig. 71). Under infrared light, either from an infrared scanner or in infrared photography, the smudges become clear, "Pagets, Warner & Allsopp/Patent," the manufacturer's name (fig. 72). Although one might expect Jefferson to buy American-made stockings during the early nineteenth century, Pagets was a family of stocking knitters in Great Britain.[42]

Today's connoisseur wants to know what people of the past accepted as quality. A gown made around 1810 is fashioned from cotton, block printed in a delicate trailing floral design (figs. 73–75). An excellent example of neo-classic style, the gown has slim lines, a raised waistline, and a small-scale printed design that complements the overall silhouette. Close examination of the printed textile

reveals that the blue colors on the printed textile appear messier than the other colors, sometimes extending beyond the outlines, and are not uniformly dense in color. To what can one attribute this apparent lack of quality? A second gown, dating between 1775 and 1785 and worn in England or Europe, is printed in a more elaborate design copied from fashionable brocaded silks. It is a fine example of printing, which uses many colors on a closely woven cotton ground (figs. 78–79). Yet, like the other block-printed textile, the blues display unevenness and stray outside the lines. Rather than marking these examples as inferior printed cotton, the blue color tells much about the limits of material and technology and hints at what people considered acceptable quality for their clothing.

To understand the anomaly of fine gowns with apparent errors in the textile requires familiarity with print methods during the second half of the eighteenth century. Printers used carved blocks to impart pattern by printing a mor-dant, or color fixative, onto the surface, then dyed the textile in a vat. The colors became permanent where the

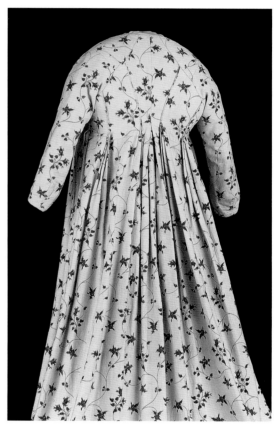

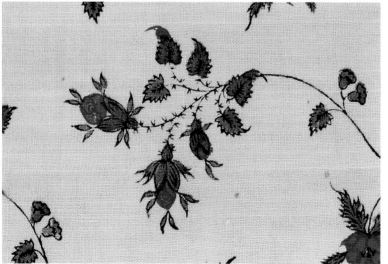

Figs. 73–75. *Gown, overall, back, and detail of fabric, British textile, made in Albany, New York, ca. 1810, block-printed and penciled cotton, bodice lined with linen, G1991-465, gift of Mrs. Cora Ginsburg.*

By the early nineteenth century, gowns with raised waists and soft gathers were in fashion. The back of this gown is fitted with tucks that release into pleats to create fullness. The blue color of the block-printed cotton was applied rapidly with a brush in a technique called penciling. Uneven color application and occasional drips are characteristic of the process.

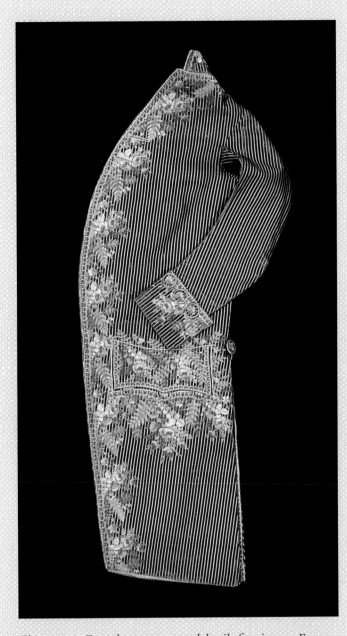

MAKING IT FIT

Grand occasions and royal court appearances required special clothing. The plain black tailcoat had not yet been accepted for formal wear, and eighteenth-century men vied with women in their use of silk embroidery, bright colors, and lace, often designed with pattern upon pattern of naturalistic flowers on striped or diapered grounds. While this suit is an elegant statement of wealth and formality, close examination of the flowers reveals secrets about eighteenth-century workmanship. Professional embroiderers worked all the shapes needed for the suit on flat lengths of textile (see figs. 39 and 277). In larger workshops, the same person did not necessarily embroider all the pieces for a single garment. Although the flowers on this waistcoat appear to match those on the coat, they are stiffer and in varying colors, which indicates different hands at work (figs. 76–77).

To make the suit, a skillful tailor had to cut into the expensive textile without ruining it. Cutting the suit was an even greater challenge when the gentleman-customer was shorter than the preembroidered pieces allowed for, as with this example. The embroidery could not be cut off at the hem because the pockets would be too low. Nor could the embroidery design be shortened near the face, since people would notice. The ideal location for an interruption in pattern was just below the waist. To solve the problem of excess length, the tailor of this suit cut through the embroidery in a meandering line around the flowers and leaves just above the pocket flaps of the coat and the waistcoat. He removed one-and-a-half inches of material and spliced the pieces back together with consummate skill. He also added a few decorative stitches to cover the seam, perhaps with the help of an embroiderer. The wearer's hands and arms hid the join as he stood in dignified formal posture with his arms gracefully bent. Invisible to the casual eye, the join can only be detected by measuring the repeat of the roses.

Figs. 76–77. Formal or court coat and detail of waistcoat, France, 1770–1800, silk embroidery and appliquéd silk net on striped silk and ribbed silk, lined with silk and linen-cotton, 1956-306, 1–2.
Slight interruptions in the repeat of the embroidery design just above the pocket flaps in coat and waistcoat indicate that the preembroidered pieces were too long for the wearer. The tailor had to cut through the needlework and remove sections. The white ribbed silk waistcoat contrasts with the dark stripes of the coat and breeches, although the embroidered design echoes that of the coat.

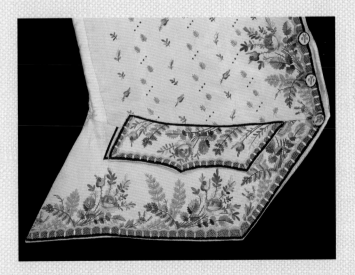

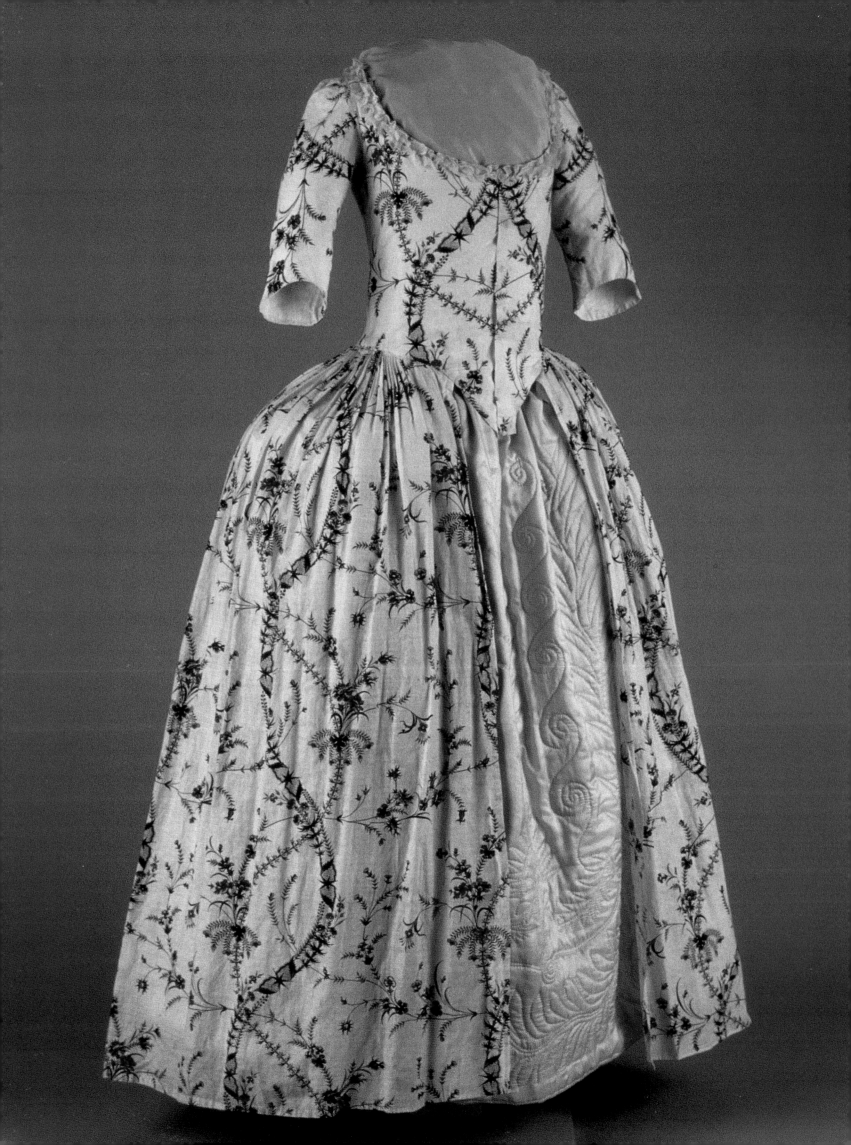

Figs. 78–79. (OPPOSITE AND ABOVE) Gown, overall and detail of fabric, Britain, ca. 1780, block-printed and penciled cotton, bodice lined with linen, reproduction quilted petticoat, 1991-450. The textile of this gown is printed in a floral design with a meandering pattern that copies fashionable woven silks. The detail shows a drip from the hastily applied blue coloring matter. The gown skirt can be drawn up in puffs, polonaise fashion, by thread loops sewn to the waist seam (see fig. 362).

mordant had been printed, but washed out elsewhere. Blue, derived from indigo, could not be printed in the same way due to its particular chemistry. Indigo became permanent on oxidation, that is, when it was exposed to air. If one tried to block print indigo from a vat of dye, the color would oxidize on the block before it could be transferred to the textile. Sometime in the 1730s, English textile printers developed the pencil blue technique. In this process, printers added chemicals to the dye to slow oxidation long enough so workers, called pencillers, could brush the color onto the textile. This was done in a separate step after the rest of the colors had been printed with blocks. Even with the addition of chemicals that slowed oxidation, pencillers had to work quickly, which explains the messy, uneven quality of the blue on printed textiles and the occasional stray spot of blue that accidentally dripped from the brush. Although other methods for printing blue existed, they were either not suitable for multicolor textiles or too labor intensive to be practical in the European labor market.[43]

Some clues in textiles cannot be interpreted correctly without knowledge of the legal history surrounding their manufacture. Many cotton textiles used in the American

colonies have thin blue threads woven into the side edges, or selvages, subtle evidence that is easily overlooked (see fig. 230). The significance of the threads becomes obvious with the discovery of an obscure English law, which mandated that three blue threads be woven into the selvages of taxed, all-cotton textiles intended for export if merchants wished to collect a drawback, or refund, of the tax. Because the law was in effect between 1774 and 1811, textiles with blue threads are dated with assurance between those years and assigned to English manufacturers.[44] Even if microscopic analysis were not readily available, the blue-thread textiles could still be identified as all cotton because the law pertained only to cotton goods.

Evidence in the selvages of certain silk textiles can point to their place of manufacture. In this group, the selvages display a characteristic pattern of multiple holes that have been identified only on Chinese silks, not on European ones (figs. 80–81).[45] The pattern derives from a step in the weaving process. Chinese silks were woven about twenty-nine inches wide, broader than European examples. To keep the wide silks from drawing in at the sides on the loom, Chinese weavers inserted sticks, or temple bars,

with forked ends between the selvages, which created the pattern of repeated holes. Other characteristics confirm their Chinese origin. The designs typically have nervous, spiky leaves and are repeated three or four times in the width of the fabric (fig. 82 and see fig. 80). Chinese silks are softer and lighter in weight than European examples, and are often a muted color.

Surviving artifacts can tell only part of the story. Many more objects existed than have survived. Scholars of decorative arts today have learned humility in the face of material survivors from the past, no longer limiting study to the artifacts that they consider worthy or beautiful. Students now ask how an artifact was judged, what it meant, in its own time, and why. Even with the advantages of modern science and museum training programs, or perhaps because of these advantages, material culture historians are no longer so certain that anyone can arrive at a single truth. They know how easy it is to be tricked by a clever forger or to get a theory wrong because they missed an important bit of evidence.

Twenty-first-century curators, conservators, and collectors are more likely to value an artifact's continuing history, evidence of age, and alterations, rather than demand pristine, unchanged quality. New connoisseurship theory might lead them to leave untouched an altered waistcoat or gown rather than disassembling and remaking the garment to its original period, obliterating much subsequent history in the process. It may mean not washing a stained garment, leaving intact evidence of the original starch. Conservators may consider using computer technology to visually restore an object, rather than washing, repainting, or remaking it. And who knows, maybe the skin cells, fingernail clippings, or perspiration on a garment will someday lead to important analytical findings about the original wearers.

While some scholars focus on the microscopic level, others take a macro view, moving beyond the object itself into the realm of symbolism. What did the clothing mean in its own cultural context? What can the surviving costume communicate about the world view of those who produced and wore it?

Figs. 80–81. (OPPOSITE) Dress textile, overall and detail of selvage, China, worn in Delaware by Jane Richardson McKinly (1727–1805), 1750–1770, silk damask, 1970-10.

Woven twenty-nine inches wide, this textile is typical of Chinese export silks. The selvages, or side edges, have a characteristic pattern of multiple holes from the use of a forked stick during weaving.

Fig. 82. (ABOVE) Dress textile, China, 1760–1775, silk twill brocaded with silk, 1970-52.

The serpentine pattern and floral sprigs copy fashionable dress silks woven in France or England. Unlike European brocaded silks, however, this example is woven twenty-nine-and-a-quarter inches wide and has a softer hand than European dress silks.

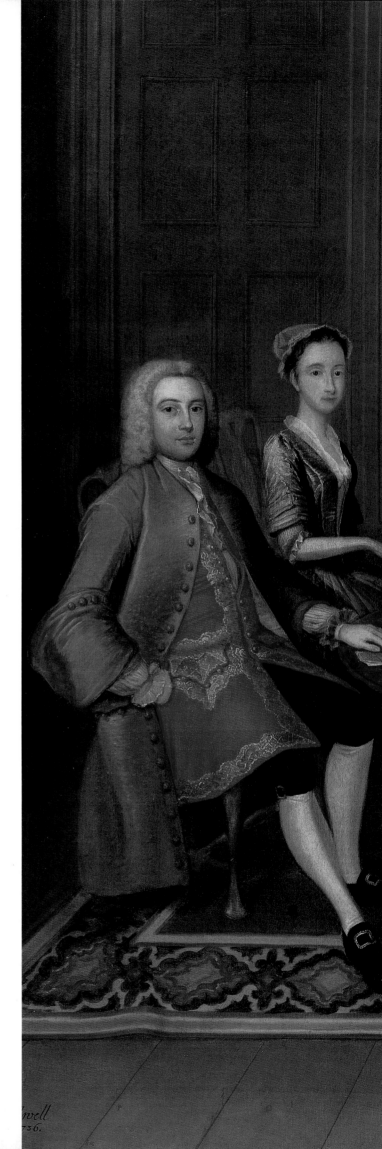

CHAPTER 2
THE MYTHS
and Meanings of Clothing

Exploring clothing's meaning and symbolism helps people today better understand those of the past, not just great and learned men who wrote most of the histories, but women who donned corsets and hoops, the illiterate, slaves, Native Americans, children, and working people. Surviving artifacts help to bridge the gap between then and now and allow humans to "encounter the past at first hand."[1] An eighteenth-century suit or an heirloom dress is far more than a tangible survival; it is an event in history that continues to happen. Stretched and shaped by the body that wore it, wrinkled by years of use, soiled from two-hundred-year-old perspiration, clothing is the most intimately human of the surviving decorative arts (figs. 84–85). In some ways, old clothing brings the original wearers back to life.

People in the eighteenth and nineteenth centuries also knew that apparel carried social and symbolic messages. That clothes make the man (or woman) was already well known by 1747 when Robert Campbell, chronicler of London trades, wrote, "No Man is ignorant that a Taylor is the Person that makes our Cloaths; to some he not only makes their Dress, but, in some measure, may be said to make themselves."[2] William Hogarth, the eighteenth-century English artist who used symbolic garments and accessories in his work, believed it was possible to "know the very minds of the people by their dress" (fig. 86).[3]

What makes clothing so significant? Certainly, it functions as warmth, protection from the elements, and modesty. These practical matters alone deserve the scholar's analysis. Delving into the underlying meaning and symbolism of historical clothing can be a rewarding and fascinating part of the study.

People living in England and America during the eighteenth and early nineteenth centuries had a surprising number of fashions, materials, and technologies available to them. They encountered foreign travelers and natives having different cultural values and shared familiarity with imported and exotic goods. Although some people accepted discrete clothing elements or materials from other cultures, few adopted foreign styles wholesale, even those that might have been considerably more practical or comfortable. Historians point out that clothing choice is ordered by

Fig. 83. THE BREWSTER FAMILY OF WRENTHAM HALL, SUFFOLK, by Thomas Bardwell, England, 1736, oil on canvas, G1971-3374, gift of Mr. and Mrs. David Stockwell.

The posture, clothing, and accessories of the members of this gentry family signal high status, leisure, and varied times in their life cycles. The twenty-four-year-old heir, Philip, sits at far left wearing a wig, a suit coat with deep cuffs, and a fine ruffled shirt; his pose seems calculated to display a waistcoat that is embellished with embroidery or brocading. The family matriarch wears black and white clothing appropriate to her status as a widow. The youngest daughter, age ten, holding the cat, has a figure shaped by stays, although her back-fastening gown indicates her youth.

Figs. 84–85. Breeches, front and back, United States, probably Southwest frontier, 1800–1825, deerskin, from the collection of Ed Charol, 1993-13B.
Made of leather that stretches and conforms to the body, these breeches were worn with the jacket in figs. 106–107. Leather breeches were sturdy and longwearing, appropriate for physical labor, horseback riding, and exploring.

cultural standards that determine (some would say dictate) what is considered appropriate wear for a given person in a particular place and time.[4]

While Anglo-American colonists generally adhered to English styles, environmental conditions in America were different from those in the British Isles. During the hot summer months in the South, even the gentry resorted to lighter, less formal clothing. Surprised travelers described southern men who went without fashionable wigs or suit coats and women who did not always wear boned stays.[5] Historian Rhys Isaac has suggested that adaptation to American conditions, especially climate, "was opening a cultural rift between the colony and its parent society."[6] The nature of this cultural rift as it relates to wearing apparel has only begun to be understood.

Clothing is often compared to a language that allows people to speak through what they put on their bodies and how they arrange the elements.[7] Most scholars agree that, although it can and does say things, clothing's message is more subtle and unclear; it shifts with time and place and is without fixed rules of grammar like a true language. Yet spoken and written communications can be misunderstood, too, because words have meanings only insofar as human beings assign them and agree on the linguistic rules.[8] The uncodified rules that dictated what to wear for various occasions in the past, or that govern what people wear today, are almost as rigid as grammatical rules.

Part of its pervasive power stems from the ways clothing differs from and goes beyond language as a means of communication. People do not read ensembles of garments in the same way they read a sentence, moving

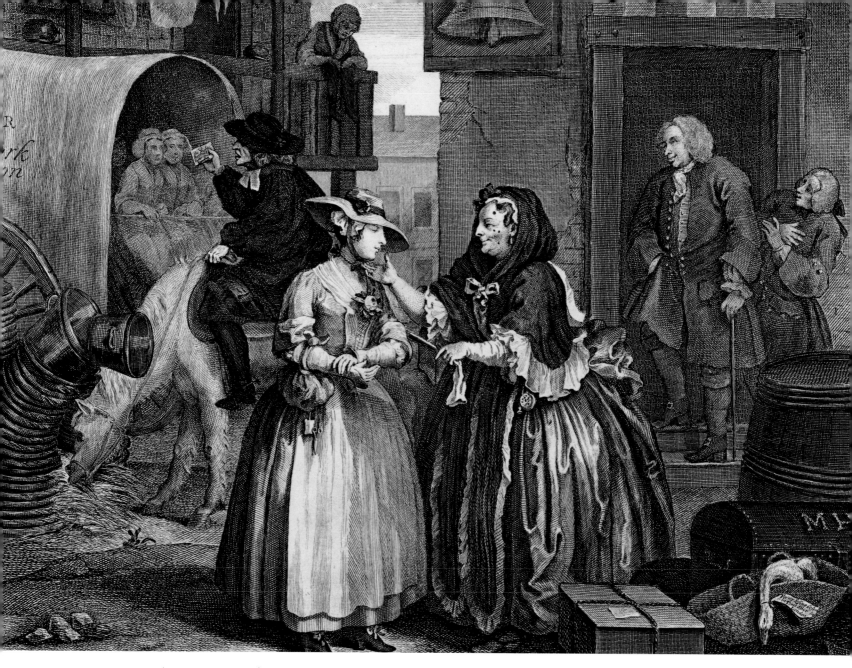

Fig. 86. *A HARLOT'S PROGRESS*, plate 1, William
Hogarth, London, England, 1734, line engraving on paper,
1972-409, 3.

This print is the first in a series of plates that trace the downfall
and eventual death of Mary or Moll Hackabout, a country
seamstress who has just arrived in London on the stage from
York. The artist contrasts her fresh complexion and modest
garments with those of the female procurer. Typical of fashions
in the 1730s, Moll's gown has a bell-shaped skirt and full
sleeves cuffed just above the elbows. Straw hats, emblematic of
countrywomen, eventually became fashionable in the city.

from one word to the next in a linear sequence. Rather, they see the outfit as a whole, as "co-present elements," to quote anthropologist Grant McCracken.[9] Humans may use clothing to carry messages that go beyond the communicative capabilities of spoken language. Through their wearing apparel, people can say subtle but important things that they would not or could not utter directly; indeed, they may not be consciously aware of the message themselves. An eighteenth-century man in a silk suit and gleaming white linen shirt probably would not say aloud, "I'm richer than you are and I don't have to perform dirty physical labor"; his clothes reveal his wealth and leisure in a much more socially acceptable way (see fig. 83).

Because many core beliefs of a particular cultural group are never written down or spoken, they remain hidden from outsiders and, in some cases, from the group itself. Art historian Jules Prown points out that some fundamental beliefs "may be so hard to face that they are repressed."[10] How, then, can scholars today begin to understand another culture, especially one removed in time? Although they do not ignore the written record, material culture historians look at artifacts to probe unwritten history. Prown points out that basic beliefs are most clearly perceived by the way in which a society acts, or its style. Beliefs are therefore "encapsulated in the form of things," especially unself-conscious, utilitarian objects.[11]

Observant viewers can usually decipher the overt messages of modern clothing, such as designer blue jeans, workers' coveralls, expensive athletic shoes, or worsted business suits with correct power ties. But the task becomes more difficult when looking back in time. People of the past saw many more levels of meaning in their own garments than can be detected more than two hundred years later. Consider the problem of dressing and accessorizing a mannequin for museum exhibition (figs. 87–88). With the possible exception of wedding attire, complete ensembles of clothing worn at a particular time by one person rarely survive together. Individual pieces such as stomachers, sleeve ruffles, and petticoats are often separated from their original gowns. Curators must select a petticoat from one source to display with a gown worn by a different person, perhaps adding sleeve ruffles and an apron from yet another wearer. Although they consult pictorial sources from the period, curators can only hope that they have correctly interpreted the fundamental aesthetic of the period, all in an attempt to present to the public an accurate depiction of historical "reality." If

curators chose well, an eighteenth-century time traveler to the museum might agree that the outfit looks right. Yet it is entirely possible that the eighteenth-century visitor could criticize the choice of petticoat as too dark for the light-colored gown or point out that the petticoat is appropriate for casual, daytime wear, but not for that formal gown. The visitor might argue that a well-dressed woman would certainly never select such an old-fashioned apron.

Seemingly minor accessories such as women's pockets can be as telling as complete ensembles. In the eighteenth and early nineteenth centuries, women's gowns did not have sewn-in pockets, probably because pockets filled with personal belongings would have ruined the lines of full, floating skirts. Instead, women carried small items in separate, commodious bags tied around their waists beneath the skirts (fig. 89). Pockets were functional and hidden from most observers. Yet many women designed them in a graceful curved shape and embellished them with fine textiles and embroidery, a clue that pockets had some importance beyond function. In her study of eighteenth-century pockets, American culture student Yolanda Van de Krol concluded that pockets incorporated a complex and changing symbolism in the period. Sometimes pockets indicated miserliness, working-class or servant status, or disreputability. At other times they symbolized female sexuality.[12] Is it coincidence that the curved, womblike shape of the pocket also served as a container for hidden valuables beneath a woman's skirts?

Similar analysis questions the reasons for and the meanings behind the nineteenth- and twentieth-century male "uniform" of a dark suit and necktie. The fashion for three-piece suits began in the seventeenth century (see chap. 1). The suit comprised a coat, waistcoat, and breeches that were worn over a white ruffled shirt and a separate neck stock or cravat (figs. 90–93). Beginning in the last quarter of the eighteenth century, daytime suits evolved from brilliant statements of status and wealth into sober ensembles of unadorned, good-quality wool. Plain suits were appropriate for businessmen whose clothing had to communicate trustworthiness, stability, and competence through personal achievement in an emerging capitalistic society.[13] As with many other fashion shifts, multiple factors came into play. The dark cloth suit developed in association with country and sporting clothing of the British aristocracy. By choosing a somber-colored ensemble made of excellent-quality British woolen cloth, the wearer distanced himself from what he believed to be

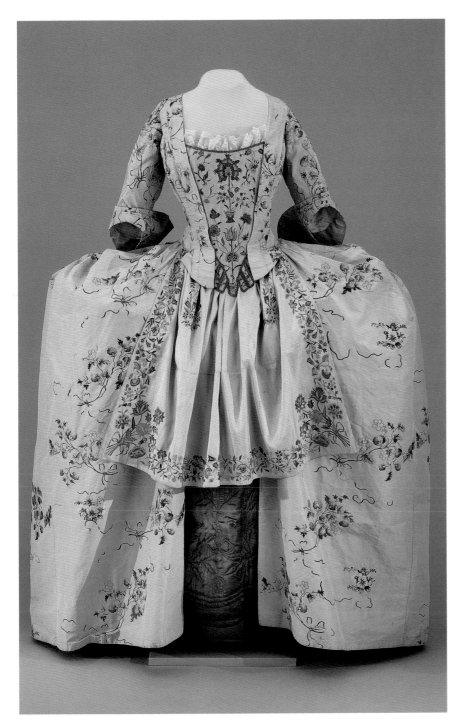
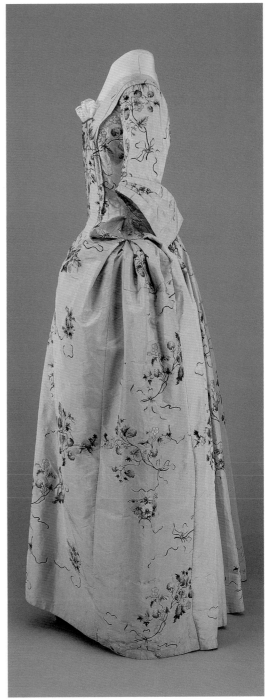

Figs. 87–88. Gown and accessories, front and side views, Gown, Britain, ca. 1745, silk brocaded with silk, bodice lined with linen, waistline later altered, from the collection of James Frere, 1953-854; Stomacher, Britain, 1730–1750, silk embroidered with silk and metal threads, 1955-373; Lace edging, Europe, eighteenth century, linen bobbin lace, from the collection of Mrs. DeWitt Clinton Cohen, G1971-1596, 2B, anonymous gift; Apron, Britain, 1730–1740, silk embroidered with silk, 1991-440, purchased with funds donated by the National Academy of Needlearts; Petticoat, Britain, 1750–1770, silk quilted to wool batting and backing, from the collection of James Frere, 1953-851.

Women's skirts achieved their greatest width during the 1740s. Side expansion, calculated to show off lavish patterned textiles, gave a flattened appearance to the gown. Short decorative aprons added richness to fashionable ensembles.

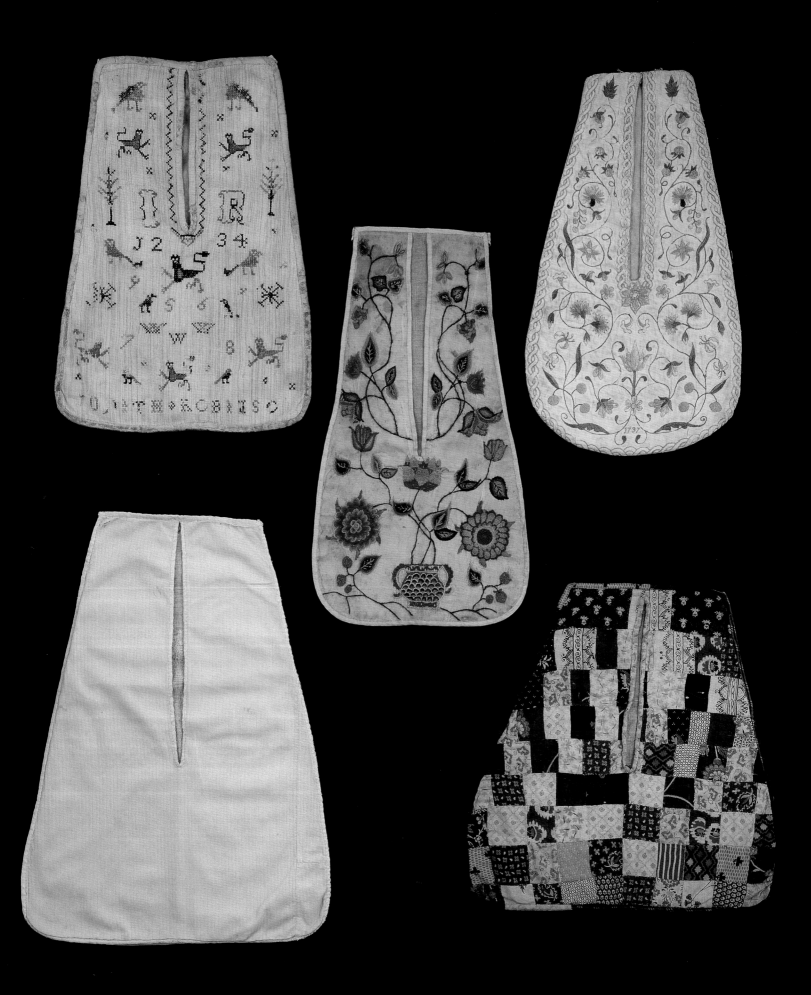

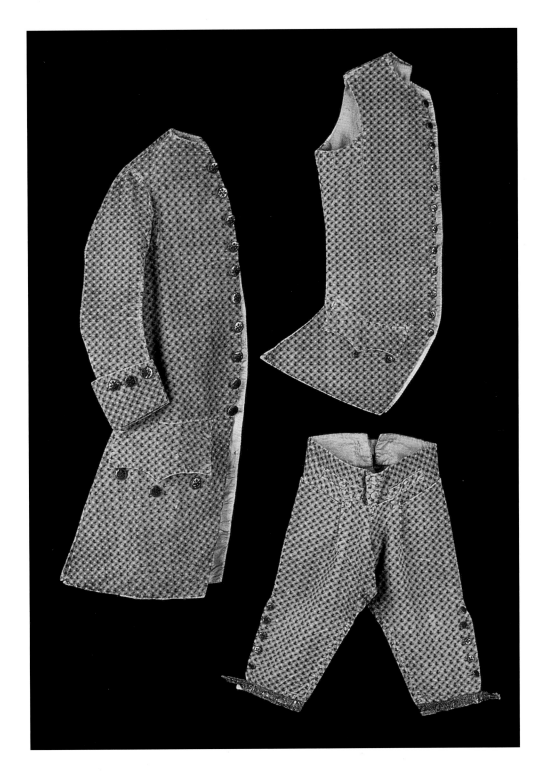

Figs. 90–91. Suit, overall and detail of button, British textile, probably worn in Virginia, 1760–1780, silk velvet trimmed with silver-bullion-and-tinsel buttons, lined with silk, linen, and linen-cotton, 1992-37, partial gift of Diane Taylor.

According to family history, a twentieth-century customer gave this suit to a tailor to settle an unpaid bill. Said to be worn by "a Virginia gentleman," the suit is made of spotted silk velvet. Although it is similar in appearance to the cotton velveret suit in fig. 137, this silk example would have been more expensive.

Fig. 89. (OPPOSITE) Pockets, from top left, Pocket with lions, made by Judith Robinson, Pennsylvania, 1780–1820, linen-cotton embroidered with wool, 1951-465; Pocket with flowers and vase, New England, 1720–1750, linen-cotton embroidered with crewel wool, lined with linen, G1958-180, gift of Ernest LoNano; Floral pocket, Britain, 1737, linen embroidered with silk, G1989-437, gift of Mrs. Cora Ginsburg; Pieced pocket, New York, probably Albany, ca. 1810, pieced block-printed cottons, backed with cotton, 1991-465B; White pocket, New York, Scotia area, 1780–1820, linen-cotton dimity, backed with cotton and lined with linen, from the Glen-Sanders family, 1964-411.

Pockets fastened around women's waists with narrow tape ties made of linen or cotton. Although pockets were hidden beneath the skirt and petticoat, women often decorated them with needlework or piecing.

Fig. 92. Stock, Britain, 1740–1760, pleated linen marked with red silk, 1993-166.
Neck stocks were the early predecessors of neckties. Sometimes pleated and at other times gathered, a generous
width of fabric was stitched to narrow tabs. The tab with buttonholes slipped over the knobs of a metal buckle
through which the other tab was drawn to secure the stock around the neck. This example came with an
envelope attesting that it once belonged to George II, king of England. The back of the left tab is marked in
cross-stitches with a crown and the number 46, probably indicating the quantity of stocks in the wearer's
extensive wardrobe.

corrupt French fashions (see fig. 93).[14] The three-piece business suit communicated multiple messages, among them business acumen and subtle status.

Like suits, neckties originated in the seventeenth century. Eighteenth-century men continued to wear various styles of neck bindings over their shirt collars (see fig. 92). Typical of the most fashionable stocks, Colonial Williamsburg's example is made of fine white linen pleated into two tabs that fasten at the back of the neck with a removable stock buckle. Men's dressy shirts also had decorative and nonfunctional ruffles sewn directly to the deep front opening and sleeve cuffs. Stocks and shirt ruffles were costly, difficult to maintain, and required considerable care to keep clean during the day's activities. Stocks could inhibit active movement that might set the neckwear askew. Expensive white linen worn around the neck was the perfect vehicle for proclaiming that one was genteel, above the laboring classes, and rich enough to support the necessary and time-consuming washing, starching, and pressing.

Modern neckties, which evolved from the decorative stocks and ruffles of two hundred years ago, have become symbols. Calling them icons of status and gender, professor Joanne Finkelstein considers modern neckties as signals of gentility, full of symbolic potential. Through their choice of tie, men may proclaim social attachment to a particular school or region of the country or announce their fashion awareness through the use of designer logos. On a more subtle level, ties may also be sexual signals. Finkelstein points to the

"bold red tie . . . purportedly eloquent of a man's sexual energy." She writes, "The conventional long tie runs from the prominent male larynx, along the torso and terminates as a signal to the male sex organ, particularly when the man is seated. In this capacity, the tie links together the physical symbols of virility, and as such, can be used as a psychoanalytic proboscis that demarcates a line from manhood to manliness."[15] Some readers may scoff or laugh uneasily at this analysis, perhaps confirming Jules Prown's assertion that there are, indeed, "beliefs of which the culture itself is not aware," or which are repressed.[16]

Why did women wear long, voluminous skirts during most of the eighteenth and nineteenth centuries? Indeed, why do many women continue to wear skirts? Although historians date clothing evolution by small details, a longer view reveals that a consistent silhouette recurs from the seventeenth century until the 1920s (figs. 94–95). With relatively short-lived exceptions, such as the period around 1800 to 1820, most women wore long, full skirts and bodices with defined waists at the natural position just above the hipbones. In a 1952 book that foreshadowed the work of later material culture scholars, anthropologists Alfred Kroeber and Jane Richardson postulated that this "basic or ideal pattern" of women's wear, like all features of dress fashion, is "largely unconscious."[17] Today's observers seek to understand why this pattern existed for such a long period and why women used cumbersome hoop petticoats and expensive yards of fabric to achieve an apparently impractical ideal.

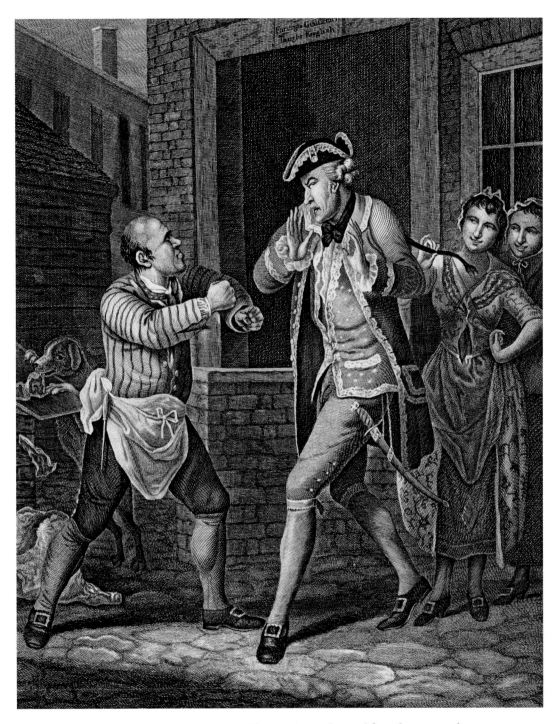

Fig. 93. FRENCHMAN IN LONDON, engraved by C. White and printed for Robert Sayer after a painting by John Collet, London, England, 1770, line engraving on paper, 1952-372.

Although some British citizens looked to France for news of the latest fashions, not everyone subscribed to foreign influences. In a satirical print that pokes fun at the French, a sturdy English butcher in his work clothes and apron intimidates a foppish, weak Frenchman wearing an elaborately trimmed suit, curled wig with long queue, and sword. Over a window in the background is a motto that reads "Foreign Gentlemen Taught English."

Fig. 94. Gown and accessories, Gown, Britain, ca. 1780, cotton embroidered with silk, bodice lined with linen, reproduction petticoat, G1991-467, gift of Mrs. Cora Ginsburg; Neck kerchief, New Jersey, worn by Rachel van Riper Williams or her mother, 1780–1810, cotton embroidered with cotton, 1982-162; Apron, Britain, ca. 1780, cotton embroidered with linen, possibly from earlier materials, G1991-523, gift of Mrs. Cora Ginsburg.

Typical of women's fashions throughout much of the eighteenth century, this gown's bodice has been constructed over the smooth cone-shaped stays worn beneath, without the use of fitting darts at the waist or underarms. The full skirt and pointed waistline give the appearance of a small waist, although this gown actually measures twenty-four inches around the middle.

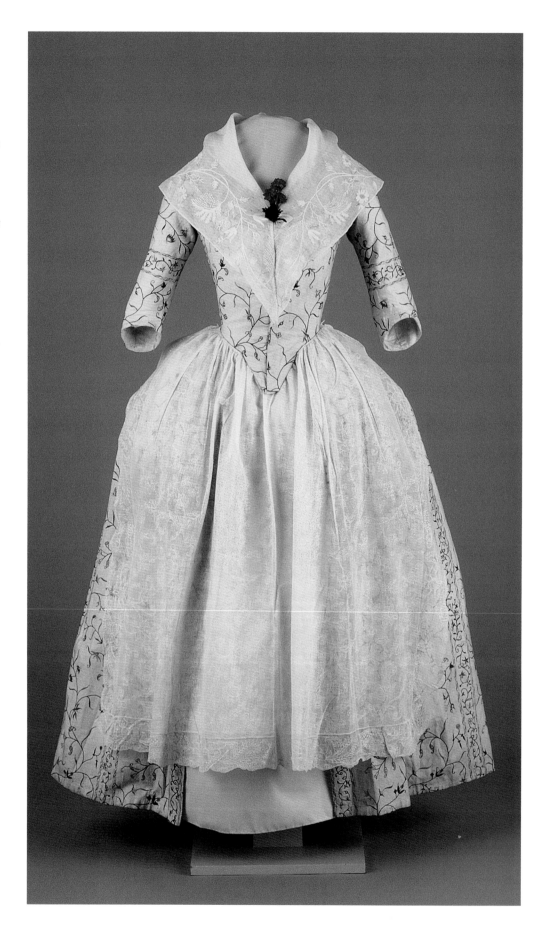

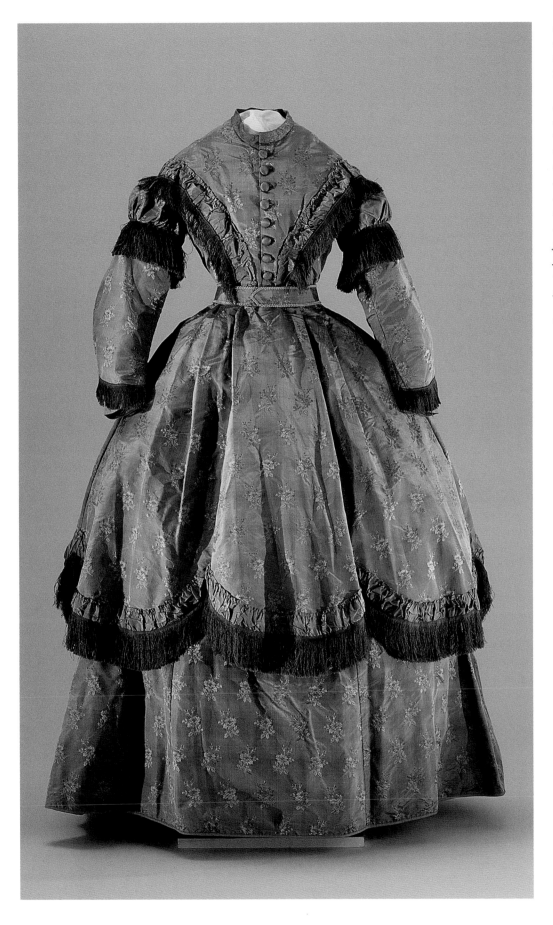

Fig. 95. Dress, Europe or United States, ca. 1867, Jacquard-patterned silk trimmed with silk fringe, lined with cotton, G1998-236, gift of Tasha Tudor.

Mid-nineteenth-century dresses shared some overall stylistic features with those of a hundred years earlier, especially full skirts supported by extra petticoats or hoops, sloped shoulders, and narrow waists. Nevertheless, their torso shapes were different. Nineteenth-century gowns had waistline darts to allow them to fit over corsets with individual cups for the breasts. Draped overskirts such as this example were especially popular from the late 1860s to the 1880s. The waist in this example has been let out to twenty-six inches.

Full, long skirts were not entirely without function, however. Convenient for personal hygiene, they hid the evidence of bulky rags or towels worn during menstruation.[18] Combined with an apron and neck kerchief, a generous skirt could also accommodate pregnancy without significant alteration much more readily than a form-fitting garment (see chap. 5).

Excellent palettes on which to display costly and beautiful silks, full skirts served aesthetic functions, as well. They announced wealth, status, and a leisurely lifestyle. They made a woman's waist appear smaller by contrast with the broad expanse of the skirts below (see sidebar, p. 66). Hoop skirts increased the wearer's visible importance by taking up a great deal of space and by keeping others at a distance. At the same time, they hampered mobility, made it inconvenient to travel, work, and venture outside the household, and required practice to maneuver gracefully.

Judging from period descriptions, full skirts distended by hoops were also sexually seductive and confusing to male onlookers. In 1747, Robert Campbell accused women of ulterior motives for wearing hoops. Combining good humor with frustration, he wrote, "I defy all the Male Creation to discover the secret Use the Ladies designed them for: Some apparent Advantages flow from them, which every one must see, but they have a cabalistical Meaning, which none but such as are within the Circle can fathom: We see they are Friends to Men, for they have let us into all the Secrets of the Ladies Legs, which we might have been ignorant of to Eternity without their Help; they discover to us indeed a Sample of what we wish to purchase, yet serve as a Fence to keep us at an awful Distance."[19] Campbell was writing during the 1740s, a time when women's hoops achieved their widest extension during the entire century (see fig. 87). Draped in shifting, layered fabric that swayed with every step, the female body took on great seductiveness.

Given the apparent expense and inconvenience of full skirts, the modern observer might wonder why eighteenth-century workingwomen wore skirts, not trousers (see chap. 4). Today, pants seem practical, comfortable, and the logical choice for active physical labor. Why did slaveholders, most of whom viewed slaves as subhuman, distinguish between garments for men and for women? With the power to choose any style for their laborers, slaveholders could have dictated unisex uniforms to streamline clothing production. Nevertheless, they gave girls and women petticoats, or skirts, to wear while working in the fields alongside men in trousers.

The answer lies in the eighteenth-century mind. With respect to clothing, female slaves were considered women first, and slaves second. Even in the hierarchical society of the eighteenth century, gender spoke louder than issues of social class and freedom. Only in the twentieth century were trousers accepted as mainstream wearing apparel for women.[20] Only then did advances in personal hygiene and easy-care clothing coincide with a growing belief that women were men's equals.

People today may be too far removed from their ancestors to plumb all the meanings of their clothing. Each artifact must be scrutinized for evidence of what it was, when and how it was made, who made and used it, and what it meant to the original wearer. For museum and material culture professionals, history and things are inseparable. Yet, as Jules Prown warns, simply "'doing history' with objects" is not enough. Scholars may know the facts, but they cannot always retrieve the rich complexity of the past and what it was like to live then. Prown points out that history "uses small truths to build large untruths."[21]

Ironically, fiction may reveal patterns and realities of history. The best poetry, novels, and films can achieve the status of mythology by distilling and illuminating a culture's beliefs. Details need not be factual to tell a larger truth. Prown believes that "literature can weave small fictions into profound and true insights regarding the human condition. It can recreate the experience of deeply felt moments and move us profoundly. It can trace inexorable patterns of cause and effect in fiction and concentrate the largest universal truths into myth."[22] How an author uses artifacts in fiction can reveal a wealth of information about the society and its relationship to objects.

Novelists and screenplay writers delineate personality (see sidebar, next page). To make fictional subjects believable, authors select from available realities, put words in their characters' mouths, invent actions consistent with the words, and construct the right settings. The best writers give their creations symbolism, meaning, and depth, often with the help of distinctive clothing to reveal multiple levels of information about the fictional person. The most successful costumes in literature or cinema are recognizable, meaningful, and based clearly enough in historical reality that the reader gets the message.

A series of five novels written between 1823 and 1841 may be used as an extended example of clothing in fiction and its relationship to actual history. *The Leatherstocking*

Fig. 96. Natty Bumppo costume, made by Tasha Tudor, United States, twentieth century, fringed cotton, fox fur, feathers, L1996-591, 5–6, lent by Tasha Tudor.

Renowned illustrator Tasha Tudor fashioned this costume for at-home theatrical productions that depicted the fictional character Natty Bumppo, also known as Leatherstocking. She made the fur hat out of her mother's fox fur stole.

AMERICA MEETS LEATHERSTOCKING

With the 1823 publication of *The Pioneers* by James Fenimore Cooper, the American public first met the character "Leather-stocking," or Natty Bumppo. The fictional hero would eventually appear in all five of *The Leatherstocking Tales,* a series of adventures that included *The Last of the Mohicans.*

In the first scene of *The Pioneers,* set in the 1790s on the relatively isolated frontier of upstate New York, Leatherstocking and a young companion are deer hunting. They meet Judge Marmaduke Temple and his pretty daughter riding in a horse-drawn sleigh. A wealthy landowner who has begun to clear and develop much of the surrounding area, Temple and his daughter are on their way home from New York City, where the daughter attends school. She wears silks and furs, while the Judge has a greatcoat "abundantly ornamented by a profusion of furs."[1] Judge Temple's fur clothing is a frivolous and wasteful use of material, contrasted with the modest leather and homespun garments of Leatherstocking (fig. 96).

When a deer appears, Leatherstocking watches as his companion and the Judge fire simultaneously. Both are convinced they can claim the kill. The Judge protests that, although he does not need the meat, his reputation is at stake: "A few dollars will pay for the venison, but what will requite me for the lost honor of a buck's tail in my cap?" Cooper's audience would have known that the buck's tail ornament in a hat or cap had long been a symbol of competence in the woods. Meanwhile, readers discover what they suspected all along, that the Judge's five shots missed the deer; after all, how could a man dressed like that be a good hunter? Not only did the Judge miss the deer, but he shot four times into a tree, and the fifth time he wounded the young hunter. Temple's boastful claim to have shot the deer contrasts humorously with his wildly misplaced shots. In a subtle way, Cooper suggests that Temple's development of the surrounding land is far more effective in exterminating deer than his hunting would ever be. Leatherstocking complains that game is getting more difficult to find because of the Judge's "clearings and betterments."[2]

As the story unfolds, the young hunter eventually marries the pretty girl and settles down. Leatherstocking reluctantly moves on because expansion and settlement have made the land too crowded for him and uninhabitable for the wildlife on which he bases his lifestyle. The last sentence of the book predicts a familiar scene played out repeatedly in the life of an America rapidly expanding westward: "He had gone far towards the setting sun—the foremost in that band of pioneers who are opening the way for the march of the nation across the continent." The stories of *The Leatherstocking Tales* raised to mythological status the self-reliant, solitary frontiersman and captured America's complex relationship with the vast lands to the West. With unique foresight, Cooper put his finger on America's complex choices: solitude or society, open land or development, leather and homespun or silk.

1 James Fenimore Cooper, *The Pioneers,* 1823, reprint (New York, 1980), chap. 1, p. 16.
2 *Ibid.,* p. 20.

SMALLER BACK THEN?

A persistent myth about eighteenth-century people has to do with size: women had tiny waists and all people were significantly smaller than modern individuals. While well-nourished people in industrialized countries are getting statistically larger and taller, the differences between then and now are not as great as mythology suggests.

Is it not true that the short beds prove people were smaller back then? No. In fact, twenty-seven tall-post bedsteads in the Colonial Williamsburg collections range from seventy-two to eighty inches long, with an average length of seventy-six-and-a-half inches, about the size of a modern double bed mattress. Even allowing for an inch or two in length taken up by the headboard of an antique bedstead, most mattresses measure more than six feet long. Because period bedsteads have tall superstructures and are frequently displayed in large rooms with high ceilings, optical illusion makes them appear much shorter than low-to-the-ground modern ones.

The myth of small ancestors has been around a long time. In the 1960s, British costume authority Doris Langley Moore attempted to correct such beliefs in a brochure for the Bath Museum of Costume in Britain. Moore pointed out that, of more than two thousand women's garments she had measured, the average waist was "at least 24 inches." Only one garment had a nineteen-and-a-half-inch girth.[1] Many of the antique dresses and men's suits Moore studied in her long career had measurements that corresponded to those of contemporary women and men's outfits. The costume collections of the Smithsonian Institution and Colonial Williamsburg corroborate these early findings.[2] Women's eighteenth-century stays and gowns in the Colonial Williamsburg collections have waists that range from about twenty-one to thirty-six inches. Gowns with full skirts give the illusion of small waists, and the optical illusion is increased by triangular stomachers that narrow to a point at or just below the waist.

How tall were people? The first president of the United States, George Washington, was taller than the forty-third president, George W. Bush. Thomas Jefferson and William Jefferson (Bill) Clinton were about the same height. Advertisements for runaway indentured servants, convicts, and slaves provide information about workingmen. Four hundred eighty-five Virginia and Maryland men who ran away between 1750 and 1780 had an average height of five feet seven-and-a-half inches. The men varied almost a foot in height, ranging from four feet, seven inches to six feet, six inches tall. Presumably, the diets of servants and slaves were often deficient, causing some reduction in height. Most eighteenth-century people could walk down a city street today without causing any notice because of their stature. In fact, a few would tower over modern men and women.

1 Doris Langley Moore, *Museum of Costume, The Story of The Collection*, p. 21, quoted by Mildred B. Lanier, Feb. 16, 1967, memo, research files, CWF.
2 Claudia Brush Kidwell and Valerie Steele, eds., *Men and Women, Dressing the Part* (Washington, D. C., 1989), pp. 52–53.

Tales of James Fenimore Cooper defined the expanding new nation called the United States of America.[23] Cooper set the books in the period from the 1740s to the early 1800s, which included early westward movement by white trappers and settlers, the French and Indian War, the Revolutionary War, and building the new nation. The novels follow the fictional life of a man called Natty Bumppo, nicknamed "Leatherstocking." Events that had occurred thirty to one hundred years before Cooper wrote about them already had a mythical quality that the novelist recognized and built on. Although fictional, the novels summarize America's spirit during the early nineteenth century and reveal the significance of the frontier to the country's costume history and mythology.[24]

If Cooper's main character was to symbolize concepts as important as America's relationship to the wilderness and westward movement, he had to be dressed appropriately. In *The Last of the Mohicans*, Leatherstocking is in his thirties, active during the French and Indian War of the 1750s. Cooper describes him as a man dressed in a green hunting shirt, a cap of animal skins, and moccasins (fig. 97):

He wore a hunting shirt of forest green, fringed with faded yellow, and a summer cap of skins which had been shorn of their fur. He also bore a knife in a girdle of wampum, like that which confined the scanty garments of the Indian, but no tomahawk. His moccasins were ornamented after the gay fashion of the natives, while the only part of his underdress which appeared below the hunting frock was a pair of buckskin leggings that laced at the sides, and which were gartered above the knees with the sinews of a deer.*

Cooper's footnote, marked by the asterisk, describes a hunting shirt as "a picturesque smock frock, being shorter, and ornamented with fringes and tassels." He points out that the colors were for concealment and that many American riflemen wore the garment, which was "one of the most striking of modern times" [1826].[25]

Cooper displayed a keen understanding of the clothing needed to exist comfortably in wilderness conditions. He used information he had acquired from personal experience and research to clothe his characters.[26] While not overly meticulous about historical dating, Cooper correctly assessed the basics when he had Leatherstocking declare, "It's necessary to take to some of the practyces of the woods, for comfort's sake and cheapness."[27]

A real-life war hero came to a similar conclusion (fig. 98). Through his choice of pragmatic garments for soldiers

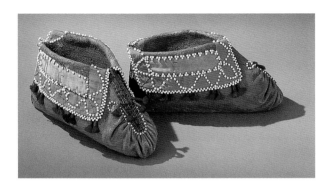

Fig. 97. Moccasins, Eastern North America, 1750–1780, deerskin decorated with silk, glass beads, metallic braid, tin cones, 1999-73, 1–2.

According to family history, these Woodlands Indian moccasins were collected by Colonel Frederick Thomas, a British officer during the American Revolution, and taken back to England around 1780. The moccasins show the interaction between Native American design traditions and imported materials.

Fig. 98. GEORGE WASHINGTON, by Charles Willson Peale, Philadelphia, Pennsylvania, 1780, oil on linen bed ticking, G1933-502, gift of John D. Rockefeller, Jr.

Washington is depicted in a uniform cut along the lines of a fashionable suit with coat, waistcoat, and knee-length breeches. Although he is wearing boots, many of his soldiers had fabric stockings or leggings to protect their legs in outdoor conditions.

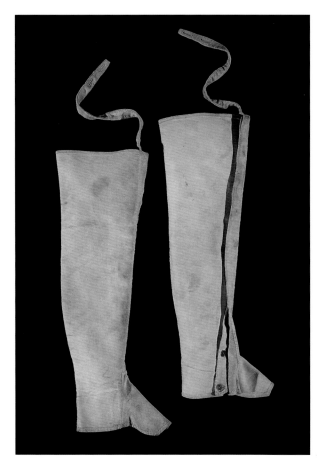

Fig. 99. Leggings, Britain, 1800–1840, napped cotton, later brass buttons, from the collection of F. M. Bennett, 1954-1049, 1–2.
British and American men wore fitted leggings for hunting and for other rural activities.

under his command, George Washington not only used clothing for tactical purposes, but also participated in the creation of a new symbolism. With first-hand knowledge of the wilderness and facing a shortage of supplies during the French and Indian War, Washington recognized that regimental uniforms were impractical under those conditions. Styled after three-piece fashionable suits, regimentals had skirted coats, waistcoats underneath, and breeches with tight bands just below the knees. These uniforms required a great deal of expensive fabric, restricted movement, and, despite considerable weight, failed to adequately protect the legs and ankles from underbrush, rocks, and snakes. One wonders why men wore such impractical knee-length pants. The forces of fashion and custom allowed modifications only under special conditions such as military duty and active labor.

Like others before him, Washington ordered supplementary clothing to protect his troops' legs. In May 1758, he sent to Philadelphia for "one thousand pair of Indian stockings, (leggings), the better to equip my men for the woods."[28] Almost twenty years later, during the American Revolution, Washington again chose "Indian Boots, or Leggins" instead of stockings, explaining that they were warmer, wore longer, and gave the men a more uniform appearance.[29]

What did Washington's Indian boots look like? J. F. D. Smythe, an early explorer, described the functional garments in his 1784 book, *A Tour in the United States of America*. Smythe wrote that men in the back settlements wore "Indian boots, or leggings, made of coarse woolen cloth, that either are wrapped around loosely and tied with garters, or are laced upon the outside, and always come better than half way up the thigh: these are a great defence and preservative, not only against the bite of serpents and poisonous insects, but likewise against the scratches of thorns, briars, scrubby bushes and underwood, with which this whole country is infested and overspread" (fig. 99).[30] English journal writer Nicholas Cresswell wore similar attire while traveling through western Virginia in 1775. His leggings were "pieces of coarse woollen cloth wrapped round the leg and tied below the knee with a string to prevent the snakes biting you."[31] Elsewhere in his account, Cresswell noted that he had "employed an Indian Woman to make me a pair of Mockeysons and Leggings," probably both of leather.[32] Historical leggings or Indian stockings like those described by real fighters and explorers were the precedents for Cooper's fictional leatherstockings. The sturdy leg coverings worn by the main character in the series reinforced the author's message of adaptation to the wilderness.

But leggings alone did not solve the problems with three-piece suits or heavy uniforms. In the wartime conditions of 1758, Washington complained about shortages of uniforms, which, he added, he would like to make more practical: "Were I left to pursue my own Inclinations I wou'd not only order the Men to adopt the Indian dress, but cause the Officers to do it also, and be the first to set the example myself. Nothing but the uncertainty of its taking with the General causes me to hesitate a moment at leaving my Regimentals at this place, and proceeding as light as any Indian in the Woods. 'T is an unbecoming dress, I confess, for an officer; but convenience rather than shew, I think shou'd be consulted."[33] Having put his plan into effect, Washington reported later that same

month, "It is evident, Sold'rs in that trim are better able to carry their Provisions; are fitted for the active Service we must engage in; [and] less liable to sink under the fatiegues of a March."[34]

Exactly what Washington's Indian dress of the 1750s looked like is not entirely clear. That it was far from formal is indicated by the fact that one of his colleagues, Lieutenant Colonel Adam Stephen, called the outfits "undress," the period term for casual clothing. Washington wrote to Stephen, "It gives me great pleasure to find this Dress; or undress as you justly remark; so pleasing to Colo. Bouquet." Washington's Indian dress must have included overshirts and leggings or Indian stockings. Apparently, some regiments wore Indian-style breechclouts, or loincloths, as well.[35]

Having learned the lessons of the French and Indian War, Washington put his experience to good use during the American Revolution. Once again he had to procure supplies and clothing for his men, but the task was even more difficult now that the traditional sources of imported British textiles were cut off. In 1775, Washington tried to obtain New England linen to make shirts. He corresponded with Connecticut Governor Jonathan Trumbull, father of painter John Trumbull (see fig. 36). Washington reported that the Continental Congress recommended coarse tow linen from Rhode Island and Connecticut "for the Purpose of making of Indian or Hunting Shirts for the Men, many of whom are destitute of Cloathing." Washington enclosed a pattern shirt to copy, and directed Governor Trumbull to "give the necessary Directions throughout your Government, that all the Cloth of the above kind may be bought up for this Use, and suitable Persons set to work to make it up . . . it is design'd as a Species of Uniform, both cheap and Convenient."[36] In a similar request to Governor Nicholas Cooke of Rhode Island, Washington also enclosed a completed garment to use as a pattern by those hired to sew the shirts.[37] Elsewhere, Washington reiterated his reasons for selecting hunting shirts instead of regimental coats: layered with warm waistcoats underneath, the shirts would be "Cheaper and more convenient."[38]

Many Revolutionary War soldiers, especially riflemen, fought in hunting shirts instead of three-piece regimentals. By the 1770s and 1780s, the shirts were often described as open before, that is, with a full front opening like a coat or jacket, making them easier to put on and take off for layering. They were made in various colors, often decorated with fringed fabric, and sometimes styled with

a cape over the shoulders. In 1775, Silas Dean, Connecticut delegate to the first Continental Congress, described the Philadelphia riflemen in considerable detail: "They have, besides, a body of irregulars, or riflemen, whose dress it is hard to describe. They take a piece of Ticklenbergh, or towcloth [linen], that is stout, and put it in a tanvat until it has the shade of a fallen dry leaf. Then they make a kind of frock of it, reaching down below the knee, open before, with a large cape. They wrap it around them tight on a march, and tie it with their belt, in which hangs their tomahawk."[39] Not all hunting shirts were long, however; those of the Sixth Virginia Regiment were described as short, with fringe trim reserved for the officers.[40]

A rare linen hunting shirt from 1776 survives in the collection of Washington's Headquarters State Historic Site in New York (fig. 100).[41] In 1962, Colonial Williamsburg copied the shirt and accessioned the copy into the collections (fig. 101). The shirt opens down the front and measures about twenty-seven inches long. Made of white linen, it is trimmed with fringed fabric on the cape, down the front, and on the sleeves that are further articulated with tucks or sewn-down pleats. The pleated sleeves were not unique; in 1779 a Charleston, South Carolina, slave ran away wearing a light blue hunting shirt "plaited in the sleeves."[42]

Although not every soldier wore a hunting shirt or Indian dress (some fought successfully while wearing regimental uniforms), Washington and other sojourners in the American interior recognized the practical nature of clothing worn by Native Americans. Cooper's fictional character, Leatherstocking, stated the obvious when he said, "Whoever comes into the woods to deal with the natives, must use Indian fashions, if he would wish to prosper in his undertakings."[43]

But the true story is more complex. The dress of the natives in eastern North America was itself an amalgamation and adaptation of styles influenced by Europeans and their trade goods. Almost as soon as contact was made, overseas textiles and certain clothing items quickly found their way into Indian wardrobes, replacing the animal skins that had been worn previously. Ironically, many of the same animals once used for Indians' clothing began to be traded for English manufactured cloth. White pioneers encountered natives wearing clothing and textiles made in the same manufacturing centers that supplied the settlers themselves.[44] European trade goods shared by white and Native American alike gave both groups common ground.[45]

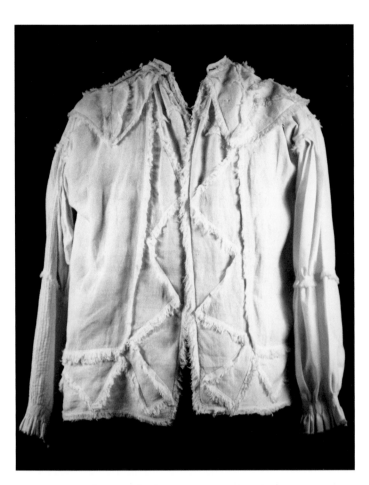

Fig. 100. (*LEFT*) *Hunting shirt, New York, worn by Captain Abraham Duryea, ca. 1776, linen, Courtesy, Washington's Headquarters State Historic Site, New York State Office of Parks, Recreation, and Historic Preservation.*

Captain Duryea of the Duchess County, New York, militia reputedly wore this shirt at the Battle of White Plains. The fringe is made of raveled strips of the same linen used to make the garment. The original proper right sleeve has a series of fine tucks that run lengthwise; the left sleeve is a later replacement.

Fig. 101. (*BELOW*) *Hunting shirt, Williamsburg, Virginia, 1962, antique linen, 1962-126.*

Staff from Colonial Williamsburg's Costume Department copied the eighteenth-century hunting shirt worn by Abraham Duryea to use as a pattern for costuming interpreters in the Williamsburg militia.

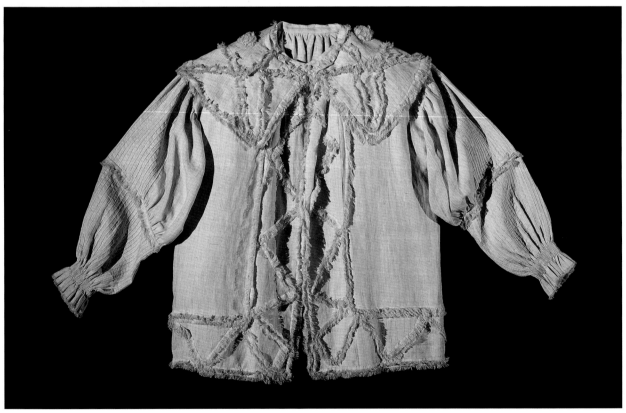

Fig. 102. THE THREE CHEROKEES, CAME OVER FROM THE HEAD OF THE RIVER SAVANNA TO LONDON 1762, engraved by George Bickham, London, England, ca. 1765, line engraving on paper, 1958-484A.

American Indians and their clothing were considered exotic curiosities in Europe during the eighteenth century. These three Cherokee men were sent to London by Virginia's Royal Governor Fauquier to meet the King. The men wear loosely fitted cloth stockings, possibly made of English textiles acquired by trade. Although their shirts were probably also trade goods, not of native manufacture, the men adapted the garments to their own traditions in their manner of wearing and accessorizing them.

Indians readily adopted imported linen shirts but wore them in "distinctly non-European ways."[46] Rather than tucking their shirts into the breeches waistband, as European men did, native men wore them as overshirts, usually shunning the impractical breeches altogether (fig. 102). Further, traders made and decorated the shirts to suit native preferences.

Although some native men embraced formal suits, others wore a combination of garments, adapted to their culture and for practicality in the woods. John Filson, the writer who first popularized the life story of Daniel Boone, described Kentucky Indians in "a shirt of the English make, on which they bestow innumerable broaches to adorn it, a sort of cloth boots and mockasons, which are shoes of a make peculiar to the Indians, ornamented with porcupine quills, with a blanket or matchcoat thrown over all, compleats their dress at home."[47] In 1775, Nicholas Cresswell saw a similar costume on Ottawa people he encountered on the frontier: "The dress of the men is short, white linen or calico shirts which come a little below their hips without buttons at neck or wrist and in general ruffled and a great number of small silver brooches stuck in it Breechclout and Mockeysons with a matchcoat that serves them for a bed at night The women wear the same sort of shirts as the men and a sort of short petticoat that comes no lower than the knee, leggings and Mockeysons, the same as the men."[48] Cresswell met four Shawnee chiefs who also wore an amalgamation of apparel from several cultures. The men had on "white men's dress, except breeches which they

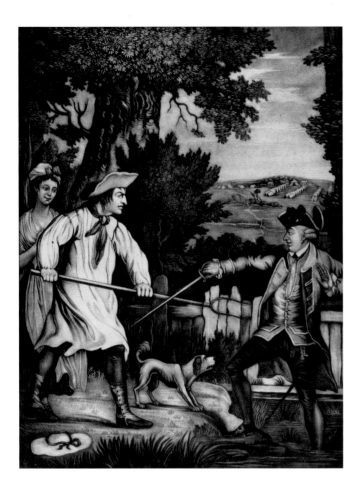

Fig. 103. *A Scene near Cox Heath; or, the Enraged Farmer*, printed for Robert Sayer and John Bennett, London, England, 1779, line engraving on paper, 1941-224.
This British farmer wears a traditional frock shirt and short leggings while working. Instead of a tight stock around his neck, he sports a patterned neck kerchief.

refuse to wear." Instead, they retained breechclouts, described by Cresswell as "a girdle round them with a piece of cloth drawn through their legs and turned over the girdle, and appears like a short apron before and behind."[49] The four chiefs who chose to wear breechclouts instead of knee breeches were not alone. As early as the 1650s, a French missionary in Canada described a similar style, adding that the Indians "regard our breeches as an encumbrance."[50]

If Native American clothing is complicated, the origin of Anglo-American frontier clothing is equally so. Although Washington used the phrases Indian dress and Indian shirts, these styles did not originate solely with Native Americans. English farmers and wagoners had for years worn loose frocks or smocks to protect their other clothing during physical labor.[51] Leggings were also worn by certain English military units and by civilians for farming and hunting (fig. 103).

Whatever its diverse origins, clothing adapted for frontier wear became a powerful symbol of the American spirit in fiction and in reality (see sidebar, next page). The symbolism was complex, and ironically appropriate for a nation that was, from its infancy, multicultural and multiracial, even if not entirely acknowledged as such at the time. The hunting shirt uniform with its appurtenances proclaimed self-sufficiency and adaptability in harsh environmental conditions; it suggested that the men could thrive and fight fiercely in the woods like the natives whose dress they adapted. The resemblance to Indians was not accidental. A Pennsylvania matron reported in 1775 that some of the Philadelphia rangers "paint their faces and stick painted feathers in their heads, in short their aim is to resemble Indians as much as possible."[52] John Joseph Henry, who published his account of the events in 1775 more than thirty-five years after the fact, recalled the clothing of the riflemen with whom he camped. Henry noted that every man carried a rifle, tomahawk, and scalping knife. Each wore "a deep ash-colored hunting-shirt, leggings and moccasins, if the latter could be procured. It was the silly fashion of those times, for riflemen to ape the manners of savages." Still, Henry added, the riflemen were "as rude and hardy a

CLOTHING A LEGEND: DAVY CROCKETT

In 1823, the same year that James Fenimore Cooper's readers first met the fictional character Leatherstocking, David "Davy" Crockett ran for a seat in the Tennessee legislature. In his autobiography eleven years later, Crockett recounted with relish the story of his successful election. He boasted that he had a large buckskin hunting shirt made for the campaign, complete with deep pockets to hold a bottle of liquor and a twist of chewing tobacco to pass out to the voters. Crockett's image as a backwoodsman with native intelligence won him the state election and later a seat in the national legislature.

In 1834, Congressman Crockett was sitting for a portrait by John Gadsby Chapman. According to the painter, Crockett objected to being depicted in ordinary, fashionable clothing, complaining that Chapman made him look like a "cross between a clean-shirted member of Congress and a Methodist Preacher." Instead, Crockett suggested, Chapman should paint him as a Tennessee hunter, and reportedly said, "If you could catch me on a bear-hunt in a 'harricane,' with hunting tools and gear, and team of dogs, you might make a picture better worth looking at."[1] Chapman agreed, and Crockett searched around Washington, D. C., for the proper hunting clothes, rifle, and mongrel dogs to use as props. The result showed Davy Crockett as a frontier hero, resplendent in his borrowed clothing (fig. 104). (The original painting was lost in a fire, but an engraving records its appearance.)

Why did the legendary hunter have to *borrow* hunting clothes and props for his portrait? In fact, Crockett's normal appearance was conservative, described by one observer as "a respectable looking personage, dressed decently and wearing his locks much after the fashion of our plain German farmers," not a "wild man of the woods, clothed in a hunting shirt and covered with hair" as expected.[2] Recalling Crockett's frequent visits to his home, another man insisted, "I never saw him attired in a garb that could be regarded as differing from that worn by gentlemen of his day—never in coon skin cap or hunting shirt."[3]

Crockett lived and died as a legend created by his own personality and life experiences as well as by his fellow Washington politicians who recognized America's need for a frontier hero. A master of symbolism, Crockett used the hunting shirt to appeal to his rural Tennessee constituency. Although he probably put on frontier clothing while hunting or traveling through rough country, he wore a standard suit in the city. Then and now, the legend of Crockett's life and clothing is as revealing as the actual events.

Fig. 104. COLONEL CROCKETT, engraved by C. Stuart from the original portrait by John G. Chapman, 1839, mezzotint on paper, Courtesy, Library of Congress, Prints & Photographs Division, LC-USZ62-93521.

1 Curtis Carroll Davis, "A Legend at Full-Length: Mr. Chapman Paints Colonel Crockett—and Tells About It," *Proceedings of the American Antiquarian Society*, LXIX (October 1959), p. 165.
2 James Atkins Shackford, *David Crockett: The Man and the Legend* (Chapel Hill, N. C., 1987), p. 169.
3 Captain William L. Foster, *ibid.*, pp. 283–284. Richard Boyd Hauck suggests that Crockett may not even have owned a deerskin hunting shirt like the one he boasted of using during his campaign. Richard Boyd Hauck, "The Man in the Buckskin Hunting Shirt," in *Davy Crockett, The Man, the Legend, the Legacy, 1786–1986*, ed. Michael A. Lofaro (Knoxville, Tenn., 1985), p. 5.

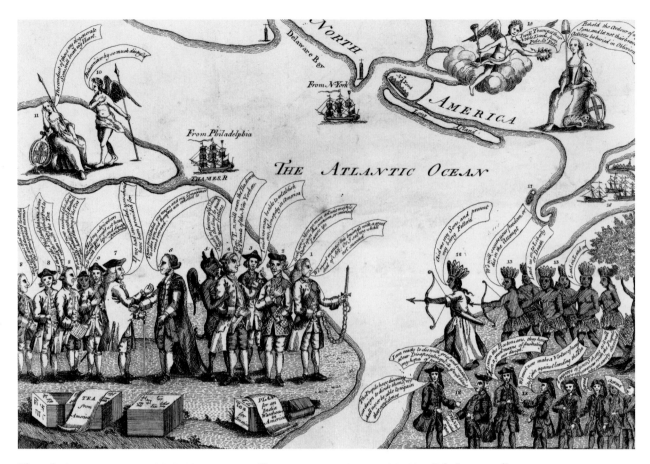

Fig. 105. LIBERTY TRIUMPHANT OR THE DOWNFALL OF OPPRESSION, Britain, 1774, line engraving on paper, 1960-44.
This political print shows the forces of British rule, at left, facing rebellious colonists across the Atlantic Ocean. The Sons of Liberty, led by America as an Indian Princess, are disguised as Indians proclaiming, "Lead us on to Liberty or Death."

race as ourselves, . . . an excellent body of men, formed by nature as the stamina of an army, fitted for a tough and tight defence of the liberties of their country."[53] The native dress at the Boston Tea Party was not merely a convenient disguise, but also a powerful symbol (fig. 105).

Colonial journal writer and tutor Philip Vickers Fithian may have summed up the symbolism best. Hearing drum beats that mustered the men at five in the morning on June 6, 1776, Fithian noted, "Every Man has a hunting-Shirt, which is the Uniform of each Company—Almost all have a Cockade, & Bucks-Tale in their Hats, to represent that they are hardy, resolute, & invincible Natives of the Woods of America."[54] A buck's tail, the trophy of a successful hunt, was worn as a proud plume in the hat or cap. In fact, the word buckskin came to be a nickname for American troops during the Revolutionary War.

These examples illustrate that the clothing worn by Cooper's fictional character Leatherstocking reflected real garments Americans wore when they explored, fought, or traveled in the nation's backcountry. Yet the artistic license taken by the author speaks of a larger truth. Always the independent, isolated man, Leatherstocking wore *only* homespun linen and leather garments styled for living in the woods. Self-sufficient and independent, he rejected elitism and social class expressed in clothing and manufactured goods. Leatherstocking's America was reality only in small parts, like the individual garments of his dress. While hunting shirts and leather clothing were practical adaptations for certain activities, few people on the frontier lived or dressed like Leatherstocking to the exclusion of more fashionable clothing. Americans were not self-sufficient in their production of clothing and textiles. Manufactured goods and

Figs. 106–107. *Jacket, overall and detail of lapels, United States, probably Southwest frontier, 1800–1825, deerskin, from the collection of Ed Charol, 1993-13A.*
Wear patterns on the shoulder of this double-breasted unlined jacket suggest it was used for shooting. Both front edges have buttonholes that allow the garment to be buttoned in either direction. The jacket was worn with the breeches in figs. 84–85.

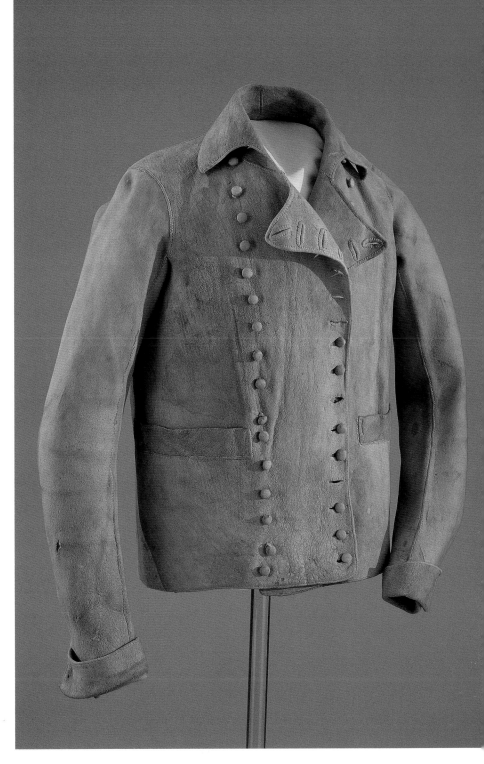

clothing reached the frontier from the beginnings of settlement. Stylish clothing continued to be an important indicator of status.[55] Leatherstocking's homespun and leather symbolized a view of America that has become part of the nation's mythology: that the country was built by self-sufficient, hearty pioneers with native common sense, able to conquer the environment and live off the riches of the land. A leather jacket still speaks to people today of adventure and self-sufficiency, of competent westerners, honest and uncorrupted by the wiles of civilization (figs. 106–107).

Although the symbolic language of clothing cannot easily be documented in written records, historical truth is complex, found in the unspoken, fictional, and mythological, just as it can be gleaned from concrete facts and artifacts of the period.

CHAPTER 3
HOMESPUN AND SILK
American Clothing

America's unique combination of peoples and landscape produced its own mythology about textiles and clothing in which Americans were independent and uncorrupted by civilization with its reliance on luxury goods (see sidebar, p. 82). People today often assume that colonists were so far removed from the sources of manufactured goods in Britain and Europe that they had to be self-sufficient, wearing clothing made out of fabrics spun, woven, and dyed by women of the household. Because of their distance from European centers, Americans must have been at least ten years behind the fashion in their clothing styles. While modern Americans imagine a homespun economy, they also visualize eighteenth-century clothing as more elegant and refined than clothing today. They assume that every garment was carefully fashioned to meet the unique specifications of each customer. What is the truth about American clothing during the eighteenth and early nineteenth centuries?

Far from being isolated and entirely self-sufficient, American colonists were, from the beginnings of settlement, part of a long-established and complicated trade network. Textiles and other goods moved around the world from the original manufacturing locations to final destinations. Available textiles were limited more by tariffs and navigation acts than by distance. In fact, any textile available to British customers in the London or Liverpool warehouses could reach the colonies as fast as a ship was able to make the voyage.

Colonial dependency on imported textiles began as soon as Englishmen and -women arrived on these shores. Historian Bernard Bailyn assessed the importance of trade goods when he compared the output of the most prolific weaver of Rowley, Massachusetts, with the yardages of imported textiles. During a nine-year period from 1673 to 1682, the weaver produced less cloth than was imported in a single shipload.[1] The trade goods that reached the colonies ranged from coarse linens to the finest silks and printed cottons with British-produced textiles predominant. As the Anglo-American population grew in the seventeenth century, the British government realized that controlling colonial production and trade was in its best economic interest. The resulting legislation sought to limit colonial production of certain goods that might compete with British manufactures, especially woolens. Laws further favored British products by restricting the sources of manufactured goods available to the colonies. The Navigation Acts of the 1660s first forbade foreign ships from carrying goods to or from the colonies, then required that nearly all European goods destined for the colonies had to come by way of British

Fig. 108. American clothing, Brocaded silk gown, Spitalfields, England, textile, worn in Rhode Island, 1726–1728, remade ca. 1775, silk brocaded with silk, bodice lined with linen, reproduction sleeve ruffles, 1951-150, 1; Petticoat, Rhode Island, ca. 1750, silk quilted to wool backing and batting, 1951-150, 2; Coat, Virginia, ca. 1780, homespun cotton mixed with wool, 1964-174A; Waistcoat, America, ca. 1780, wool lined with linen, 1952-113. For overall views, see figs. 141 and 197.

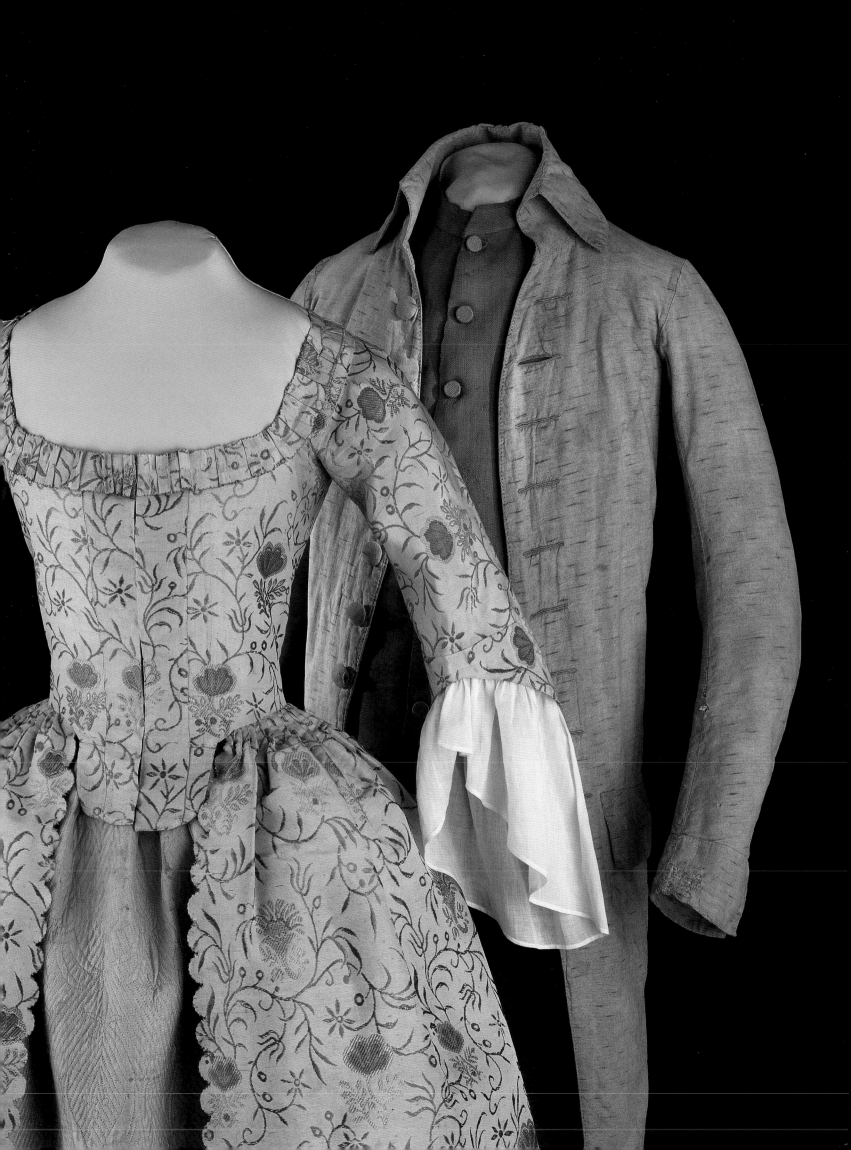

ports. The laws effectively eliminated direct trade between the colonies and Continental Europe, except for smuggling.[2] Further, a series of export bounty acts in the eighteenth century encouraged trade in British textiles over foreign goods, especially sailcloth, silk, and linens. Historian Oliver M. Dickerson has concluded, "It just did not pay to produce cloth under American conditions when goods of as good or better quality could be had from abroad for less money."[3]

This discussion of America's reliance on imported goods is not to oversimplify the economics or diversity of the American colonies. Many Americans did produce some textiles, yet, except for the period leading up to the Revolution, colonial textile production on a scale large enough to approach self-sufficiency was not economically advantageous. Even in the period preceding hostilities with Britain, many Americans could not justify self-sufficiency on economic grounds. George Washington compared the cost of imported goods with similar items spun and woven on his plantation in 1768. He concluded that the modest savings in homemade textiles were not enough to defray the expenses of spinning wheels, of hiring a white woman (probably to oversee the work), and of clothing and feeding five female slaves.[4] Americans could not, and, indeed, did not want to, escape participation in the worldwide trade of consumer goods and textiles.

Thousands of yards of imported textiles reached the American colonies each year. Export statistics for plain linens, the utility fabrics of the period, exemplify the volume of this trade. Used for men's shirts, women's shifts, summer outerwear for laborers, and bedding, linens came in a variety of qualities that ranged from unbleached, rough, and coarse fabric to fine, bleached goods (fig. 109). In the three-year period ending in January 1772, almost six-and-a-half-million yards of plain linens were exported to the colonies from Britain and Ireland; more than one-and-a-half-million yards went to the James River area of Virginia alone.[5] Most of the linens exported to America were made in Scotland, Ireland, the northern parts of England, and the northern parts of Continental Europe. The inexpensive linen called osnaburg, used extensively for clothing of laborers, was named for the German town of Osnabrück where it was originally made, although the textile (and its name) were later copied by the Scottish.[6]

The wool textiles that reached the colonies were almost exclusively British products (figs. 110–111). Woolens had been the staple manufacture of England for centuries,

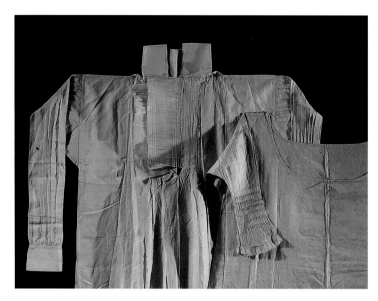

Fig. 109. Detail of linen garments, Man's shirt, British or European textile, worn in America, probably New Jersey, ca. 1800, linen, mother of pearl buttons, 1989-401; Woman's shift, British or European textile, worn in Albany, New York, by Ann Van Rensselaer, 1780–1790, linen marked with silk cross-stitches, cotton ruffles, G1990-7, gift of Mrs. Cora Ginsburg.

Throughout the colonial period and continuing into the early years of the new nation, most of the linen yardage used for clothing, sheets, and tablecloths came from the British Isles or Continental Europe. Linen was especially practical for underwear and household furnishings that required frequent washing. This shirt and shift survive with their original starched finish and pattern ironing, labor-intensive decorative features that had to be reapplied after every washing.

exported around the world well before the colonization of America. Not only were British woolens jealously protected and regulated by law, they came in a myriad of types and qualities, from the finest broadcloth for men's suits and brocaded worsted damask for women's gowns, to cheap yet sturdy materials for slaves' blankets and winter clothes. Although many counties of Britain produced wool textiles of various types, several areas excelled in goods for the export trade. East Anglia made fine worsteds of long-staple wool that often imitated silk in weave and finish (see fig. 70). The West Country was famed for expensive broadcloth as well as less-expensive utilitarian woolens. Wales was an especially important source of plain woolens used for slave clothing throughout the southern colonies. Yorkshire produced some worsted textiles and inexpensive napped woolens used for slaves' clothing.[7] American merchants and planters were quite conversant with British woolens and worsteds, and often ordered them by name: Welsh plains, Yorkshire kersey, Norwich stuff, and Kendal cotton. All these were

wool textiles during the eighteenth century, including Kendal cotton, which actually was napped wool, apparently named for its resemblance to fluffy cotton fiber.[8]

True cottons (as opposed to the wool textiles called cottons) and linen-cotton mixtures came from the Lancashire area, gaining momentum in use during the second half of the eighteenth century.[9] Cotton goods also reached America from as far away as India. Beginning in the early seventeenth century, the British East India Company imported Indian cotton textiles. The bright, washable Indian products became so popular that British linen and cotton manufacturers petitioned for protection from the competition. Accordingly, a 1720 law (effective beginning in 1721) prohibited wearing and using Indian chintzes in Britain and only allowed their entry for the purposes of reexport. Ironically, this exemption may have given fashion-conscious colonials an advantage, for they could legally import, wear, and furnish their homes with Indian cottons that were outlawed in Britain (figs. 112–114).[10]

Figs. 110–111. Coat, overall and detail of neckline, British or American textiles, made in Massachusetts, worn by Amos King, ca. 1770, wool broadcloth lined with worsted and linen, left pocket of leather, replaced buttons, 1953-59.

Typical of the woolen known as broadcloth, this red textile was fulled, or shrunk, so it would not ravel when cut. All the edges of the collar, front opening, and hem are left unfinished. In contrast to the soft, napped woolen of the outer fabric, cream-color worsted with a shiny, pressed finish lines the coat fronts and tails. The coat fastens with hooks and eyes; the decorative corded buttonholes were not cut open. The neckline has an unusual mock collar made of a single layer of cloth applied around the neck and stitched down.

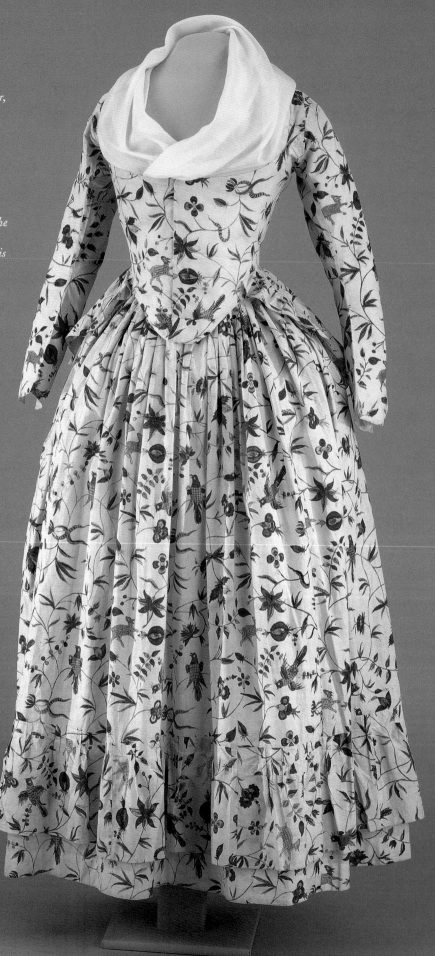

Figs. 112–114. *Jacket and petticoat, front, back, and detail of textile pattern, East Indian textile, worn in Albany, New York, by Ann Van Rensselaer, ca. 1790, textile earlier in date, mordant-painted and dyed cotton chintz, bodice lined with linen, reproduction kerchief, 1990–10.*

American customers with sufficient wealth prized cotton textiles painted and dyed in India for the export market. With their brilliant, colorfast hues and luxurious polished surface finish, Indian chintzes were the most expensive and desirable of the printed cottons. This two-piece dress has a fitted jacket with ruffled peplum at the waist. The jacket is worn over a pleated petticoat with flounced hem. Informal jacket ensembles became increasingly fashionable in the 1780s and 1790s.

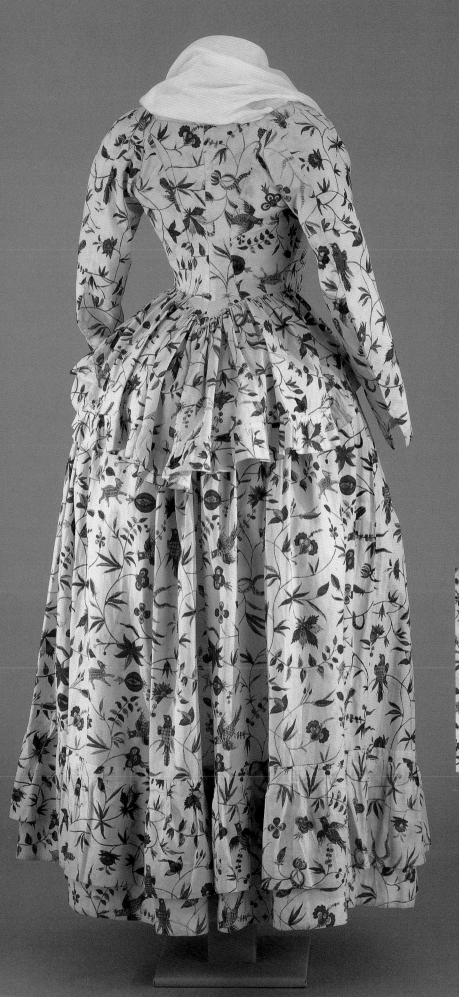

The prohibition was eased somewhat in the second half of the eighteenth century. Yet as late as the 1770s, customs officials seized a customer's Indian chintz from the shop of London cabinetmaker and upholsterer Thomas Chippendale while he was making it into bed hangings.[11] About the same time, India chintz was openly advertised and offered for sale in Williamsburg, Virginia.[12]

Although silks were imported in much smaller quantities than other textiles, their expense and elegance led people to treasure them, which assured their survival in greater quantities than woolen, linen, or cotton goods. One source of finished silk textiles was China, a country that made many products specifically intended for export to the West. The Chinese silks used in Britain and America were imported by the East India Company, and were often erroneously referred to as India silks for that reason. Like the imported cotton chintzes, the silks brought in by the East India Company were prohibited in Britain through a series of acts in the first two decades of the eighteenth century, yet, like the chintzes, they could be legally worn in the colonies (see pp. 49–51). A fragment of buff-colored silk damask woven in China was once part of a gown worn in Delaware by Jane Richardson McKinly (see figs. 80–81). This silk has the typical characteristics of Chinese silk in its twenty-nine-inch width, temple-stick holes in the selvages, and design with three repeats in the width.[13]

The widespread use of export textiles in all the British colonies meant that regional preferences were somewhat blurred. The same types and colors of cheap Welsh woolens were used for slaves in Maryland, south to the Carolinas, and later in Mississippi and Georgia; British osnaburgs were available in stores throughout the colonies. Expensive items such as silks were sometimes duplicated, as well. A woman from Ulster County, New York, had a gown of Chinese silk identical to that of McKinly of Delaware (fig. 115).[14]

Mary Lynch Egberts of New York owned a Chinese damask gown of brighter hue than the previous examples (figs. 116–118). The garment is made of orange and greenish-gold silk in a scrolling floral pattern. Now remade from earlier silk in the polonaise style of the 1770s, the gown has its skirt drawn up in puffs by a series of loops sewn to the inside of the skirt.

It is perhaps ironic that silks from as far away as China were worn in America, while fashionable French silks

THE TRUTH OF MYTH

Is a myth necessarily untrue? Although one of the definitions of the word is "an unfounded or false notion," the meaning of myth goes far beyond that of an erroneous perception. Like parables, myths are stories that, while their details may not be literally factual, disclose an important truth about the society holding the belief. The underlying verity buried deep within most myths speaks volumes about the world view or ideals held by the group. For example, there is no proof that young George Washington cut down a cherry tree and confessed, "I cannot tell a lie." The story reflects, among other things, the esteem Americans held for their first president and their belief in his irreproachable honesty and integrity. The myths and stories about the nation's early history can reveal who modern Americans believe they were—and still are.

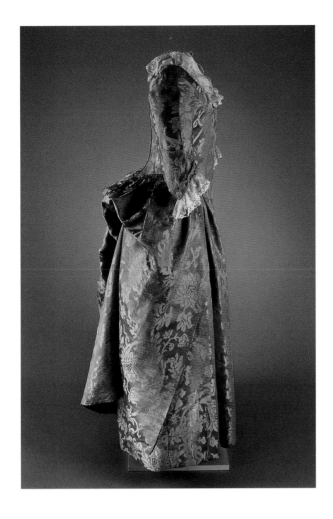

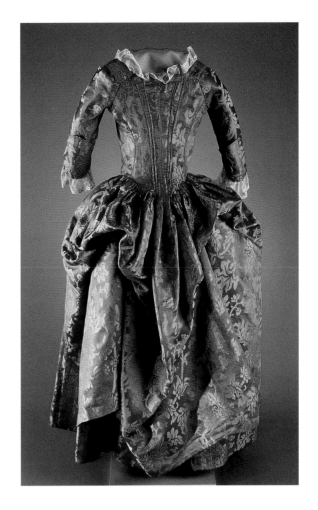

Fig. 115. (*LEFT*) *Gown, Chinese textile, worn in New York, silk textile 1750–1770, remodeled ca. 1780, silk damask, bodice lined with linen, reproduction kerchief, Courtesy, Daughters of the American Revolution Museum, gift of Mrs. Mays Beatty, Ella Dowdney England, Mrs. Herbert K. England, Abraham Clark Chapter.*

The textile trade in the eighteenth century was international in scope. Although the silk damask in this gown was made in China, it was used in New York. The same design occurs in a textile once worn in Delaware (see figs. 80–81). Typical of Chinese silks, the textile measures more than twenty-eight inches from selvage to selvage (the width as woven on the loom).

Figs. 116–118. (*ABOVE AND RIGHT*) *Gown and petticoat, side, back, and detail of textile pattern, Chinese textile, worn in New York, 1740–1760, remodeled 1770s, silk damask, bodice lined with linen, trimmed with eighteenth-century linen needlepoint lace, 1985-143, 1953-152.*

This two-color damask is typical of Chinese export silks in its use of three pattern repeats between the selvages and its twenty-nine-and-a-quarter-inch width. The back view shows the gown skirt looped up in puffs, polonaise style.

were virtually nonexistent in the colonies until after the Revolution. Again, this dearth was attributable to law rather than geography. Direct French trade with the colonies had been prohibited by the Navigation Acts. An additional series of laws to protect British silk manufacturers meant that French silks were usually prohibited from entering Britain and were therefore unavailable in the London warehouses, even for reexport.[15]

English weavers supplied most of the silks exported to the American colonies. Many surviving American gowns were made of silks from Spitalfields in eastern London, where French Protestant weavers had settled in the last half of the 1680s following the revocation of the Edict of Nantes.[16] Panels of silk damask from a gown skirt have a tradition of ownership by Virginian Martha Dandridge before she married George Washington (fig. 119). Although woven in a cloth color similar to some of the Chinese silks illustrated previously, the Dandridge dress fragments display typical English design and scale for the period 1734 to 1740. English silks were woven more narrowly than Chinese examples. This textile is only twenty-and-a-quarter inches wide from selvage to selvage, compared with the twenty-nine inch Chinese silk. The English pattern is bolder, more baroque, and fills up the full width of the textile. The silk's design is attributed to the London silk textile designer Anna Maria Garthwaite by comparison with her watercolor paintings held at the Victoria and Albert Museum.[17] Dandridge was born in 1731 and would have been too young to have worn the gown when it was new in the 1730s; more likely, the gown had been handed down in her family, a common practice in an era when textiles and clothing were too expensive to discard.

Mrs. Charles Willing of Philadelphia proudly posed in a gown of similar silk damask when she sat for her portrait by American artist Robert Feke in 1746 (fig. 120). Her gown dramatizes the speed with which new designs in textiles reached the American colonies. Like Martha Dandridge Washington's damask, Willing's silk can be traced to Garthwaite, whose watercolor for the textile bears the date June 1743. Textile historian Natalie Rothstein, who first made the connection between the two designs, discovered that the watercolor pattern was sold to a silk weaver named Simeon Julins, who could have completed the yardage by autumn 1743 or spring 1744. Conceivably, the textile reached Philadelphia by summer 1744. Even taking into account the weeks the textile spent aboard a ship, the hours needed to select fabric, to fit, and to sew a dress, and the time it took to execute the painting, the finished portrait was completed only three years after the textile design was originally conceived thousands of miles away.[18] The Willing portrait proves that Americans with sufficient resources could, and did, stay up to date in their fashions.

Judging from surviving textiles with colonial histories, from the 1740s to the 1770s American women favored silks brocaded with multicolor scattered flowers on white grounds. Elizabeth Dandridge, Martha Washington's sister, wore a gown and matching petticoat of brocaded silk made into a sack-back style with deep pleats at the rear shoulders (fig. 121). Often, ownership or association with a well-known family or individual is the only reason a textile or garment survived (see figs. 32 and 313).

The revolutionary events that propelled people such as Martha Washington to fame also changed the character of America's relations with Britain. American independence brought the elimination of the Navigation Acts and trade restrictions and a temporary disruption of trade with Britain. Yet even during the hostilities, British woolens that were needed for warm clothing had been imported through circuitous routes. Merchant John Norton of Virginia offered British woolens for sale in October 1779, at the height of the war. The woolens Norton advertised were "Bath coating [and] Kendall cottons," the latter, napped wool made in Kendal, England.[19]

Immediately after the war's end, many Americans resumed trade with Britain. Just as the Americans needed imported goods and wanted to stay in fashion, so, too, the British textile producers had come to rely on the overseas markets and made efforts to cater to the newly independent Americans. This new market thrust is dramatically represented by furnishing fabrics printed with patriotic scenes commemorating the careers of American heroes (see sidebar, p. 87).

While many textiles were imported from Britain, Americans acquired their finished apparel from a variety of sources. Some garments were made in the home, especially baby clothes, everyday garments, and the family's linen underclothes that did not require close fit or expert tailoring. A few people in isolated rural areas were relatively self-sufficient. In country and city, most women or their household servants sewed the family's linens such as shirts, drawers, and shifts. Hand sewing was part of girls' basic education. From early childhood, they learned how to cut out personal linens and sew the meticulous seams that were required to prevent garments from falling apart

Fig. 119. (ABOVE) Gown skirt panel, designed by
Anna Maria Garthwaite, Spitalfields, England, worn
in Virginia, 1734–1740, silk damask, G1975-342, 1,
gift of Mrs. R. Keith Kane and daughters, Mrs. James
H. Scott, Jr., Mrs. Lockhart B. McGuire, Mrs. Timothy
W. Childs, and Mrs. N. Beverly Tucker, Jr.

Woven at Spitalfields, the silk-weaving district near
London, this textile has a characteristically bold pattern
over the full width of the twenty-and-a-quarter-inch-
wide fabric. Skirt pleats and pocket slit are visible at the
top. According to family tradition, the panel is from one
of Martha Washington's gowns.

Fig. 120. (RIGHT) MRS. CHARLES WILLING,
by Robert Feke, Philadelphia, Pennsylvania, 1746, oil
on canvas, Courtesy, Winterthur Museum.

The watercolor design for the damask Willing wears is
still extant. Conceived in 1743 by Anna Maria
Garthwaite, a well-known silk designer, the textile was
woven at Spitalfields, near London, and exported to
Philadelphia. The gown itself does not survive.

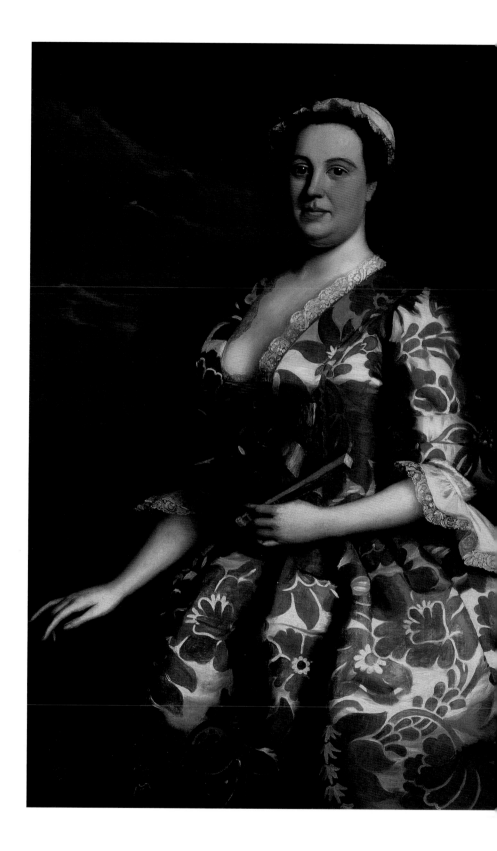

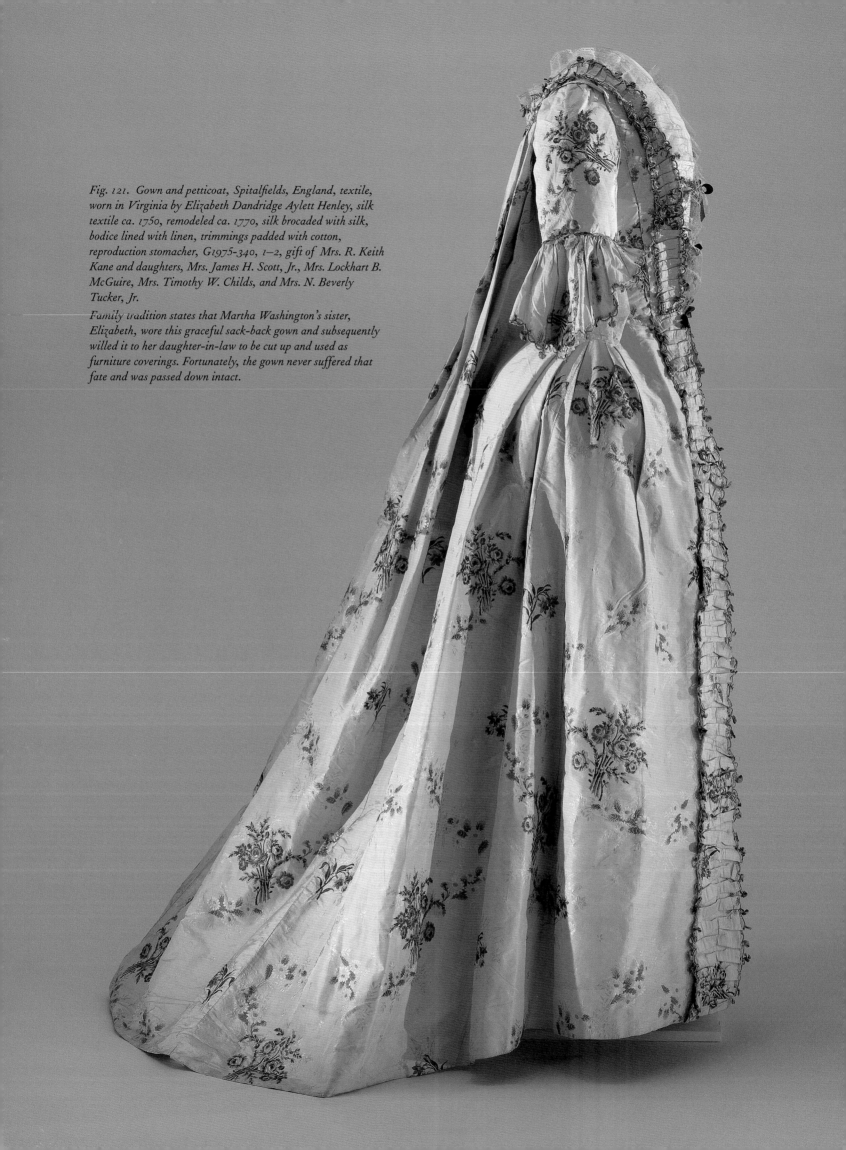

Fig. 121. Gown and petticoat, Spitalfields, England, textile, worn in Virginia by Elizabeth Dandridge Aylett Henley, silk textile ca. 1750, remodeled ca. 1770, silk brocaded with silk, bodice lined with linen, trimmings padded with cotton, reproduction stomacher, G1975-340, 1–2, gift of Mrs. R. Keith Kane and daughters, Mrs. James H. Scott, Jr., Mrs. Lockhart B. McGuire, Mrs. Timothy W. Childs, and Mrs. N. Beverly Tucker, Jr.

Family tradition states that Martha Washington's sister, Elizabeth, wore this graceful sack-back gown and subsequently willed it to her daughter-in-law to be cut up and used as furniture coverings. Fortunately, the gown never suffered that fate and was passed down intact.

During the depths of the Revolutionary War, George Washington could hardly have predicted that his heroic image would later appear on a bed curtain printed in Britain, the land of his enemy (fig. 122). After hostilities ceased between the two countries, British merchants quickly responded to Americans' desires for fashionable textiles with patriotic motifs. A plate-printed furnishing textile, for example, had the pro-British "Royal Artillery" design altered to make it acceptable to United States customers (fig. 123). The textile came in two different versions, one clearly intended for the export market. With a few passes of the engraver's tool, the words "Royal Artillery" on the drumhead were obliterated from the printing plate, thus removing all traces of British military and monarchism, so that the American customer might purchase the textile without prejudice. In the eighteenth century, as today, commerce could speak louder than political differences.

Fig. 122. (ABOVE) Detail of "Apotheosis of Benjamin Franklin and George Washington" bed curtain, Britain, ca. 1785, plate-printed linen-cotton, 1959-18.
Washington drives a chariot; Franklin, wearing his trademark fur cap, stands next to the female figure of Liberty.

Fig. 123. (RIGHT) Detail of two "Royal Artillery" furnishing fabrics, designed after the engravings of Henry Bunbury, Britain, ca. 1785, plate-printed cotton and linen-cotton, G1971-1506, anonymous gift; 1970-26.

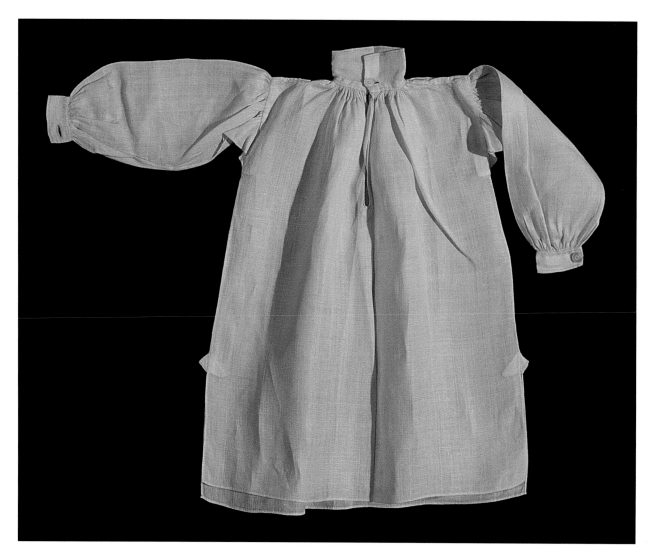

Fig. 124. Sampler shirt, Britain, 1800–1825, linen, 1985-212.
This miniature version of a man's shirt was the sewing project of a young girl learning
to make personal linens. The shirt measures twelve-and-three-quarter inches tall.

during washing. By the early nineteenth century, these sewing lessons became more formal. Some schoolteachers taught from sewing workbooks, and students made miniature garments to keep as a resource and record of the task learned (fig. 124). In addition to sewing linens and everyday clothing, many women embroidered their own decorative pockets, knitted the family's stockings and gloves, and quilted petticoats (figs. 125–127 and see fig. 89).

Despite home production of numerous clothing items, urban areas with sufficient population supported many professionals who made clothes and sold accessories. Shoemakers, wigmakers, and milliners sold ready-made imported items and provided some custom-made clothing

for their clients. Tailors and leather breeches makers produced men's clothing from work pants to formal suits. Seamstresses and mantua-makers specialized in women's gowns.

Like many other people during the eighteenth century, a young boarding school student combined her own production with professionally made garments and purchased accessories. Courtney Norton, granddaughter of merchant John Norton, attended school in Philadelphia in 1791. The typical schoolgirl wrote home that her high expenses were not really because of extravagance in dress. Courtney explained to her father, John Hatley Norton, that the schoolmaster's charges were "immencely

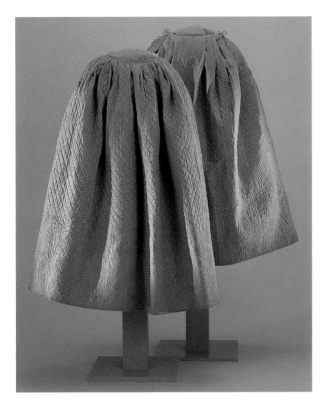

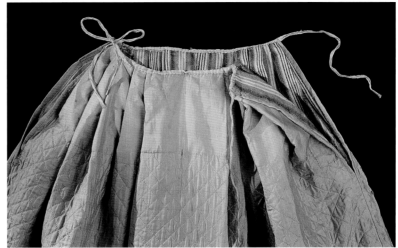

Fig. 125–126. (LEFT AND ABOVE) Quilted petticoats, Petticoat with diamonds, Connecticut River Valley, 1755, silk quilted to worsted backing, woolen batting, linen waistband, 1994-88; Petticoat with floral border and detail of waistband, made by Margaret Bleecker Ten Eyck, New York, 1770–1775, silk quilted to plain and striped worsted backings, woolen batting, 1995-191.

Although women could purchase ready-made petticoats from milliners, many quilted their own at home or with friends. The Connecticut petticoat at left has a series of three-inch diamonds filled with floral, animal, and human motifs, including Adam and Eve, cupid shooting an arrow, and the lion and unicorn from the British coat of arms. The unknown quilter signed her initials S. W. The New York petticoat features a bold undulating floral border. Margaret Bleecker Ten Eyck used several different wool textiles on the reverse, including the bright striped textile in the detail.

Fig. 127 (BELOW) Glove, New York, New York, 1750–1770, knitted linen, G1996-855, gift of Mr. William Asadorian.

high," and besides, she had only bought stays, a bonnet, a cloak, two muslin handkerchiefs, and a few pairs of shoes and gloves. Regarding the construction of her gowns, she explained, "I have also put out to be made two of my best dresses which I was afraid (being a young hand at the business) I shou'd spoil." Norton continued that she did, nevertheless, sew much of her own clothing: "All my common apparel, I take the greatest pleasure in fixing and making myself & feel very happy that I know how."[20]

Courtney probably patronized a milliner for most of her accessories. Not just suppliers of hats and headwear, milliners retailed ready-made clothing, accessories, and grooming aids. Catherine Rathell, a milliner who

Fig. 128. (ABOVE) *Detail of letter with attached pieces of silk ribbon and chenille, Catherine Rathell, Williamsburg, Virginia, to John Norton & Son, July 22, 1772.*
Catherine Rathell ordered a variety of goods from London for her millinery business, including chenille threads and narrow pink, blue, and white ribbons. To ensure that she received exactly what she wanted, Rathell enclosed cuttings of the desired colors and types of material.

Fig. 129. (RIGHT) *Folding toothbrush, Britain, 1750–1800, ivory and bristle, G1977-43, gift of Mr. Leon F. S. Stark; Tooth cleaner, France, 1750–1830, ground gypsum and pigment in paperboard box, 1950-593.*
The label on the box translates to "coral powder for cleaning teeth." Coral refers to the color of the powder, as no actual coral is present in the gypsum and pigment mixture. The folding toothbrush is also fitted with a nail pick, toothpick, and ear spoon.

operated in Fredericksburg and Williamsburg, Virginia, between 1767 and 1775, sold a wide range of stylish items that were typical of those available throughout the colonies (figs. 128–132). She ordered a wide variety of shop merchandise directly from London. In fact, she traveled to London periodically to select and bring back her inventory in person.[21] Rathell's familiarity with London gave her personal knowledge of the most fashionable goods and meant that she could direct her overseas contacts to specific stores and price ranges. For example, she wrote for "3 Doz.n Sword Canes from Mr. Masden in fleet Street Near Temple Bar, Such as I had from him at 7/ ps." Rathell was able to recognize overpriced merchandise when she received it and did not hesitate to send back to London some "Tupees" that were too expensive.[22] For the household, she sold items such as candlesticks, candles, candlesnuffers, sealing wax, soup ladles, sauce spoons, salts, glasses, cinder shovels, and gilt and silvered leather "listing" (bordering) for doors, complete with matching nails. If a customer needed materials for

making her own clothing or accessories, there were piece goods, laces, ribbons, trimmings, buttons, and threads. Rathell sold gloves for men and women, mitts for women and children, hose (some with flowered clocks), and a variety of shoes for men, women and children. For men, Rathell had sword canes, shoe and knee buckles, watches, Morocco leather pocketbooks (some stitched with silver wire), memorandum books, razors, pocket knives and forks, tobacco, and "Thread hair Nets, Such as gentlemen Sleep in."[23] Women's accessories included fans, pocketbooks, necklaces, earrings, and hatpins. For personal grooming, customers could purchase flesh brushes, nail nippers, powder machines for dusting wigs, toothbrushes, and "Essance of Pearl" tooth powder.[24] Rathell's tooth powder may have resembled an eighteenth-century French example that contains ground gypsum and coral-colored pigment (see fig. 129).[25]

Despite local availability of goods and services, many wealthy planters and merchants ordered their family's

Fig. 130. Imported clothing accessories (left to right), Gloves, Britain, worn in Albany, New York, by Ann Van Rensselaer, 1775–1800, leather, G1990-8, gift of Mrs. Cora Ginsburg; Fan, Britain, used in Suffolk, Virginia, by Catharine Reid, 1780–1820, bone, sequins, engraved and painted paper, 1978-90; Fan, China, used in Philadelphia, Pennsylvania, by Anna Clifford, 1770, bamboo, painted and silvered paper, G1980-238, gift of Miss Beatrix Rumford.

These gloves have open fingertips, a construction technique seen in Diderot's eighteenth-century ENCYCLOPÉDIE. *The fan at the left features an engraving of Shakespeare, masks of comedy and tragedy, and an angel representing Fame. The Chinese fan at the right has Anna Clifford's name and 1770 written in ink directly on the paper leaf. The dated inscription may commemorate a friend's wedding or another special event. Clifford married Jacob Giles, Jr., three years later.*

Fig. 131. Pairs of shoes (clockwise from top), White shoes, probably Britain, worn in New York by Elizabeth Van Rensselaer, ca. 1785, silk lined with linen, leather soles, from the Glen-Sanders family, 1964-393; Green braided shoes, Britain, ca. 1730, silk trimmed with silk braid, lined with linen, leather soles, 1954-1025; Pale green and white shoes, Massachusetts, worn in Maine by Jane Hodge Nichols, ca. 1816, leather trimmed with silk, lined with linen, leather soles, G1990-190, gift of Mr. and Mrs. Charles D. Carey; Blue-green damask shoes, possibly America, 1740–1765, worsted damask or calamanco lined with linen, leather soles, 1964-476.

Shoes such as the green pair with closely spaced braid trimming, above right, were known as laced shoes because of their decoration; the term did not refer to the method of closure. Shoes with straps over the instep were fastened with removable buckles. The flat, light green leather open shoes, or sandals, are labeled by the T. A. Chadwick Shoe Store, located at 92 1/2 Court Street in Boston, Massachusetts.

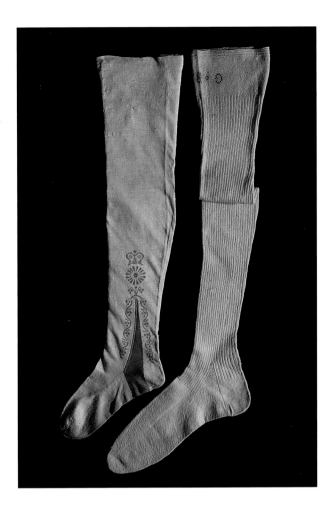

Fig. 132. *Stocking with pink clocks, Britain, worn in Westmorland, England, by Sir William Fleming, ca. 1750, frame-knitted linen with silk design, 1967-131; Ribbed stocking, possibly Connecticut, 1790–1830, hand-knitted cotton marked with silk cross-stitches, 1991-446.*

Many women made utilitarian stockings by hand in their homes for family members. At the same time, milliners and other storekeepers sold ready-made stockings that had been professionally knitted on stocking frames. The clock, or design at the ankle of the frame-knitted stocking, was inserted during the knitting process in a technique called plating.

clothing and accessories directly from London, an early version of mail order. Sometimes they ordered all the materials to make one garment, in effect a kit to take to a nearby tailor. Robert Carter Nicholas, lawyer and treasurer of the Virginia colony, sent for "as much super fine fashionable broad Cloth as will make a large Man a full suit with and two pr Breeches Garters [knee bands for the breeches] and Trim:gs of all sorts" and "as much blue bath Coating as will make a large Man a close bodied great Coat with Trim:gs."[26]

Some prominent men ordered suits and greatcoats from London tailors who worked from measurements kept on file. As might be anticipated in an era when dress clothing was closely fitted to the body, the results were not always satisfactory. Wealthy planter Robert Carter had to have one of his London-made suits altered after it arrived in Virginia. He wrote to Robert Cornthwaite, the London tailor, "The cloths you sent my Neighbour George Wythe fitted him much better than my last suit did me, for the sides of the Coat and Wastecoat were let out before I could wear them, ye Breeches were not

altered. . . . My Size and Shape of body resemble Capt. William Fauquer of the Guards."[27] Washington also had trouble with the fit of his London-made suits, complaining in 1761, "my Cloathes have never fitted me well." In exasperation, Washington ordered a suit without sending any measurements, directing his London tailor instead to "take measure of a Gentleman who Wares well made Cloaths of the following size: to wit, 6 feet high and proportionably made; if any thing rather slender than thick for a person of that highth with pretty long Arms and thighs."[28] Washington and Carter were not alone in directing the tradesman to someone of similar size. Virginian Francis Jerdone ordered two wigs from Glasgow, Scotland, from merchant-factors to whom he was sending his tobacco; he suggested that the wigs be "made to fit Mr. Hugh Brown's head which I believe will do for me."[29]

Shoe sizes could be a problem, as well. Sometimes shoes were ordered by the length of foot in inches. At other times, correspondents used a shoe as a pattern. Plantation owner Rawleigh Downman sent single shoes from himself

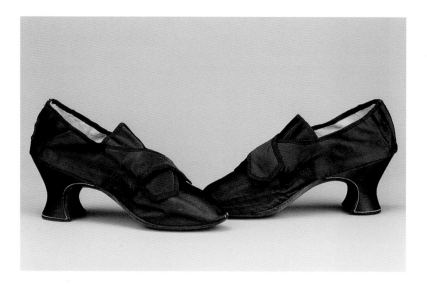

and his wife to use for sizing. For his daughters, Downman ordered shoes by foot length: "Rose colour'd calamanco Shoes with low flat heels for my Girls; that is 2 pair for a foot 8¼ inches long, and 2 pair for a foot 7¾ inches long."[30] Jerdone did not leave anything to chance; he not only sent an old shoe as a pattern for the twelve pairs of shoes ordered from Joseph Carpue, but also enclosed measurements: "In case the old shoe should miscarry, that you may not altogether be at a loss how to make them my foot is exactly 11 Inches in length, 11 Inches round the thickest part of the foot & 10 inches round the widest part of the toes: I intreat you'll have them made in the best manner to suit a heavey man."[31]

Some women's shoes apparently came in standard sizes. Several Virginians ordered shoes for their wives, referring to "Satin Shoes; Fives" or "4 pr. of black shoes, size small 5"; Martha Washington wore "the Smallest fives."[32] A silk satin shoe in the Colonial Williamsburg collection has the words *Small 6* inked on the interior of the shoe. The shoe corresponds roughly to a modern size six (figs. 133–134).

The overseas merchant-factors and relatives who selected goods played an important role in setting American styles. (A factor was an agent or deputy for the American customer.) It is clear from the correspondence that colonists wanted clothes of quality and of the newest fashion. They tried to exert control over what they received by giving specific instructions, sometimes enclosing textile swatches for color or pattern. Nevertheless, the judgment of the British factor was the final arbiter of taste. Sometimes the factor's wife or daughter was enlisted to help select goods for the female members of the colonist's family. This was the case with the clothing ordered for Robert "King" Carter's daughters in 1729. Carter wrote to Mrs. Jane Hyde, commending her for the selection of his daughters' clothes: "I receiv'd yr Obliging lines with my Daughters cloths I beleive your Care was Extraordinary And the Genteelness and richness of the silk shews they were no bad pennyworth. . . . I continue to send for my Childrens things to your Father."[33] Although the merchant's wife selected items ordered for Mrs. Mann Page from John Norton & Sons in 1769, the Pages reassigned the task to a relative in London the following year. The letter explained to the Nortons, "My Wife desires her Compliments to Mrs. Norton and returns her Thanks for the trouble she was at in buying her Things last year; but as Mrs. Lucy Randolph is a Relation & has solicited that she may be employed, my Wife has inclosed an Invoice to her for

Figs. 133–134. Shoes, overall and detail of lining inscription, made by Gresham's, London, England, ca. 1770, silk lined with linen, leather soles, 1957-148.

One of the shoes in this pair has a paper label on the foot bed that reads, GRESHAM'S AT THE CROWN/ TAVISTOCK STREET/ COVENT GARDEN/ LONDON. *American milliners, including Mary Davenport of Williamsburg, Virginia, imported Gresham's shoes for sale to their customers. The size,* SMALL 6, *is written on the lining of the tongue, in the detail.*

some Things; I shall take it as a particular Favour if you'll pay her for Them & let them be sent with the other Goods."[34] When Mrs. Robert Carter wanted a new dress in 1761, she left the style entirely up to the London mantua-maker. Her husband's letter requested "a Sack if worn, but if not fashionable a fashionable undress to cost 15£ sterlg from ye mantua-maker."[35] Sack referred to a gown with pleats at the back shoulders, falling in an uninterrupted line to the hem; the undress mentioned as an alternative was probably a gown with fitted bodice (see figs. 108 and 121).

Close contact with Britain ensured that colonists with sufficient money (or credit) dressed in quality British fashions. As early as 1619, John Pory, member of the first Virginia legislative assembly at Jamestown, had written, perhaps with a bit of hyperbole but certainly with conviction, "Nowe that your lordship may knowe, we are not the veriest beggers in the worlde, our Cowe-keeper here of James citty on Sundayes goes acowtered all in freshe flaming silkes and a wife of one that in England had professed the black arte not of a scholler but of a collier of Croyden, weares her rough bever hatt with a faire perle hattband, and a silken suite thereto correspondent."[36] English parson Hugh Jones wrote of Williamsburg, Virginia, residents in 1724, "They live in the same neat manner, dress after the same modes, and behave themselves exactly as the gentry in London."[37] A visitor to Boston, Massachusetts, in 1740 expressed a similar sentiment: "Both the ladies and gentlemen dress and appear as gay in common as courtiers in England on a coronation or birthday."[38] Both William Eddis and Nicholas Cresswell found Annapolis, Maryland, a fashionable city when they visited in the 1770s. Cresswell said that the people, "Game high, Spend freely, and Dress exceedingly gay."[39] Eddis backed up that view when he wrote from Annapolis, "I am almost inclined to believe that a new fashion is adopted earlier by the polished and affluent American, than by many opulent persons in the great metropolis."[40] While cautioning that expensive silks "were a luxury imported in small quantities by the few," textile historian Natalie Rothstein has nevertheless asserted, "The quality demanded [in the colonies] was clearly not lower than it was in London. . . . The Americans wanted value for their money and were quite capable of recognising it when they got it."[41]

Most surviving clothes and travelers' accounts illustrate what affluent, white colonists wore. Nevertheless, African-Americans formed the majority of the population in some colonies.[42] Obtaining textiles and clothing for a large working population was a challenge for slaveholders. Most large planters relied on imported textiles for their slaves and for themselves. It was more economical to use their land and labor to grow a cash crop such as tobacco, rice, or indigo, rather than to produce textiles that could be had more cheaply from abroad. In the same orders, wealthy planters sent for their own fine silks and worsteds along with the coarse, inexpensive textiles for their slaves (see chap. 4).

The American colonists looked to Great Britain for clothing styles and for many of their textiles before and after the Revolutionary War. The war and events leading up to it, however, disrupted the normal supplies. Great change was underway in the 1760s and 1770s as Americans moved, at first reluctantly, toward independence as a nation. In response to a series of taxes and acts of Parliament they perceived as unfair, colonists periodically wrote and signed associations, or agreements, not to import certain British goods, thereby hoping to apply pressure through economic boycott. Inspired by nonimportation agreements in other colonies, in May 1769 a group of Williamsburg's former burgesses (the House of Burgesses had been dissolved) signed an association to avoid a wide variety of imported goods; a similar agreement was adopted the following year, as well.

The provisions of Williamsburg's early nonimportation pacts offer insight into the minds of the colonists. Aware of their leverage as consumers of British manufactures, they also recognized that they could not produce enough textiles to clothe themselves and their slaves. So important were inexpensive British woolens and linens to southern planters that some were loath to do without them, even in the face of growing hostility with Britain. The initial strategy was to ban luxury items, including ribbons and millinery items, hats, lace, all "India" goods (which included Chinese silks and India chintzes), woven silks, and all expensive cottons, linens, and woolens above a certain price. The few items allowed as imports included spices, inexpensive cotton, linen, and woolen textiles, sewing silk, bolting cloths, Irish hose, and plaid hose. The Williamsburg Association of 1770 again exempted spices, inexpensive textiles, and certain clothing items such as bonnets, hats, shoes under five shillings per pair, and stockings under thirty-six shillings per dozen.[43] The nonimportation agreements made the colonists acutely aware of their vulnerability with regard to supplies of manufactures.

Many Americans rose to the challenge of producing and wearing their own textiles as a means of protest. The

Virginia Gazette newspaper reported that on December 13, 1769, a ball was held at the Capitol where "the same patriotic spirit which gave rise to the association of the Gentlemen on a late event, was most agreeably manifested in the dress of the Ladies on this occasion, who, to the number of near one hundred, appeared in homespun gowns."[44]

Some colonists chafed against the necessity to wear homespun. Martha Goosley of Yorktown, Virginia, complained to her son, John Norton, in London, "Is there no Probability of Making your great ones act right or will they Put us under the necessity of wearing homespun altogether [?] I assure the Gentlemen wear nothing else all Summer & we have made great improvements however I cant help wishing Sincerely that all our Differences were happily made up [.]" William Nelson was more philosophical in his response to the British Revenue Acts. The Virginian wrote in 1770, "They have already taught us to know that We can make many things for ourselves, & that We can do very well without many other things we used to indulge in. I now wear a good suit of Cloth of my Son's wool, manufactured, as well as my shirts in Albemarl & Augusta Counties, my Shoes, Hose Buckles, Wigg, & Hat etca of our own Country, and in these We improve every year, in Quantity as well as Quality."[45]

The earliest Williamsburg associations had exempted inexpensive textiles, primarily because of the requirements for slaves' clothing. By 1774, however, tensions had risen to such a level that the agreement banned all British merchandise except medicine.[46] (It may seem surprising that southern planters proudly wore homespun at the same time that many of their slaves continued to wear imported textiles, albeit cheap ones.)[47]

Throughout the eighteenth century, colonists had produced limited amounts of linen, cotton, wool, and had even experimented with silk, yet they could not produce enough textiles to begin to clothe all residents. The southern colonists put most of their resources into staple crops to sell abroad and were at a particular disadvantage with regard to textiles. Shortly after signing the 1769 Association, Nicholas wrote, "If the Steps we have already taken do not produce their desired Effect, the Virginians must in a great Measure desert their Staple [crop of tobacco] to provide the Necessaries of Life."[48]

Samples of hand-woven Virginia linen attached to a letter attest to the quality of Virginia textile production (fig. 135). Matthew Pope of Yorktown enclosed three small swatches of linen in his 1775 letter to a London correspondent. Pope said that the samples represented "Virginia Linnen made in the County of Augusta," and should "convince any Body the Virginians can do without oznabriggs [coarse linen] for I speak from my own Knowledge that this one County only can furnish all Virginia with Linnen both for black and white [people.]"[49]

Although cotton was not yet the important cash crop it became in the nineteenth century, it was grown in Virginia on a small scale throughout the eighteenth century. In 1711, Lieutenant Governor Alexander Spotswood reported to the Board of Trade that parts of Virginia "have been forced into the same humour of planting Cotton and Sowing Flax, and by mixing the first [cotton] with their wool to supply the want of coarse Cloathing and Linnen, not only for their Negros, but for many of the poorer sort of house keepers."[50]

Sheep were scarce during the colonial period, especially in the South, and so colonists mixed wool with other fibers to make it go further. Because of the differences in climate and in the labor force, northerners mixed wool with linen, producing linsey-woolsey, while southerners typically mixed it with cotton, as Spotswood had suggested. Cognizant of the wool shortage in 1775, two Virginia fullers, or woolen cloth processors, instructed their clients to combine small amounts of wool with cotton during weaving so that the woven goods would shrink up in processing and produce a warm fabric suitable for servants' and children's winter clothing: "A cotton chain [warp] filled in with a thread of cotton and a thread of wool, slack twisted together, thickens very well in the [fulling] mill, and we believe will weave exceeding well." To make a mixed cloth with two different colors, weavers should use a cotton warp "filled in with mixed wool of two pounds and an half of white, to one pound of black. . . . The filling shou'd be even spun, and slack twisted."[51] An unknown Virginia spinner and weaver used this technique to produce homespun fabric for a coat (see sidebar, p. 101). The textile combines a warp of cotton and a weft of blue, yellow, and brown wool spun together with cotton.

Despite fledgling American production, continuing shortages of textiles caused problems for American soldiers fighting for independence. That was one of the challenges facing Washington in late summer 1775, shortly after he had been appointed commander in chief of the Continental Army. Washington's job was not limited to directing troops and developing strategy. He also

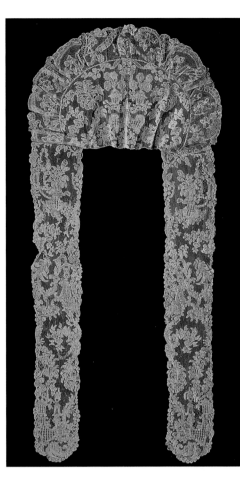

Fig. 135. *(LEFT) Linen swatches, Augusta County, Virginia, 1775, plain-woven linen, Courtesy, British Library, Add. Ms. 34813.ff.80–90R.*

Matthew Pope of Yorktown, Virginia, included three cuttings of Virginia homespun in an August 25, 1775, letter to John Jacob, a London druggist. Pope believed that these textiles, made on his Augusta County, Virginia, plantation, proved Americans could be self-sufficient in their production of utilitarian textiles.

Fig. 136. *(RIGHT) Lappet cap, Brussels, 1740–1750, linen bobbin lace, from the collection of Marian Powys, 1953-187.*

Although women's everyday caps were made of plain white linen or cotton, expensive dress caps were sometimes fashioned from handmade lace. The long decorative strips hanging from the cap were called lappets. The cap Benjamin Franklin sent to his wife may have resembled this example.

concerned himself with mundane matters such as finding clothing for his men (see chap. 2). His letter to Connecticut's Governor Jonathan Trumbull shows Washington's hands-on approach to locating linen for hunting shirts: "the Honble. Continental Congress, recommends my procuring from the Colonies of Rhode Island and Connecticut, a Quantity of Tow Cloth [coarse linen], for the Purpose of making of Indian or Hunting Shirts for the Men, many of whom are destitute of Cloathing. A Pattern is herewith sent you; and I must request you, to give the necessary Directions throughout your Government, that all the Cloth of the above kind may be bought up for this Use, and suitable Persons set to work to make it up, As soon as any Number is made, worth the Conveyance, you will please to direct them to be forwarded. It is design'd as a Species of Uniform, both cheap and Convenient."[52] Washington's hunting shirt was not only cheap and convenient, but also symbolically appropriate for the newly independent states.

Two other prominent Americans, Benjamin Franklin and Thomas Jefferson, shared Washington's ability to com-

bine practicality with symbolism in their clothing. Franklin and Jefferson grew up in the colonies, but had the opportunity to travel to Britain and France. Both men developed a cosmopolitan interest in art and consumer goods. They shared the eighteenth-century man's knowledge of textiles and clothing as exemplified by personally selecting clothing for the women in their households and placing orders for their families. In 1766, Franklin sent from London to his homebound wife some tablecloths, curtain materials, a Turkey carpet, satin to make a dress, and lace for two lappet caps (fig. 136).[53] Jefferson himself selected some of the clothing for his daughters and gave them detailed instructions on how to wear the new hat veils he sent from Philadelphia, where he was serving as Secretary of State.[54] Jefferson followed in Franklin's footsteps to France, where both were presented separately at the French court in ceremonies characterized by extreme formality and ritual. And although they participated in some of the pomp and ceremony of the eighteenth century, both men were shrewd enough to use their appearance and clothing to make statements about their American origins and personal philosophy.

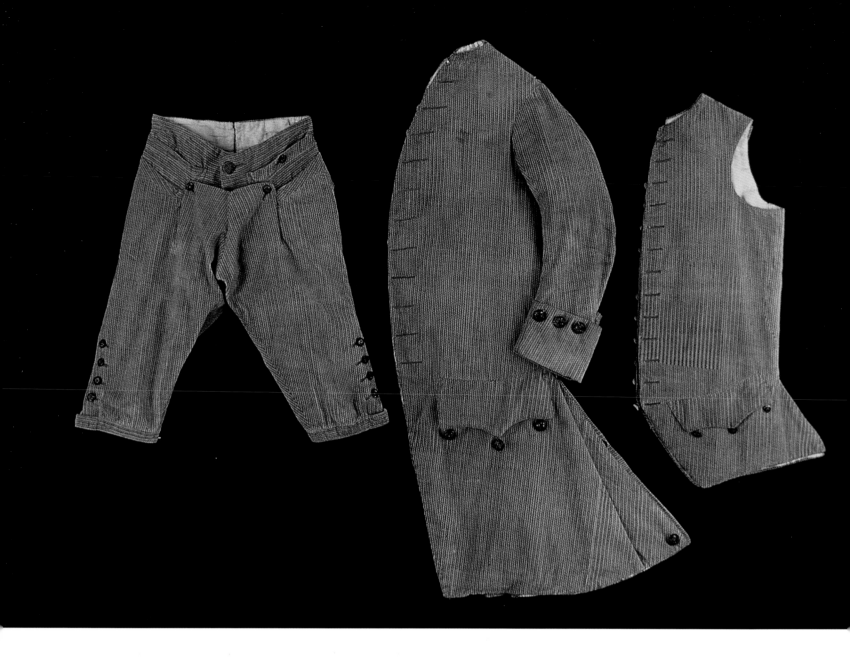

Even as a young tradesman getting his start in Philadelphia, Franklin was aware of the ability of clothing to create an image. He wrote, "In order to secure my Credit and Character as a Tradesmen, I took care not only to be in Reality Industrious & frugal, but to avoid all Appearances of the Contrary. I drest plainly."[55] Franklin displayed his knowledge of correct clothing and behavior when he appeared before the French court of Louis XV in 1767; the tailor and wigmaker for that occasion "transformed [me] into a Frenchman. Only think what a Figure I make in a little Bag Wig and naked Ears!"[56]

Franklin also recognized when he had to dress in a politically correct way. In 1774, at a low point in his career, Franklin was obliged to appear before some of the most influential men of Britain in the Privy Council to defend himself against charges revolving around let-

ters Franklin had made public. He must have put careful thought into his selection of "a full dress suit of spotted Manchester velvet" for the appearance.[57] The suit may have resembled one in the Williamsburg collection of about the same date (figs. 137–138). A full dress suit was formal wear, conservatively cut and trimmed and comprising three pieces: a coat with fitted body, a matching waistcoat, and knee-length breeches. Spotted Manchester velvet was printed cotton velvet, one of the cottons for which the north of England was becoming famous. By selecting Manchester cotton velvet, Franklin wore correct, quality British cloth with some of the sheen of velvet, yet without the ostentation and expense of true silk velvet. The message was one of respect for the group, appreciation of British textiles, yet with an overlay of financial conservatism. After all, a penny saved is a penny earned, or, as Franklin actually

Figs. 137–138. (LEFT AND ABOVE) Suit, overall and detail of cuff, Britain, ca. 1780, block-printed cotton velvet, or velveret, buttons trimmed with sequins and metallic threads, lined with silk, linen-cotton, and linen, interlined with wool and linen, 1985-145, 1–3.

A design of small-scale wavy lines is block printed on the cotton velvet. Uneven registration of the printing blocks is especially evident above the pocket flaps of the waistcoat. Suits usually had decorative buttons in several different sizes. Large buttons fastened and trimmed the coat, while smaller buttons fastened the breeches knees and waistcoat front. These buttons are trimmed with silver gilt, tinsel, and sequins.

said in *Poor Richard's Almanack*, "A Penny sav'd is Twopence clear."[58]

Franklin's real triumph was his return to France after the colonies had declared independence. By his appearance alone, he showed himself to be a master of symbolism and political propaganda. Franklin arrived in clothes-conscious Paris wearing a brown suit, his famous spectacles, and the marten fur cap he had picked up on a trip to Canada the year before (fig. 139 and see fig. 122). That he was now a seventy-year-old man with failing eyesight and a scalp condition may have given him an excuse to break the rules of correct dress. Nevertheless, Franklin appears to have known exactly what he was doing. He wrote to a woman friend in England, describing with obvious enjoyment the effect he was making in France: "Figure me in your mind as jolly as formerly, and as

Fig. 139. BENJAMIN FRANKLIN, engraved by John Martin Will after a drawing by Charles Nicolas Cochin, France, 1777, mezzotint engraving on paper, 1959-82.

In his later years, Benjamin Franklin became known for his distinctive appearance, including spectacles, a fur cap, and long hair, which he wore down instead of drawn back in a queue.

Fig. 140. Fashion magazines, *MAGASIN DES MODES NOUVELLES, FRANÇAISES ET ANGLAISES, and JOURNAL DE LA MODE ET DU GOUT, Paris, France, 1789–1791, printing and hand-colored engraving on paper, Special Collections, John D. Rockefeller, Jr. Library, Colonial Williamsburg Foundation.*

By the last quarter of the eighteenth century, magazines with fashion plates played an increasingly important role in disseminating new styles. When he was in Paris, Thomas Jefferson sent a similar magazine to his daughter back home in the United States.

strong and hearty, only a few years older; being very plainly dress'd, wearing my thin gray strait hair, that peeps out from under my only coiffure, a fine Fur Cap, which comes down to my Forehead almost to my spectacles. Think how this must appear among the Powder'd Heads of Paris!"[59] The fur cap was a powerful symbol, conjuring up images of the philosopher Jean-Jacques Rousseau, who also wore one, at the same time that it suggested the independence and self-sufficiency of Americans who lived on the frontier.

When he was to appear at the court of Louis XVI in 1778, having headed a successful commission to secure treaties with France, Franklin ordered a wig for the occasion. He abandoned it at the last minute, however, apparently because of ill fit. Instead, Franklin met the king in his bald head, wearing a suit of plain dark velvet and no sword, causing the artist Elisabeth Vigée-Le Brun to write, "I should have taken him for a big farmer, so great was his contrast with the other diplomats, who were all powdered, in full dress, and splashed all over with gold and ribbons."[60] Perhaps because of the freedom of old age, but more likely because he knew he had become a symbol of agrarian, freedom-loving Americans, Franklin was now dressed quite differently from his appearance before Louis XV eleven years before.

Thomas Jefferson may have taken his cue from Franklin's example when he appeared before Louis XVI. Thomas Shippen, a young American visitor, described Jefferson as "the plainest man in the room, and the most destitute of ribbands crosses and other insignia of rank." Nevertheless, he was "most courted and most attended to (even by the Courtiers themselves)."[61] Jefferson was not unaware of high fashion. While in France, he purchased embroidered silk waistcoats and many other fine clothes for himself, along with a French fashion publication, *Magasin des Modes*, for his daughter (fig. 140).[62] His slave, Isaac, recalled, "He brought a great many clothes from France with him: a coat of blue cloth trimmed with gold lace; cloak trimmed so too. Dar say it weighed fifty pounds. Large buttons on the coat as big as half a dollar; cloth set in the button; edge shine like gold. In summer he war silk coat, pearl buttons."[63] Yet President Jefferson set quite a different style at the White House. He became famous for his disdain of pomp and for changing many of the rules of etiquette people had come to expect from the leader of a country. Thomas Jefferson Randolph reported that his grandfather went out to ride as usual on the first day that a levee, or open house, was normally held at the White House. The president returned to find a

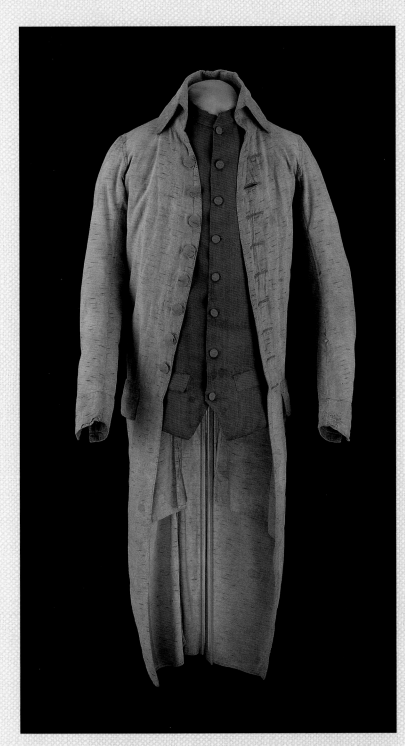

A HOMESPUN COAT

A remarkable homespun coat has descended in the Askew or Pruden family of Goochland or Isle of Wight County, Virginia. Family tradition says that it was the uniform of a private in the Revolutionary War, although his exact identity is unknown. The coat is cut in the fashionable style of the 1780s with a high turndown collar, cutaway fronts, and tight sleeves ending in small cuffs. The buttons are wood, probably maple, covered with the fabric of the coat. Somewhat unusual in men's coats of the period, this one is unlined, a response either to shortages of materials or to the warm Virginia climate (figs. 141–143).

The fashionable cut belies the homespun textile. Although the coat fabric looks like coarse cotton to the naked eye, microscopic analysis of the textile shows it to be a mixture of two different fibers. The warp threads (that is, the lengthwise threads that were stretched on the loom) appear under the microscope as twisted ribbons or flattened macaroni, characteristic of cotton. The wefts of the Virginia coat are two different types of fibers twined loosely together. Some of the weft fibers are natural-color cotton. The rest of the weft consists of blue, brown, and natural-color fibers, all of which show scales under magnification that are characteristic of wool. The wool fibers in the Virginia cloth coat were dyed different colors before spinning, a technique known as "dyed in the wool."

Over the years, the coat's wool fibers disintegrated more than the cotton threads, possibly hastened by washing in alkaline detergents to which wool is more vulnerable. Only in protected areas can one see that the coat originally had a napped surface and was blue flecked with brown. The textile tells the story of Virginia's response to the shortage of woolen materials during the Revolution.

Figs. 141–143. Coat, overall and details of center-back vent flanked by pocket flaps and buttonholes, Virginia, ca. 1780, homespun cotton mixed with wool, 1964-174A, Waistcoat, America, ca. 1780, wool lined with linen, 1952-113.

crowd of fashionably dressed people, but instead of changing clothes, he strode in and greeted them in his riding garb. Randolph added, "They never again tried the experiment."[64] British diplomat Sir Augustus Foster complained that the president rode out without attendants, received guests in yarn stockings and slippers, and presided over a "raw and rude court" quite unlike that of Washington and John Adams. To be fair, Foster did concede that Jefferson's formal wear was a respectable black suit and silk stockings.[65] Jefferson received considerable criticism for his manner of dress—one senator called it "undress"—yet the man who grew up a Virginia aristocrat, attended court at Paris, and furnished Monticello with fine art and French furniture was clearly making a political statement with his dress. Like Franklin before him, Jefferson was partaking of and adding to American mythology: this was a land of equality, homespun values, and agrarian simplicity.[66]

Events that began during Jefferson's presidency from 1800 to 1809 gave another boost to American homespun textile production and can be seen as symbolic of the developing American character. Europe was at war, Napoleon Bonaparte was advancing on the Continent, and American shipping interests were getting caught up in the hostilities between Britain and France. Jefferson and Congress participated in a series of events and acts that culminated in a stringent embargo that attempted to protect American shipping and other economic interests and to avoid getting pulled into the European war.[67] The situation was extremely complicated and questioned the very nature of American economics; agricultural interests were pitted against commercial interests, Federalists against Republicans, North against South. Ultimately, Jefferson came to believe that the best hope for American prosperity and peace lay in an agricultural base, independent of the perceived corruption and corrupting commercial activity of Europe. He was not alone in this belief. One Pennsylvania congressman said, "We might want the fine clothes we wear . . . our wives might be deprived of their silk gowns. . . . but would this diminish our happiness?" His answer was no, although history does not record whether his wife shared his opinion.[68]

Once again, homespun became fashionable, at least among those who supported the embargo. In February 1808, Jefferson replied to his granddaughter's report that the "ladies of Williamsburg" did not fully support the embargo. Jefferson criticized their lack of patriotism, and added, "I hope this will not be general and that principle and prudence will induce us all to return to the good old

plan of manufacturing within our own families most of the articles we need. I can assure you from experience that we never lived so comfortably as while we were reduced to this system formerly."[69] Another of Jefferson's granddaughters reported that the family was doing its part in March 1808: "The embargo has set every body to making homespun, Mama has made 157 yards since October, you will see all the children clothed in it."[70] Later that same year, Jefferson reported to his grandson, "We mean to exhibit ourselves here [Washington] on New Year's day in homespun." By using the word homespun, Jefferson is not implying that anyone was spinning or weaving in the president's house, but rather that the president was selecting American manufactures. Jefferson asked his grandson to try to purchase in Philadelphia some black homespun or thick, ribbed, or corded cottons "now so much used for pantaloons," because he could not find an appropriate American-made material in Washington.[71]

A Connecticut man's coat, dating from around the time of the embargo, is made of homespun cotton that is probably of American manufacture (fig. 144). Another homespun cotton coat, worn in South Carolina, dates from about the same period (figs. 145–146).

Rosalie Stier Calvert, mistress of a large Maryland plantation near Washington, D.C., was one of many who responded, not altogether enthusiastically, to the embargo. In the face of trade interruption, she had to divert some of her tobacco cultivation to textile production to supply the plantation's needs: "There is nothing we can cultivate with our negroes which produces as much profit [as tobacco], but if all commerce with Europe remains interdicted, we are going to have to become manufacturers. Neither flax nor hemp suit us as well as wool and cotton. The latter is cheaper than linen and substitutes for it very well."[72] By summer 1809, Calvert reported that people dressed in American-made cloth at a "sheep shearing" party on the banks of the Potomac River, where "all the guests were asked to come dressed in American-made clothes. The wine had been made in Virginia, as were all the beverages. . . . It was a completely patriotic fête." She went on to add that she, too, was "a manufacturer—all the women in my house are dressed in pretty cloth made right here [on the Riversdale plantation.]"[73] (Calvert directed the activities of slave artisans.) Despite her pride in their manufactures, Calvert was adamantly against the embargo and predicted that the new United States could not long survive such stresses. She wrote, "Just between ourselves, it

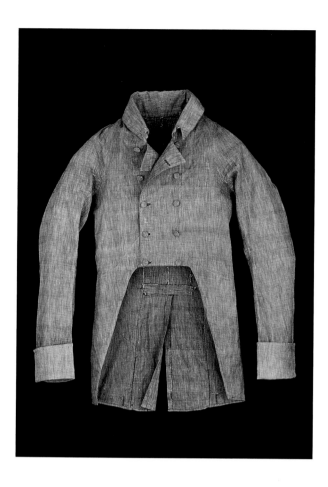

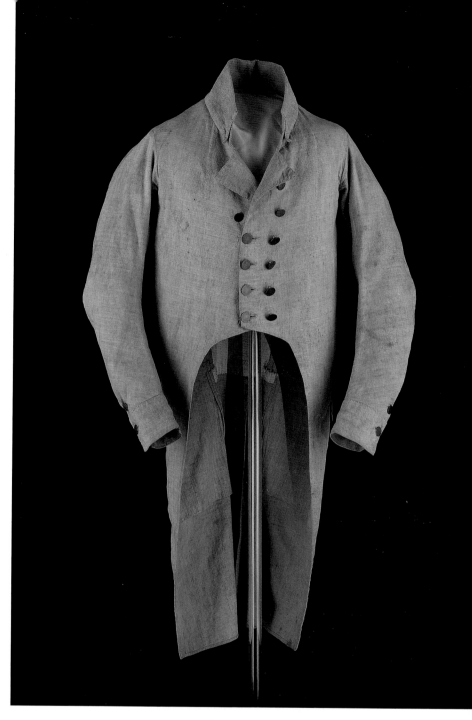

Fig. 144. (*ABOVE*) *Coat, probably Connecticut, 1805–1810, cotton, linen pockets, 1991-442.*

Woven from a mix of blue and white cotton fibers, this coat is fashioned with a short double-breasted front that can button in either direction.

Figs. 145–146. (*RIGHT*) *Coat, overall and detail of side-back pleat, probably South Carolina, 1805–1810, cotton, later metal buttons, 1999-74.*

Found near Columbus, South Carolina, this homespun coat may have been woven and made there. Typical of early nineteenth-century styles, the front is cut across at the waist and curves to form graceful tails at the back. Formal tailcoats of the later nineteenth and twentieth centuries developed from this basic silhouette.

Figs. 147–148. Waistcoat, overall and detail of lining, Massachusetts, ca. 1801, silk lined with cotton, cotton back, G1988-499, gift of David S. and Clara J. Johnson.

A paper tag accompanying the waistcoat stated that New Englander Peter Speer wore it as his wedding vest in 1801. The purple and black silk textile is woven with a design of bald eagles, the national emblem of the United States since 1782. The cotton lining retains the stamp of the Charlestown Bleachery, a textile finishing plant established in 1801 under its full name, Charlestown Bleachery and Dye Works. The plant was located in Somerville, then part of Charlestown, Massachusetts.

is high time we had a king. This constitution, which has been so much lauded, worked very well at the beginning and as long as Washington was at the head, but ever since, the people have become more corrupt and the executive power has become weaker."[74] Calvert had been born in Belgium and maintained close ties with her family there, perhaps explaining her preference for a king.

Certainly not all Americans made a show of republican simplicity, yet many people noticed something different about the new nation. English visitor Henry Wansey wrote that, although Americans generally dressed in British fashions in 1794, "In these States, you behold a certain plainness and simplicity of manners, which bespeak temperance, equality of condition, and a sober use of the faculties of the mind."[75] In 1801, a New York retailer could boast, "he is not dependent on Europe for his variety of Fashion but assures them they are of true

American origin."[76] When he was married, New Englander Peter Speer chose a waistcoat of silk woven with eagles, lined with American-made calico (figs. 147–148). And when the most extreme nude-look French fashions arrived in the United States in the early nineteenth century, most American women adapted them to a more modest, covered up appearance (figs. 149–150).[77]

The early years of the nineteenth century were an important formative period for the new nation. The events of the embargo and the eventual entry of the United States into the War of 1812 with Britain show the people testing their maturity and character. Would the United States be an agricultural nation, isolated from the influences of an old European world, or would she participate in world events and trade? Would the union even survive? More to the point of this chapter, would Americans wear homespun or would they wear imported silks, fine

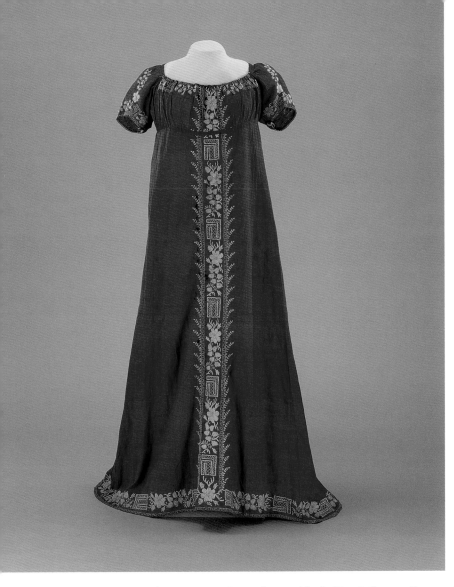
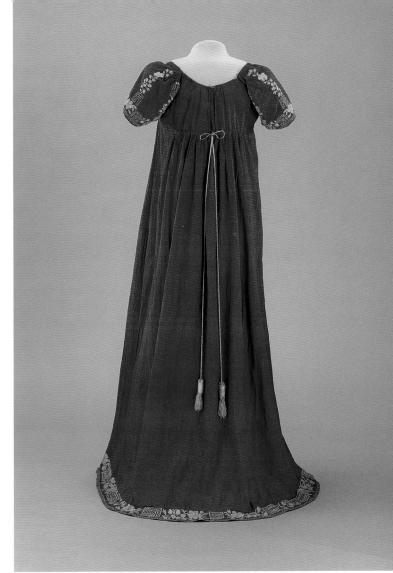

Figs. 149–150. Gown, front and back, East Indian textile, worn in Washington, D. C., by Ann Cary Selden Breckinridge, 1809–1817, cotton embroidered with cotton, silk and wood tassels, G2000-48, gift of Frances D. (Mrs. Richard S.) Aldrich.

Ann Breckinridge was the wife of Colonel James Breckinridge, who served in Congress as a representative from Botetourt County, Virginia, from 1809 to 1817. A paper label gives the gown's history: "A gown from East India worn at a Congressional Ball in D. C. by Mrs. Genl. Breckinridge (nee) Ann Cary Selden, of 'Grove Hill,' Botetourt Co., Virginia." The brilliant red color of the imported India cotton signals fashion's departure from all-white neoclassic gowns.

woolens, and lace? The answer is both. Americans had always relied on imported goods, not only because it was more economically efficient to do so, but also because they wanted to be in style. Americans also spun, wove, and made some of their own clothing, however, especially when current events, patriotism, or their isolated location made it desirable or necessary.

Such was the dual nature of American clothing—Americans dressed in style and wore the latest fashions from Britain and Europe, yet they also believed in the mythol-

ogy of agrarian simplicity that made homespun appropriate. Perhaps it is not a coincidence that Reverend Devereux Jarratt's reminiscences about his early childhood south of Richmond, Virginia, appeared in 1806. He wrote proudly (likely exaggerating somewhat) of self-sufficiency and homespun production, "Our raiment was altogether my mother's manufacture, except our hats and shoes."[78] America was, indeed, still is, a land of diverse people and styles, a blend of native and importation, of homespun and silk, of country practicality and city chic.

CHAPTER 4

COMMON DRESS
Clothing for Daily Life

Eighteenth-century Anglo-American society was characterized by great variety and disparity, from plantation mansions to slave cabins, from those who lived in grand city houses to beggars on the street. Slaveholders whose wives were not allowed to vote wrote eloquent arguments for liberty and freedom. Nowhere was social inequality more evident than in the clothes people wore. Wearing apparel proclaimed status, or the lack of it, through the style of the garment, the fabric and color selection, the amount of clothing required to be considered "properly dressed," even the subtleties of movement and posture, the latter achieved through training and tight stays.

Although humans instinctively value and save the best of the past—master paintings, handmade furniture with elegant proportions, delicate porcelain, elaborate silk gowns, and embroidered suits—they are also fascinated by less-exalted artifacts. Ordinary clothing, trade tools, and meager possessions of manual laborers seem closer to the daily experience of most people. Yet when a museum or collector seeks to find such mundane artifacts, few are to be had. Everyday clothes had less elaborate trimmings and textiles and practical adaptations to cut. They were styled for practicality and often altered during their useful lives to salvage valuable textiles. While stylish formal wear was cherished and saved, perhaps becoming part of a museum collection, informal and work clothing wore out and was discarded. Scholars must consult written and pictorial sources, along with the few garments that have survived, to fill in the missing evidence of what was worn on a daily basis, what the clothing meant to its wearers, and what the pieces were called in their own time (figs. 151–152).

Written sources, including store and plantation records, indentures, and diaries, illuminate the lives and daily apparel of housewives, slaves, and other workers. Eighteenth- and nineteenth-century newspapers contain revealing advertisements for goods and services. Runaway advertisements, in which a master placed a notice in the newspaper for the return of an indentured servant or slave who had absconded in search of freedom, are excellent sources for studying the appearance of workers. Hundreds of advertisements describe anonymous, enslaved, or impoverished men and women whose possessions would never enter a museum collection, but whose clothing, physical appearance, and talents are still evident.

Interpreting written sources from the past requires a new lexicon. What were plaid fabrics, banyans, or bed gowns (see sidebars, pp. 113 and 133)?

Fig. 151. "Industry and Idleness" handkerchief, Britain, ca. 1775, plate-printed cotton, 1950-104. This large handkerchief is printed with moralistic scenes of industrious and lazy servants named William Goodchild and Jack Idle. The vignettes are excellent sources for studying the dress of workingmen. At bottom right, a convict servant in jacket and trousers works alongside slaves in the tobacco field.

INDUSTRY AND IDLENESS REWARDED

JACK IDLE BREAKING THE SABBATH

Of Idleness comes no good-
ness & by breaking the
Sabbath other Evils
ensue.

WM GOODCHILD AT CHURCH

Teach me Wisdom and
Knowledge, that I
may keep thy Com-
mandments.

THE IDLE SERVANT GOING TO SEA

THE FAITHFUL SERVANT REWARDED BY HIS MASTER

Frugality & Industry is the Hand of Fortune

THE SLEE SLOTH OF HEALTH

AND PARTS AND OF ARTS

THE CANKER OF ALL GOOD OF WEALTH OF HONOUR

J IDLE FRIGHTED FROM HIS SLEEP

The Sound of a falling
Leaf shall affright
him.

WM GOODCHILD CHOSEN SHERIFF OF LONDON

J IDLE TAKEN FOR A ROBBERY

For their feet run to evil & make
haste to shed blood.

WM GOODCHILD MARRIES HIS MASTERS DAUGHTER

COMMERCE

TRANSPORTATION

Fig. 152. "Nice Prussian Matches New pinched pointed Matches," attributed to Paul Sandby, London, England, ca. 1759, watercolor on paper, from the collection of Lord Bruce, 1965-131, 3. Because clothing of poor laborers seldom survives, prints and paintings such as this watercolor are an important source of information. The match seller wears ragged clothing and a large handkerchief tied over her head instead of a cap.

Even today, terminology is not consistent. People use different names for similar, if not identical, garments. One day, they might call their light-brown trousers "pants"; the next day, "khakis." Adding to these inconsistencies are variations among individuals and cultural groups and changes over time. (Are short pants called pedal pushers, clam diggers, or capris this year?) Few antique textiles or garments carry labels that identify their original names. There are great challenges in interpreting written and visual sources from more than two hundred years ago.

Even the wealthiest people owned everyday clothing. For riding, relaxing at home, and going about daily business, men chose suits that were more comfortable than their formal garb. With their loose fit and turndown collars, frock coats were practical alternatives to dress clothing (figs. 153–154). Most frocks were made of closely woven, sometimes expensive wool textiles such as broadcloth, a material that was shrunk, napped, and shorn to produce a compact fabric that resembled felt and did not ravel. Because it was a woven material, broadcloth was stronger than nonwoven felt.

When men relaxed at home or performed physical labor, they often removed their cocked hats and wigs and put on soft caps (figs. 155–157). Although embroidered and lace ones were more likely to survive than plainer examples, caps ranged from masterpieces of material and decoration for the wealthy to unadorned, inexpensive, and functional head coverings for workingmen. Despite the prevailing

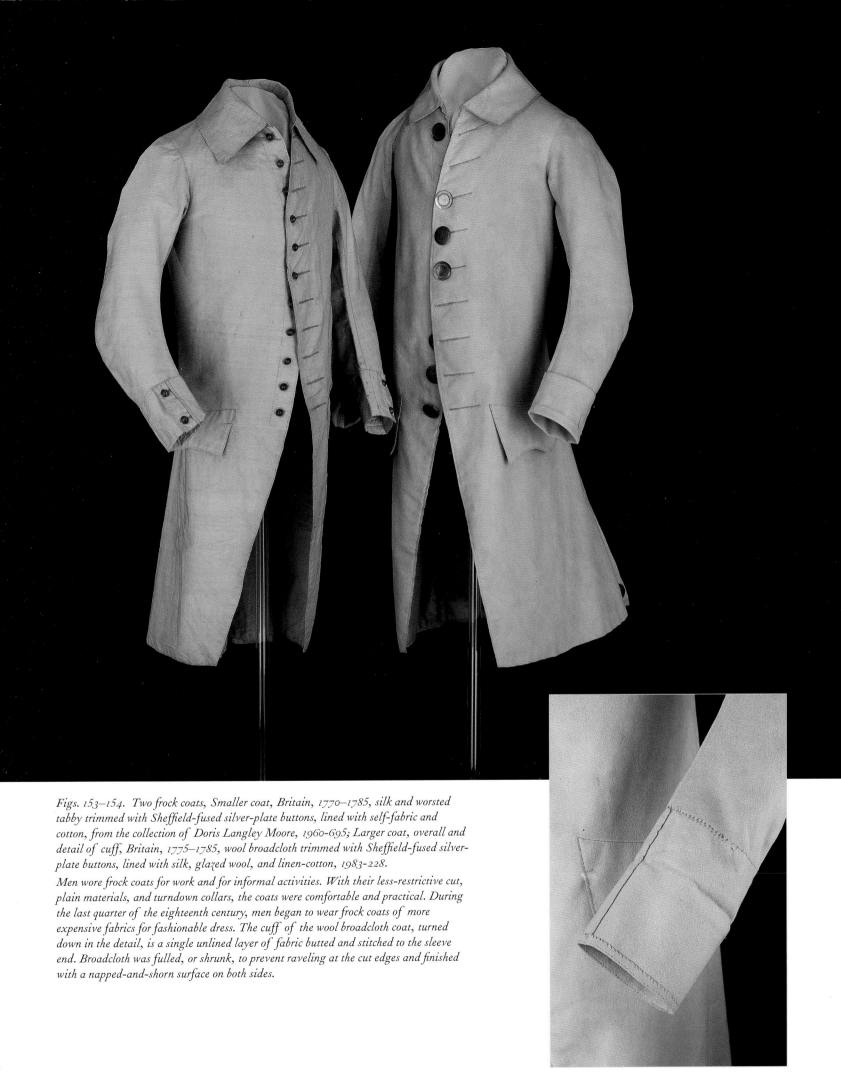

Figs. 153–154. Two frock coats, Smaller coat, Britain, 1770–1785, silk and worsted tabby trimmed with Sheffield-fused silver-plate buttons, lined with self-fabric and cotton, from the collection of Doris Langley Moore, 1960-695; Larger coat, overall and detail of cuff, Britain, 1775–1785, wool broadcloth trimmed with Sheffield-fused silver-plate buttons, lined with silk, glazed wool, and linen-cotton, 1983-228.

Men wore frock coats for work and for informal activities. With their less-restrictive cut, plain materials, and turndown collars, the coats were comfortable and practical. During the last quarter of the eighteenth century, men began to wear frock coats of more expensive fabrics for fashionable dress. The cuff of the wool broadcloth coat, turned down in the detail, is a single unlined layer of fabric butted and stitched to the sleeve end. Broadcloth was fulled, or shrunk, to prevent raveling at the cut edges and finished with a napped-and-shorn surface on both sides.

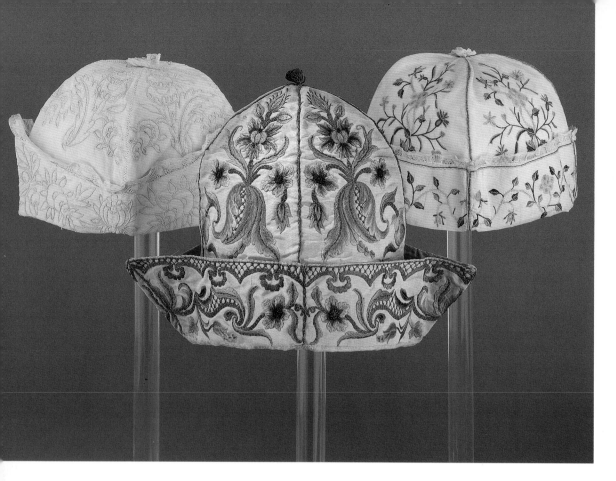

fashion for wigs, one traveler reported in 1732 that wealthy Virginia men resorted to wearing caps during the hot summer months: "In Summertime even the gentry goe Many in White Holland [linen] Wast Coat & drawers and a thin Cap on their heads." The observer added that Virginians returned to greater formality when the weather cooled, "In Winter [they dress] mostly as in England and affected London Dress and wayes."[1]

Many men relaxed in banyans, or loose gowns, which came in two different styles. Some gowns were cut like large T-shaped kimonos and others tailored more closely to the body (figs. 158–159). Robert Carter Nicholas, lawyer and member of the Virginia House of Burgesses, ordered a gown from England in early September 1768. He asked for "A grave Narrow Striped Callimancoe large Wraping Gown for a large Man to be sent by the very first Opportunity lined with thin green Bayes."[2] The wool materials Nicholas requested suggest that the gown was for winter wear. Banyans or gowns made of light textiles offered comfort in summertime. Plantation tutor Philip Vickers Fithian wore a gown in his Virginia schoolroom when it was too hot for his coat in July 1774. "The wind itself seems to be heated! We have a fine Room, & sufficiently open; & I dress in a thin Waist-Coat, & a loose, light linen Gown." Fithian added that the boys dressed only in breeches and shirts, clothes that were sufficiently

Fig. 155. (LEFT) Men's caps, left to right, White cap, Britain, 1730–1750, linen embroidered with linen, trimmed with linen bobbin lace, G1991-498, gift of Mrs. Cora Ginsburg; Tall embroidered cap, England, ca. 1700, silk embroidered with silk and couched silver-gilt threads, lined with silk, G1991-497, gift of Mrs. Cora Ginsburg; Floral cap, Britain or France, 1760–1780, cotton embroidered with silk, trimmed with linen bobbin lace, lined with linen, from the collection of Mrs. DeWitt Clinton Cohen, 1952-53.
Caps decorated with needlework and lace were elegant accessories for informal situations and at-home wear. For another view of the white and floral caps, see fig. 158.

Fig. 156. (ABOVE RIGHT) Cap, top view, France, 1720–1740, linen-cotton embroidered with crewel wool, trimmed with linen bobbin lace, lined with linen, G1990-15, gift of Mrs. Cora Ginsburg.
This cap is constructed of four segments embellished with wool chain-stitch needlework. The upturned brim is similarly embroidered and edged with lace.

Fig. 157. (BELOW RIGHT) Cap, Britain or America, eighteenth century, linen, 1999-216.
This plain cap is typical of the style worn by most men while laboring or sleeping. The durable linen and closely stitched seams survived years of wear and laundering. The cap is unlined and cut in one piece with a single seam up one side and continuing over the curved crown. The bottom rolls up to form a brim. For another view, see fig. 158.

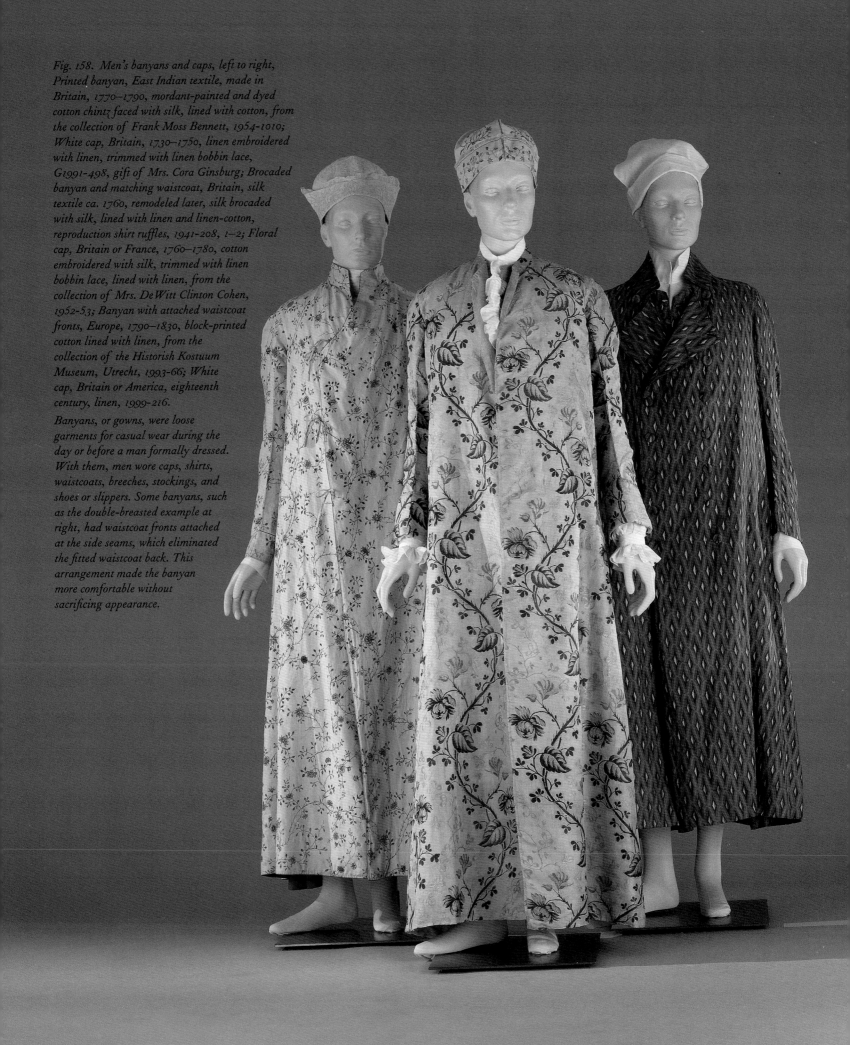

Fig. 158. Men's banyans and caps, left to right,
Printed banyan, East Indian textile, made in
Britain, 1770–1790, mordant-painted and dyed
cotton chintz faced with silk, lined with cotton, from
the collection of Frank Moss Bennett, 1954-1010;
White cap, Britain, 1730–1750, linen embroidered
with linen, trimmed with linen bobbin lace,
G1991-498, gift of Mrs. Cora Ginsburg; Brocaded
banyan and matching waistcoat, Britain, silk
textile ca. 1760, remodeled later, silk brocaded
with silk, lined with linen and linen-cotton,
reproduction shirt ruffles, 1941-208, 1–2; Floral
cap, Britain or France, 1760–1780, cotton
embroidered with silk, trimmed with linen
bobbin lace, lined with linen, from the
collection of Mrs. DeWitt Clinton Cohen,
1952-53; Banyan with attached waistcoat
fronts, Europe, 1790–1830, block-printed
cotton lined with linen, from the
collection of the Historish Kostuum
Museum, Utrecht, 1993-66; White
cap, Britain or America, eighteenth
century, linen, 1999-216.

Banyans, or gowns, were loose
garments for casual wear during the
day or before a man formally dressed.
With them, men wore caps, shirts,
waistcoats, breeches, stockings, and
shoes or slippers. Some banyans, such
as the double-breasted example at
right, had waistcoat fronts attached
at the side seams, which eliminated
the fitted waistcoat back. This
arrangement made the banyan
more comfortable without
sacrificing appearance.

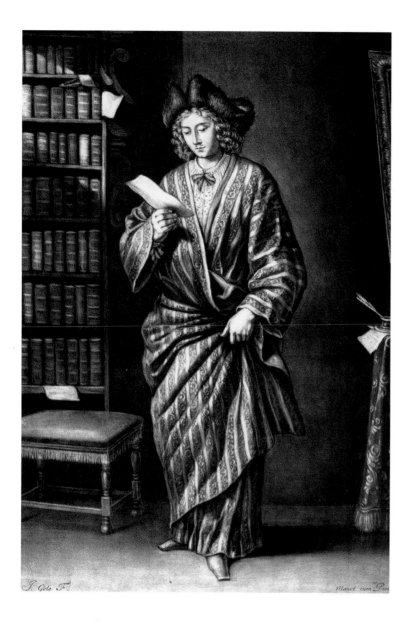

Fig. 159. Untitled print, engraved by Jacobus Gole, Amsterdam, Holland, 1693, mezzotint engraving on paper, 1990-170, 1.

The gentleman wears a voluminous T-shaped gown, or banyan, of striped material. Besides being easy and comfortable, banyans were often used symbolically in prints and portraits to suggest that the wearers were scholarly or philosophically inclined.

bare by the standards of the day to cause comment in his journal.[3] Patterned banyans made of expensive materials and caps trimmed with colorful embroidery testify to the elegance of some wardrobes, even for informal occasions. Such garments allowed the wearer to be comfortable while proclaiming status, wealth, and fashion-consciousness.

Virginians, reportedly, were particularly apt to judge people by their appearance. Peter Collinson, a London cloth merchant, counseled someone preparing to visit the colony: "these Virginians are a very gentle, well-dressed people—and look, perhaps, more at a man's outside than his inside. For these and other reasons, pray go very clean, neat, and handsomely dressed, to Virginia."[4] Throughout the American colonies and in Europe, a subtle but constant struggle existed between those who

thought they *should* be able to judge status by people's clothing and those who sought to beat the system by wearing better clothes than their social level would normally allow. Sometimes it was difficult to tell the lady's maid from the lady (see fig. 68).

During the eighteenth century, a woman's status was evident in the clothing materials and quantity in which they were used; the addition of beautiful but nonfunctional trimmings such as lace and needlework; the elegance of style and fit; and the number of garments she could afford. As much as twenty yards might be required for a gentry woman's dressy gown made with a long, full skirt that was open in front to reveal still more elaborate fabric in a decorative petticoat (the skirt worn underneath). The sleeve ruffles that fell gracefully over the elbows

NAMING FABRICS

When it comes to knowing how people dressed in the eighteenth century, correct identification of the materials is essential. Hearing that a man's formal suit of 1775 was made of broadcloth or that three slaves ran away in December 1770 wearing "osnabrug shirts, cotton jackets and breeches, [and] plaid hose," a twenty-first-century person may well conjure up an inaccurate picture of the garments. [1]

Is the man's suit in fact made of lightweight cotton, like today's broadcloth (fig. 160)? Are the slaves dressed in unsubstantial cotton clothes in the middle of winter, and are their stockings really patterned? Not at all.

Many fabric names of the eighteenth century are either obsolete or completely changed in meaning today. Now a thin cotton or cotton-blend textile, today's broadcloth bears no relationship to eighteenth-century broadcloth, which was made of substantial wool similar in appearance to modern billiard table covers. Osnaburg of the seventeenth and eighteenth centuries was made of rough linen or hemp, usually undyed and unbleached. In the nineteenth century, the fiber content of the fabric called osnaburg changed to cotton and remains so today.

The word cotton had two very different meanings two hundred fifty years ago. Sometimes it indicated a textile made from the fibers of the cotton plant, as it does today. But the word also encompassed heavy woolen textiles, probably so named because their napped surface resembled the fuzzy fibers of the cotton boll. Eighteenth-century Kendal cotton and negro cotton were relatively inexpensive woolens especially desired for slaves' winter clothing. Virginia Governor Dinwiddie reported, "The People in y's Dom'n are supplied from G. B. [Great Britain] with all sorts of Woolen Manufactories such as B[roa]d Cloth, Kersey, Duffils, [and] Cottons."[2] During the nineteenth century, negro cotton ceased to be made from wool. Instead, manufacturers substituted increasingly plentiful and inexpensive fibers of the cotton plant.

Just as cotton was not always made from cotton, so plaid was not always woven in a checkered design. Slaves' plaid hose were usually made from a type of white woolen twill. References to "white Plading" and "twilled white Scotch plaiding" prove that the fabric often was unpatterned.[3]

1 *Virginia Gazette* (Williamsburg) (Purdie and Dixon), Dec. 13, 1770.
2 *The Official Records of Robert Dinwiddie, Lieutenant Governor of the Colony of Virginia, 1751–1758*, I (Richmond, Va., 1883), p. 385.
3 Sarah ran away wearing a "white Plading" petticoat. *Maryland Gazette* (Annapolis), Apr. 3, 1760; George Mason to Thomas Jefferson, listing woolens and other materials for slaves' use, in Julian P. Boyd, et al., eds., *The Papers of Thomas Jefferson* (Princeton, N. J., 1950–), XII, pp. 392–393.

typically were made of expensive, difficult-to-maintain lace or fine white embroidery (see fig. 21). Such an ensemble clearly did not function well for hard physical labor. Yet work had to be done, and people modified the elegant styles of the period for greater ease of movement, durability, and affordability.

While formal gowns were usually made of silk, working-women's gowns were of sturdier "stuff." Stuff referred to a broad category of worsted textiles that were constructed from long fibers of fine combed wool, spun tightly, and woven firmly; often the material was pressed to impart a shiny, glazed surface (fig. 161 and see figs. 70 and 257). Stuff included plain goods, such as shalloon, as well as patterned materials such as worsted damask and calimanco, a type of fine glazed wool. The scratchy but durable textiles were used for women's gowns and household upholstery.[5]

Worsted stuff was considered appropriate for poor work-ingwomen who owned few outfits. A 1796 list of clothing expenses in Hertfordshire Parish, Britain, lists "a common stuff gown" at 6 shillings 6 pence as the main item of a laboring woman's wardrobe.[6] A 1789 book titled *Instructions for Cutting out Apparel for the Poor* recommended either stuff or grogram for older girls' gowns. The author added that stuff, measured at half a yard wide, was best for children's clothes, while grogram, at slightly more than thirty inches wide, was recommended for women.[7] Sometimes impressed with wavy markings called watering, gro-gram was made of worsted or of a wool and silk mixture.[8]

American women dressed in worsted, too. In 1752, a con-vict servant woman who ran away in Lancaster County, Virginia, wore a motley assortment of clothing that included a stuff gown. She had a "Woman's black Hat, an old red Silk Handkerchief round her Neck, an old dirty blue Stuff Gown, with check Linen Cuffs, old Stays, a black and white strip'd Country Cloth Petticoat, an old blue quilted ditto, a check Linen Apron, and a brown Linen Shift."[9]

Stripes were popular (see fig. 161). A convict servant from Fairfax County, Virginia, had on a gown of "Strip'd Stuff . . . pretty much wore," while a Norfolk, Virginia, runaway had one made of "striped red, white, and yellow calimanco."[10] A South Carolina slave woman named Bess ran away in 1775, taking with her a "reddish brick coloured callimancoe gown" and another one made "of blue and white striped linnen."[11] It is not clear whether Bess personally owned the gowns she "took away," but the advertiser does not accuse her of theft. Colorful cali-mancoes that had been glazed mimicked more expensive

Fig. 161. Worsted textiles, Striped textile, Norwich, England, 1700–1750, wool, 1961-55; Flowered panels from skirt, Norwich, England, 1760–1780, wool damask brocaded with wool, 1968-768.

Piece goods made from firmly spun worsted wool were hardwearing and inexpensive, yet colorful substitutes for silk dress materials. The floral textile was calendered, or pressed, after weaving to impart a glossy shine. It measures eighteen inches wide between the selvages.

silks, yet their long-lasting worsted fiber content was appropriate for a workingwoman's garment.

The choice of textile was as important to the language of class differentiation and occupation as the basic cut of the dress or petticoat. Linens, woolens, worsteds, and even silk came in a wide range of qualities, from coarse to fine, and were indicative of status, or the lack of it. Specific types of inexpensive woolens were associated with slaves' clothing. Slaveholders imported many yards of plains (also known as Negro cloth), plaid, and the variety

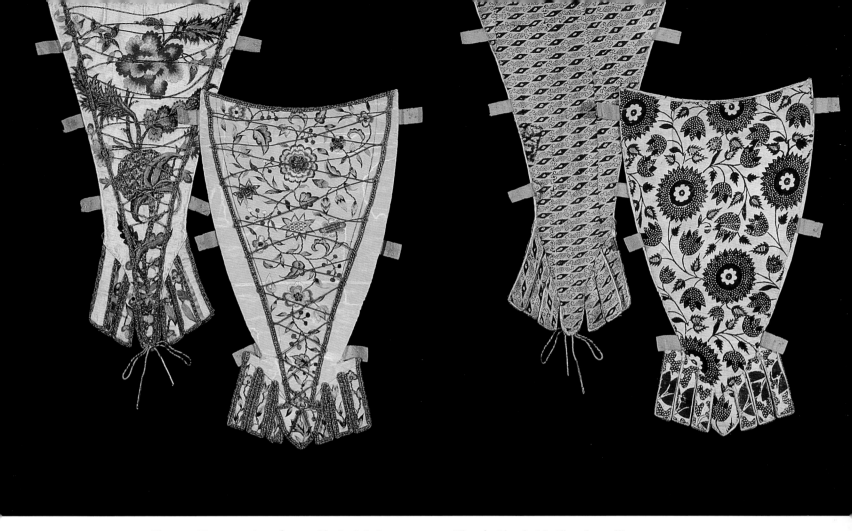

Fig. 162. Two stomachers, front and back, Britain, 1720–1740, silk embroidered with silk and metallic threads, lined with block-printed cotton, 1993-45; G1991-487, gift of Mrs. Cora Ginsburg.

Seldom did early printed cottons survive years of laundering and daily wear. These rare printed cotton goods endured only because they were used to line silk embroidered stomachers that were worn infrequently and saved for their beauty.

of woolen known as cotton. Many gowns and suits worn by slaves were made from these three wool fabrics, which were substantial and relatively warm, but coarse in appearance. Slaves' textiles were purchased in a restricted range of colors, usually white, blue, or green.[12]

Workingwomen also wore linens (especially the cheap unbleached linen fabric known as osnaburg), mixtures of linen and wool, varieties of homespun, and lower grades of silk.[13] British printed cottons, which often imitated more expensive India chintzes, were increasingly avail-

able during the eighteenth century and embraced by women from all levels of society (fig. 162 and see figs. 73 and 78).[14] Elizabeth Berry, a convict servant who ran away from her master near Winchester, Virginia, in 1769, had a gown made of "red grounded callico," in addition to her "black worsted gown."[15] Printed cottons and linen blends were comfortable and washable, a vast improvement over wool work clothing.

Everyday long gowns seldom survived, but prints and paintings suggest the gowns were cut like fashionable

Figs. 163–164. Apron, overall and detail of mark, America, 1776, linen marked with silk, G1999-225, gift of Evelyn Schroedl.

Workingwomen wore aprons of washable linen or cotton, sometimes patterned with checks, such as this example. The unidentified maker embroidered her initials E F and 1776 in minuscule cross-stitches near the waistband.

dresses of the period, leaving off the trimmings and ruffles (see fig. 86). Neck handkerchiefs, caps, aprons, and mitts protected the worker's body and clothing from soiling and abrasion (figs. 163–165). Although the Colonial Williamsburg collections do not have any long gowns with known histories of use by poor or laboring women, two gowns made of worsted materials could have been the best dresses of women of the middling or lower sort (see figs. 70 and 257).

When a long, fitted gown was too impractical for the work to be done, women put on a shorter garment that fit loosely and required less fabric than a full gown. One variety was known as a bed gown (see sidebar, p. 123). Eighteenth-century records indicate that a bed gown had pieced-out sleeves and gored skirts that were cut in one as extensions of the bodice. Because it opened completely down the front like a jacket, a bed gown was fastened with pins or by wrapping it around the body and holding the front in place with an apron (fig. 166). Costume author James Robinson Planché indicated that the term "bed-gown" was still in use as late as 1876. Referring to women's clothing of the eighteenth century, he wrote, "countrywomen and domestics are seldom seen [in eighteenth-century sources] depicted in gowns, except of that description which within my recollection was, and is still, I believe, termed a bed-gown, and resembled a

jacket rather than a gown, of white or coloured cotton or calico, with a string to tie about the waist."[16]

This loose, short, and comfortable garment was as practical for active work as for the childbed, or period immediately following childbirth (see chap. 5). According to an eighteenth-century writer, the wardrobe of poor workingwomen in 1797 Cumberland, England, generally consisted of "a linen bed-gown, (stamped with blue,) mostly of the home manufacture; this usually costs in the shops about 5s. 6d." With her bed gown, the typical Cumberland workingwoman also wore a black stuff hat, cotton or linen "neck-cloth," two flannel petticoats, coarse woolen stockings, linen shift, and stays. The author added that women sometimes wore gowns made of "woollen stuff," instead of linen, but that Sunday clothing consisted of cotton gowns and black silk hats.[17]

American women chose bed gowns for work and everyday occasions. A white Virginia runaway in 1752 had a colorful ensemble that consisted of "fine Pink coloured Worsted Stockings, and Leather Shoes, an old dark brown quilted Petticoat, a check'd Apron, a strip'd Manchester Cotton Bed Gown, and a black Beaver Hat."[18] In 1760 and 1769, two Maryland convict servants had bed gowns made of "Chintz" and "striped Linen."[19] The loose fit of bed gowns allowed women to layer other

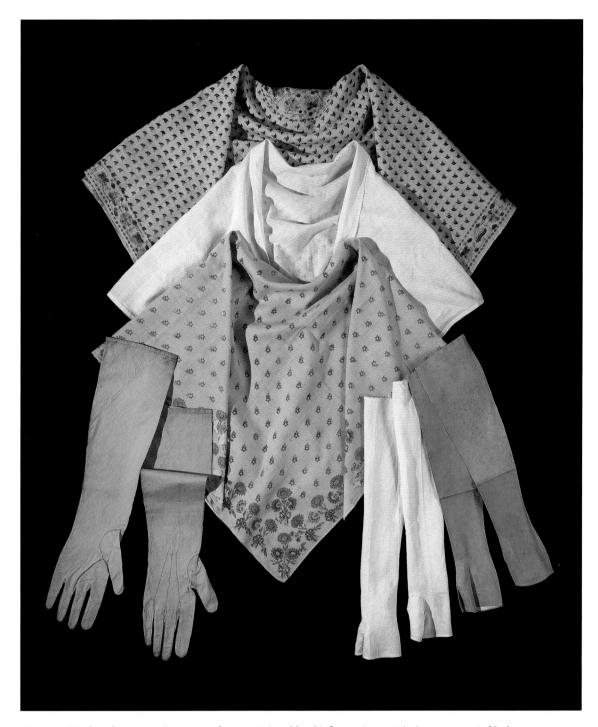

Fig. 165. *Neck and arm coverings, top to bottom, Printed kerchief, America or Britain, 1800–1825, block-printed cotton, G1974-377, bequest of Grace Hartshorn Westerfield; White kerchief, Pennsylvania or Delaware, 1780–1810, cotton, G1983-303, gift of Frances Matthews; Floral kerchief, America or Britain, 1795–1810, block-printed cotton, G1974-376, bequest of Grace Hartshorn Westerfield; Yellow gloves, Britain or America, 1780–1840, cotton sewn with silk, 1986-206; White mitts, America, ca. 1800, cotton dimity, G2000-20, gift of Titi Halle; Grey mitts, Britain, ca. 1800, leather, 1991-445.*

Neck kerchiefs, gloves, and mitts protected women's chests and forearms from exposure to cold or excessive sunlight. Further, kerchiefs offered greater modesty when fashion dictated low necklines. Workers and older women especially relied on such accessories. Mitts left fingers free to sew or do manual labor. These gloves and white mitts were cut on the bias of the fabric for increased stretch. The two printed kerchiefs are large squares folded into triangles; the white kerchief is a single-layer triangle.

Fig. 166. Detail from MODERN LOVE: THE
ELOPEMENT, by John Collet, London, England, ca. 1764,
oil on canvas, 1969-48, 2.

*This woman wears the baggy, patched clothing of a poor
laborer. Her loose gown of striped material is belted around the
waist with a cord or apron string. Unfitted garments with short
skirts such as this example were called bed gowns or short
gowns.*

clothing beneath for warmth and comfort. In Pennsylva-
nia, a white servant ran away, apparently wearing two at
once. She "had on when she ran away, two Bed-Gowns,
one blue and white, the other dark Ground, both Calli-
coe."[20] African-American women occasionally wore bed
gowns, also. Phebe ran away from her Chester County,
Pennsylvania, master with "Three fine Shifts, and one
coarse Ditto, a Calicoe Gown and Bed-gown, a striped
Linsey Bedgown and three Petticoats."[21]

Workingwomen also wore a garment called a short gown
(fig. 167). It is unclear just how short gowns differed from
bed gowns, if, indeed, they did differ significantly.[22] Short
gowns appear in American eighteenth-century records
concurrently with bed gowns; both were made of similar
materials such as calico, chintz, striped linen, and linsey-
woolsey. As with bed gowns, workingwomen wore short
gowns over petticoats that sometimes matched in fabric and
color. In 1763, a Pennsylvania African-American runaway
had on "a black, red and white striped Linsey-woolsey
short Gown, and Petticoat." She also had "a light coloured
Cloth short Cloak, with a small Leghorn Hat, and Check
Apron" (see fig. 163).[23] An Irish servant woman's mis-
matched clothing was equally colorful. She "had on and
took with her a calicoe short gown stamped with red and
white lines running through the same, one pea green
quilted petticoat, [and] one flannel ditto," along with stock-
ings, black shoes, a check apron, and two handkerchiefs,
probably to wear around her neck.[24] Sally Hemmings, the
slave maid who accompanied Thomas Jefferson's daughter
to France in 1787, wore calico short gowns with matching
petticoats. She received "12 yds. calico for 2 short Gowns
& coats," along with three pairs of stockings, a "Shawl
handkerchief," linen for aprons, and two additional yards
of linen for an unspecified use. In contrast, Jefferson's
daughter, Mary, had four fine Irish Holland (linen) frocks,
or dresses, and expensive checked muslin and lace edging
for another frock. To accessorize her dresses, Mary had
blue sash ribbon to wear around her waist, a brown beaver
hat with feathers, leather gloves, and diaper, a fine linen or
linen-cotton material, to make "arm Cloths," probably
mitts to protect her arms (see fig. 165).[25]

Despite their relative lack of fashionable details and
trimmings, many short gowns did follow contemporary
styles in their overall silhouette. After waistlines rose and
long dresses began to be shaped to the body with draw-
strings or gathers, short gowns followed suit. A printed
cotton garment, probably a short gown, has a high waist-
line and long, tight sleeves typical of the period around
1800 (see fig. 167).

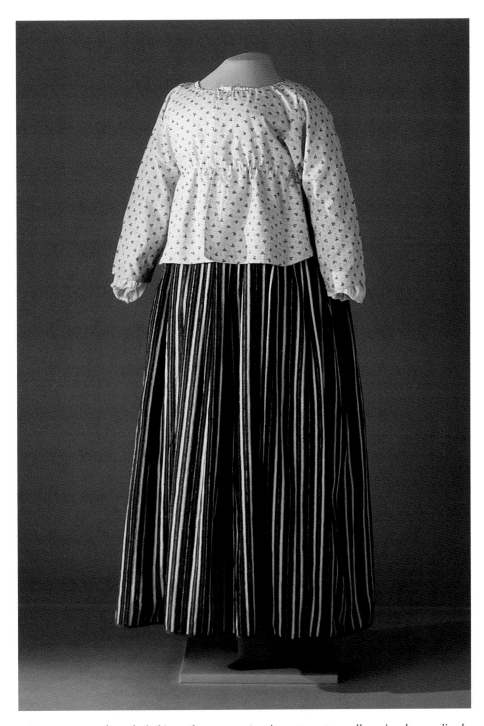

Fig. 167. Women's work clothing, Short gown, America, 1800–1820, roller-printed cotton lined with linen, reproduction shift, 1996-95; Petticoat, New England or Britain, 1770–1820, linen-wool, wool hem binding, linen waistband, 1991-444.

Even everyday clothing kept pace with fashion changes. This short gown has the high waist of late eighteenth- and early nineteenth-century styles. Purchased in the New York vicinity, the printed garment came with a handwritten tag that reads, "Aunt Logan' Short Gown, given to Emily by Cousin Sarah M. Walker." Nothing more is known about Aunt Logan or her location. The striped petticoat is woven with linen warps and wool wefts. Unlike that of typical garment construction methods, the fabric here is used horizontally with the warps running around the body, not up and down. Originally discovered in Connecticut, the petticoat may be the work of a New England weaver. Similar textiles were also produced in Kendal, England.

Some women dressed in bodices called waistcoats or jackets; the two terms appear to have been interchangeable. These fitted garments were laced, pinned, or buttoned down the front close to the torso and worn with petticoats. As early as the seventeenth century, this type of two-piece suit was associated with poorer women. Randle Holme's 1688 *Academy of Armory* described a waistcoat as "the outside of a Gown without either stayes or bodies fastned to it; It is an Habit or Garment generally worn by the middle and lower sort of Women, having Goared skirts, and some wear them with Stomachers."[26] In other words, a waistcoat was a fitted, unboned bodice that may or may not have had a stomacher front. The reference to gored skirts probably indicates a short flare or tabs below the waist.

The descriptions of waistcoats worn by eighteenth-century American women offer further clues to the appearance and use of the garment. When Venus, a Virginia slave, ran away in 1767, she was wearing a two-piece waistcoat-and-petticoat ensemble of green plains (wool). According to the advertisement, "the waistcoat had metal buttons and button holes instead of a lace before, and without skirts."[27] By describing how Venus's waistcoat differed from the norm, the advertiser suggests that most other waistcoats were laced down the front and had some sort of skirts.

Ann Stowers, a destitute Virginia woman who was living in a poorhouse in 1774, received a two-piece ensemble and other items as charity: "1 blanket, a Waste Coat and Petticoat, linen for 2 shifts, a pr of shoes & stockings, 1 coarse Handkerchief & ½ yard of linen for caps."[28] Obviously, Stowers was to sew her own shifts and caps from the linen provided. Virginia plantation owner Colonel Landon Carter also expected his household servants to sew their own waistcoats and petticoats from the Virginia cloth he gave them in 1776. Carter's diary indicates that each woman received four yards to make a petticoat and two yards for a waistcoat.[29]

Garments called waistcoats appear more often in Virginia records than in those of other colonies. Although this usage may represent a regional variation in style, more likely it was a matter of terminology. Waistcoat may have been an alternative term for jacket, since the garments appear to be similar, if not identical, to each other. The use of the term waistcoat may be an archaic holdover from the seventeenth century.

Free and slave women alike wore jackets (figs. 168–171). Period references suggest that, like waistcoats, most jack-

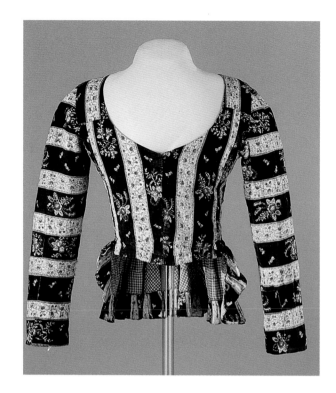

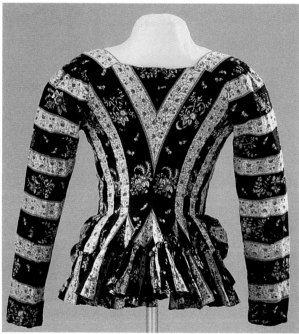

Figs. 168–169. Jacket, front and back, France, ca. 1790, block-printed cotton lined with linen and checked cotton, G1991-520, gift of Mrs. Cora Ginsburg.

Given the stylish textile and detailing of the ruffled peplum over the hips, this jacket was probably part of a fashionable informal ensemble with a matching petticoat. The peplum in this example is cut in one piece with the bodice and fans out in released pleats below the waist. Because their short length was practical, plain jackets of sturdy materials were also worn by laboring women.

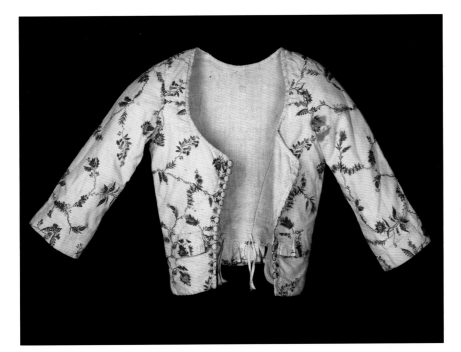

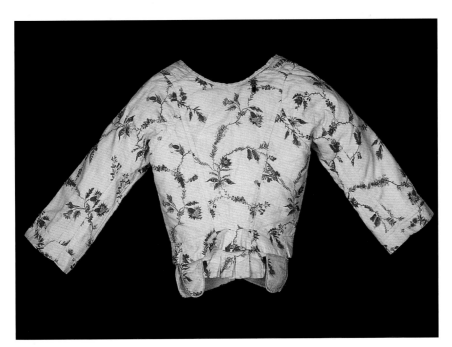

Figs. 170–171. Jacket, front and back, France or England, ca. 1780, altered ca. 1800, block-printed cotton trimmed with silk binding, lined with linen, metal lacing rings, 2000-86.

This jacket was modified to keep up with fashion. Without altering the basic cut of the original garment, a strip of self-fabric was roughly stitched above the natural waistline for fastening a petticoat in place after waistlines rose. The lining of the jacket was probably cut from an old sheet or other household linen; red marking initials from the original sheet are located on the interior under the arm.

ets had sleeves and short skirts. A Virginia runaway had a "fine Virginia Cloth Jacket, bound at the Skirts and Sleeves with Pieces of Calico and Virginia Cloth."[30] A Maryland woman had a "Callico Jacket without Cuffs, and a Callico Petticoat, the fore Part Patch-Work."[31] Jackets with adjustable center-front lacings were worn during pregnancy (see sidebar, p. 153). An African-American runaway "had on when she went away a white negro cloth jacket and [petti]coat, and was very big with child."[32]

Many workingwomen wore stays, considered essential for properly dressed women in eighteenth-century Anglo-American society. Stays did more than mold a small waistline. In fact, eighteenth-century stays restricted the waist less than many nineteenth-century corsets (see fig. 41). Laced onto most young white girls and many little boys, stays molded the body from an early age and helped teach genteel posture and movement. As a result, men and women learned how to stand

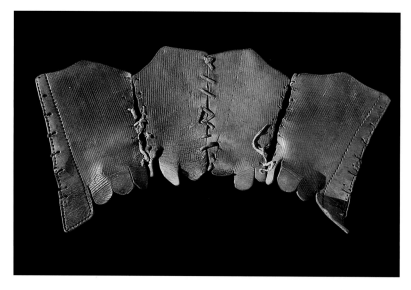
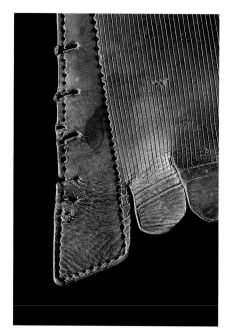

Figs. 172–173. Stays, overall and detail of lacing holes and tabs, Britain, 1760–1780, leather, 1993-329.

Sized to fit a child with a waist of twenty inches and a chest of twenty-three inches, these rare leather stays were inexpensive alternatives to boned stays. To help the stiff material conform to the body, the leather was scored following similar lines as hand-stitched stays.

with dropped shoulders, prominent chest, and erect posture. The exaggerated stance shown in portraiture was not painterly convention; the narrow, flat backs of surviving eighteenth-century garments confirm what pictorial sources suggest (see figs. 5 and 171).

The foundation garment was considered so essential that Englishwomen living in poorhouses were expected to have stays in their wardrobes, although the women were limited to one new pair every six years.[33] Leather was a cheap alternative for children and for those who could not afford expensive boned stays (figs. 172–173). Although some American women in backwoods areas neglected to wear stays, especially in the hot summer months, this practice was not considered suitable behavior for a lady, certainly not for public appearances. Tutor Philip Fithian was surprised to see Mrs. Robert Carter, a Virginia gentry matron, without her stays one day in 1774, so much so that he noted the event in his journal. "To day I saw a Phenomenon, Mrs. Carter without Stays!" He added that she was not wearing them because of a pain in her breast.[34] Sarah Fouace Nourse wore a minimum of clothing while trying to cope with the July heat on her plantation in Berkeley County, Virginia. She recorded in her diary that it was very sultry, so after dinner she remained

"up stairs in only shift & petticoat till after Tea." Nourse did not leave the privacy of her own upstairs rooms in this comparative state of undress.[35]

Like that of women, men's work clothing deviated from the fashionable ideal in basic silhouette, textiles, and accessories. Men found that stylish close-fitting knee breeches and long, full coat skirts were impractical and unsuited to vigorous physical movement (see chap. 2). Even if they could have afforded them, white ruffled linen dress shirts and fine silk knitted stockings would have been too delicate for laborers. As they did on the frontier, workingmen added comfortable, protective accessories. Instead of tight stocks around their necks, many men wore generously sized neck handkerchiefs or neck cloths. Fabric leggings protected the shins more than thin stockings did (see figs. 99 and 103). A runaway barber from Maryland had a pair of check "Spaterdashes," or leg coverings, and a farmer and gardener who ran away from a plantation in Gloucester County, Virginia, took with him the "leather leggins" often worn by farmers.[36] Aprons gave protection from dirt and flying sparks. An African-American blacksmith was described as someone who "usually wears a leather apron."[37]

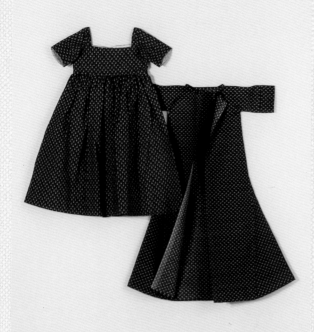

Fig. 174. *Reproduction children's clothing based on 1789 sewing instructions, sewn by Phyllis Putnam, 1991, printed cotton and linen, R1991-590, 1 and 5.*

The blue garment was based on instructions for a bed gown to be made of printed linen; the burgundy dress was called a frock of printed cotton.

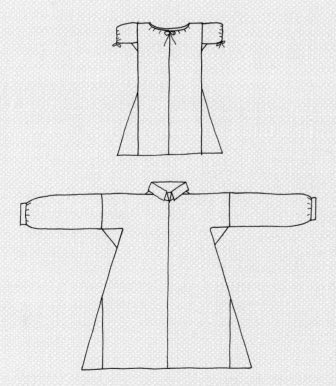

Fig. 175. *Modern drawings of infant's and mother's bed gowns based on instructions in an 1808 sewing book.*

BED GOWNS

Because so few examples of everyday apparel survived the rigors of wear and laundering, costume scholars must do detective work using period written sources to determine what some items of clothing looked like. Females of all ages wore a garment known as a bed gown. Despite the name, women did not confine their use of the gown solely to the chamber. They used it for everyday wear around the house and for work outdoors. Just what was a bed gown? The best sources are sewing instruction books. A 1789 book called *Instructions for Cutting out Apparel for the Poor* describes how to cut the pieces for what are labeled "Bedgowns Made of printed linen."[1] Although the book does include a few pattern shapes for caps and bodices, most of the directions are written. The only pattern given for the bed gown is a negative one, the shapes to remove material from the neckline of the infant's gown. Nor does the book say *how* to stitch the garment; the author correctly assumes that the typical eighteenth-century reader, who learned to sew on her sampler from an early age, would know basic clothing construction. Cutting the pieces along straight lines according to the instructions and assembling them using period sewing techniques produces an infant-size collarless garment with three-quarter length sleeves that end in cuffs. The sleeves are not set in at the shoulders; rather, they are cut in one with the bodice and are pieced to give the required length. The body is shaped slightly at the waist and flared at the skirt with triangular gores (fig. 174).

A slightly later book, *The Lady's Economical Assistant, or The Art of Cutting Out, and Making the most useful Articles of Wearing Apparel* from 1808, gives further evidence. The volume describes how to cut out bed gowns for infants and for women to use after childbirth (fig. 175). Like the 1789 bed gown, the infant's garment has a skirt cut in one with the bodice and gores to give it flare, a center-front opening, and collarless neckline cut from a shaped outline provided in one of the plates. The sleeves are short and gathered. The larger bed gown for the mother shares many features with the two infant bed gowns. Like them, it is cut along straight lines and opens down the front; the sleeves and the skirt are cut in one with the bodice and are pieced out to give the needed length or flare. Unlike the infant garments, however, the adult's example has a collar and long sleeves that gather into wristbands. The practical thirty-six-inch-long garment was easier to sew and required much less fabric than a full gown, only two-and-three-quarters yards of a colored print at twenty-seven inches wide.

Sources such as these two books indicate that, although bed gowns could be constructed with a variety of neck and sleeve treatments, the main characteristics of the garment appear to be the straight-line cut, front opening, loose fit, gored skirts extending from the bodice, and the lack of a waist seam.

1 *INSTRUCTIONS for Cutting out Apparel for the Poor; Principally intended for the Assistance of the PATRONESSES of SUNDAY SCHOOLS, And other Charitable Institutions, But USEFUL in all FAMILIES* (London, 1789), p. 74.

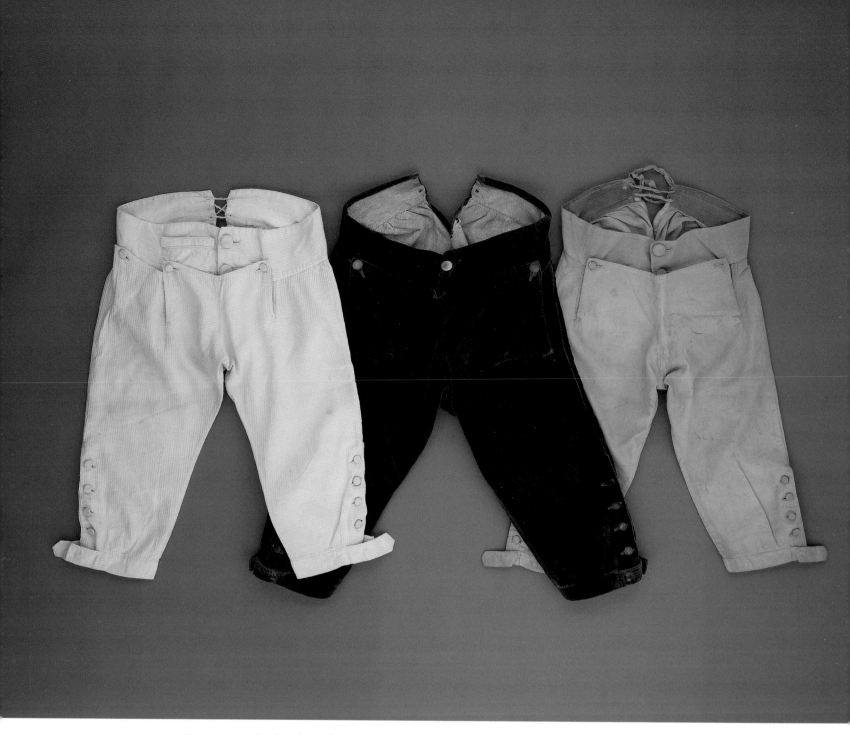

Fig. 176. Everyday breeches, left to right, White breeches, Britain or America, 1765–1785, linen-cotton dimity, waistband and fall flap lined with linen, 1987-730; Brown breeches, Britain or America, 1785–1825, cotton velvet lined with leather, 1995-35; Tan-yellow breeches, Chinese textile, probably used in Philadelphia, Pennsylvania, 1785–1815, cotton, waistband and fall flap lined with linen, G1998-7, gift of William E. Housel, Jr., Frederick James Housel, and Elizabeth S. Housel Stone in memory of Marjorie E. Pew Housel Lloyd.

By the last quarter of the eighteenth century, cotton was increasingly available in a variety of weights for men's suits and breeches. The white breeches are made of heavy pattern-woven material known as dimity. The cotton velvet of the brown breeches was probably called Manchester velvet or velveret. The breeches at the right are made of naturally yellow nankeen cotton from China; the textile measures only eleven-and-three-quarter inches wide.

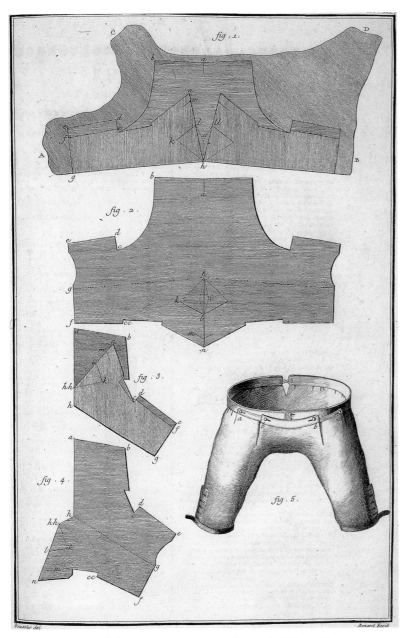

Fig. 177. "Boursier" from ENCYCLOPÉDIE, by Denis Diderot, France, 1762, John D. Rockefeller, Jr. Library, CWF.

In his essay on making leather goods, Diderot includes patterns for breeches. The top two illustrations of this plate, labeled figs. 1 and 2, show how to cut fall-front breeches out of a single skin, eliminating inseams between the legs. Figs. 3 and 4 use two skins. The author calls the fall-front style "à la bavaroise," literally translated as Bavarian style. The fall-front style developed around the mid-eighteenth century (see time line, p. 228).

Textiles had to be practical, cost-effective, and functional. Work shirts and suits were made from strong yet inexpensive fabrics of linen, wool, or cotton, usually imported, but sometimes homespun. Inexpensive imported linens included osnaburg, crocus, and rolls. Woolens, most of them from the British Isles, often had names that suggested longevity, such as everlasting and fearnothing. Kendal cotton, broadcloth, and plains were among the woolens in common use. Men's clothing textiles made of true cotton fiber included nankeen, Manchester velvet, and dimity (fig. 176).[38]

Dubbed by some the blue jeans of the eighteenth century, leather breeches were worn by men from all social levels (see figs. 84 and 85).[39] Because the material was strong, somewhat elastic, and able to conform to the body in motion, rich men found leather breeches comfortable for riding and laboring men wore them for work. In 1766, Virginian James Terrell, by trade a leather breeches maker, ran away from his master in a pair of leather breeches, possibly of his own making.[40] A convict servant who had been born in Yorkshire also ran away in Virginia-made buckskin breeches.[41] Although many leather breeches were produced in the colonies, ready-made ones were imported, as well. In 1766, merchants Balfour and Barraud of Norfolk, Virginia, had London-made leather breeches for sale in their store; other Virginia merchants sold examples said to be imported from Philadelphia and Europe.[42] In Pennsylvania, a slave man ran away with "buckskin breeches, tied at the knees with strings, and cut without seams between the thighs," probably similar to the leather breeches illustrated in Denis Diderot's *Encyclopédie* (fig. 177).[43] In 1751, an apprentice house carpenter and joiner ran away with "new tann'd Sheep Skin Breeches with a Bawdy-house Flap, with carv'd white Metal Buttons."[44] The bawdy-house flap probably indicates breeches with a fall front, a corruption of the French term *bavaroise.*

By the last quarter of the eighteenth century, men in the fashion mainstream adopted some of the garments worn by countrymen and laborers. Like blue jeans of the twentieth century, leather breeches became fashionable among the wealthy; at the same time, they remained in use as practical work and riding pants.

Workingmen's trousers eventually entered high style as well.[45] Worn by sailors, agricultural workers, convicts, and numerous other laborers throughout the eighteenth century, trousers often were made from durable, washable materials such as heavy linen. Today usually defined as long fitted pants, eighteenth-century trousers varied in

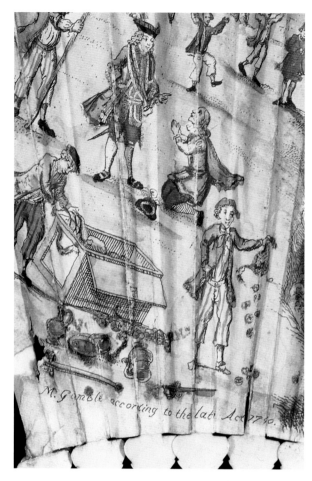

Fig. 178. (LEFT) Detail from "Battle of Portobello" fan, signed by M. Gamble, London, England, 1740, ivory, mother-of-pearl, brass, watercolor on printed paper, 1981-195.
Some of the sailors wear jackets and short trousers typical of workingmen's clothing. Costume accessories often reflected current events. This fan was made to celebrate England's victory in November 1739 over Portobello, a wealthy Spanish settlement in Panama. For another view, see fig. 39.

Fig. 179. (RIGHT) Detail from WATSON AND THE SHARK, by John Singleton Copley, 1778, oil on canvas, Courtesy, Photograph © Board of Trustees, National Gallery of Art, Washington, Ferdinand Lammot Belin Fund.
The young seaman depicted in John Singleton Copley's painting wears a pair of full trousers over his knee breeches, a style frequently described in written sources from the eighteenth century. Copley was a keen observer of clothing and often painted garments with great attention to detail.

length from the knees down to the shoe tops (fig. 178 and see fig. 151). While some trousers were relatively fitted, others were described as wide or petticoat trousers.[46] Some men wore them over other clothing for extra warmth and to protect their breeches from wear. A convict servant had narrow short osnaburg (linen) trousers drawn over his old brown breeches; a mulatto slave ran away wearing "leather breeches, and linen trousers over them"; and another runaway had trousers layered over his black knit breeches.[47] Similar clothes are evident in John Singleton Copley's *Watson and the Shark*. The man holding a spear wears trousers cut like a split skirt, layered over knee breeches (fig. 179).[48]

Just as many women substituted jackets for full-length gowns, workingmen wore shortened versions of the more formal long coat (figs. 180–181 and see figs. 178–179). Today jackets are outer garments, distinct from waistcoats or vests worn beneath suit coats. During the eighteenth century, however, the words jacket and waistcoat were often synonymous. When he ordered a suit in 1739 from his London tailor, South Carolina merchant Robert Pringle used the two words as equivalents:

"a Best superfine Scarlett Broad Cloath Jackett or Waist Coat, full trimm'd & pretty Deep or Long."[49] Runaway advertisements describe the garments in similar terms: jackets and waistcoats could be worn as under or outer garments and both came with or without sleeves. Jack, who ran away in 1768, had three jackets; his red jacket had sleeves, but the white and green ones were "without sleeves."[50] A Maryland runaway had an old flannel jacket with black stocking sleeves.[51] The addition of knitted or stocking sleeves added warmth without restricting mobility. The blue wool waistcoat worn by an indentured runaway in 1752 had "large Coat Sleeves to the Waistcoat."[52] None of these men owned a coat, so the jacket or sleeved waistcoat was their only warm outside layer.

Men also layered their jackets and waistcoats. A convict servant trained as a blacksmith ran away in a spotted, lapelled cotton jacket worn over a plain cotton under jacket "which laces."[53] In Charleston, South Carolina, an under jacket was sometimes referred to as a robbin. A carpenter had "an under jacket, called a robbin, welted with strip'd tape."[54]

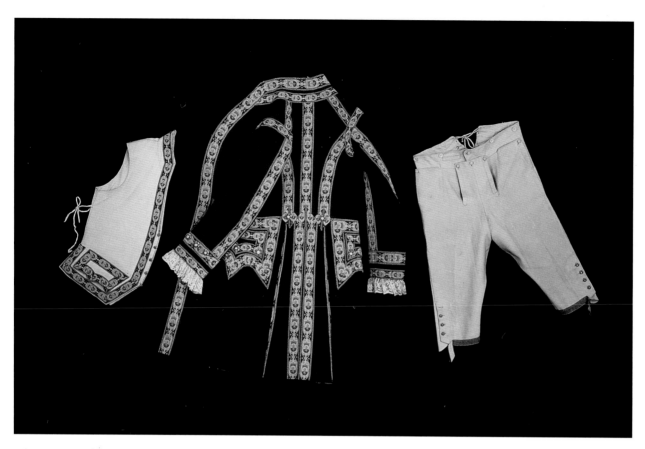

Figs. 182–183. (*ABOVE AND BELOW*) *Livery suit, overall and detail of cuff, probably Europe, 1810–1850, wool broadcloth trimmed with silk livery lace, silk thread buttons, and cotton lace, lined with worsted and cotton, 1986-141, 1–3.*

Suits for liveried servants followed distinctive formulas. The coat, waistcoat, and breeches were constructed of two contrasting colors and elaborately trimmed with woven edgings called livery lace. This suit was found in Connecticut in a cedar chest along with newspapers from the 1860s.

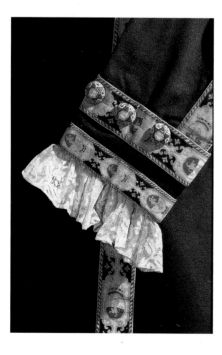

Some work clothing was symbolic rather than practical. Male servants whose jobs made them highly visible were required to wear elaborate and expensive livery uniforms. Modeled on gentlemen's fashionable three-piece suits, liveries had certain standard design elements that set them apart (figs. 182–186 and see fig. 37). Livery was usually made of woolen cloth in two colors based on the master's coat of arms. Contrast was achieved by making the collar, cuffs, or waistcoat a different color from the body of the coat. Liveries were embellished with "livery lace," elaborate edgings woven in cut or uncut velvet using worsted or silk, sometimes with gold and silver. Livery lace and buttons often featured motifs taken from the coat of arms (see fig. 186). Although the use of livery for male servants began as a European custom, wealthy colonial residents adopted the style. In Virginia, prominent men such as Royal Governor Botetourt, Robert Carter, Landon Carter, and George Washington all had

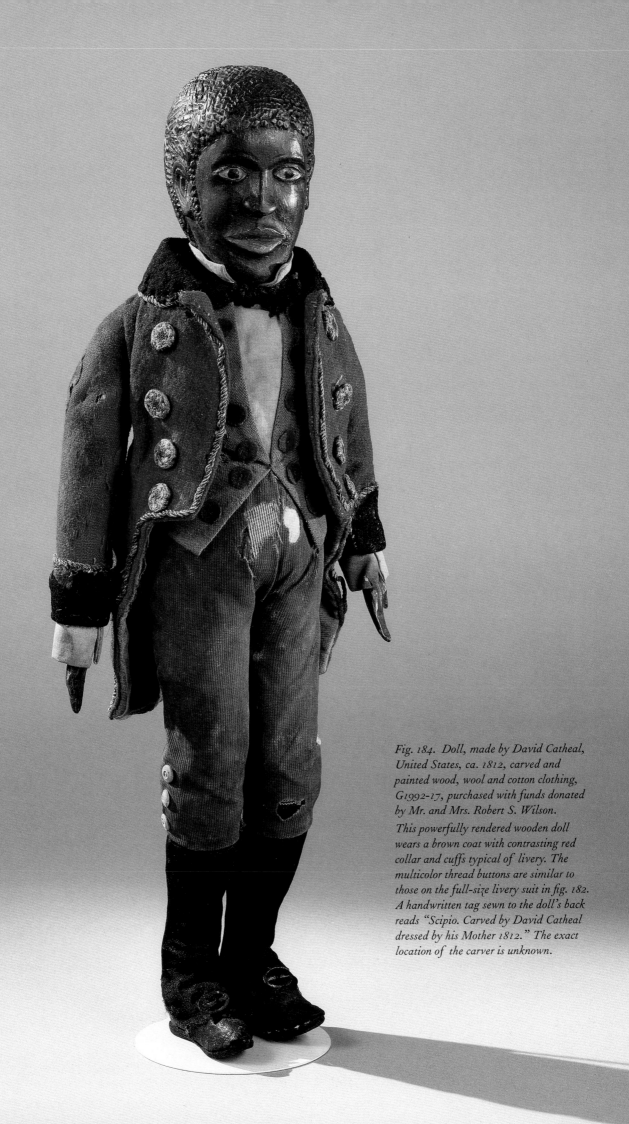

Fig. 184. Doll, made by David Catheal,
United States, ca. 1812, carved and
painted wood, wool and cotton clothing,
G1992-17, purchased with funds donated
by Mr. and Mrs. Robert S. Wilson.
This powerfully rendered wooden doll
wears a brown coat with contrasting red
collar and cuffs typical of livery. The
multicolor thread buttons are similar to
those on the full-size livery suit in fig. 182.
A handwritten tag sewn to the doll's back
reads "Scipio. Carved by David Catheal
dressed by his Mother 1812." The exact
location of the carver is unknown.

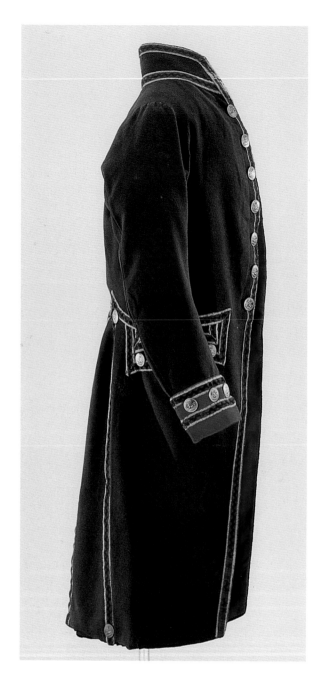

Figs. 185–186. Livery coat and detail of button and trim, Britain, 1795–1825, wool broadcloth trimmed with wool and linen livery lace and cast brass buttons, lined with wool and linen, from the collection of Frank Moss Bennett, 1954-1032.

A household servant in a British gentry family probably wore this coat. The coat's lining of glazed wool twill was probably called shalloon. The buttons, cast with the crest from the unknown family's coat of arms, are marked HUNTER & CO., 93 ST. MARTINS LANE, LONDON. John Hunter was a button-seller and mercer, or textile merchant. He was located at 93 St. Martin's Lane beginning in 1791. In 1812, he was a partner with Michael Hunter, and in 1825, the firm's name was changed to Hunter, Longstaff & Heslopp.

liveried servants. Jacob Read of Charleston, South Carolina, described the livery of his runaway servant, Mungo: "his livery is of brown Yorkshire cloth lined with white, with a scarlet cape [collar]." Mungo's hat was trimmed with a band of broad gold lace. Read added that the servant took with him several suits of clothes, probably because the distinctive livery would be easy to spot. Mungo would have changed clothes soon after running away.[55]

Washington ordered materials for his scarlet and off-white livery several times in the eighteenth century. In

1755, he gave specific instructions as to the size and style of two servants' suits. The colors were to be taken from the Washington coat of arms, although the white should be modified to match a swatch enclosed with the order. Further, he wanted the suits trimmed with livery lace, if it was still in fashion: "The Servants that these Liverys are intended for, are 5 feet, 9 Inc. and 5f. 4In. high and proportionably made. I wou'd have you choose the livery by our Arms; only, as the Field of the Arms is white. I think the Cloaths had better not be quite so but nearly likely the inclos'd. The Trimmings and Facings of Scarlet and a Scarlet Waistcoat, the Cloath of w'ch to be 12s 6 pr. yd.

Figs. 187–188. Breeches, front and back, Britain, 1780–1820, mohair and wool velvet lined with cotton, from the collection of Frank Moss Bennett, 1954-1036.

Long-nap wool or mohair velvet, called shagg, was popular for workingmen's clothing and livery breeches. In contrast to today's construction methods, these breeches were cut with the nap running in different directions on the front and back, a feature that is especially evident at the inseam.

If livery Lace is not quite disus'd, I shou'd be glad to have these cloaths laced. I like that fashion best; and two Silver lac'd hats for the above Livery's." Along with the suits, Washington also ordered matching "horse Furniture, with livery Lace, and the Washington Crest on the housing."[56] In August 1764, Washington ordered another suit of livery, this time made of wool "Shagg," long-pile wool or mohair velvet, lined with red "shalloon," fine, glazed worsted wool (figs. 187–188 and see fig. 185). The waistcoat and collar of Washington's livery were to be red, and all the pieces trimmed with livery lace. Two months later, however, Washington changed his mind

and cancelled the order for the lace.[57] Washington did not give up his liveried servants after the Revolutionary War ended. In 1784, he ordered seventy yards of red and white livery lace that was to measure between three-fourths and an inch wide.[58]

Even Jefferson, who deliberately eschewed elaborate clothing for himself while president, ordered livery for male servants several times between 1802 and 1807, during his tenure.[59] His liveried servants wore blue coats trimmed with scarlet cloth over waistcoats of scarlet. The trimming, or lace, was silver.

Fig. 189. "The High Mettled Racer" textile, Lancashire,
England, 1820–1830, plate-printed cotton, G1974-407, bequest
of Grace Hartshorn Westerfield.

These scenes of horse racing depict English rural people in their
everyday clothing. The farmer standing in front of a cottage
wears a smock or frock and short leggings. His wife has on a bed
gown. The jockey wears a short jacket and cap that forms the
basis for jockey costumes today, an example of style
fossilization. A postboy rides one of the two horses pulling the
carriage (see figs. 180–181). This textile illustrates the verses of
a song written by Charles Dibdin (1745–1814), a prolific
composer of operas and popular verses. High mettled meant
high-spirited.

The symbolism of the uniforms worn by footmen, wait-
ers, and carriage drivers was not lost on contemporaries.
Although livery suits are elegant in appearance, they
were intended to enhance the person served, not the per-
son wearing the livery. What did liveried servants think
about their clothes? The suits were of higher quality and
more decorative than the coarse, scratchy, inadequate
clothing of many slaves and indentured servants. Still,
the elaborate beauty of the suit may have been negated
by the implied inferiority of the wearer, who was, after
all, a servant required to wear a uniform. Too, the
woolen suits were hot and stifling in the climate of the
southern colonies. Although some liveried servants may
have been proud of their responsible jobs and grateful
not to be laboring in tobacco fields or rice paddies, most
probably felt constrained under the constant supervision
of masters who expected immediate attention. That liv-
ery was perceived negatively as a mark of servitude can
be inferred from a white man's refusal to wear it. William
Holland, a parson from Somerset, England, recorded in
his journal, "Mr. Charles my man it seems does not chuse
to wear a Livery so he is to go at the month's end."[60]

Field labor required a different set of clothes. A few men
wore loose overshirts as part of their working attire (fig.
189). Called a frock in period records, this garment should
not be confused with the man's coat and the child's dress
that went by the same name (see figs. 153 and 174). A
Maryland runaway in 1746 had a coarse linen frock that was
described as an "Oznabrigs shirt (or Frock)." He also had
trousers, a jacket, and a waistcoat under the jacket, layered
to keep him warm on the winter day that he ran away.[61]
The description suggests that a shirt and frock were simi-
lar garments. In the stifling heat of southern summers,
some slaves wore sleeveless linen frock shirts, described as
"an oznabrug frock or body of a shirt, without sleeves" or
"a crocus [linen fabric] shirt without sleeves."[62] Although
most references to sleeveless frocks occur in South Car-
olina records, two African-born men ran away from a Vir-
ginia slaveholder in August 1736 wearing "Cotton Frocks,
without Sleeves, which they had when I bought them."[63]
Slave Charles Ball described another variation of the frock
in his narrative that was published in the 1830s. About the
clothing of a group of laborers he encountered, Ball
wrote, "Each person had a coarse blanket, which had holes
cut for the arms to pass through, and the top was drawn up
round the neck, so as to form a sort of loose frock, tied
before with strings. The arms, when the people were at
work, were naked."[64] Sleeveless frocks appear to be unique
adaptations to the Virginia-Carolina climatic conditions,
although long-sleeved smock frocks came from British

traditions, where rural men wore them over their clothing (see figs. 103 and 189).

The individual pieces of clothing worn by many slaves are the same as those of indentured or free white men and women in similar occupations: breeches, trousers, jackets, waistcoats, and petticoats. Nevertheless, the wearing apparel of enslaved African-Americans is a fascinating and complex study in what clothing meant to people of the eighteenth and early nineteenth centuries. It is also a story of adaptation.

Newly imported slaves, called "new Negroes" in the period, arrived by ship with only the few clothes and ornaments allowed by their captors. Modern readers cringe at the conditions described in 1732:

The men are Stowed before the foremast, then the Boys between that and the main-mast, the Girls next, and the grown Women behind the Missen. The Boyes and Girles [were] all Stark naked; so Were the greatest part of the Men and Women. Some had beads about their necks, arms, and Wasts, and a ragg or Peice of Leather the bigness of a figg Leafe. And I saw a [white] Woman [who had] Come aboard to buy Examine the Limbs and soundness of some she seemed to Choose. Dr. Dixon . . . bought 8 men and 2 women . . . and brought them on Shoar with us, all stark naked. But when [we had] come home [they] had Coarse Shirts and afterwards Drawers given [to] them.[65]

Considering the wrenching experience new slaves were undergoing, unfamiliar garments may have been the least of their concerns. Still, clothing and ornaments are powerful symbols of cultural and personal identity; new shirts and drawers were yet another reminder of the enormous transition in their lives.

Pictorial sources show the importance of clothing, or the lack of it, to indicate status (fig. 190). Racist white slaveholders viewed African-Americans and American Indians as subhuman, justifying in their minds the institution of slavery.[66] Absence of clothing, unthinkable for white adults in the eighteenth century, was viewed as acceptable for slaves. Laws codified a growing belief in the innate inferiority of African-Americans; in 1705, for example, it was forbidden to "whip a christian white servant naked, without an order from a justice of the peace."[67] No such prohibition pertained to African-American servants.

In contrast to the everyday attire of white women, the summer clothing given to most female field slaves

SAM'S TURNED COAT

Although nothing is known about his background or family, a young mulatto slave named Sam entered the written historical record when he ran away from his master in Bute (now Warren) County, in northern North Carolina. Sam may have been successful in his quest for freedom when he fled September 1775 because almost three months later his master was still trying to locate the runaway in Williamsburg, Virginia, 150 miles away. The advertisement in the December 2, 1775, *Virginia Gazette* describes Sam in some detail: "Run Away . . . a likely Mulatto Man Slave named SAM, about 5 Feet 7 Inches high, 21 Years old, well made, wears his own Hair, much curled; he had on a fine white broadcloth Coat, which has been turned, a lapelled green Sagathy Waistcoat laced behind, with Breeches of the same, an old Beaver Hat, Thread Stockings, and Country shoes."

What can be inferred about Sam from his appearance? He was not wearing the clothing of an outdoor laborer. Although most workingmen wore a variety of mismatched garments, layering them for warmth instead of style, Sam's waistcoat and matching breeches of green sagathy had fashionable elements. Sagathy was a fine twill-woven wool textile, sometimes mixed with silk. The waistcoat had lapels and was "laced behind," probably a reference to eyelets for adjusting the fit with lacing strings. Over the green clothes Sam wore "a fine white Broadcloth coat, which has been turned," perhaps similar in style to an extant broadcloth coat (see fig. 153). Although broadcloth was an expensive wool textile, the fact that Sam's coat had been turned, or remade with the inside brought to the outside to camouflage soiling and wear, indicates the coat was not new. Sam's beaver hat, originally an expensive material made from beaver pelts, was old and possibly secondhand. Thread stockings, which were knitted from linen, were of better quality than the cut-and-sewn fabric ones many slaves wore, but not as stylish as knitted silk stockings. Sam showed his ethnic roots in the way he wore his hair "much curled."

Why did Sam's master remember his clothing in such detail months after he had left? Sam had been a manservant, or a personal slave in the household, whose appearance and apparel were intimately known to family members. The worn yet fashionable clothes may even have been hand-me-downs from the master.

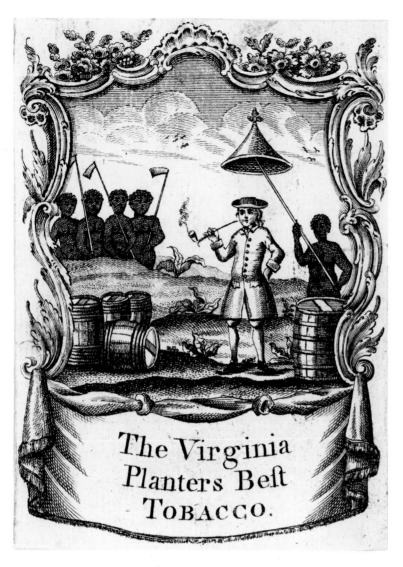

Fig. 190. *"The Virginia Planters Best Tobacco" label, Britain, eighteenth century, line engraving on paper, 1980-165, 16.*
By contrasting the well-dressed Virginian with nude slaves hoeing in a tobacco field, the engraver depicted eighteenth-century hierarchy in a society that placed great importance on being covered.

consisted only of a coarse shift and a petticoat. Stays were absent. People today would consider the woman who did not have to wear stays fortunate. In the context of the eighteenth-century mindset, however, the absence of stays among the garments given to female field slaves signaled inferiority through lack of clothing. Slave women labored in public wearing the same petticoat and shift ensemble in which Sarah Nourse, a white plantation mistress, had remained out of sight inside her home. Such

was the clothing of two Charleston, South Carolina, slaves who ran away in June and July 1750. Phoebe wore only a "dirty oznabrig shift and petticoat" and Sarah "had on an oznaburg shift and blue petticoat."[68]

Although slaveholders considered it their responsibility to provide wearing apparel for their laborers, the style and quality of clothing varied greatly and depended on the occupations, as well as the workers' perceived importance and status within the white community. Visible household servants received special treatment. Thomas Jefferson indicated as much in an early nineteenth-century letter to his overseer, Edmund Bacon: "Mrs. Randolph [Jefferson's married daughter] always chooses the clothing for the house servants."[69] Similarly, Martha Washington's maids wore gowns of relatively fine fabrics such as calico and linen.[70]

Tradition has it that slaves routinely received hand-me-down clothing from whites. In actuality, only favored or close personal servants, a small percentage of the total slave population, benefited from the practice. Giving cast-off clothing to servants had been an English tradition, and some colonists did extend the custom to slaves in their households. From London, plantation owner Joseph Ball sent to Virginia used clothing that had been in his own wardrobe and that of his slave, Aron. The clothing was to be given out to slaves on Ball's Morattico plantation in Lancaster County: "The old Cloths must be disposed of, as follows: The Grey Coat Wastecoat & breeches, with brass buttons, and the hat to poor Will: The Stuff Suit to Mingo: and the Dimmity Coat & breeches and the knife in the pocket to Harrison: and Aron's Old Livery with one pair of the Leather breeches and one of the Linen frocks to Moses." On another occasion, Ball sent an old "banjan" (probably a banyan, or dressing gown) and breeches for slave Israel, black velvet breeches for Will, and another pair of breeches for Aron, who was then residing in Virginia (see fig. 158).[71] Mary Willing Byrd of Westover plantation in Virginia provided for her slave maid, Jenny Harris, in her 1813 will; according to the will, Harris was to be emancipated "whenever she may chuse it." In addition to a small bedstead with its bed, bedding, and curtains, Harris was to receive "such of my wearing apparel as my children may think proper for her to have."[72]

The great majority of slaves, however, did not receive their master's used clothing. There were insufficient hand-me-downs to supply the thousands of field slaves working on large plantations. Moreover, such clothing

would have been inappropriate in style and impractical in fabric for laborers or those considered of lower status. Although she had freed Harris, Byrd judged that not all of her used clothing was proper or appropriate for an emancipated slave.

One of the characteristics of field slaves' clothing was its lack of individuality. The clothing of agricultural workers on large plantations was a type of occupational uniform, just as livery was. Advertisements describe runaway men in identical outfits "such as crop Negroes usually wear" or "the common dress of field slaves," the latter spelled out as consisting of osnaburg shirts, cotton jackets and breeches, plaid hose, and Virginia-made shoes.[73] Given that the men ran away in December, the cotton jackets were probably winter clothes made of the wool fabric called cotton. Frances Yonge, a South Carolina plantation owner, had his initials applied to his workers' field uniforms. Six of Yonge's workers ran away wearing identical suits of "blue negro cloth jackets and breeches, with the letters F. Y. in scarlet sewed upon the forepart of their jackets."[74] (During this period, negro cloth was usually made of coarse wool.) Similarly, four men originally from Guinea ran away clothed alike in jackets and breeches of white plains, or inexpensive woolen material. Instead of sewing initials to their clothing, their master, Daniel Ravenel, had lead tags engraved with his own initials and the men's names, which he tied around their necks. The tags may have resembled slave badges of the nineteenth century (see fig. 28). Only one of the four men had managed to acquire more personalized clothing, "a jacket dyed with hickory bark, with red pockets."[75]

Knowing the mechanics of how and where plantation owners acquired slave textiles is basic to understanding the clothing itself. Except for the period around the American Revolution, when homespun cloth predominated, most of the textiles for slaves' clothing were imported. Colonists could acquire fabric from Britain, China, India, or Europe, as long as the goods first landed in England, as the law required, before being shipped to the colonies. Despite the incredible variety available in the market, only a few textiles were considered appropriate for slave garments and blankets. They included coarse linens from Germany and Scotland, such as osnaburg and rolls; and inexpensive woolens from England, Wales, and Scotland, such as Kendal cotton, plains, and plaid. Local stores and planters themselves ordered the textiles seasonally in enormous quantities. In 1770, a Williamsburg merchant announced a public auction of

"SUNDRY WOOLENS," consisting of "coarse broadcloths, beaver coating, bearskin, Dutch and other blankets, and cottons."[76] Planter Robert Beverley ordered most of his slaves' textiles directly from a Liverpool, England, supplier; in about 1768, he sent for one thousand ells of German osnaburg, three hundred yards of Kendal cotton, one hundred yards of "plaidding for negroe Children" and 60 ready-made "fear nothing waistcoats of the cheapest color." He also ordered twenty-four dozen, or two hundred eighty-eight, buttons, half of which were to be white metal in two sizes. Another twelve dozen were to be horn molds for coat buttons, made without shanks. The molds would have been covered with fabric that was drawn around the horn and gathered at the back.[77] Each season, planters repeated their orders for textiles and ready-made inexpensive garments, complained about inevitable delays, and set into motion the construction of clothing.

Once the hundreds of yards of textiles came in, they had to be cut out and sewn. On most plantations for which records survive, field slaves received only two suits of clothing per year, one for winter and another for summer. A man's winter ration usually consisted of a waistcoat with sleeves, breeches or trousers, and two shirts. A woman generally received a jacket, petticoat, and two shifts. For summer, female slaves who worked outdoors received linen petticoats to wear with their shifts; men got summer breeches or trousers to wear with shirts.[78] Both sexes would have worn their last winter's wool jacket if it got cool during the summer season, for only a few plantations provided summer linen jackets. Even with this meager allotment per person, a large labor force meant that many suits of clothing had to be made in a hurry. Some planters hired professional tailors to make the woolen clothing. Virginian Nathaniel Burwell hired tailor John Grymes to make "35 Suits for Crop People @ 1/6" and paid an extra six shillings for putting pockets into them.[79] Occasionally, the planters' wives cut out and sewed some of the clothing themselves, especially on smaller plantations. Plantation mistress Nourse cut out shirts and shifts for her laborers and made jackets and petticoats for Cloe, probably a household slave.[80]

George Washington had some of his slaves trained to sew linen shirts and shifts. Although the sewing had to be done by hand, Washington complained that the women worked too slowly, producing only six shirts each week, when their usual quota was to make nine apiece. One slave, Caroline, had produced only five shirts, possibly because she had been assigned the task of cutting out the

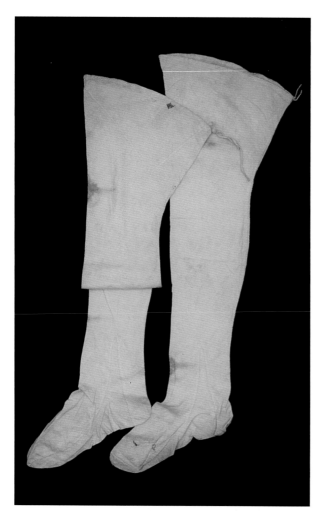

Fig. 191. Stockings, Britain, ca. 1800, woven linen, 1988-466, 1–2.

These stockings are constructed of woven fabric, cut on the bias and sewn together by hand. Although these examples are linen, the woolen plaid hose worn by slaves were probably cut and constructed in the same manner.

linens. Two months later, Washington directed that the gardener's wife should cut out the linens instead of Caroline, whom he suspected of dishonesty and embezzling materials.[81] Joseph Ball expected slaves who were skilled in sewing to make their own and their children's linen garments. He wrote in 1743/4, "Bess, Winny, Nan, Hannah, and Frank, must have their shifts, and Linen Petticoats, and their Children's Linen, Cut out and thread and needles given them, and they must make them themselves. . . . The rest of the folks, must have their Linen made by somebody that will make it as it should be."[82]

The fact that textiles were ordered in bulk and all the suits made at the same time helps explain the uniformity

of field slaves' clothing. It is unlikely that any slave was fitted personally or carefully for his or her suit. Even if it were new, the ill-fitting clothing set slaves apart from those who could afford to have their apparel personally sized or skillfully altered. Additional ready-made clothing ordered by the dozens such as fearnothing jackets, plaid hose, and knitted Monmouth caps, also added to the impression of uniformity and lack of individual sizing.

The large order of stockings Edward Ambler received had to be altered by the slaves themselves because the hose were too small. Ambler wrote to his plantation manager, "I am apprehensive the Women's Stockings will prove too small, I shoud therefore be [g]lad [if] you wou'd give out some slipes of Kendall Cotton [woven wool fabric] and thread to make them larger."[83] Given the context of the reference, the stockings must have been made out of woven fabric, not knitted, which helps clarify what was meant by plaid hose. Judging from period references, plaid hose were leg coverings made out of bias-cut and seamed woolen plaiding, a far cry from formfitting knitted silk or linen stockings worn by the gentry. Stockings of cut-and-sewn fabric could be made larger by opening the seam and inserting strips of wool fabric, or "slipes of Kendall Cotton." Despite their name, plaid hose were not necessarily patterned; references such as "twill'd white Scotch plaiding" suggest that the slaves' hose most likely were unpatterned (fig. 191).[84]

The uniformity of clothing provided by slaveholders went beyond economics. Cognizant of the fact that distinctive clothing could instill individuality, dignity, and cultural identity, some slaveholders tried to prevent such personal expression. In 1735, South Carolina's "Negro Act" attempted to legislate against African-Americans who wore clothing described as being "above the condition of slaves."[85] Almost forty years later, the master of a South Carolina runaway who played "remarkably well on the Fiddle" echoed a similar belief that the man's clothing was "really too good for any of his Colour."[86]

Despite slave owners' attempts to ensure uniformity in clothing, many slaves were able to exert some personal choice, often revealing their African backgrounds. One South Carolina slave had decorated his "white negro cloth" suit with "some blue between every seam, and particularly on the fore part of the jacket, a slip of blue in the shape of a serpent."[87] Born in Angola, the man must have known that the snake was an African symbol of fertility and of an intermediary with one's ancestors.[88]

Judging from complaints in the *South-Carolina Gazette*, the Negro Act and other attempts to restrict clothing choices were decidedly unsuccessful: "many Negroes in Charles-Town . . . do openly buy and sell sundry sorts of Wares . . . it is apparent, that Negro Women in particular do not restrain themselves in their Cloathing as the Law requires, but dress in Apparel quite gay and beyond their Condition."[89] Indeed, slaves throughout the colonies participated in the market economy through money they earned from selling chickens, growing crops in their gardens, playing the banjo or fiddle, or earning tips for household service. Many purchased extra clothing with their money. Newspaper accounts complained of slave women who affected "gaiety in dress," or who were "very fond of dressing well."[90] Women were not the only ones who aspired to better clothing, for a mulatto slave man in Stafford County, Virginia, was described as being "extremely fond of dress; and though his holiday clothes were taken from him . . . I make no doubt he has supplied himself with others, as such a fellow would readily get employment."[91]

Gradually, it became an accepted practice that slaves could purchase their own holiday clothes, which they wore when they were given time off from work on Sundays, for funerals, and during the Christmas holidays.[92] On Christmas day 1801, New Englander Ruth Henshaw Bascom observed local African-Americans when she visited Norfolk, Virginia: "The streets all day mostly filled with negroes ["drest in their holiday cloths" crossed out] of all ages & sizes & figures, drest in their best, playing, dancing, shaking hands &c. . . . This and the five following days being the negro's holidays, during which time, their time is their own."[93]

Slaves, both male and female, sometimes used earrings as ornamentation, a practice carried over from Africa. A Virginia mulatto slave woman wore a pair of silver bobs along with a colorful gown of striped red, white, and yellow calimanco, and the five-year-old daughter of a runaway slave in South Carolina had "silver drops in her ears."[94] The custom of men's wearing jewelry in one or both ears was especially prevalent in South Carolina, an area with many newly arrived slaves; a few men born in America continued the custom. A recently arrived Angola slave had a silver ear ornament, and a man named August had a handkerchief about his head and a silver jewel in one of his ears.[95] Another man, described as a "new Negro," had "in his left Ear Three Beads strung for an Ear-Ring."[96]

Although African jewelry could be taken away or lost during slavery, body modifications such as filed teeth or

Fig. 192. Runaway advertisement from the VIRGINIA GAZETTE, *October 3–10, 1745.*
One of the runaway Virginia slaves sought in this advertisement bore distinctive African tribal markings acquired as a young man in his homeland. The winter jackets, breeches, and shirts provided by their master are made of inexpensive woolens and linens that were imported from Britain for slaves' use. Cotton was a type of napped woolen cloth.

ritual scars remained with the person for life. There is no direct proof that these practices continued in America; nevertheless, many slaves who were brought to the colonies had body ornamentation that might have served as a continual reminder of a culture left behind. It has been suggested that tribal markings gave African-Americans "a distinctive sense of history."[97] Filed teeth were considered a sign of beauty among some peoples of the west coast of Africa. Scarification and tattooing were, according to one author, more than fashion; usually acquired during initiation into adulthood, the marks carried the message that the people were civilized, socialized members within their community.[98] Advertisements for runaway slaves sometimes described them with "teeth filed," "country marks," or both. Many slaves in South Carolina bore body markings, such as "Scars on each side of his Stomach down his Belly," and an unusual example of a man who had "the skin of his legs cut in the exact form of ribbed stockings."[99] A man from Gambia had facial marks described by his Hanover, Virginia, master as "3 small Strokes on each Side of his Face, like this Mark (/)"; he was said to have stolen a silk handkerchief, possibly to wear on his head (fig. 192).[100]

Whereas Anglo-Americans traditionally carried handkerchiefs in their pockets or wore them about their necks and shoulders, African-Americans often wrapped them around

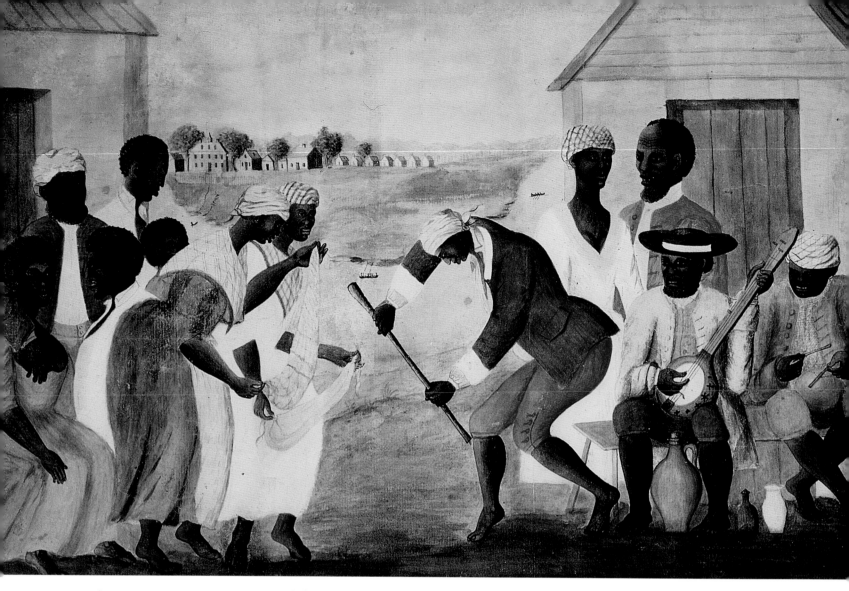

Fig. 193. THE OLD PLANTATION, probably South Carolina, ca. 1790, watercolor on paper, 1935.301.3. The clothing of these African-Americans reveals a blending of traditions. Although most of their garments were made in Anglo-American styles, these men and women have added distinctive head wraps that came out of their cultural ties to the African continent. The artist of this painting is unknown. Descendants of the Columbia, South Carolina, family who owned it believed that their ancestor, a plantation owner, painted it. Family history suggested that the painting depicted a plantation lying between Charleston and Orangeburg.

their heads in a distinctively African manner.[101] African-Americans depicted dancing in South Carolina wore gowns and jackets made in European style, combined with head kerchiefs from an African tradition (fig. 193).

One young Charleston, South Carolina, waiting man symbolized this blending of African and Anglo-American culture in his style of head wear. He was described as someone who wore his hair "in the maccaroni taste . . . teazed into side locks, and a queue, but when too lazy to comb, ties his head with a handkerchief."[102] Although the writer attributed the runaway's choice of a handkerchief

to laziness, the head wrap could be viewed more positively as an expression of the slave's cultural origins.

Although most American slaves dressed in clothing that was derived from Anglo-American styles, some apparently found ways to modify their uniform garments by dyeing them. It is not possible to say with certainty who dyed the outfits described in runaway ads as "dyed with Indico . . . dyed with Oak," or "dy'd of a Purple Colour," yet it is conceivable that the slaves themselves individualized their clothing.[103] Captain Basil Hall suggested as much when he reported on his visit to a

Georgia plantation in 1827 to 1828. He noted that the slaves were dressed in white Welsh plains winter clothing, and added, "They prefer white cloth, and afterwards die it of a purple colour to suit their own fancy."[104]

From the India chintz banyan worn by a wealthy man for leisure to the coarse wool suit of a working slave, everyday clothing said as much about individuals as their finest suit of clothes. Leisure wear suggested one's level of wealth and taste. Like consumers of the twenty-first century, eighteenth-century people were alert to clothing construction and quality. They, too, were aware of subtleties in material and decoration, even when the clothing was for everyday use. They did not fail to notice the quality fabric, good tailoring, and fine fit of a wealthy landowner's otherwise plain frock coat. The finely woven linen shirt of a wealthy man would not be mistaken for the coarse tow linen shirt of a laborer, even when the two were cut and constructed in much the same way. Clothing often revealed one's occupation. Observers recognized the blacksmith's apron, the farmer's leggings, and the field slave's trousers. A suit of livery was known to be servant's clothing, despite its impressive facade. How someone combed his hair or wore a handkerchief could be a sign of group identification, although the significance might be missed or misinterpreted by another group.

Wealthy men and women knew that fine apparel helped solidify and maintain their status. Those with less money recognized that clothes were valuable tools, as well. Having the right clothing helped people meet their aspirations. For the disadvantaged with few garments, a change of clothing could give them more options in life. Amy, also known as Betty Browne, was an African-American who had "silver buckles, and a change of apparel." The runaway woman undoubtedly knew the importance of clothing as well as her master, who pointed out that it "makes her appear more like a free woman."[105] Work or leisure attire was as diverse as the people who wore it, but everyone seemed to know that clothing mattered.

CHAPTER 5
CRADLE TO COFFIN
Life Passages
Reflected in Clothing

People of the past were acutely aware of life's cycles. They shared each other's joy at weddings and christenings. They endured illness and equally painful attempts to cure illness. They helped each other through childbirth, visited the sick and bereaved, and attended numerous funerals of children and adults who succumbed to disease and accident. More rarely, some people lived to see their grandchildren grow up. Esther Edwards Burr, married to a prominent clergyman, the mother of a healthy little girl, and pregnant with her second child, was cognizant of her happy but precarious position when she visited someone less fortunate. In 1755, Burr wrote, "I have been to see a poor Woman that is a Widow, has a Child a dieing with the bloody Flux, poor Woman. She seems much sunk. I feel greatly grieved for her— What a differance God is pleased to put between this poor Widow and me!" Burr herself died a widow at the age of twenty-six, leaving two orphaned children.[1] (The second child, Aaron Burr, would grow up to become vice president of the United States.)

Life experiences greatly affected people's choice of clothing in the eighteenth and early nineteenth centuries. Celebratory events called for special finery. Pregnancy and nursing, near-constant conditions in many women's lives between marriage and menopause, mandated that women adapt their fashionable wardrobes. Body and health changes brought about by age caused people to dress differently than in their youth. Death of a loved one required clothing to symbolize the survivors' feelings of mourning. Commemorating life's passages through symbolic ceremonies and apparel emphasized the joy of happy events and helped people deal with grief at sad occasions. Special celebrations and clothing instilled in people an awareness of the cycle from birth to death. With every sneeze, the user of a handkerchief printed with scenes from "Cradle to the Coffin" was reminded of happy, productive times and of life's inevitable end (fig. 195). Although the life story on the handkerchief starts with the infant in a cradle, the tale begins before that. While rocking her six-months-old daughter, Burr wrote to her sister in 1754, "I have no news to tell you, I think. O yes I have! Miss Elizabeth Eaton is like to be married at RoadIsland, ant you glad?"[2]

Just as today, weddings of the past ranged from small ceremonies at home to royal occasions (fig. 196). Weddings called for the best clothing and accessories the bride and groom were able to afford, although few could invest in a dress, suit, or other item dedicated solely to a single event

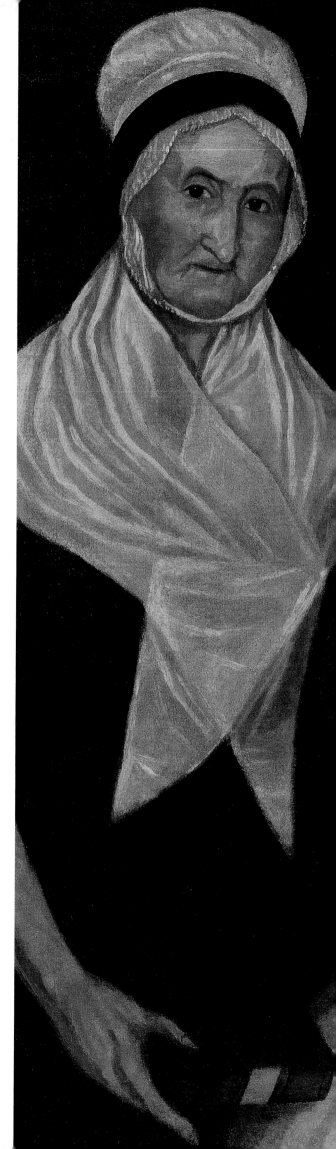

Fig. 194. EGE-GALT FAMILY, Virginia, 1801–1803, oil on canvas, 1976.100.1.

This painting shows four generations of family members: Maria Sherer Ege, left, about seventy-eight; Elizabeth Ege Galt, right, about fifty-four; Elizabeth Galt Williamson, about twenty-three; and baby Frederick Williamson, born in 1801. The older women wear dark colors, generous kerchiefs, and caps with flaps that tie beneath their chins. They have rejected the fashionable gowns with raised waistlines worn by the young mother and her child. Frederick died in 1803.

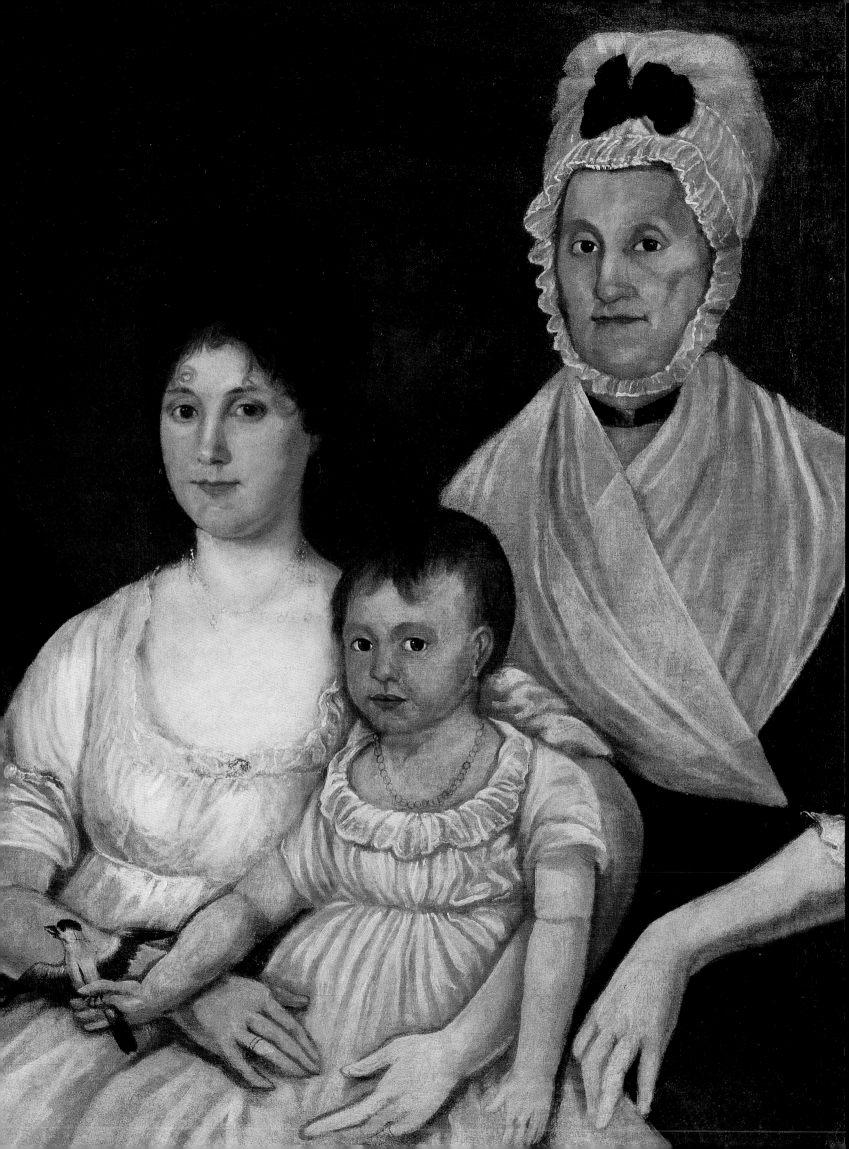

Fig. 195. "Cradle to the Coffin" handkerchief, Britain, ca. 1785, plate-printed cotton, G1971-1442, anonymous gift.

Worn and stained from years of use, this handkerchief is decorated with scenes from the life of a successful man beginning with his infancy in a cradle. As he learns to walk (top row, second circle from left), the toddler's mother supports him with leading strings tied around the waist of his frock. The printed design follows the exemplary man through his schooling, apprenticeship, and career as a draper. His wedding is in the second row, third circle from the left. The man's story continues with his service as magistrate and lord mayor, old age, failing health, and eventual death.

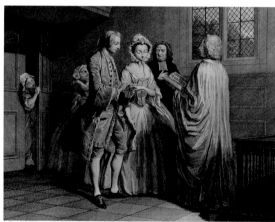

Fig. 196. THE STORY OF PAMELA, *plate 9, engraved by L. Truchy after a painting by Joseph Highmore, London, England, 1745, line engraving on paper, 1968-280, 9.*

Samuel Richardson's successful 1740 novel, PAMELA OR, VIRTUE REWARDED, *followed the life of a virtuous servant girl. A later series of engravings illustrated scenes from the popular story. In this plate, Pamela and her master are married in a private ceremony. According to the novel, the bride wore a second-hand gown of rich white satin that once belonged to her mistress.*

(figs. 197–200 and see figs. 13–14 and 147). Because they expected to wear their wedding gowns for years afterward, many brides chose patterned silk or a practical color. Elizabeth Porter of Hadley, Massachusetts, wore a dark brown "weding Gown" for her marriage to lawyer Charles Phelps in June 1770. Apparently, Mrs. Phelps was still wearing it eighteen years later, for she recorded, "Miss Molly Wright [was] here to alter my Weding Gown."[3] A silk dress believed to be the wedding attire of a Wickford, Rhode Island, woman is made of floral-patterned brocaded silk (see fig. 197). The textile is an English import that dates between 1726 and 1728, although the gown was altered around 1775, probably by a descendant of the original bride.[4] Blue silk damask shoes, reputed to be part of the wedding finery, fall between the date of the textile and the gown's last alteration; they probably were worn with the dress in the interim.

According to a contemporary observer, an English bride of 1772 also wore brocaded silk with a flowered pattern.

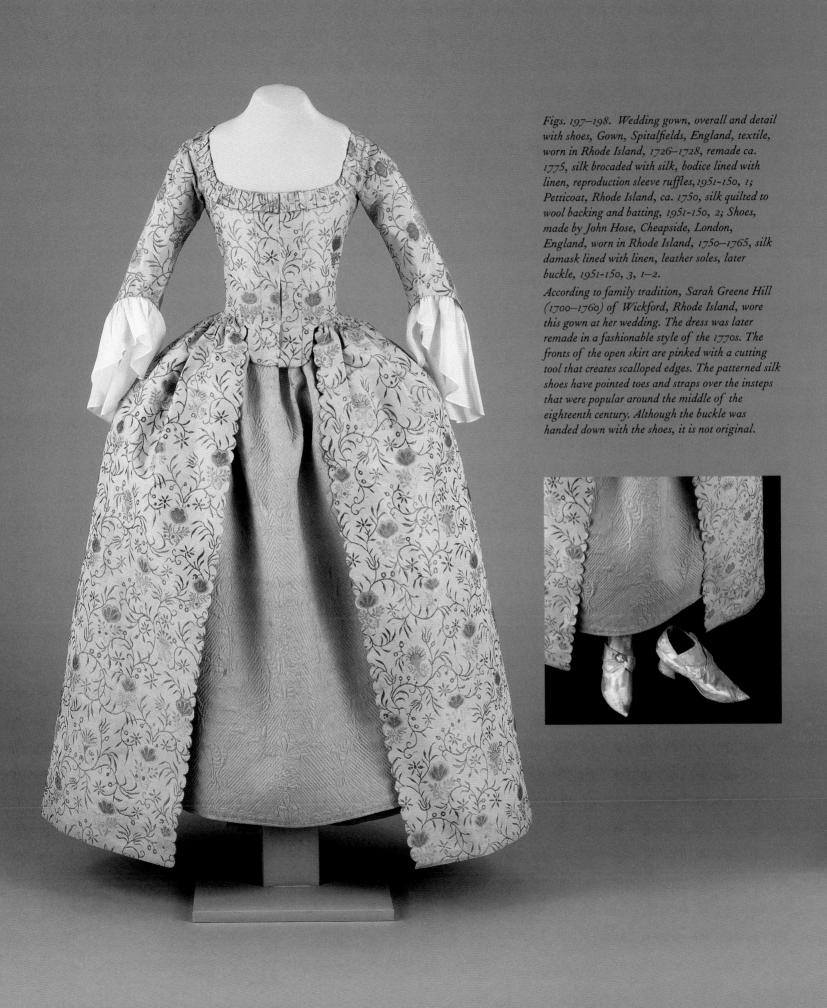

Figs. 197–198. Wedding gown, overall and detail with shoes, Gown, Spitalfields, England, textile, worn in Rhode Island, 1726–1728, remade ca. 1775, silk brocaded with silk, bodice lined with linen, reproduction sleeve ruffles, 1951-150, 1; Petticoat, Rhode Island, ca. 1750, silk quilted to wool backing and batting, 1951-150, 2; Shoes, made by John Hose, Cheapside, London, England, worn in Rhode Island, 1750–1765, silk damask lined with linen, leather soles, later buckle, 1951-150, 3, 1–2.

According to family tradition, Sarah Greene Hill (1700–1760) of Wickford, Rhode Island, wore this gown at her wedding. The dress was later remade in a fashionable style of the 1770s. The fronts of the open skirt are pinked with a cutting tool that creates scalloped edges. The patterned silk shoes have pointed toes and straps over the insteps that were popular around the middle of the eighteenth century. Although the buckle was handed down with the shoes, it is not original.

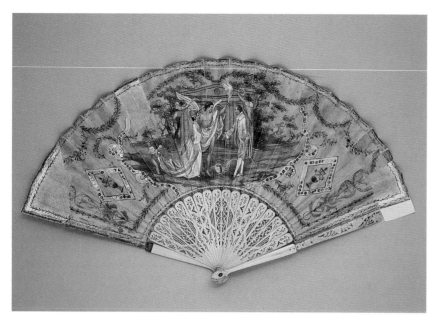

Fig. 199. Wedding fan, Britain, used in Virginia, ca. 1780, hand-colored engraved and etched paper, bone, wood, tin-plated copper sequins, copper alloy, portions of paper leaf restored, 1992-172, 1.

A couple stands in front of a temple with the winged god Hymen between them. The fan came in a case labeled "Miss Nancy Bland." Tradition states that Nancy was Ann Poythress Bland (born in 1735), daughter of Richard Bland, a prominent Virginia burgess. Since the style of the fan is too late for her own marriage to John Pryor sometime around 1760, the fan probably belonged to her son's wife, also named Ann Poythress Bland.

Fig. 200. Shoe and knee buckles with case, Britain, worn in New York, 1768–1785, steel, paste, shagreen leather, silk, paper, from the Glen-Sanders family, 1964-297, 1–4.

A paper inscription glued to the bottom of the buckle case states that Philip and Maria Van Rensselaer wore these buckles at their wedding about 1770 (it actually occurred in 1768) and that J. Glen and Pearl Green Sanders wore them when they married in 1922. The silk box lining is inscribed with ELIZA VAN RENSSELAER. Eliza, or Elizabeth (1771–1798), was the daughter of Philip and Maria.

The bridal gown was described as "a sacque and petticoat of the most expensive brocaded white silk, resembling net-work, enriched with small flowers, which displayed in the variation of the folds a most delicate shade of pink." The bride's gown had a deep, pointed stomacher and was worn with a lace apron, lace sleeve ruffles, and a kerchief to cover her bosom.[5]

Although white was by no means universal, wealthy brides who could afford a special outfit sometimes chose white or a combination of silver and white (see figs. 13–14, and 57).[6] Princess Anne, who married William IV, Prince of Orange, in 1734, was described as in "her Virgin robes of silver tissue" with a train six yards long.[7] Another observer thought her dress was "the prettiest thing that ever was seen—a *corps de robe*, that is, in *plain English*, a stiff-bodied gown."[8] The silver tissue worn by Anne was an expensive fabric in which metallic silver threads were woven into the weft of the silk textile (see figs. 49–50 for an example of tissue). A stiff-bodied gown was one in which the bodice itself was boned like a pair of stays. Princess Charlotte,

who married King George III of England in 1761, wore similar attire (fig. 201). The bride dressed in "a silver Tissue stiffen body'd Gown, embroidered and trimmed with Silver," diamond jewelry, a purple velvet cap, and an enormous ermine-lined mantle. The royal bridegroom had on a silver-trimmed suit.[9]

Fans designed especially for weddings were carried by the bride or given as commemorative gifts to attendants and close friends. In Williamsburg, Virginia, milliners offered "all sorts of wedding fans" to their customers.[10] In 1772, milliner Catherine Rathell ordered "6 Nice White Silver paperd Weding fans, Pierced Ivery Sticks" from her London supplier, John Norton.[11] A fan showing a man and woman facing each other before a classical temple and the mythological god Hymen was either a wedding souvenir or a bride's accessory (see fig. 199).[12] The engraved scene is hand colored in gray and white to imitate silver.[13]

In America, many communities followed the custom of the bride's visit, or wedding visit, at which people called

Fig. 201. "The Royal Family of Great Britain" handkerchief, engraved by T. Laughton, Britain, ca. 1775, plate-printed linen, 1959-17.

George III and Charlotte were married in 1761. This snuff handkerchief shows the royal couple surrounded by the ten children that were born in their first thirteen years of marriage. The queen holds the youngest boy, Frederick, born in February 1774. The handkerchief can be dated before April 1776, when their eleventh child was born. Some of the children are dressed in Van Dyck-style clothing that was considered appropriate wearing apparel for having one's portrait taken (see fig. 35).

on the bride within the first few months of the marriage. Elizabeth Phelps attended a wedding on November 28, 1771, and on December 30, she and three friends and relatives "paid the Weding visit."[14] The affairs must have been elegant, judging from the account of young matron Nancy Shippen of Philadelphia, who attended a bride's visit in 1785. Shippen described her preparations and what she wore, although she neglected to say what the bride had on: "After dinner I gave some necessary orders in the family, & then began to dress for a Brides visit. It is a tedious employment this same dressing. It took me 3 hours at least, what a deal of time to be wasted! but custom, & fashion must be attended to. . . . The room was full of company, & the Bride look'd beautiful, & I judg'd from the looks at the Company towards me that I look'd tolerable; I was dres'd entirely in white except a suit of pink Beaus [bows] & had on a new Balloon Hat."[15] Shippen's balloon hat may have been a billed cap with puffed crown (see figs. 15–16).

Esther Burr made several wedding visits in her community of Newark, New Jersey. The visit on Monday, July 18, 1757, must have been particularly dreadful. She wrote furiously in her journal upon returning home, "Made a *set, starched stiff Lazy Trifeling Wedding Vissit—did no good nor got any*. Came home more tired by half then if I had been hard at Work the Whole day—O the Nonsense of this World!"[16] Burr was more introspective following another wedding visit to "a young New Married Pair." (At this date, Burr herself had been married five years.) "I cant help feeling a tender Concern for new Married people, first because their Happiness much depends on their Conduct to wards each other when first Married. Now they begin to discouver that they are not perfect, and till now most are apt to think that the party Beloved has no faults—It requires some degree of prudence in a Woman that has been always used with the greatest Complesance and as if she was absolute Monarch, to be Gently blamed in some prety artfull Way let kn[o]w that He is her Head and Governor—On the other hand the Husband has need of his share of good Temper, When the Wife that he [has] always seen in print grows Carles of her [. . .] seems more concernd to appear decent befor[e any] body then her Husband—Each observes the alte[rati]on. The Wife supposes His affections cooling, the Husband concludes she has more Respect for any[b]ody then him self."[17]

As a couple began their married lives of earning a living, rearing families, and participating in the community, some might have lessened their emphasis on clothing in the press of daily events or because of a need to economize. Yet

eighteenth-century people placed great importance on clothing and appearance. Thomas Jefferson counseled his newly married daughter about the importance of keeping up her appearance, citing the same reason Burr had stressed, the importance of pleasing one's spouse. After urging economy in married life, Jefferson hastened to add, "The article of dress is perhaps that in which economy is the least to be recommended. It is so important to each to continue to please the other, that the happiness of both requires the most pointed attention to whatever may contribute to it—and the more as time makes greater inroads on our person. Yet, generally, we become slovenly in proportion as personal decay requires the contrary."[18]

While the everyday clothing of most men was dictated by their occupations (see chap. 4), women's clothing was in large part affected by their biology. Without effective birth control, married women expected to bear five to ten or more children, of whom several would likely die in infancy or early childhood. As a result, many women were pregnant or nursing a child much of their adult lives. Elizabeth Drinker, a Quaker from Philadelphia, cataloged many such occurrences in the lives of her women friends in a diary kept over a period of forty-nine years. She chronicled events such as the death in childbirth of her "dear Friend and old acquaintance Hannah Stevenson [who] departed this life, Sepr. the 19 1783 in Child-Bed, in the 51st. year of her Age—the child a Daughter who they call Susanna." A few weeks later, Drinker was "call'd up in the Night to S. Hartshorn; the child was born just before I entred the room a Daughter, nam'd Rebecca—it dyed in less than 2 Days."[19] In the twenty-year period between her marriage and the birth of her last child at age forty-seven, Drinker herself gave birth to nine children and apparently miscarried twice. Four of the children, including her last child and "dear little Companion," Charles, died before they reached their third birthdays.[20] Although she had only two children at the time, Esther Burr felt overwhelmed shortly after Aaron's birth in 1756: "When I had but one Child my hands were tied, but now I am tied hand and foot. (How I shall get along when I have got ½ dzn. or 10 Children I cant devise.)"[21]

Pregnancy clearly signaled the beginning of a major life change as a child entered the family unit. Yet most women's letters and journals are strangely silent about the facts of their own pregnancies. Given the uncertainty of survival of mother or child, few, if any, women recorded what they wore, much less set aside and preserved clothing worn during pregnancy. Women who did write about

their pregnancies were far more likely to stress the danger of dying in childbirth or the problems of having too many children than to express happy anticipation.

Such are the spirited letters between Rosalie Calvert, residing near Washington, D. C., and her sister in Belgium, Isabelle van Havre. In 1812, van Havre shared some private thoughts with her sister in America. "In your last letter, dear Sister, you mentioned that you were afraid you were pregnant again, and you asked me how we were managing not to have any more babies. Alas, that is one of those decisions that a moment of folly can do in. I've had experience and I am sorry to have to confide that I am five months pregnant. I am extremely downcast and rather ashamed . . . Ah, well, one can only be patient. I shall never again take a trip—each one unfailingly results in a baby."[22] In 1816, Calvert reported to her sister that she, too, was pregnant again, with her ninth child: "To my great sorrow I find myself pregnant again—I had hoped to have no more children."[23]

Despite the myth that women of the past secluded themselves when pregnant, such was not the case with those who left written records from the eighteenth and nineteenth centuries (fig. 202). Pregnant women maintained an active schedule of work and socializing, right up to the day of their delivery.[24] Esther Burr's diary confirms her hectic pace. While pregnant, she cared for her first child, kept up the housework, including cleaning, whitewashing, baking cakes, ironing, and putting up beds, traveled to New York and Princeton, went out to public

worship services, dined at the governor's, visited friends, and hosted numerous visitors in her home. When she was about six months' pregnant, Burr rode out in a chaise with her husband, nearly being injured when it overturned. Just before her son, Aaron, was born, she was again out socializing with women friends who urged her to make a wedding visit with them. Burr declined to go, explaining, "women in my circumstances had no business to go sticking themselves up at Weddings." Perhaps she was right, for the baby was born the next day.[25]

Salem, Massachusetts, matron Mary Vial Holyoke was equally social during her pregnancy. She continued to attend the opera, religious services, assemblies, dances, and teas, in addition to doing her housework and salting 188 pounds of pork.[26] Elizabeth Porter Phelps rode into town and "Drank tea at Brother Warners" one day before she went into labor with her first child.[27] Barbara Johnson, a British girl, recorded that a pregnant woman jumped into the Ouse River to rescue her drowning child.[28] Virginian Sally Row continued to go out to dinner in her last month of pregnancy. On May 5, 1797, she went to Major Buckner's, where two of the young women present were "hard fixing for the dancing school," although Row and her friend, Frances Baylor Hill, "help'd quilt on a very pretty bedquilt." Two-and-a-half weeks before her delivery on June 1, 1797, Row was again out to dinner at a nearby plantation.[29]

Not only were women forced into activity by the requirements of their busy lives, exercise was actively encouraged

by some physicians. Dr. William Buchan of Edinburgh, Scotland, wrote a how-to book that was circulated and reprinted in America. In *Advice to Mothers* (1807), he suggested that the best exercises during pregnancy were those to which a woman was already accustomed, only in moderation. These included "Slow, short walks in the country, or gentle motion in an open carriage." Buchan observed that laboring countrywomen suffered no ill effects by continuing their work throughout pregnancy, although he advised against dancing or "great bodily exertions."[30] Perhaps Sally Row was aware of Buchan's advice when she chose to sit and quilt instead of dance.

Given their active schedules, women had to cope with the challenge of dressing for pregnancy in an era in which the fashionable figure and attendant undergarments called for lacing that shaped a woman's body into a smooth cone from a narrow waist up to the breasts. In 1735, Sarah, Duchess of Marlborough, reminisced to her granddaughter about her pregnancies and the clothing to which she resorted in an attempt to be comfortable: "I remember when I was within three months of my reckoning, I could never endure any bodice [corset] at all; but wore a warm waistcoat wrapped about me like a man's and tied my petticoats on top of it. And from that time never went abroad but with a long black scarf to hide me I was so prodigeous big."[31] The Duchess did not avoid going out, but adapted her clothing to her condition.

The Duchess's warm waistcoat may have been a vest that laced or tied at the front (fig. 203). Dated from the first quarter of the eighteenth century, a waistcoat is made of fine silk quilted to linen with a woolen batting between. On the interior, linen tapes sewn to the center back and side seams create vertical channels for inserting supportive boning. Silk ribbons at the center-front closure allow for easy size adjustment by loosening or tightening the ties.

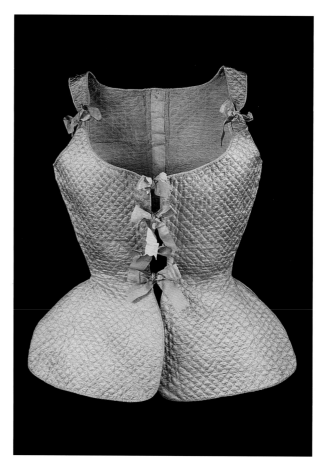

Fig. 203. Woman's waistcoat, England, ca. 1700, silk satin quilted to wool batting and linen backing, silk ribbons, linen tapes, G1991-510, gift of Mrs. Cora Ginsburg.
When heavily boned stays were too uncomfortable, women wore quilted waistcoats for warmth and support. This example has vertical strips of linen sewn down the center back and under each arm, probably channels for light boning.

THE MYTH OF SCARLETT O'HARA

Popular literature has a profound ability to shape people's views of historical events. The lives of fictional characters Scarlett O'Hara and Melanie Wilkes from *Gone With the Wind* have forever altered the way many people understand the history of pregnancy. As author Margaret Mitchell wrote, "Scarlett knew she would be forced to retire into Aunt Pitty's house and remain secluded there until after her child was born. Already people were criticizing her for appearing in public when she was in such a condition. No lady ever showed herself when she was pregnant."[1] Although Scarlett and Melanie's social circle may have been embarrassed by the mere mention of pregnancy, taking great pains to seclude themselves during their condition, the historical record reveals a far different picture for real women in the eighteenth and nineteenth centuries. Letters and diaries indicate that women not only ventured outside their homes, they enjoyed active social lives while pregnant. They dined with friends, attended religious services and cultural events, and went about their daily business.

1 Margaret Mitchell, *Gone With the Wind*, 1936, reprint (New York, 1964), chap. 38, p. 661. See also chaps. 16, 17, and 41.

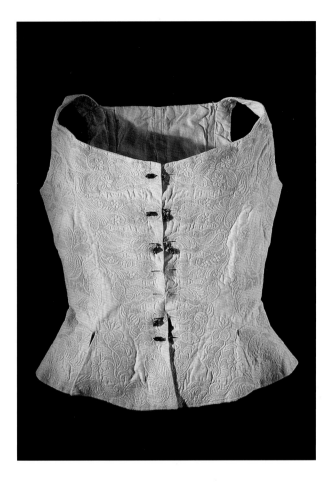

Figs. 204–205. Woman's waistcoat, overall and detail of embroidery, Europe, 1720–1750, cotton, cord quilted and embroidered with linen, lined with linen, silver links, boning, G1971-1566, anonymous gift.

This waistcoat underwent alterations to narrow the shoulder straps and enlarge the waist. Originally, the garment had removable sleeves that fastened with cords laced through eyelets in the armholes. The fine cotton material is cord quilted with backstitches and further embellished with French knots for dense texture. Buttonholes worked on both sides of center front allow the waistcoat to be closed either by lacing or by using linked buttons, as presently fitted. Interior channels enclose remnants of boning material.

Another quilted example has several widely spaced bones for light shaping and the remnant of an eyelet at the enlarged armhole, suggesting that it once had tied-on sleeves before the alterations were undertaken (figs. 204–205). The sleeves do not survive. Although nothing is known about its early history or use, the waistcoat was pieced under the arms, enlarging the waist and bust approximately an inch. Perhaps the alterations accommodated the expanding figure of a pregnant woman. This waistcoat relates closely in shape to the sleeved support garment illustrated by the French author Denis Diderot (fig. 206).[32] His *Encyclopédie* shows the individual pattern pieces for a garment he calls a corset. The shapes consist of front and back pieces that have tabs below the waist and front lacings as well as sleeves cut in two sections that curve slightly over the elbows.

Despite the availability of more comfortable waistcoats, some women continued to wear heavy stays during their pregnancies. Diderot illustrates a pair of stays for *les femmes encientes*, or pregnant women (fig. 207). Shown in profile, these stays are patterned much like the others in his *Encyclopédie*. Constructed with shoulder straps, a flat back, a point at center-front waist, and tabs over the hips, the stays have additional lacings under the arms to allow expansion.[33]

Stays with front lacings may have served as maternity clothing and would have been equally useful during breast-feeding. A pair of front-lacing stays has a rather large waist in proportion to the bust, suggesting maternity wear; they measure thirty-two-and-a-half inches at the chest and twenty-nine inches at the waist (fig. 208). The stays are quite heavy, constructed from brown worsted wool, boned with baleen, and lined with coarse linen.[34]

As uncomfortable as they appear to twenty-first-century viewers, stays did provide support for the back and helped preserve some semblance of the fashionable figure by maintaining a flat line at the bodice front, pushing the bosom into a high, rounded shape. The pregnant women in the 1774 print "The Man of Business" wear stays under their fashionable clothing (see fig. 202).

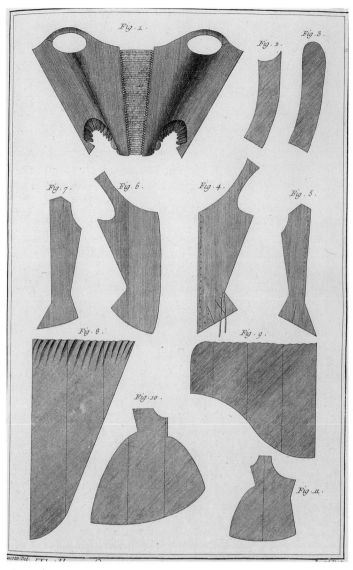

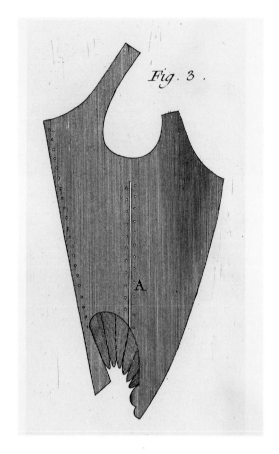

Fig. 206. (ABOVE LEFT) *"Tailleur de Corps," from ENCYCLOPÉDIE, by Denis Diderot, France, 1771, John D. Rockefeller, Jr. Library, CWF.*
In the upper right of the illustration, figs. 2–5, are pattern pieces for a jacketlike garment with sleeves and a tabbed bodice, which the French author calls a "corset." He identifies the more heavily boned stays by the term "corps," roughly translated as bodies.

Fig. 207. (ABOVE RIGHT) *Side view of stays for pregnant women, "Tailleur de Corps," from ENCYCLOPÉDIE, by Denis Diderot, France, 1771, John D. Rockefeller, Jr. Library, CWF.*
Diderot's stays for pregnant women, or "Corps pour les femmes enceintes," were constructed with shoulder straps, flat back, pointed front that dips below the natural waist, and tabs over the hips. Their only concession to pregnancy was expansion lacings at each side under the arms in addition to the usual center-back lacing eyelets.

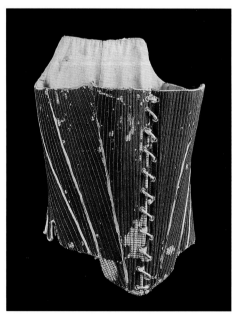

Fig. 208. (LEFT) *Stays, possibly America, 1760–1775, worsted wool lined with linen, leather binding, unidentified boning, 1993-336.*
These strapless stays laced up the front instead of the back. This arrangement made them more convenient for pregnant and nursing women and for those who did not have assistance while getting dressed.

Fig. 209. DILIGENCE & DISSIPATION, plate 4, engraved by Thomas Gaugain and Hellyer after a painting by James Northcote, London, England, 1796, color-printed etching and line engraving on paper, 1974-94, 5.

This print is part of a series that traces the histories of two women: one remains virtuous and diligent, while the other enters a life of dissipation. In this scene, a disgraced unwed pregnant woman wears a long apron tied above the bulge of her abdomen. A man leering from the shadows at right wears newly fashionable tight trousers instead of knee-length breeches.

Although some people criticized tight lacing during the eighteenth century, it was only after stays had been abandoned for fashion reasons that the most vocal outbursts against them were heard. In 1807, Dr. Buchan praised the new uncorseted fashions and described with disapproval the former practice of wearing stays. "Among many improvements in the modern fashions of female dress, equally favourable to health, to graceful ease and elegance, the discontinuance of stays is entitled to peculiar approbation. It is, indeed, impossible to think of the old straight waistcoat of whalebone, and of tight lacing, without astonishment and some degree of horror. . . . I need not point out the aggrevated mischief of such a pressure on the breasts and womb in a state of pregnancy."[35] The fashion for tight corsets, however, returned later in the nineteenth century.

Visual and written sources from the eighteenth and early nineteenth centuries suggest that most women modified their usual clothing when they became pregnant. Short gowns or bed gowns were easily adapted to this purpose. These relatively unfitted garments were worn with petticoats as two-piece outfits (see fig. 167). Because they were cut full and loose, these gowns could be worn without alteration throughout pregnancy and afterward.

Pregnant women were not limited to loose bed gowns, however. Given the expense of textiles, alterations were commonplace and the task was well within the sewing skills of most women. Frances Baylor Hill altered two "habbits" for her pregnant sister-in-law.[36]

Even without alteration, fitted gowns during much of the eighteenth century were surprisingly adaptable to changes in style or size through manipulation of their lacings and the clever addition of accessories. Gowns usually fastened at the front, sometimes with hidden lacings that could be let out to accommodate the new figure. The triangular stomacher at the bodice front was usually removable and could be replaced by a wider one to allow waist expansion. In the absence of a stomacher, a large neck handkerchief could fill in the gaps (see fig. 202). Petticoats, which usually fastened at the sides with narrow tapes, were adapted to pregnancy by loosening the ties and wearing the petticoat above the bulge. Prints show that, although this practice affected the hemline, little attempt was made to keep the hems from hiking up in the front (fig. 209). One woman awaiting birth appears to have modified a short jacket to suit her condition (fig. 210). The front opening is caught by a bow at the chest, yet gaps open over her abdomen where the space is filled by a petticoat and apron.

Indeed, many pregnant women wore a long apron tied over the clothing just beneath the breasts to cover the abdomen (see figs. 202 and 209). As early as 1669, English diarist Samuel Pepys associated aprons with pregnancy: "I waited upon the King and Queen . . . she being in her white pinner

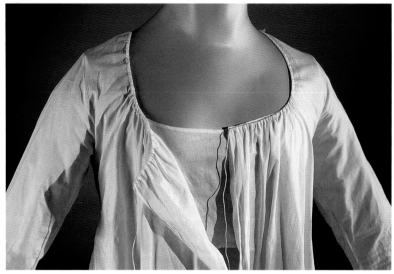

Fig. 210. (ABOVE) Illustration from ELEMENTARWERKE FÜR DIE JUGEND UND IHRE FREUNDE, by Johann Bernhard Basedow, engraved by Daniel Chodowiecki, Germany, 1774, John D. Rockefeller, Jr. Library.
A woman in advanced stages of pregnancy is dressed in an apron, petticoat, and jacket partly closed over the chest. A cradle is ready to receive the child, and a narrow swaddling band is draped over the drying rack at left (see fig. 222).

Fig. 211. (BELOW) Detail of gown bodice, possibly America, 1800–1810, cotton, bodice lined with linen, 1985-279.
High-waisted, loosely fitted gowns of the early nineteenth century could easily be adapted to changes in body shape resulting from pregnancy and nursing. Although the back of this gown has shaping seams, the front is constructed in one panel from neckline to hem. Self-fabric bands attached at the back are brought to the front and tied to define the raised waistline. The inner bodice, or lining, consists of two pieces attached at the side seams and pinned across the chest. For overall view, see fig. 379.

and apron, like a woman with child."[37] Perhaps it is no coincidence that two little Virginia girls wore aprons when they were pretending to be pregnant. In September 1774, the Carter girls were observed at play by their tutor: "Fanny & Harriot by stuffing rags & other Lumber under their Gowns just below their Apron-Strings, were prodigiously charmed at their resemblanc to Pregnant Women!"[38]

As Buchan had suggested, the high-waisted, uncorseted styles of the period around 1800 were even more convenient for maternity wear. They were often fitted with drawstrings or ties that could be loosened as necessary, and the absence of a natural waistline made camouflage and fit easier than it had been in the past (fig. 211 and see figs. 73–75 and 379).

Because clothing was either adapted to pregnancy without alteration or was made over afterward to reuse the expensive textiles, few maternity gowns survive in their original form from the eighteenth century.[39] Most of the gowns that have been identified as maternity wear date from the last decades of the century, when women's styles were in transition from stomachers to edge-to-edge center-front closures. This new style without a stomacher was less adaptable to changes in body size and shape.

Another reason for the dearth of maternity gowns may lie in the perceived danger of childbirth during the period. There was genuine uncertainty regarding the survival of mother or child; the real life passage to be celebrated was not the pregnancy, but the successful birth.[40] While ceremonial clothing of weddings and christenings was often identified as such and cherished by family as a reminder of happy events, few women set aside and preserved clothing that was worn during the stressful time of pregnancy. More likely, maternity clothing was altered back to regular size or given away to other family members.

Despite the rarity of specialized maternity gowns, an example survives in the Colonial Williamsburg collections (see sidebar, next page). Why did such a plain, colorless, and enigmatic ensemble survive intact for more than two hundred years? Did the wearer die in childbirth and her grieving family set the suit aside as a memorial? Did she gain too much weight to fit into the slim sleeves of the jacket? Or was the ensemble put away carefully for future pregnancies, only to find that the march of fashion had rendered it obsolete after a few years? While procreation remains a universal condition in the human race, fashion continually demands new responses to the question of what to wear when pregnant.

AN EIGHTEENTH-CENTURY MATERNITY GOWN

For years, curators puzzled over the unusual cut and size of a three-piece ensemble that consisted of a jacket, a petticoat, and a strange-looking vest with long tails at the fronts (figs. 212–215). Made from an old white cotton bed quilt, the odd size and shape of the individual pieces did not appear to fit together. The petticoat's thirty-and-a-half-inch waist is more than three inches larger than the jacket's waist. While most petticoats are slightly longer at the center back, this petticoat is reversed; it measures two-and-a-half inches longer in front. Further, when dressed on a normal-sized mannequin, the points of the vest hang well below the jacket's hem. Only after trying it on a padded mannequin did curators discover its original function as a maternity outfit.

The under vest is the key to the enigmatic costume. With its adjustable laced back and long front tails, the vest fits neatly over a pregnant figure and fills in the front space where the jacket fronts do not meet over a protruding belly. The gaping jacket can be laced across the vest, which expands the waist by at least eight inches.

The full petticoat works with the two bodice pieces to comfortably accommodate an expanding figure. Because the front is slightly longer than the back, the petticoat's hem does not hike up as much from the length taken up over the belly. The waist size is easily adjusted by means of the deep side slits and tape ties. The side openings can be expanded or overlapped as needed. The folded tape that forms the petticoat's front waistband is narrow enough to comfortably tuck beneath the breasts, while the rear waistband is a wide strip of fabric, supporting the back and giving a comfortable lining over which the waistline tapes can be tied.

Given the expense of clothing in the eighteenth century, it is not surprising that the ensemble functions equally well for a nonpregnant woman. After delivery, the new mother could set aside the under vest, lace the jacket closed, and draw the petticoat in by means of the adjustable waistband, creating a fashionable daytime suit.

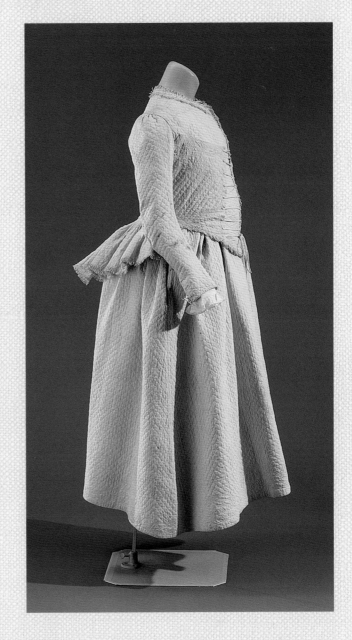

Figs. 212–215. Three-piece maternity gown, overall and details of jacket laced over vest, vest back, and jacket without vest, Britain, 1780–1795, cotton quilted to linen backing and cotton batting, eighteenth-century shift, reproduction kerchief, 1936-666. Worn beneath the open jacket, the sleeveless vest expands the waist size for use during pregnancy. The vest has adjustable lacings at the center back. The jacket can also be worn without the vest.

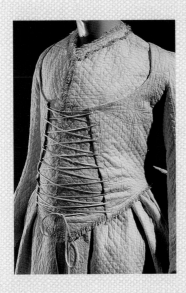
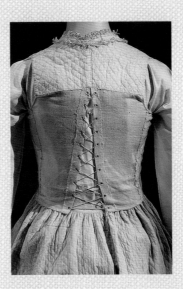
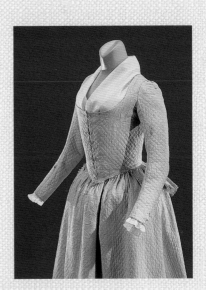

When a woman had come to term, her female friends, relatives, neighbors, and sometimes a midwife gathered around to assist in the delivery and form a valuable support system to ease the mother's fears and comfort her if the infant did not survive. In fact, historian Laurel Thatcher Ulrich describes childbirth as "a semi-public event."[41] Throughout most of the eighteenth and early nineteenth centuries, it was customary for a woman to adhere to the practice of "lying in" for about a month following delivery to regain her strength. Occasionally, this long period was shortened to as little as two weeks, or even ten days. By the late eighteenth century, some women in cosmopolitan cities went out sooner than the norm. Josiah Wedgwood, the famous British potter, reported in 1774, "it is becoming fashionable here for the Ladies in the straw [women who have just given birth] to become well and leave it as soon as they are able; and even a Lady of Fashion may be seen in her Carriage again, without shame, in ten days, or a fortnight after delivery."[42] Nevertheless, most women apparently stayed in at least three weeks, if their responsibilities allowed. After her son's birth on May 17, 1770, Mary Holyoke first got out of bed three days later, on May 20, but did not leave the house until June 20. (The infant had died four days after birth.) Another child was born to Holyoke on September 12, 1771. About three weeks later, she had her "sitting up week" when visitors came to see her and the baby, and she first went out on October 22. Her eighth child was born on April 8, 1782, and numerous friends came to visit, even before her sitting up week that began April 28, again about three weeks after delivery.[43]

It was the responsibility of the new mother to reciprocate by arranging to have cake and wine served when friends came to call. "Drinking cordial" became synonymous with visiting a new mother during her confinement. Esther Burr wrote that she had received an invitation "to drink Cordale next august on account of Mrs Donaldson," a reference to an expected birth five months from then.[44] Sarah Goodwin of Portsmouth, New Hampshire, baked plum cakes before each of her confinements in the 1820s and 1830s, and later received company upstairs while a hired nurse served the food and did the housework. Goodwin met her friends seated in an easy chair and dressed in a cap and "white flannel wraps trimmed down the front and all round with satin ribbon."[45] Artist's wife Mrs. Benjamin West, holding her second child on her lap in 1772, is similarly wrapped in warm clothing to receive the visit of family (fig. 216).

Although Goodwin described her clothing during her confinement, most women were silent. Scholars must turn to other sources such as advertisements and published instructional books to solve the puzzle of what women wore during this phase of their lives. Two books, published in 1789 and 1808, respectively, give revealing directions for making clothing used by a mother during her confinement. *Instructions for Cutting out Apparel for the Poor* was published in London; *The Lady's Economical Assistant, or The Art of Cutting Out, and Making the most useful Articles of Wearing Apparel* appeared in London and Edinburgh. Both books responded to the needs of churchwomen who sewed clothing for poverty-stricken members of the parish as a charitable activity. The lists of "Child-Bed Linen," or clothing for the infant and the mother that was lent to poor women during the time of lying in, reveal what was considered essential for even the poorest mother and new baby. Since the mother was expected to remain in bed much of the time, both lists include a pair of sheets; the 1789 list adds two pillowcases to the bed linens.[46]

Although separated by almost twenty years, many of the items described in the two books are remarkably consistent. Both sources list garments designated as skirts, based on the directions, cut full and measuring a yard long. One skirt is about ninety inches in circumference; the other, seventy-eight inches. Both skirts are pleated to waistbands that have a finished width of about nine inches before seam allowances are taken. In the 1789 source, the skirt's fullness is concentrated in the front, "the most plaits before." The wide waistband, fastened with pins at the back, substituted for stays and supported the mother's abdomen. The 1841 book *Hints to Mothers* helps explain the function of the waistband. The writer suggests that a "broad bandage" or belt should be worn during labor and for at least a few weeks afterward. Stretching "from the chest to the lowest part of the stomach," the belt must be worn "so long as the abdominal muscles appear to require support."[47]

Both sewing books suggest short, unfitted linen garments to be used as the mother's sleepwear. (The earlier book describes them as shifts; the other, night gowns.) The hip-length shifts would be easier than longer ones to keep clean during the mother's recuperation from childbirth. These garments are comparable to "Holland [linen] half Shifts" that appear in an eighteenth-century trade card among other ready-made goods suitable for new mothers.[48]

A short or half shift with long sleeves has a tradition of use by Ann Van Rensselaer of Albany, New York (fig. 217). Although Van Rensselaer did not have any living children, one can speculate that she made a set of

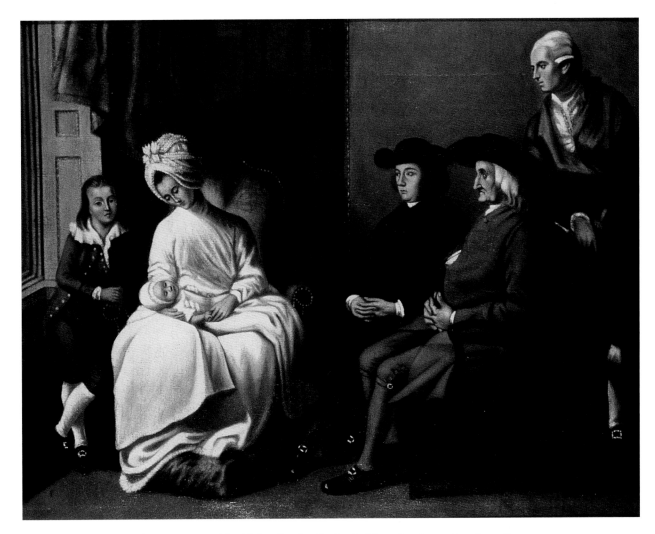

Fig. 216. THE ARTIST'S FAMILY, unidentified artist after Benjamin West, America, 1780–1800, oil on canvas, G1979-193, gift of the John D. Rockefeller 3rd Fund.
Benjamin West painted his wife receiving family after the birth of their second child in 1772. She is dressed in an unfitted bed gown with wrapping front. The infant wears a cap and long dress. An engraving was made of the painting in 1779. The unknown artist of the Colonial Williamsburg painting probably based his version on the engraving.

clothing in anticipation of childbirth after her 1787 marriage to Philip Van Rensselaer. That she never had the opportunity to use the shift may account for its survival.[49] The garment opens down the front and fastens with drawstrings. Another short shift, worn by an unknown woman, has a slit at the center front that is reinforced at the bottom by needle lace (fig. 218 and see fig. 66).

Although the 1789 instruction book does not mention bed gowns, other sources indicate that most women wore

them during their confinements. Just as it had been practical for pregnancy, a jacketlike bed gown would have been appropriate for greeting visitors to the chamber (see sidebar, p. 123).[50] The modest, washable printed bed gown described in the 1808 instruction book had more elegant counterparts in the elaborately quilted and embroidered examples made by professional embroiderers and sold with layettes.[51] Milliners in America offered ready-made "Suits of Childbed Linen" and "baskets" that probably included clothing for the mother as well as the baby.[52]

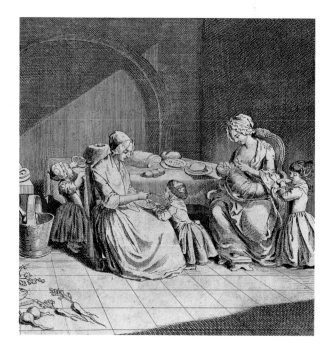

Fig. 217. (ABOVE LEFT) Shift or nightgown, New York, worn by Ann Van Rensselaer, 1790–1800, linen, G1990-6, gift of Mrs. Cora Ginsburg.
Unlike knee-length shifts women wore beneath their gowns, this shortened style with front opening was used during the lying-in period following childbirth. Stitch marks indicate that the shift originally had a drawstring under the bust.

Fig. 218. (ABOVE RIGHT) Shift or nightgown, Britain, ca. 1750, remodeled 1790–1820, linen, marked E. P. with silk cross-stitches, sleeves shortened, later cotton sleeve ruffles, 1984-79.
This short shift has a reinforced slit at center front for ease in nursing. For detail view, see fig. 66.

Fig. 219. (LEFT) Illustration from ELEMENTARWERKE FÜR DIE JUGEND UND IHRE FREUNDE, by Johann Bernhard Basedow, engraved by Daniel Chodowiecki, Germany, 1774, John D. Rockefeller, Jr. Library.
The mother has pushed down the neckline of her gown to nurse her swaddled child. Although swaddling was intended to encourage straight limbs and erect posture, it also rendered infants immobile. The practice of swaddling gradually died out in Europe and America during the second half of the eighteenth century. Toddlers standing nearby wear pudding caps.

Women who were able to do so nursed their children for at least a year following birth. Breast-feeding became increasingly fashionable during the century. Queen Caroline of Britain, wife of George II, is said to have breast-fed all her own children.[53] For those women unable or unwilling to breast-feed, hired wet nurses or slaves took over the task. Burr, who had been breast-feeding five-and-a-half-month-old Aaron, hired a temporary wet nurse when she went out of town with her husband. Burr wrote, "I . . . have got the best Woman in Town for that purpose to late and suckle it."[54] Her phrase "to late" probably derives from the French words *lait* meaning milk and *allaiter,* meaning to nurse or suckle.

Once they emerged from the chamber following their lying in period, most women wore their usual clothing while nursing. As long as necklines on stays and gowns remained low-cut, women could nurse by unpinning or

pulling aside their dress or bed gown (fig. 219). For convenience, some women chose stays that laced in front, rather than in the back (see fig. 208). When necklines became higher in the nineteenth century, various arrangements allowed women to nurse their infants without disrobing. A dress from the 1820s has an overlay of fabric on the bodice that can be lifted for nursing (figs. 220–221).

Weaning usually occurred when the child was between one and two years old.[55] There is convincing evidence that some women separated themselves from their child during weaning, sending the child away to another home or going away themselves on a "weaning journey."[56] In January 1797, Frances Baylor Hill helped to wean baby Hetty Row, who had been dropped off by her parents. She "cri'd and scuffled a little at first but slept tolerable well" the first night. Hetty's mother and father came and

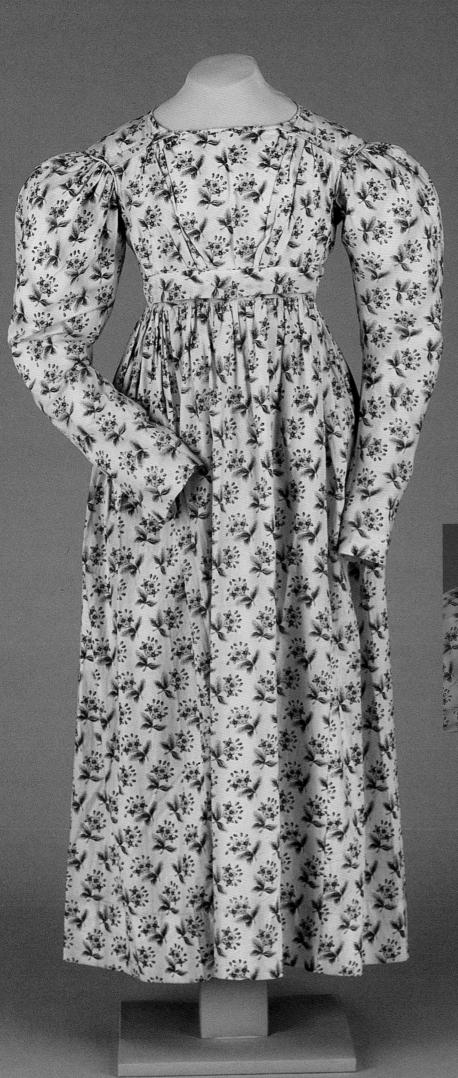

Figs. 220–221. *Nursing dress, overall and detail of bodice front, Britain or America, 1825–1830, roller-printed and plain cottons, modern hooks and snaps, G1998-231, gift of Tasha Tudor.*

By the 1820s, many daytime dresses had high necklines and back closures, which required modifications to their design for nursing mothers. In this example, the bodice front was made with a loose panel that could be unfastened at the waist and raised for nursing.

Fig. 222. Swaddling band, Europe, ca. 1700, linen embroidered with linen and trimmed with linen needlepoint lace, from the collection of Leopold Iklé, G1971-1668, anonymous gift.

Measuring 144 inches long, this strip of decorated linen was wrapped around an infant's body for swaddling (see figs. 210 and 219). Intended for an aristocratic baby, the elegant decoration includes cutwork, pulled threads, satin stitch embroidery, and separately applied needlepoint lace.

got her fifteen days later.[57] After a child was weaned, the mother could resume her life and her usual clothing, at least until the next pregnancy.

Children's clothing underwent significant change during the eighteenth century, moving away from restriction toward greater ease appropriate to an active child. The new philosophy regarding children's clothing began in the seventeenth century with the work of John Locke, medical student and philosopher.[58] Locke argued against physical constraints for children, especially the long-standing practice of swaddling, which involved wrapping the infant's partly clothed body with a narrow band of fabric (fig. 222). At least for the first few weeks, swaddling immobilized both arms and head, rendering the child "as stiff as a log of wood."[59] Other authors and philosophers, including Jonathan Richardson and Jean-Jacques Rousseau, echoed Locke's opposition to swaddling and tight clothing. By the late eighteenth century, most parents ceased the practice of tight swaddling altogether. The infant's clothing described in the 1789 *Instructions for Cutting out Apparel for the Poor* is relatively loose and comfortable (see sidebar, p. 123).

The basic item of infant's apparel was a napkin or clout, period terms for a diaper. (The American use of the term diaper for a baby's napkin was derived from the linen fabric originally used to make it.) New mothers could purchase piece goods for making diapers, although poorer families had to use recycled linen or rags. Because safety pins had not yet been invented, diapers were secured with straight pins. Enlightened mothers sewed

tape ties to their children's napkins to avoid using dangerous pins. Such was the recommendation of the 1838 *Workwoman's Guide,* which illustrates a style of triangular napkin tied on with tapes through a loop.[60]

Eighteenth-century infants' shirts were cut on straight lines, with long sleeves and a center-front opening (figs. 223–224). An especially fine example is constructed of thin white linen, trimmed with insertions of Hollie point, or needle-made lace, at the shoulders and narrow bobbin lace at the openings of the gusseted sleeves. Another shirt, worn in America by an infant member of the Hodge or Nichols family, has ruffled lace at the neck and cuffs, the latter of which are fastened with gold sleeve buttons, or cuff links.

A related style of infant's overshirt, probably called a waistcoat in the period, was constructed like a shirt without underarm gussets (fig. 225). Waistcoats may have provided additional warmth, similar to a baby's sweater today. One example is made from thick linen and cotton that was napped for extra comfort. Two other waistcoats are pattern knitted from white cotton. Traditionally thought to date from the late seventeenth century, these tiny knitted garments were made and worn well into the eighteenth century. The two knitted waistcoats are similar to each other in size and appearance and probably were products of the English frame-knitting industry.[61]

Caps were considered indispensable accessories for all children. In some cases, close-fitting undercaps of undecorated white linen or cotton lined more elaborate caps

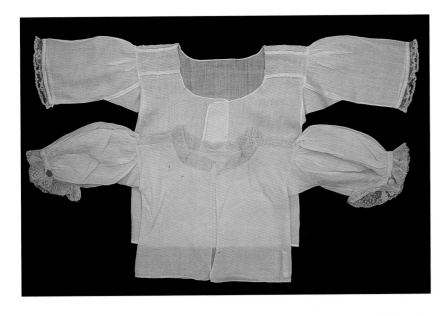

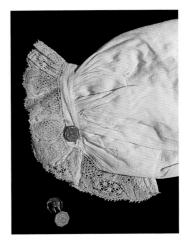

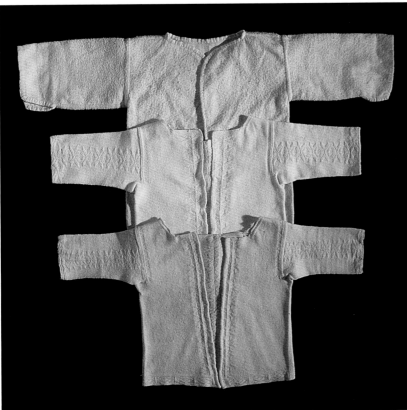

Figs. 223–224. (ABOVE) Infants' shirts, Shirt with insertions at shoulders, Britain, 1700–1750, linen decorated with linen Hollie-point needlework and bobbin lace, from the collection of Mrs. DeWitt Clinton Cohen, G1971-1570, anonymous gift; Lace-trimmed shirt and detail of sleeve with cuff links, probably Maine, ca. 1784, sleeve buttons 1730–1760, linen trimmed with linen bobbin lace, gold, G1991-1180, 1–2, gift of Mr. and Mrs. Charles D. Carey.

Baby clothes were usually sewn with minute seams and fine stitches. All raw edges in these two examples have been turned under and neatly finished to prevent chafing and to keep seams from raveling during laundering. The shirt with shoulder decoration has insertions of Hollie point, a needlework technique that used buttonhole stitches with an extra twist. The design features potted flowers. The lace-trimmed shirt and cuff links have a history of use by Jane Hodge (later Mrs. Thomas Nichols) of Maine. She was born in 1784. The linked gold buttons descended in the family with the shirt, although their design appears earlier than the 1780s. They may have been handed down from a previous generation.

Fig. 225. (LEFT) Infants' waistcoats, Top waistcoat, Britain, seventeenth or eighteenth century, napped linen-cotton, linen tape, 1985-140; Middle waistcoat, Britain, 1700–1750, knitted cotton, fronts bound with linen, G1998-31, gift of Kathleen A. Epstein; Bottom waistcoat, Britain, 1700–1750, knitted cotton, 1985-139.

The plain linen-cotton waistcoat came with a document asserting that it was "Oliver Cromwell's Shirt." Cromwell, who led Britain during the Commonwealth period of the seventeenth century, was born in 1599. Although undecorated garments such as this example are difficult to date, the shirt probably originated in the eighteenth century, not Cromwell's period. Scholars disagree on the dates of the knitted cotton waistcoats: some assign them to the seventeenth century; others feel they date no earlier than the first quarter of the eighteenth century.

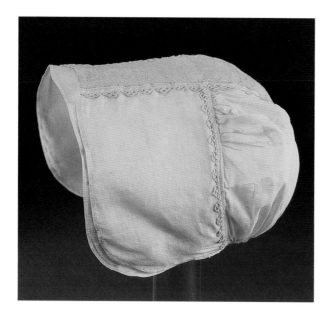

Figs. 226–227. Infant's cap, overall and detail of crown, Britain, 1748, linen decorated with linen Hollie point and needlepoint lace, 1985-220.

An insertion of Hollie-point needlework over the top of the cap from forehead to the back of the neck has a design of flower vases, birds, and an inscription, SUSANNA PORTER MARCH 26, 1748. *Nothing is known about Susanna Porter or her parents.*

Fig. 228. Child's cap, New York, 1750–1800, linen trimmed with linen bobbin lace, from the Glen-Sanders family, 1964-386.
This child-sized cap is styled like women's everyday caps.

decorated with lace edging, ribbon, Hollie-point insertions, or silk and metallic embroidery (figs. 226–228 and see figs. 24–25).

Babies and young children wore several styles of outer garments called bed gowns and frocks (see sidebar, p. 123). Bed gowns were often made of inexpensive small-scale printed linen or cotton. Frocks were fitted dresses intended for public wear, usually fastened at the back with ties or laces. A tiny dress from around 1790 combines elements of the bed gown and the frock (figs. 229–230). Characteristic of a bed gown, it is designed along straight lines with the skirt and bodice cut in one piece and triangular gores added for skirt fullness. Like a frock, however, it fastens at the back and is fitted at the bodice with drawstrings at the waist and chest. Modest printed cotton frocks such as this example survive far less often than expensive silk gowns, especially those associated with christening.

For many Christian families, the christening was the first public appearance for mother and new baby. The significance of the occasion required a special gown for the infant, if the family could afford it. The 1763 christening gown of a well-off baby boy is constructed of cream silk satin, trimmed with gathered ribbons that undulate down the fronts of the open skirt and separate petticoat (fig. 231). The trimmings are much like those on adult women's skirts and petticoats; unlike women's gowns, however, the infant's bodice is made in one piece with the skirt and is shaped by tucks. An untrimmed satin gown, probably also worn for christening, is constructed with cuffed

Figs. 229–230. *(ABOVE) Child's frock, overall and detail of selvages, British textile, worn in Britain or America, ca. 1790, block-printed cotton, 1992-139.*

Designed for comfort and practicality, this small dress (it measures twenty-six inches long) is fitted with one adjustable drawstring at the neckline and two on the bodice. The washable printed cotton would hide stains and be easy to maintain. The presence of blue threads in the selvages indicates that the textile is all cotton, of English manufacture, and made between 1774 and 1811 (see p. 49).

Fig. 231. *(RIGHT) Christening gown and petticoat, Britain, 1763, silk satin trimmed with silk ribbon, bodice lined with silk, G1991-552, 1–2, gift of Mrs. Cora Ginsburg.*

This boy's christening gown is made in two pieces: a gown with skirt open at the front and a separate petticoat that is pleated to a narrow silk waistband. Both pieces are trimmed with applied ribbons similar to the ruchings on women's gowns and petticoats. A paper document accompanying the gown indicates that it "Belonged to Dr Baruard [or Barnard] Provost of Eton College" and that the garment was used in 1763.

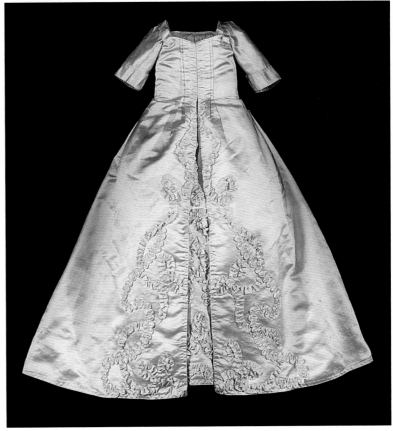

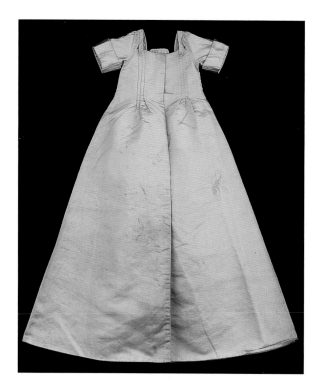

Fig. 232. (LEFT) Christening gown, Britain, 1750–1775, silk satin lined with silk, 1985-122.
The gown is unusual for its plainness; it may have had a lace overdress or other trimmings at one time.

Figs. 233–234. (BELOW) Infant's gown and matching cap, Europe, 1750–1775, silk satin trimmed with silk and metallic ribbons, bodice lined with linen, skirt faced with green silk, cap trimmed with linen bobbin lace, paper flowers, silk ribbon, metallic tape, G1991-551, 1–2, gift of Mrs. Cora Ginsburg.
This gown has separate sleeves tied to the shoulder straps with ribbon, a fashion that persisted into the early nineteenth century. The torso is shaped for a child in stays.

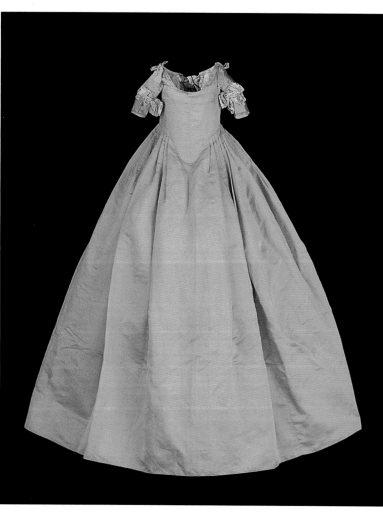

sleeves, a low neckline, and bodice tucks that release into the full skirt, similar to the more elaborate example (fig. 232). It is missing the petticoat that would have been worn underneath. An elegant silk gown with matching cap is made of brilliant yellow satin (figs. 233–234). The gown has a fitted bodice that ties at the back, separate sleeves that tie in place at the shoulders, and a long, full skirt. The gown's history is unknown, although it may have been worn for christening.[62]

Despite the movement toward less restrictive children's clothing, progress was gradual. Throughout most of the eighteenth century, stiffened stays were considered essential foundation garments for children of both sexes from the middling and upper classes (fig. 235).[63] Babies less than a year old sometimes wore stays. In 1771, Williamsburg milliner Catherine Rathell advertised that she sold "thin Bone and Packthread Stays for Children of

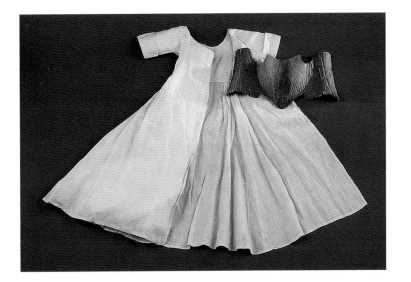

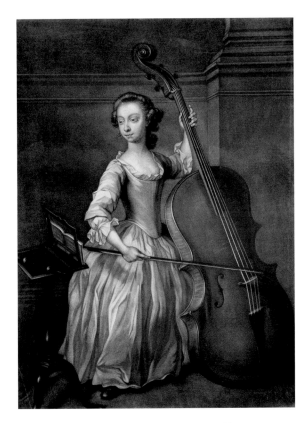

Fig. 235. *BENJAMIN HALLET, engraved by James MacArdell after a painting by Thomas Jenkins, Britain, ca. 1750, mezzotint engraving on paper, 1979-313.*
Benjamin Hallet, about five years old, wears body-shaping stays and a frock with long skirts. He has not yet been put into knee breeches, a process called breeching. Hallet was a musical prodigy who played flute and violincello at Drury Lane Theater at a young age.

Fig. 236. (*ABOVE*) *Child's frock and stays, probably Rhode Island, ca. 1760, linen, linen-cotton, baleen, leather, 1986-212, 1–2.*
In 1883, the great-granddaughter of the wearer recorded that these garments originally belonged to Elizabeth Butler (later wife of Captain Robert Davis) when she was one year old. The stays have a chest of fourteen-and-a-half inches and a waist of thirteen-and-a-half inches. Like many children's garments, the frock would have been fastened shut with straight pins.

Fig. 237. (*BELOW*) *Child's stays, Britain or America, worn in New York, 1740–1760, worsted satin lined and bound with linen, baleen boning, paper, from the Glen-Sanders family, 1964-405.*
Children as young as three months old were put into stays. This pair laces up the back through hand-worked eyelets. The waist measures seventeen inches.

three Months old and upwards."[64] Stays or corsets were believed to encourage good posture, provide support, and form a fine figure. The effect of stays from a young age can be seen in the shape of most adult clothing of the eighteenth century. Garments for men and women have sloping shoulder lines, flat backs, and prominent chests because stays molded the shoulders and torso into that shape. Although little boys usually shed their stays when they graduated to breeches or trousers, girls continued to wear them into adulthood.

Tiny stays with a waist of thirteen-and-a-half inches are constructed of linen, stiffly boned with whalebone, and bound with leather (fig. 236). Family history states that one-year-old Elizabeth Butler of Rhode Island wore them under her white linen frock. Slightly larger stays worn by a New York child are made of green worsted satin, fully boned, and lined with linen (fig. 237).

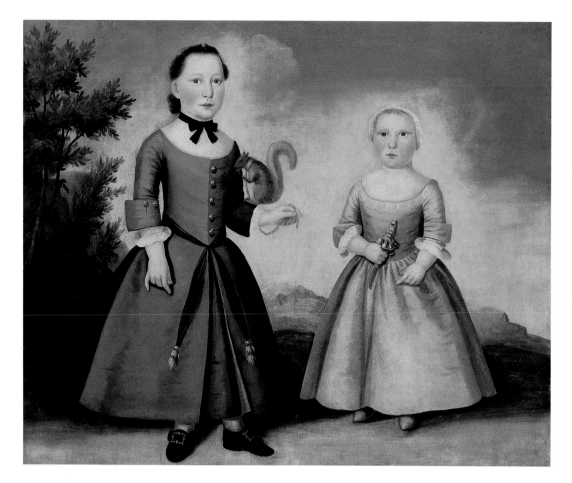

Fig. 238. PORTRAIT OF TWO CHILDREN, attributed to Joseph Badger, probably Boston, Massachusetts, 1755–1760, oil on canvas, 1957.100.15.

Although the boy holding a squirrel wears a masculine hairstyle, he has not yet received his first pair of breeches. Except for the addition of a sash, his blue open-skirted frock is similar in styling to the embroidered example in fig. 239. The sleeves with their button-decorated cuffs are cut to curve over the elbows, echoing those on men's coats of the period. The child at right, probably a girl, wears a gold gown with a tight bodice that closes at the back, undoubtedly worn with stays underneath.

It is often difficult for modern viewers to determine a child's gender in paintings and prints from the eighteenth century. Because the corseted torsos of boys echo the feminine cone shape of the girls, there appears to be little, if any, difference between the clothing of girls and boys. Sets of childbed linens were unisex garments, suitable for an infant of either gender. Indeed, both sexes of young children wore skirts when they were not in their shirts or bed gowns. Skirts apparently had an unspoken but genuine symbolic value in the society of the time. They symbolized children's dependence, in the same way that adult women, all of whom wore skirts, were also dependent on their husbands or fathers. People who wore pants (men) were the dominant members of the family and society. Skirts also had a more concrete, practical value for the mother of a child who was not yet fully toilet trained; it would be easier to keep the child clean if clothing did not fit closely around the loins.

Despite the apparent unisex appearance of children's garments, there were distinct differences between clothing of boys and girls. The signals of gender were subtle, and some may yet go unrecognized. Nevertheless, they were obvious to people at the time. The young boy at the left in Joseph Badger's painting wears a low-neck dress that looks quite feminine (fig. 238). Yet studies of known sitters in paintings and prints reveal that boys, not girls, wore this particular style with coat sleeves, a complete front opening to the hem, and full skirts. A boy's gown from about 1710 is styled without buttons but is otherwise similar to the garment in the painting (fig. 239). The small frock is made with a collarless neckline, cuffed sleeves, and a full skirt that fans out in pleats from the waist. The linen ground fabric is masterfully embroidered with silk in coiling flowers and quilted in a vermicelli pattern using closely spaced backstitches. Green silk tape defines the seam lines and green silk lines the skirt.

Gender distinction had nothing to do with the presence of petticoats, the color of the fabric, or the use of flowers, silk, or delicate textiles. Lace and embroidery were worn by males of all ages, from infancy to adulthood. Clothing

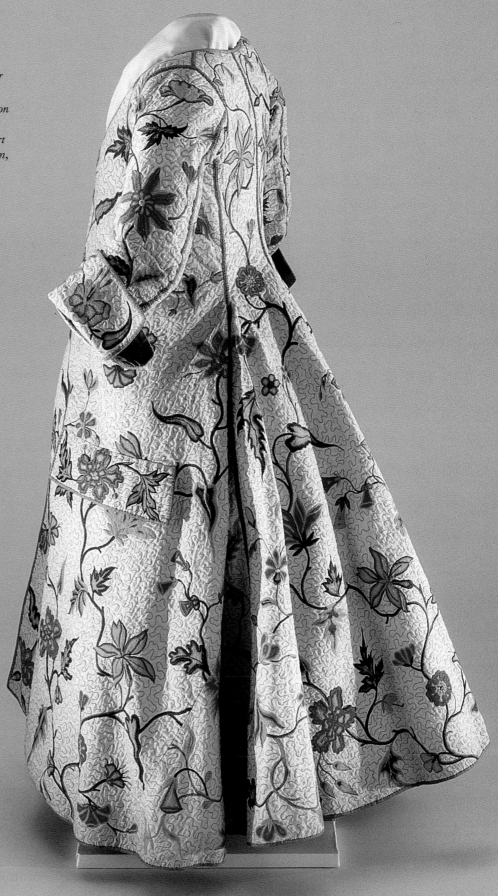

Fig. 239. *Boy's frock, Britain, ca. 1710, linen embroidered with silk and bound with silk tape, silk lining, linen-cotton pockets, from the collection of Roger Warner, G1989-441, gift of Mrs. Cora Ginsburg.*

A masterpiece of design and technique, the embroidery on this frock was the product of professional needleworkers. The garment was included in the Third International Art Treasures Exhibition at the Victoria and Albert Museum, London, England, in 1962.

that was color coded—pink for girls, blue for boys—did not occur until well into the twentieth century.[65]

Cap decoration may have been symbolic of a child's gender. Analysis of the articles of clothing left with children in a British foundling hospital between 1741 and 1760 reveals that cap ribbons nearly always indicated a female child, while cap cockades were limited to males.[66] Cockades, many of which still survive in the hospital records, were circles of ribbon styled like those on grown men's hats. The position of the ribbon on the cap might also have had symbolic value. An 1838 source stated that a rosette of ribbon should be worn on the left side of the hood if the child was a boy and on the front if a girl.[67] Although this prescription has not been confirmed for the eighteenth century, it does suggest the complexity of deciphering symbols from another time period, or even of knowing about a symbol's existence.

As children learned to walk, loving parents tried to protect them from the consequences of falls. Padded caps known as puddings served as crash helmets for unsteady toddlers (fig. 240 and see fig. 219). The pudding cap apparently got its name from its resemblance to pudding molds used in kitchens. The affectionate phrase pudding head comes from these caps many toddlers wore. Abigail Adams, wife of future president John Adams, wrote to her sister in 1766, requesting to borrow the "quilted contrivance" for little Nabby who was beginning to walk. Adams explained that she needed the padded cap for her daughter because "Nabby Bruses her forehead sadly she is fat as a porpoise and falls heavey."[68] Many milliners sold ready-made pudding caps. Williamsburg shopkeepers Margaret Hunter and Catherine Rathell offered "quilted Puddings for Children" and "quilted Satin Puddings for Children."[69]

Leading strings, or ribbons, sewn to the shoulders of tight clothing helped parents control an unstable toddler just learning to walk (figs. 241–242). On a handkerchief, a robust little boy is being held back by a ribbon or cord tied around the waist of his full-skirted dress (see fig. 195). Apparently, not every parent used such restraints. According to her mother, Sally Burr learned to walk by hanging onto the furniture: "she has walked by things all over the house almost 4 months."[70]

The change from petticoats to breeches was a big event in a little boy's life. Occurring anywhere from four to eight years of age, depending on the time period and the family's desires, breeching symbolized growing up and moving

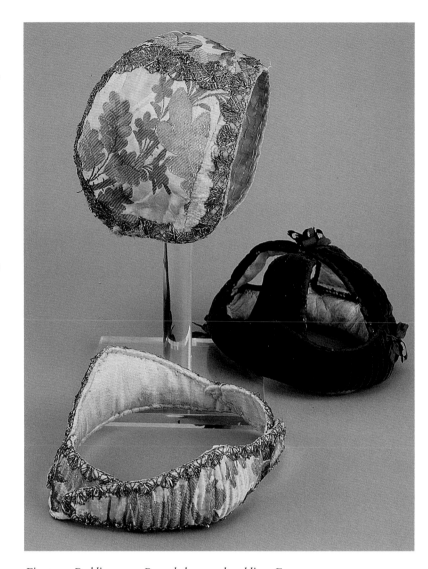

Fig. 240. Pudding caps, Brocaded cap and pudding, France, 1730–1750, silk brocaded with silk and metallic threads and trimmed with metallic lace, lined with linen, pudding stuffed with straw or bast fiber, from the collection of Mrs. DeWitt Clinton Cohen, G1971-1383, 1–2, anonymous gift; Blue-green pudding, Britain, 1770–1785, cotton velvet lined with leather, bound with silk, stuffed with curled horsehair, from the collection of Mrs. DeWitt Clinton Cohen, 1952-55.

Puddings were elegant, protective helmets for children who were learning to walk. Parents could slip the padded ring over the matching brocaded cap when needed.

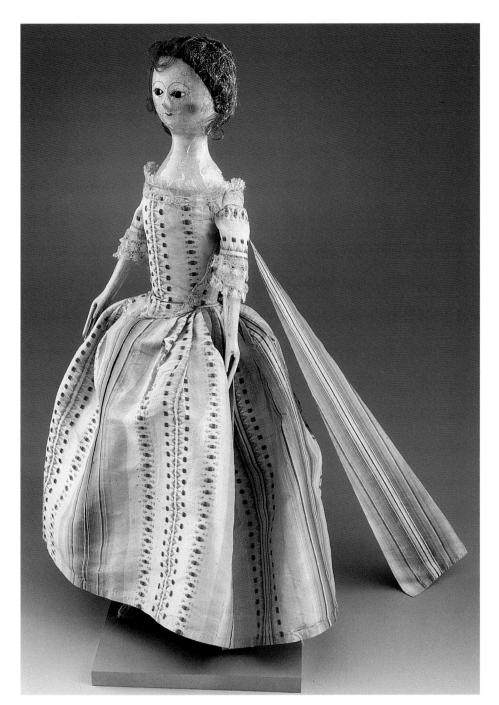

Figs. 241–242. *Doll, overall and detail of back bodice, Britain or Germany, probably early nineteenth century, dressed in the style of 1770–1780, gessoed and painted wood, glass eyes, human hair, silk dress, linen and wool underwear, from the collection of Janet Pagter Johl, G1971-1739, anonymous gift.*

Despite the apparently adult figure, this doll's clothing represents that of a child. Like children's gowns, this garment laces in the back and is fitted with leading strings, or strips of self-fabric, sewn to the shoulders. The striped textile and the construction of the gown and petticoat are typical of 1770 to 1780 fashions, although the doll's body more nearly resembles early nineteenth-century examples. Possibly, someone dressed the doll in old-fashioned styles remembered from her youth.

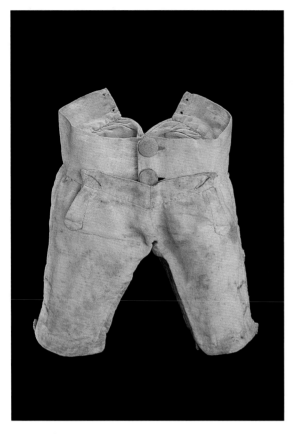

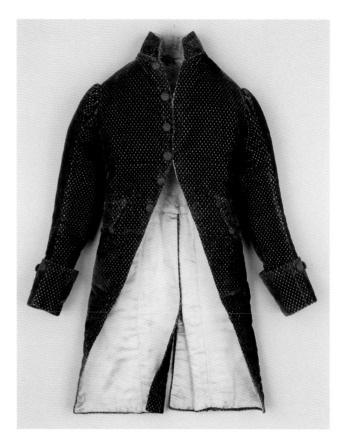

Fig. 243. (LEFT) Breeches, probably New Hampshire or Maine, 1775–1800, linen, 1993-46.
Judging from the stains, holes, and tears, an active little boy wore these breeches. With a waist of eighteen inches and an overall length of just thirteen inches, the garment is unusually small.

Fig. 244. (RIGHT) Boy's coat, probably Britain, 1800–1840, silk velvet lined with silk and cotton, chest padded with cotton, 1991-443.
Constructed in a formal, conservative style, this small coat must have been worn for special occasions. By this time, most boys this size would have been wearing more comfortable skeleton suits. The coat measures twenty-eight inches long. The rest of the suit does not survive.

from the female domain to that of the male. Billy Drinker's mother recorded that he first wore coat and breeches May 12, 1772, at the age of five years and three months.[71] Judging from the small size of his linen breeches, a New England boy was breeched at an early age (fig. 243).

A boy's first dress coat or suit was often styled like his father's (fig. 244 and see fig. 34). Although their suits were cut along fashionable adult lines, young boys often wore shirts that signaled an intermediate stage between childhood and adulthood. Instead of the stiff stocks that older boys and full-grown men put on, little boys wore ruffled shirt collars (fig. 245). (Boys' shirt ruffles resembled those women wore with riding habits, corroboration that boys in ruffled shirts were not yet considered fully independent.)

During the second half of the eighteenth century, the philosophical movement that helped cause swaddling to go out of fashion also affected garments for older children. Parents began to view children as individuals whose clothing needs were unlike those of adults. This trend was in part spurred on by the writings of Locke, Rousseau, Buchan, and others. People were ready for a less formal lifestyle, overtly affectionate family relationships, and a new view of childhood as a separate stage in life. Instead of decorously greeting their grandfather, children play and tumble outdoors (figs. 246–247). Clothing echoed the changing philosophical sentiments. Increasingly, children dressed in clothes that were, ostensibly at least, more comfortable and suitable for active young people. Frocks, or dresses, made of practical washable materials gained favor for little boys and for girls of

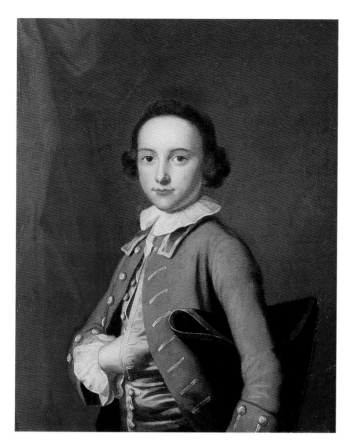

Fig. 245. (ABOVE) DAVID MEADE, JR., by Thomas Hudson, Britain, 1752, oil on canvas, G1938-190, gift of Mr. Tyrrell Williams.

David Meade, Jr., was born in Nansemond County, Virginia, in 1744. His parents sent him to boarding school in England at the age of seven. They hoped that the British climate would be better for the frail child and wanted him to have the advantages of education at Harrow and Fuller's Academy. Meade returned to Virginia in 1761. The eight-year-old schoolboy wears a shirt with a ruffled collar, a style that was symbolic of youth. Even at his young age, Meade displays polish in his pose and grown-up bearing. Etiquette books of the period suggested that men stand with one hand resting inside the waistcoat. He carries his three-cornered, or cocked, hat under his arm.

Fig. 246. (RIGHT) WISHING A HAPPY NEW YEAR TO GRAND PAPA, engraved by Richard Houston after a painting by P. C. Canot, London, England, 1746–1750, hand-colored mezzotint engraving on paper, 1964-474.

These two children wear formal outfits to greet their grandfather who wears a full-bottomed wig that was fashionable when he was in his prime. The little girl's wide skirt is supported by hoops worn underneath, a style especially prevalent in the 1740s. Shortly after the period of this print, children's clothing diverged from adults' styles. The woman's cap is similar to an extant lace example (see fig. 136).

Fig. 247. *"THE AVIARY, OR BIRD FANCYERS RECREATION"* handkerchief, engraved by I. or
J. Laughton, 1765–1780, plate-printed linen, marked M. B. in silk cross-stitches, 1950-103.

*The scene in the center of the handkerchief shows the process of collecting birds using a large two-part net
that snaps together, trapping the birds inside. Boys energetically climb a tree and play. The boy riding a
hobbyhorse wears a frock with sash at the waist. The boy next to him has a suit with a double-breasted jacket
over a shirt with a large ruffled collar. Their playful activities and more comfortable clothing reflect changes in
how society viewed children.*

Fig. 248. Boy's suit, Britain, 1775–1790, cotton lined with linen, from the collection of James Frere, 1953-841, 1–2.

This cotton suit was made of practical, washable materials. The choice of loose trousers instead of breeches with tight bands below the knees gave active boys more freedom of movement. The suit would have been worn over a shirt with a ruffled collar (see fig. 247).

all ages. Made of white linen, cotton, or small-pattern printed goods, frocks were sashed at the waist with a wide ribbon or gathered by drawstrings that tied at the back (see fig. 247). A white linen frock, worn in Rhode Island around 1760, has cuffed sleeves and a fitted bodice cut in one with the full skirt, which is pleated at the sides and center back to give a wide sweep (see fig. 236). Although tradition says a girl wore it, this garment shares some of the features of little boys' coatlike frocks from earlier in the century (see fig. 239). Other frocks for older children had separate skirts pleated or gathered to the bodice.

The practicality of frocks for active children is questionable. Although made of washable materials, light-colored dresses soiled easily and required frequent washing and ironing, no easy tasks in an era before automatic washers or permanent-press fabrics. The frocks of poor children were usually made of dark printed cottons that did not show soil as easily. The low necklines and thin fabrics of frocks were appropriate for warm days, but less so when the weather turned cold. The five Carter girls, ages five to fourteen, struggled to keep warm in their thin frocks on a chilly day in July 1774. Their tutor wrote, "The Girls too, in their white Frocks, huddle close together for the benefit

of warming each other, & look like a Flock of Lambs in the Spring—I wish they were half as innocent."[72]

While small boys and girls were being dressed in white or printed frocks in the second half of the eighteenth century, many older boys received a new style of suit for daily wear. Instead of heavy materials and constricting fit, suits were made of washable linen or cotton. Shirts worn with the suits had open necklines and ruffled collars, more comfortable than a tight collar or stock fastened around the neck. Long trousers replaced breeches that bound the leg below the knees. A cotton suit from around 1790 has trousers that end at calf level, without knee bands (fig. 248). Trousers were not new to men's wear; workingmen and soldiers had worn them and continued to do so (see chap. 4). The new development of the late eighteenth century was that trousers were welcomed into the fashionable wardrobes of well-off young boys.

The trouser suit evolved into the skeleton suit, a form in which the jacket and trousers buttoned together at the waistband (fig. 249). A suit in which the two pieces fastened together allowed more freedom of movement than one made of separate elements. There were no flapping

Fig. 249. Skeleton suit, Europe, 1780–1810, cotton trimmed with copper-alloy buttons, lined with cotton, formerly in the collection of the Historisch Kostuum Museum, 1992-138.

By the late eighteenth century, boys wore comfortable skeleton suits in which the jackets were tucked into the trouser waistbands and held in place with buttons. With the suits, boys wore shirts with open collars instead of tight neckbands. The name skeleton suit apparently derived from the skeletal appearance of little boys in such closely fitted attire.

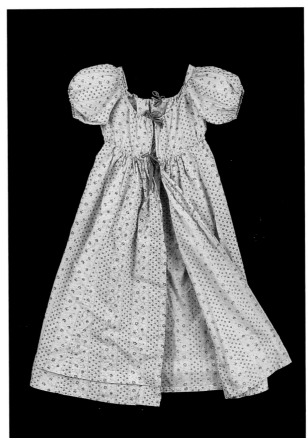

Figs. 250–251. Frock dress, front and back, possibly Pennsylvania, ca. 1810, block-printed cotton, 1987-769.

This child's dress has a raised waistline and extra fullness at the back of the skirt. These features are typical of fashionable clothing during the early nineteenth century. The dress opens completely down the back and fastens with drawstrings. Tucks in the skirt would allow the garment to be lengthened as needed.

coat skirts to get in the way of active play, and the breeches stayed up without requiring a tight waistband.

Children's clothing kept up with and, in some ways, led fashion trends in the second half of the eighteenth century. Increasingly, older girls adopted white frocks that had been limited to little girls and boys around the middle of the eighteenth century. By 1800, even adult women sported the fashionable white cotton gowns. The silhouette evolved over time. Like adult counterparts, children's frocks of the 1750s and 1760s had natural waistlines, fitted cone-shaped torsos, and three-quarter-length sleeves. By the turn of the century, children's frocks had high waistlines, short sleeves, and a looser fit. A frock from about 1810 of printed cotton has short, gathered sleeves and a full back opening that fastens with ties (figs. 250–251). Three early nineteenth-century infant's dresses are made

of sheer white cotton with high waistlines that echo adult women's fashions (figs. 252–253).

As children grew up and entered adulthood, they made wise or foolish choices in their voyage of life, like the journeys depicted on a printed handkerchief (fig. 254). Many, such as Elizabeth Phelps, chronicled life's passage philosophically: "[1771] this Day just one year since I became the wife of the Kindest of Husbands—with what Love and thankfulness ought my heart to be filled. . . . [1782] Tuesday this day Thirty five Years old. Now I have arrived at what is called the meridian of Life—how few arrive to my Age [1788] Wednesday this day forty one years old—one year more is added and a peculiar one it has been—many mercies I've had and some new sorrows [1790] This day forty-three years old—thus I pass on the Journey of Life [1795] This day

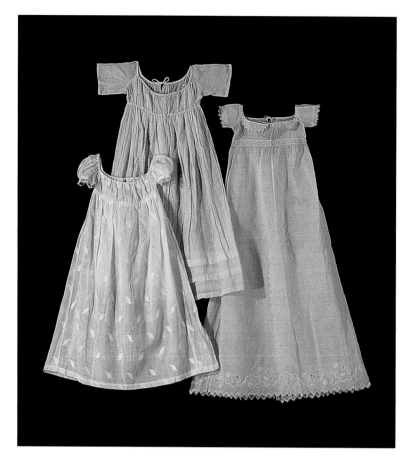

Figs. 252–253. *Three infants' gowns (left to right), Gown with puffed sleeves, Britain or America, 1800–1815, sheer cotton brocaded with linen, G1997-172, gift of Tasha Tudor; Gown with tucks in skirt, Britain or America, 1790–1815, sheer cotton embroidered with cotton, G1997-144, gift of Tasha Tudor; Gown with embroidered edgings, overall and detail of hem, probably Maine, 1810–1825, cotton decorated with cotton needlework and net insertions, G1991-1178, gift of Mrs. Charles D. Carey.*

An infant member of the Nichols-David-Carey family of Maine wore the gown at right. White embroidery creates a zigzag edge on the hem and continues up the center back.

Fig. 254. *"Map of Human-Life" handkerchief, Britain, ca. 1769, plate-printed linen marked E. WESTON 1769 in silk cross-stitches, 1957-118.*

This satirical handkerchief is printed with an allegorical map of human life. It contrasts the "Road to Honour and Happiness" on the left side with "The Road to Destruction" on the right. Readers are cautioned to avoid places such as the Lands of Obstinacy, Indifference, Luxury, and Ceremony.

DOLLS AND FASHION

Little Patsy Custis, George Washington's four-year-old stepdaughter, must have been excited by her new clothes and toys from London (fig. 255). In 1759, Washington had ordered a long list of items for the little girl, including linen for making clothing, mitts, gloves, shoes, fans, masks, stays, bonnets, a cloak, handkerchiefs, and a set of accessories that included caps, ruffles, tuckers, bibs, and aprons, "if fashionable." Although Patsy received some rather grown-up clothing, Washington did not overlook the fact that she was still a little girl. He included in the order "1 Fash.-drest Baby 10/.; and other Toys 10/."[1] The baby was a doll dressed in the fashions of the day. When she was six years old, Patsy got two more dolls from London, along with more serious items that included another pair of stays, a Bible, and a Prayer Book.[2]

Another little American girl had a special doll from London, too. Five-year-old Peggy Livingston's doll came from her Uncle Tommy Shippen, who was studying in London in 1787. Judging from his letter written to Peggy's mother, Shippen had great fun selecting the gift. He wrote that he purchased the doll "in embryo" from a toy seller on Bond Street. Providing clothing for the naked doll required the combined efforts of various professionals and the women in the household of Lady Hunter, an old friend of Peggy's grandmother. Shippen reported, "I must speak of *the doll*, because Mrs. Hunter has become a party concerned The hair dresser is making for it a wig or chevelure, the whalebone man a pair of stays, the milliner a full dress, and the—shifts—petticoat and handkerchief divide the cares of the ladies." Shippen continued that the doll had one unfortunate flaw, a crooked mouth he had not noticed while he was flirting with the saleswoman who sold him the toy. He went on, "Mrs. Home is afraid that *our ladies* will think it [the crooked mouth] a part of the fashion and will attempt to imitate it, I reply to her that if they did, they would fail, their mouths being too beautiful to admit of distortion."[3] One gets the impression that the adults enjoyed the doll more than little Peggy, who later admitted to preferring her dog over her doll.

Fig. 255. L'ENFANCE. CHILDHOOD, *engraved by Simon François Ravenet after a painting by Philip Mercier, Britain, 1750–1760, hand-colored engraving on paper, 1951-412. The little girl has leading strings attached to the back of her gown as a symbol of her youth.*

Although the grown-ups in these girls' lives may have enjoyed seeing how the dolls were dressed, most of the dolls shipped to America were playthings, not vehicles for fashion information. Americans did not need to rely on dolls when so many other means of receiving information were available. Communication with style centers was remarkably frequent, even given the primitive state of correspondence. Imported clothing, usually selected by an overseas merchant-factor or his wife, came from the same tailors, mantua-makers, and warehouses where English customers themselves shopped. Travelers "lately arrived" from overseas brought with them new clothing and knowledge of what was being worn when they left. Local newspapers reported on the styles in London and other fashion centers. Illustrated fashion magazines got their start in the late eighteenth century, as well. New Yorkers, for example, could pay admittance to view new issues of the 1800 London *Gallery of Fashion*, "consisting of the Morning and Evening Dresses, for February and March, and the court dress for February, in 4 elegant coloured prints." Those who wanted to keep abreast of the styles could do so. The advertisement noted, "This publication will be regularly received."[4]

1 John C. Fitzpatrick, ed., *The Writings of George Washington* (Washington, D. C., 1931–1944), II, pp. 334–335.
2 *Ibid.*, pp. 369–370.
3 Ethel Armes, ed., *Nancy Shippen, Her Journal Book* (New York, 1968), pp. 254–255.
4 *New-York Gazette and General Advertiser* (N.Y., N.Y.), June 26, July 18, and July 23, 1800, in Rita Susswein Gottesman, comp., *The Arts and Crafts in New York, 1800–1804* (New York, 1965), p. 376.

Fig. 256. ANN FITZHUGH ROSE, by John Hesselius, Virginia, 1771, oil on canvas, 1989-338.

This painting is inscribed on the reverse, "Mrs Ann Rose. AEtat. 50/ J. Hesselius Pinx 1771." As a fifty-year-old widow, Ann Fitzhugh Rose wears accessories appropriate to her age and status in life, including a cap with lappets that cover her neck and a kerchief around her neck and shoulders. Fine, white shift sleeves are visible beneath the flounces of her dark satin gown. The second wife of Reverend Robert Rose, Mrs. Rose bore six children. The couple lived on the Tye River in Virginia.

twenty five years since we were united in the marriage relation and how tender the feelings of this day . . . [1805] O God make our children & grand children thine in the covenant of grace."[73] Phelps could not have known how prophetic her words would be; thirty-five *was* the meridian of her life, for she died at the age of seventy.

Elizabeth Drinker believed that reaching menopause ushered in better times for most women. After hearing about a forty-two-year-old acquaintance who died in childbirth with her seventh child, she reflected, "probably, had it pleased providence to have spared her, she might never have had another [child]—I have often thought that women who live to get over the time of Child-bareing, if other things are favourable to them, experience more comfort and satisfaction than at any other period of their lives."[74]

As new fashions came and went, aging people decided which styles suited them. Fashionable clothing was modified to fit the individual's changing body shape or life circumstances. As the housekeeper for a Virginia governor said of a new pair of stays she ordered, "I dont mind the fashion if they are made easy & full in the Stomick."[75] Judging from period portraits, mature women covered more of their bodies than younger women, perhaps in response to changes in the appearance of their skin, which was no longer as firm or supple as in their youth. Sensitivity to cold or ideas about propriety may also have led older women to cover up. They wore caps, kerchiefs to fill in the necklines of their gowns, and mitts on their arms. Widow Ann Fitzhugh Rose posed for artist John Hesselius in 1771 at the age of fifty. Her hair and neck are covered with a cap that ties beneath the chin and her gown's low neckline is filled with a large kerchief (fig. 256 and see fig. 165).

Older people, such as the senior women of the Ege-Galt family, often became more conservative, dressing in clothing styles that had been fashionable in their younger days (see fig. 194). While the young mother and little boy in the painting are dressed in the latest white gowns with short sleeves and high waistlines, grandmother and great-grandmother wear styles of ten or fifteen years earlier. Like many others in their generation, the two older women chose clothing suitable for their ages, including gowns of solid, dark colors with few trimmings, generous kerchiefs, and large caps that tied under the chin.

Following a death, survivors signaled their grief and honored the memory of the deceased by wearing special clothing and accessories. For those who could afford them, mourning clothes followed the cut of the current

Figs. 257–258. Gown, overall and detail of back bodice, British textile, possibly worn in New York, damask 1740–1760, gown remade 1780–1800, worsted damask, bodice lined with linen, reproduction kerchief and petticoat, 1989-446.

This black worsted gown may have been worn by a widow. Alterations and numerous mended holes are evidence that the garment saw many years of use. Typical of most elaborately patterned worsted textiles, this fabric measures only seventeen inches between the selvages.

fashions, in colors and specialized materials considered appropriate to the occasion. The first stage of deep mourning required black textiles without gloss or shine. Second mourning clothes could be made of shinier textiles and lighter colors, often gray, purple, white, or dark prints (figs. 257–258).[76] Several varieties of silk and worsted textiles were considered proper choices for deep mourning, including poplin and Norwich crepe, both made of silk and wool mixed, silk tabby, and worsted stuff. A Virginia mourner wore the latter material. When Polly Hill died following childbirth in 1797, her relative, Frances Baylor Hill, cut out and sewed her own black stuff mourning gown in four days. (This timing was unusually slow for Hill, an expert seamstress, but she lost a day because she never sewed on Sunday, and she noted that her finger had been sore during that period.)[77] For first mourning gowns, the most appropriate choice of material was bombazine, a blend of fine wool and silk.

Despite changes in fashion in favor of lighter textiles, bombazine was a traditional choice for mourning and continued to be sold throughout the eighteenth and early nineteenth centuries. Barbara Johnson kept cuttings of the bombazine she purchased following the deaths of her mother in 1759 and her "Brother Johnson" in 1814.[78] American colonists purchased the imported material from milliners and other shopkeepers.[79]

Following the death of England's Queen Caroline in 1737, Virginians, who prided themselves on keeping up with fashion, followed the news of the official court mourning in their local newspapers. According to the account, mourners were to wear one of two different ensembles, depending on the formality of the occasion: "The Ladies full Dress; Black Bombazeen, broad hemm'd Cambrick Linen, Crape Hoods, Shammy Shoes and Gloves, and Crape Fans. Their Undress; Dark Norwich

Crape, and glaz'd Gloves. The Gentlemen, to wear Black Cloth, without Buttons on the Sleeves or Pockets, Cambrick Cravats, and Weepers, broad hemm'd, Shammy Shoes and Gloves, Crape Hatbands, Black Swords, Buckles and Buttons."[80] Weepers were white linen bands worn as cuffs. Deep mourning for the Queen lasted for six months and second mourning another six months.

Men's deep mourning suits were often made of dense black woolens, especially the variety known as cloth, which was shrunk, or fulled, after weaving, then napped and shorn to give it a feltlike texture. After the death of Virginia's Governor Lord Botetourt in October 1770, seven of the governor's servants and staff received new "Superfine black cloth" suits, charged to his estate.[81] Although Botetourt's mourning suits do not survive, the description indicates they were typical of most broadcloth suits, except for color. Like many other extant cloth suits, those ordered for Botetourt's servants were lined with shalloon, a glazed worsted material, and dimity, usually woven of cotton and linen at that date. Preparations had to move quickly after the governor's death. He died on October 15, the invoice for the suits was dated October 17, and the funeral was held on Friday, October 19, at which "His Excellency's servants, in deep mourning," marched in the funeral procession.[82]

Botetourt's executors were following custom by charging the seven mourning suits to his estate. Just as a monarch's subjects wore mourning clothes (supplied at their own expense, however), personal servants or slaves were also expected to dress in mourning on the death of their master. Following her unexpected demise in Boston in July 1709, Mrs. Martha Wingfield's estate was billed for the expense of "a Mourning suit for her negro woman." Mall, the woman in question, was a slave listed in Wingfield's inventory and was willed to the deceased woman's daughter in Virginia.[83] Another slave woman had a more personal reason to wear mourning clothing. Isabella, a twenty-six-year-old needlewoman, ran away from a plantation near Charleston, South Carolina, in 1780. The advertiser seeking her said that Isabella "has appeared lately in mourning cloaths for the death of her mother."[84]

During the early nineteenth century, some women adopted white and black for their mourning clothing (fig. 259). Although President and Mrs. Adams wore black mourning clothes following Washington's death in December 1799, other women in their circle appeared in white dresses trimmed with black fabric and ribbons. Reporting on a drawing room reception two weeks after Washington's

death, the first lady wrote, "The Ladies Grief did not deprive them of taste in ornamenting their white dresses: 2 yds of Black [silk] mode in length, of the narrow kind pleated upon one shoulder, crossed the Back in the form of a Military sash tyed at the side, crosd the peticoat & hung to the bottom of it, were worn by many. Others wore black Epulets of Black silk trimd with fring[e] upon each shoulder, black Ribbon in points upon the Gown & coat some plain Ribbon, some black Snail [trimming] &c. Their caps were crape with black plumes or black flowers. Black Gloves & fans. The Gentlemen all in Black."[85]

In addition to the fabric and color used in an outfit, accessories also symbolized the depth and stage of mourning. Merchants advertised for sale accessories such as "mourning, second mourning, and other genteel fans," "black fans," "Suits [ruffles and kerchiefs] of deep and second Mourning," "very handsome Black & white Second Mourning Ribbon," and "Second Mourning Buckles Very neat Ovel."[86] Although deep mourning fans were solid black, other mourning fans were painted or printed in shades of gray with sober designs (fig. 260).[87] Scores of gloves made of chamois or lamb were distributed at large funerals.[88] Receiving a pair of gloves prior to a funeral gave Bostonian Samuel Sewall incentive to attend the service in December 1727: "I was inclin'd before, and having a pair of Gloves sent me, I determined to go to the Funeral, if the Weather prov'd favourable."[89] Merchants offered mourning rings for sale, along with engraving services to personalize them with a name, age, and year of death to memorialize the deceased (fig. 261).[90]

Late in the eighteenth century and during the nineteenth century, mourning brooches and pendants became more fashionable than rings, although all coexisted for a period of time. The inscription on a mourning brooch expresses the agony of a family who lost their little girl before she reached six months old: "Our darling Babe to Heaven has flown and left us in a World of Pain/ FCB April 3 1780" (see fig. 260). FCB was Frances Courtnay Baylor, born October 10, 1779. She was the child of Colonel John Baylor and Frances Norton of New Market, Virginia. Mary Rothery, a twenty-six-year-old widow, wears a pendant tucked into her gown, possibly a memorial to her late husband who had died the year before (fig. 262). Rothery has abandoned mourning clothes for a fashionable blue silk gown.

Toward the end of her long life, Elizabeth Drinker had to nurse her beloved daughter, Sally, who died of cancer in 1807 at the age of forty-six. After Sally's death, Drinker looked back on the losses she had witnessed during her

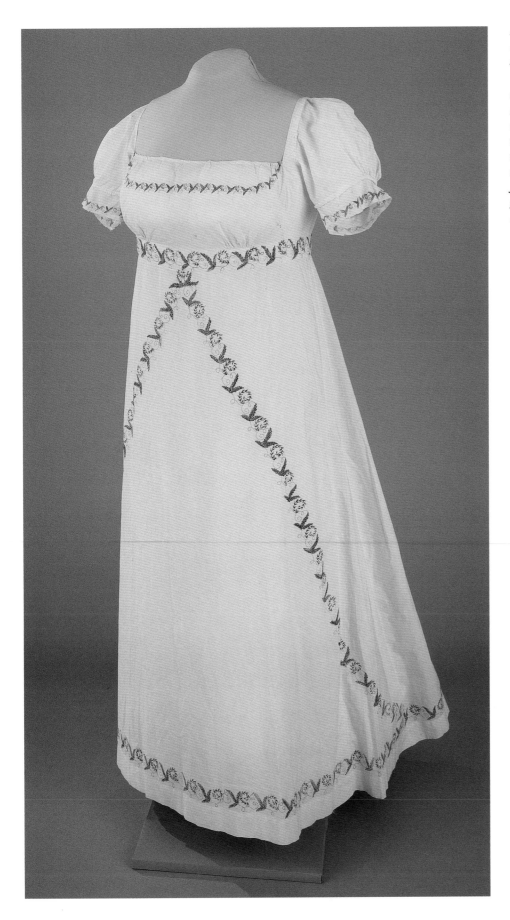

Fig. 259. Gown, possibly Virginia, 1817–1825, cotton with inked decoration, sleeves shortened, 1996-105.

Women sometimes wore white dresses with black trimmings for mourning. The black-inked design on this dress appears to be later than the original construction, possibly added during remodeling for mourning wear. A fragmentary note with this gown identifies it as a "Dress made and worn by Mrs. [torn] White When James Monroe was inaugurated 181[7]." The gown was found in Accomac, Virginia, and may have been made in that area.

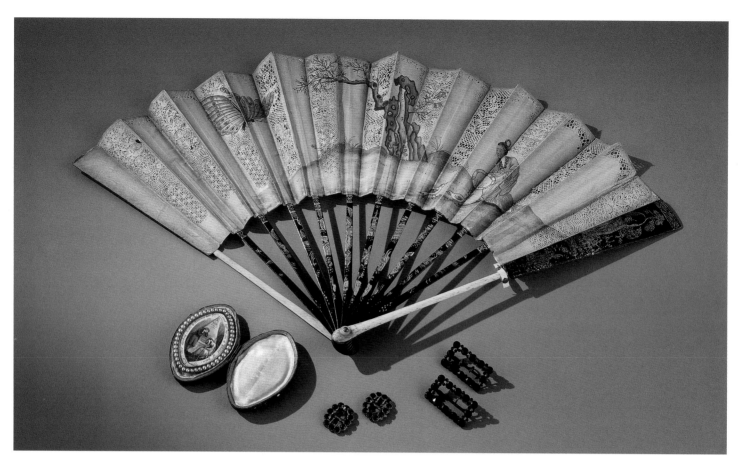

Fig. 260. Mourning accessories (clockwise from top), Fan, Britain, ca. 1760, painted and pierced paper, bone, 1992-36; Rectangular knee buckles, Britain, 1750–1780, jet, steel, copper alloy, 1953-1013, 1–2; Oval knee buckles, Britain, 1775–1800, jet, gold, 1954-621, 1–2; Brooch and case, Britain, worn in Caroline County, Virginia, 1780, watercolor on ivory, glass, pearls, gold, silk, leather, G1962-138, gift of Mr. George Baylor.

Milliners and other shopkeepers sold a wide variety of mourning accessories. The brooch commemorates the short life of Frances Courtnay Baylor, who was born in October 1779 and died five-and-a-half months later. Her mother's wedding dress is in figs. 13–14.

Fig. 261. Mourning rings (left to right), Amethyst ring, Britain or America, 1757, gold, amethyst, 1953-235; Monogrammed ring, Britain, 1770, gold, enamel, hair, paste, 1954-623; Skull and bones ring, Britain or America, 1752, gold, enamel, 1953-231; Scroll ring, Britain, 1759, gold, enamel, 1954-627.

Rings were given to close mourners as memorials to the deceased. Their poignant inscriptions can only hint at the lives commemorated.

KAT. WALDRON OB 31 JULY 1757 AE 91

ELIZ: HUMBY OB: 16 JULY 1770 AE: 8 Ys

D CONEY 4 JUNE 1752

MARTHA SLADE OB: 14 JAN: 1759 AE: 51

life: "Oh! what a loss! to a mother near 72 years of age, My first born darling,—My first, my 3d. my 5th, 7th. and 9th. [children] are in their graves,—my 2d. 4th. 6th. and 8th. are living, if Henry is yet spared to us." Henry, who was traveling in Calcutta, India, at the time, returned safely. Drinker herself died two months after Sally.[91]

Drinker's lament of life's losses seems a lonely, hopeless way to end stories that began in elation and optimism with marriage and the birth of beloved children. Words ring out from letters, diaries, and newspapers to reveal what it was like to live and die in the past. People relied on their relatives, friends, and neighbors to help them celebrate the joy and get through the pain. They used their possessions to signal feelings of happiness, pride, or grief. Fortunately, surviving artifacts and clothing help today's generations remember the lives that might otherwise have been lost.

CHAPTER 6
TAILORING MEANING
Alterations in Eighteenth-Century Clothing

Things have life cycles, just as people do. Artifacts begin as brand new commodities, purchased or made to fill a particular role in the owner's life. Yet few objects retain the same form and meaning during their entire life cycles. Most new clothes, for example, begin as up-to-date, fresh, and unfaded goods. If they are not fashion statements, at least they are strong and functional, able to withstand daily wear and cleaning. Gradually, the effects of use, laundering, sunlight, and fashion changes take their toll. The once-new suit becomes old, out of date, and in need of mending or alteration. Some people continue to wear old clothing, of course, but the message is no longer that of fashion, rather one of comfort, conservatism, eccentricity, or poverty. Some clothes are discarded because they have become too worn for the owner to bother reusing. Clothes that are not completely worn out may be put away in attics or basements, forgotten and ignored in a state of limbo, awaiting rediscovery and reclassification. There the garments are subject to benign neglect and the less benign effects of time and environment. When an object in limbo is rediscovered, it takes on new meaning. A dress may be remade or retrimmed in an attempt to make it look new, and the cycle begins again. Other things become heirlooms that remind people of a revered ancestor or a past time, perhaps brought out to wear at a special occasion or else lovingly stored away in an acid-free box for preservation. If the original owner was famous, clothing might take on mythological status, symbolic of a person, concept, or belief, whether literally true or not. Some items become another kind of commodity, a valuable antique worth hundreds or even thousands of dollars on the auction block. A garment that enters a museum collection acquires new functions. No longer *wearing* apparel, the item of clothing now becomes a "costume," a museum artifact touched only with white gloves. The garment has become a work of decorative art to inspire today's public, a document of past technology, and a text for teaching history.[1]

Collectors and museum curators have traditionally valued antiques that are in unaltered, mint condition. Objects with original color, finish, and workmanship, seemingly untouched by the ravages of time, command the highest prices in salesrooms. There are good reasons for valuing unaltered artifacts. To study the aesthetics and technology of an era,

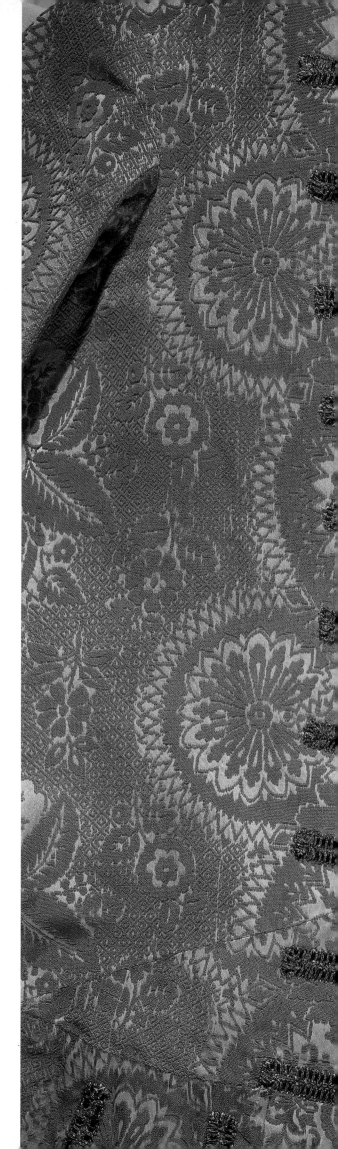

Fig. 263. *Men's British suiting materials, left to right, Gold lace pattern, ca. 1730, uncut voided silk velvet trimmed with metallic braid and buttons, from the collection of James Frere, 1953-836, 1; Silver-blue and yellow small floral, 1760–1775, compound-weave silk, 1953-838, 1; White solid, ca. 1765, wool broadcloth trimmed with metallic needlework and sequins, 1964-32, 1; Zig-zag stripes, ca. 1780, printed cotton velvet trimmed with metallic buttons and sequins, 1985-145, 1; Tan solid, ca. 1780, silk and worsted trimmed with copper alloy buttons, from the collection of Doris Langley Moore, 1960-695.*
Materials used for men's suits were heavier in weight and of different patterns than women's dress fabrics. Early in the eighteenth century, bold designs in rich velvet were used for high-style menswear. Later in the century, small-scale enclosed patterns and solid textiles gained prominence. The tan coat at right has faded from its original mauve color. For overall views, see figs. 137, 153, 329, 349, and 350.

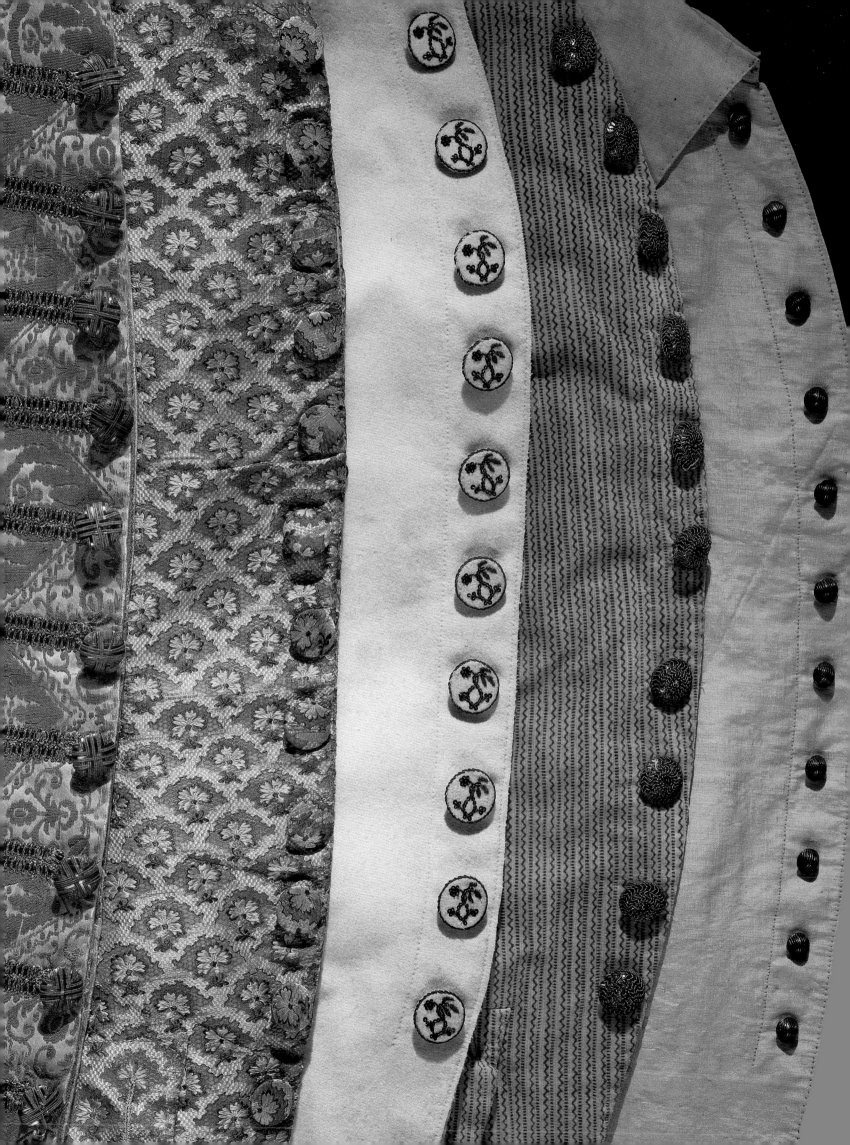

scholars need objects that can be trusted as documents. An unaltered historical artifact is a standard against which to assess the remaining examples from the period. Only by recognizing what is right about a pristine object can scholars detect what is "wrong" with an altered one. Does the top of an antique table look replaced? Are the pulls on a chest of drawers original? Has a gown's bodice been let out (fig. 264)? How does one account for unexplained creases in a garment? If the object has been changed, when and why did it happen?

To analyze and catalog a collection of garments from any century requires thorough familiarity with the period and its material culture. The process includes examining unaltered garments by known makers or wearers, familiarizing oneself with painting and print sources, understanding how people shaped their bodies, knowing what textiles were available, and recognizing period construction techniques. But costume historians need to know the same information about the centuries following because so many antique garments were altered when the original wearer changed shape, when styles evolved, or when ownership changed. The fact of an artifact's survival over two hundred or three hundred years means it passed through the hands of many people, each with a different need and agenda. Costume scholars use their knowledge of sewing technology, materials, and body shaping to help determine whether the garment was changed and, if so, when.

While any museum strives to find the perfect example that is unfaded, unchanged, and as compelling as when it was first made, Colonial Williamsburg has more altered costumes than unaltered ones. In more than seventy years of collecting, the Foundation has acquired not only incomparable masterpieces, but also garments that fall into less-exalted categories. Some costumes are unassuming but important; some remain puzzles; and others are masterful despite their alterations (see fig. 21). All artifacts have individual stories to tell about their past lives if the clues can be deciphered (see sidebar, p. 186).

It is not surprising that so much clothing of the eighteenth century has been changed over time. Textiles were more expensive than labor, and the responsible householder did not allow useful cloth to go to waste. Clothing was routinely left in wills to survivors who presumably made the garments over for themselves or their families. In January 1763, John Johnson of Norfolk County, Virginia, willed the remaining clothing of his deceased wife to five different women, probably family members. To Sarah Simons, he gave "one Camblet Gown"; to Mary

Cills, "One white Satten Gown, [and] One pair of Gold laced Shoes"; to Ann Wood, a "Worked Mantle"; to Whitey Nisbet, "One Brocade Gown [and] one white Satton Petticoat"; and to Mary Drury, a "printed Linin Gown."[2] Clothing historian Anne Buck published similar examples from Britain. In 1782, Nancy Woodforde received a brown silk gown that once belonged to a relative who had died eleven years earlier. Although the dress was described as "old," it was pronounced "very good nevertheless," and Woodforde commissioned a mantua-maker in Norwich, England, to remake it. In 1790, Woodforde received an almost twenty-year-old green silk damask gown, yet she remade it to wear.[3]

The relatively low cost of labor compared to the high price of textiles meant that it was cost-effective to take household furnishings or clothing apart for thorough cleaning. London upholsterer Thomas Chippendale unpicked an entire set of cotton bed hangings for cleaning in 1771. He charged the customer £1.14.0 for "ripping the furniture entirely & making up afterwards tape, thread &c." The process of cleaning and pressing to restore the sheen, referred to as "Scowering & Calendring," cost an additional £1. 5. 0.[4]

Women's gowns were sometimes taken apart in a similar manner when they needed extensive cleaning. (Spot removal was done in the interim.) A recipe to wash and starch chintz cotton textiles with rice added the instruction, "If a gown, it must be taken to pieces."[5] Cleaning often resulted in remodeling because a garment disassembled for cleaning one, five, or ten years after its initial construction would naturally be remade to the current fashion, not the older style.

The clothing of the poor must have been altered countless times, although such garments seldom survive in museum collections. Written sources help document the extent to which laborers' clothing was repaired and altered. A slave named Sterling ran away from his Virginia master wearing an osnaburg (coarse linen) shirt and a pair of breeches and jacket of purple or bluish color. The altered jacket, "being too narrow, had a piece of blue cloth put in to widen it at the neck and shoulders."[6] George Hunt, an indentured servant who worked as a caulker, ran away wearing an assortment of mismatched and mended clothing. He had a jacket of brown linen, laced instead of buttoned, a cinnamon-colored coat, and trousers layered over a pair of cloth breeches that had "Peices set on the Seams between the Thighs."[7] Probably Hunt's breeches legs had been too small, and this patch-

ing method gave him some extra ease. When the imported plaid hose, or fabric stockings, proved to be too small for his slaves, Virginia planter Edward Ambler instructed that pieces of woolen fabric be given out so the slaves could enlarge the stockings themselves. Because plaid hose were cut and sewn from woven fabric, not knitted, it would have been a relatively easy task to open up the back seams and set in strips of wool to increase the width (see chap. 4).[8]

Some clothing was made from recycled textiles. Plantation owner Joseph Ball instructed that his worn-out bed sheets and other linens be torn up and reused to make clothing for slave children.[9] Robert Craig, an indentured weaver from Scotland, had a jacket made out of an old blanket, along with a drab cloth coat that was "much patched."[10] A runaway woman from Charleston wore a petticoat made out of a bed quilt.[11] This reuse of a quilt is not an isolated example; a maternity ensemble in Colonial Williamsburg's collections was also made from an old bed quilt (see sidebar, p. 153).

Alterations occurred at every social and economic level, not just among the poor. Like many less-famous people, Thomas Jefferson wore mended and altered clothing. His surviving stockings, underwear, and waistcoats betray a pattern of patching and "making do."[12] People with vast wealth were no less careful of their textile belongings. Even the extensive wardrobe of England's Queen Elizabeth I was periodically refurbished and altered, down to her stockings, which were redyed or had new feet knit into them.[13]

The practice of altering knitted stockings persisted for hundreds of years. In 1748, Elizabeth Boyd of New York advertised that she not only repaired stockings, but also made new items of clothing out of old stockings: "All sorts of Stockings new grafted and run at the Heels, and footed; also Gloves, mittens and Children's Stockings made out of Stockings." Three years later, Boyd again advertised her skills at working with knitted clothing: "Elizabeth Boyd . . . will continue, as usual, to graft Pieces in Knit Jackets and Breeches, not to be discern'd, also to graft and foot Stockings, and Gentlemen's Gloves, Mittens or Muffatees made out of old Stockings, or runs them in the Heels. She likewise makes Children's Stockings out of old ones."[14] The concept of refooting becomes more comprehensible with the knowledge that many eighteenth-century stockings were frame knitted in two operations and, thus, were easier to alter; the bottom of the foot was a separate piece partly knitted in place and finished by sewing (see fig. 132).[15]

Fig. 264. Detail of gown bodice, Britain, silk textile ca. 1740, remodeled ca. 1750, silk brocaded with silk, bodice lined with linen and silk, reproduction ruffles, G1989-427, gift of Mrs. Cora Ginsburg.
Lines from earlier pleats and seams are evidence that this gown was remodeled. The collector called these creases "past life lines." For overall view, see fig. 343.

Alterations sometimes had to be done immediately after new apparel was received. Not all clothing was custom-made to people's measurements, and even that made by tailors occasionally needed adjustment. In 1751, gentleman landowner Henry Purefoy of England complained to his tailor, "The grey Breetches you made mee are too shallow in the Seatt and must be let out, so desire you will bring with you a naill of grey cloath the same to the

APRON OR VEST?

A loose vest that is unlined, without pockets, and was quickly stitched together on a sewing machine came to Colonial Williamsburg as a part of a gift in 1971 (fig. 265). Despite its machine construction, almost certainly done in the twentieth century, the vest's beautiful silk needlework borders showed every evidence of being eighteenth-century workmanship. In fact, the modern vest was made from a woman's silk apron of 1730 to 1750. The unknown twentieth-century person who did the alterations removed the apron's waistband and gathers, folded in the two outer edges of the flattened apron to create fronts, cut into the fabric to form armholes, and bound the raw edges with silk fabric. Fortunately, the modern seamstress made no attempt to unpick the concentrations of u-shaped needlework originally intended to frame pocket slits, but that now are positioned awkwardly on the shoulders of the new garment (fig. 266).

Today's preservation and museum ethics strongly discourage adaptive reuse that not only cuts into an original artifact, but also drastically changes its original identity. Colonial Williamsburg curators and conservators had to decide whether to undo the twentieth-century alterations to return the vest to its original apron form. The process would require unpicking the machine stitching, filling in missing silk that was cut away at the armholes with matching modern material, and gathering the apron to a new replacement waistband. There are unanswered questions. What was the original waistband made of? Was the fabric gathered or pleated to the waistband? What kind of sewing thread and stitches were used in the original construction? The restored apron would not be entirely true to its original period nor would it be true to its altered period. If this were the only apron in existence, or the only apron in Colonial Williamsburg's collection, conservators and curators might have agreed to restore it. Instead, they decided to preserve the vest as it had come down to the present, complete with the alterations that may be regrettable, but which are nevertheless part of its long history. One can be grateful that the apron-vest survived its foray into the world of twentieth-century fashion.

Figs. 265–266. Vest and apron, overall and detail of embroidery, Cream vest made from apron, Britain, 1730–1750, remade 1920–1925, silk embroidered with silk and metallic threads, lined with silk, metal weights, G1971-1561, anonymous gift; Green apron, Britain, 1710–1740, silk embroidered with silk, waistband missing, from the collection of Mrs. DeWitt Clinton Cohen, G1971-1541, anonymous gift.

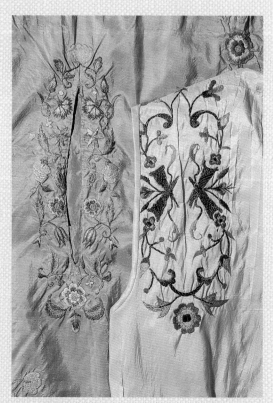

pattern enclosed to enlarge them."[16] (A nail measured two-and-a-quarter inches.) Americans ordering from long distances were accustomed to fine-tuning the fit when the clothing arrived. Both George Washington and Robert Carter complained about the fit of their imported suits (see p. 93). Washington ordered for his twelve-year-old stepdaughter a silk lustring "Corderobe," a type of dress made out of crisp silk, from Mrs. Harris via his London agent. Washington requested that Harris send two extra yards of fabric "in case an Alteration be necessary."[17] Rosalie Calvert altered some garments she commissioned for the family through her sister in Antwerp, Belgium. Regarding a shipment from Belgium in 1817, Calvert wrote that her own blue gown was somewhat too long, but that was "easily remedied." Daughter Caroline's gown was too small and required more extensive alteration. Calvert "opened the bodice under the arm and inserted a small piece there as well as in the sleeve, and now it fits her quite well." On another occasion, she requested that the dressmaker include a little extra material with the clothing "in case of mishap."[18]

In times of scarcity, textiles and clothing became even more valuable and subject to alteration. During the Revolutionary War, both sides in the conflict experienced shortages of supplies. British soldiers stationed in Montreal, Canada, in 1777 had not received their supply of clothing the year before, so their worn clothing had to be cut down to extend its useful life. Thomas Anbury, a British lieutenant, reported that "the commanding officers of the different regiments have received orders to reduce the men's coats into jackets, and their hats into caps, as it will be the means of repairing their present cloathing." Besides, Anburey explained, shorter coats were more practical "for wood service."[19]

On the other side of the conflict, colonists were doing much the same thing. Woolens were no longer available from England, the former supplier to the colonies but now the adversary. In February 1783, expected supplies had not been received from Europe. The Americans decided to shorten their coats and, to extend the life of the wool, to rip them apart and turn the material inside out. Orders issued from the Newburg, New York, headquarters stated, "The Non arrival of the Cloathing expected from Europe renders the gratest Oeconemy in that article doubly necessary. The Commander in Chief [George Washington] therefore recommends that the business of turning and repairing the Coats of last year should now be considered as a primary object, in doing which a certain Model as to the fashion and length (for

the coats ought to be made something shorter than at present) will be established by the Commanding officer of the Corps, from which there must be no deviation." Trying to maintain consistency in the appearance of the uniforms, Washington specified that the men should not be allowed to make alterations themselves "according to their own whim and caprice."[20]

The process of turning, referred to in Washington's orders, was a way to freshen the appearance of a reversible textile that had gotten abraded, faded, or stained on the outside. The entire garment (or a worn part, such as a collar) was taken apart and remade with the other side of the fabric uppermost. Not all clothing could be turned; success obviously depended on whether the textile could be used with the reverse side up. Most printed textiles and those with loose or carried threads on the back, such as brocaded silk, were not reversible. On the other hand, woven checks, plain woolens, ribbed silks, and damasks were reversible (see figs. 12 and 154).

Connecticut tailor Asa Talcott spent a large part of his time cutting apart, turning, and remaking old clothing for his clients.[21] Records of other tailors reveal the same pattern of activity.[22] Indentured servant John Harrower hired a tailor to work on an old coat he had brought along when he came to Virginia three years earlier. In 1775, Harrower had his brown coat "new mounted and turned" at a cost of six shillings. This must be the same "Superfine Brown Cloath Coat full mounted" that was listed in his 1774 clothing inventory.[23] Superfine cloth was a fine grade of wool that was fulled, or shrunk, napped, and shorn to give it a feltlike texture and a smooth surface (see fig. 154). The ideal candidate for turning, superfine cloth was reversible and too expensive to discard when it became worn. Colonel Francis Taylor of Virginia had one of his coats turned in June 1792. He wrote, "I sent an old Coat this morning to get turned by Mrs. Stewart."[24]

Women's gowns could be turned, also. Elizabeth Jervis of Staffordshire, England, had two of her gowns turned. Her accounts record charges in 1753 and 1757 for "Turning Scarlet gown & Sleve Linings 4s. 6d." and "turning my Lutstring [silk] negligee by Vernon 5s."[25] An orange silk damask gown in the Colonial Williamsburg collections has been turned (figs. 267–268). Although the gown has considerable piecing, the turning is most evident in the present seams, which have old creases where they were once pressed open in the opposite direction. *The Workwoman's Guide* of 1838 suggested that turning an old

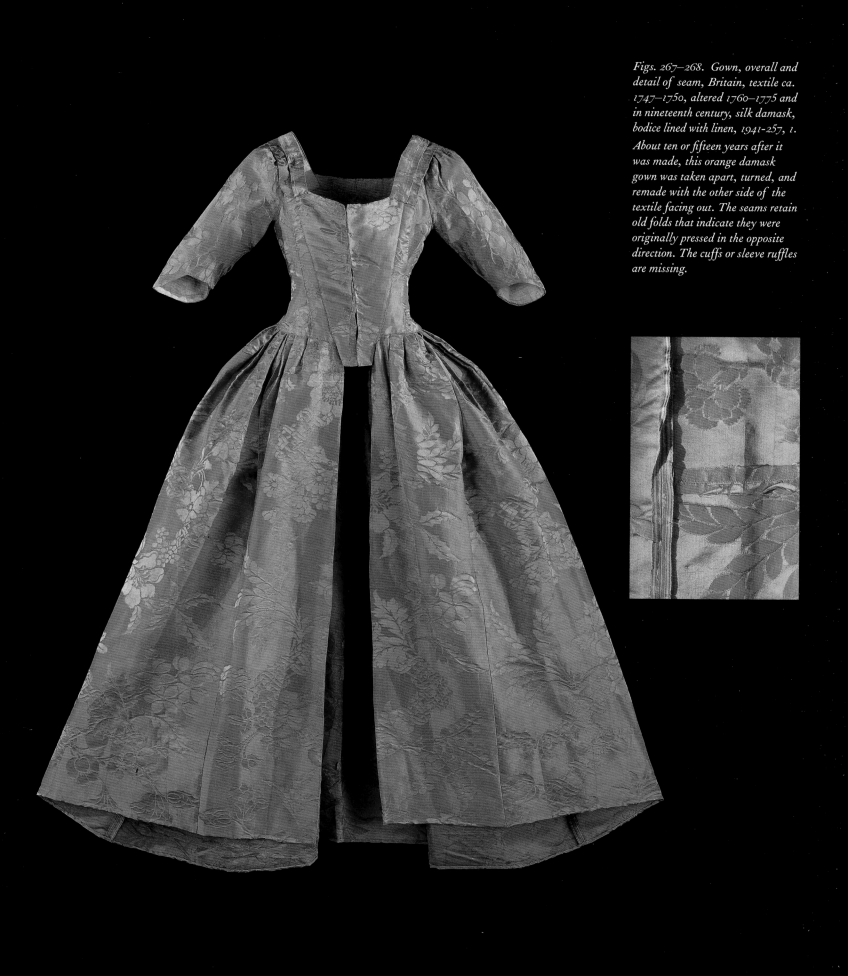

Figs. 267–268. Gown, overall and detail of seam, Britain, textile ca. 1747–1750, altered 1760–1775 and in nineteenth century, silk damask, bodice lined with linen, 1941-257, 1.

About ten or fifteen years after it was made, this orange damask gown was taken apart, turned, and remade with the other side of the textile facing out. The seams retain old folds that indicate they were originally pressed in the opposite direction. The cuffs or sleeve ruffles are missing.

Fig. 269. (LEFT) Shirt, America, 1775–1790, collar and cuffs replaced 1810–1830, linen, G1974-268, bequest of Grace Hartshorn Westerfield.
The collar and cuffs of this shirt were replaced with linens of different quality from that of the earlier body. The new parts were stitched with cotton instead of linen thread. The shirt has a typically generous length of forty-one inches.

Fig. 270. (RIGHT) Child's shift, Middlesex County, New Jersey, worn by Mary Compton, 1807–1815, linen, G1991-106, gift of Mrs. Richard Killion.
The triangular pieces that add flare to the sides and the wide band at the hem are made of coarser linen than the sleeves and upper body. Apparently, a baby shirt was converted to a shift as the girl grew. The shift measures twenty-four-and-a-half inches long. According to family history, Mary Compton (Mrs. George Greason), wore this shift as a child. She was born in 1807.

gown was not only accepted, it was planned from the start: "it is economical to line the skirt, as it keeps the dress cleaner and makes it look better if turned."[26]

Replacing selected worn parts was also an option. In 1791 and again in 1797, Colonel Taylor sent out some shirts to get new wristbands.[27] Similarly, an eighteenth-century shirt in the Colonial Williamsburg collections has had its collar and wristbands replaced, probably early in the nineteenth century (fig. 269). The shirt's linen body is sewn with early linen thread. The collar and cuffs, which would have received the most wear, are not only constructed of different-quality replacement linen, but also sewn and topstitched with later cotton thread.[28]

Pregnant women had to adapt their clothing in size and shape to accommodate their condition because few could afford specialized maternity gowns. Although many dresses and petticoats could be varied in girth by means of lacings and ties, pregnancy often necessitated more

extensive alteration, especially after fashionable women abandoned stomacher fronts in favor of stylish, but less adjustable, edge-to-edge closures (see chap. 5).

Children's garments had to be let out or expanded as young wearers grew. A girl's tiny shift, made over from an earlier linen baby shirt, typifies the challenge of remaking children's clothes (fig. 270). In this example, coarser linen was added to the straight-cut shirt to create a garment both longer and wider, with the typical flare of a feminine shift.

Children's clothing was sometimes made out of adult's garments, cut down in size after the adult could no longer wear it for one reason or another. A boy's waistcoat appears oddly proportioned, with oversized pocket flaps and out-of-scale embroidery (figs. 271–272). Comparison with other antiques reveals that the small waistcoat was actually made from a full-size embroidered one for which the scale of the embroidery and larger pocket flaps would

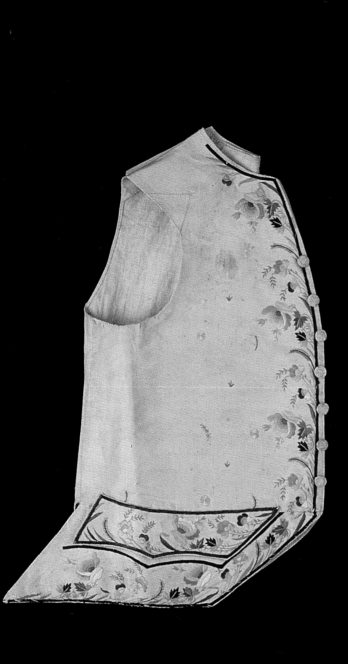

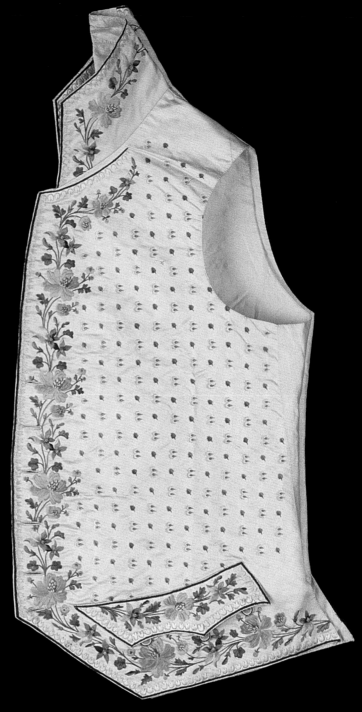

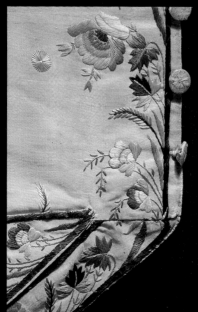

Figs. 271–272. Two waistcoats, Boy's waistcoat, overall and detail of alteration, France, 1790–1810, cut down later, silk embroidered with silk, lined with linen, linen back, 1970-109; Man's waistcoat, Europe, 1790–1810, silk embroidered with silk, lined with silk, silk back, cotton pockets, G1971-430, gift of Mark Clark.

The out-of-scale pockets and seams at the flaps are clues that the boy's waistcoat was cut down from a full-size man's garment similar to the example on the right.

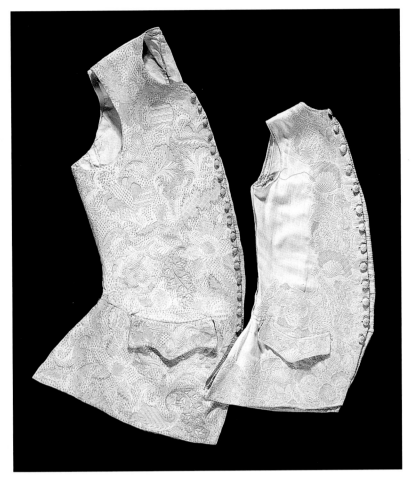

Figs. 273–274. Two waistcoats, overall and detail of needlework below both pocket flaps, Man's waistcoat, Britain, 1730–1740, altered 1750–1765, cotton embroidered with linen, lined with cotton, linen back, from the collection of Doris Langley Moore, 1960-700; Boy's waistcoat, Britain, 1730–1740, altered later in the eighteenth century, cotton embroidered with linen, linen-cotton back, lining missing, from the collection of Mrs. DeWitt Clinton Cohen, G1971-1577, anonymous gift.

Both waistcoats were altered to extend the useful life of the elegant white-on-white embroidery, which was worked primarily in French knots and cord quilting. The man's waistcoat had a wedge removed from above each pocket flap to imitate the cutaway shape that became fashionable later in the eighteenth century. Added sections under the arms expanded the girth for a heavier man. The boy's waistcoat was trimmed down around the edges. Further, the pocket flaps were repositioned directly on top of the densest portion of needlework. In unaltered examples, flaps were usually stitched within a blank area framed by the embroidery design.

have been more appropriate. The boy's waistcoat was cut down above the pocket flaps to shorten the body; the original linen back and linings were cut down and reused, as well.

A child's white embroidered waistcoat was also made from a larger one. Instead of cutting the waistcoat across the pockets, the person doing the alterations shaved fabric from the hem and fronts (figs. 273–274). The new location of the hem and the front angle of the boy's

waistcoat interrupt the embroidery design without regard for its original shape. The pocket flaps are merely decorative, lacking functional openings beneath, and are placed well forward of the original pockets, which were lost when the garment was cut down.

A boy's patterned silk coat was probably made into its present form in the early nineteenth century (figs. 275–276). The prominent chest is padded to emphasize its shape, reflecting men's fashions around 1800 to 1820. The

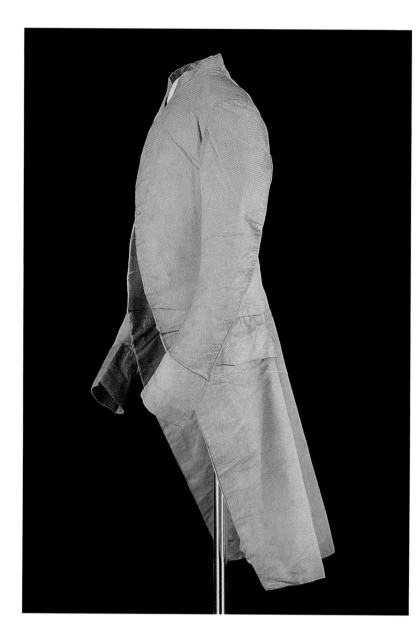

Figs. 275–276. Boy's coat, overall and detail of front opening, Britain, ca. 1790, altered 1800–1825, compound-woven silk lined with silk and linen, padded with cotton batting, from the collection of Doris Langley Moore, 1960-694.

This small coat, which measures about thirty-seven inches long, was cut down at the waist through the outer silk fabric and the lining beneath. Additional fabric was removed from the outside edges. Old buttonholes are still partially visible at the fronts.

fact that the chest padding extends from shoulders to waist indicates that the boy's garment was recycled from a man's coat. In a larger garment with correct proportions, the padding would have been confined to the chest area. Both the outer fabric and the silk lining were cut across the waist to shorten the coat while retaining the old lining.

The clothing of adults was also altered in size when wearers gained or lost weight. Some men grew in girth beyond the garment's ability to expand, despite the prevalence of adjustable ties or buckles on breeches and waistcoats. Many waistcoats have added pieces at the sides or center-back seams, positioned so the outer coat covers the enlargements (see fig. 273 and sidebar, p. 195).

Evolution in fashion accounted for many alterations. Because waistcoats grew shorter and more cutaway during the eighteenth century, men had to have their long waistcoats shortened to conform to the new style. Yet the distinctive cutaway shaping and the presence of pockets with flaps meant waistcoats could not easily be shortened. Those that were either embroidered or brocaded to form were especially difficult to alter because the embellishment was specifically designed to follow the garment's contours (figs. 277–278 and see fig. 39). Decoration was concentrated at the center fronts and hems, became more dense and elaborate around the pockets, and typically created reserves or blank spaces for the pocket flaps. Resizing a waistcoat by trimming edges or turning up hems would have meant cut-

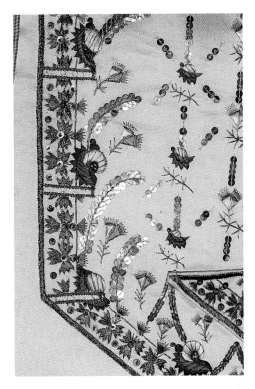

Figs. 277–278. Unmade waistcoat, overall and detail of needlework, France or Britain, ca. 1780, silk embroidered with silk, silver, and sequins, from the collection of Mrs. Evelyn Kendall, G1993-38, gift of Mr. William Strole.

Never cut up and made into a waistcoat, this elegant needlework was originally destined to become part of a gentleman's formal suit. Sometimes called waistcoat patterns, these pre-embroidered panels included the fronts, pocket flaps, collars or lapel facings, and button covers; tailors added plain backs, pockets, and lining materials.

ting into the carefully planned decoration. Yet the expense and beauty of embroidered or brocaded waistcoats argued for their continued use. For these reasons, many were expertly altered by cutting through the embroidery or brocaded design where it would show the least, usually across the top of the pocket flaps.

A man's white embroidered waistcoat, altered to increase the angle of cutaway, is an excellent example (see fig. 273). The tailor or seamstress removed a thin wedge of material beginning at the side seams and tapering toward the pocket flaps. This technique avoids cutting through the needlework at the center fronts where a pattern interruption might be visible, especially when the outer coat

was worn unbuttoned. The old lining accommodates the new shape by means of long horizontal darts from the side seams across the pocket flaps, reaching almost to the center fronts. In addition to changes in contour, the waistcoat has enlargement pieces under the arms.

By the end of the eighteenth century, men's fashionable waistcoats were shortened to just below the waist. The front angled cutaway was eliminated, and the waistcoats buttoned completely down the front. Pocket placement rose along with hems, and welt openings eventually replaced shaped flaps. At the same time, high, standing collars came into fashion (fig. 279). It was more difficult to transform an older style into this new silhouette, yet

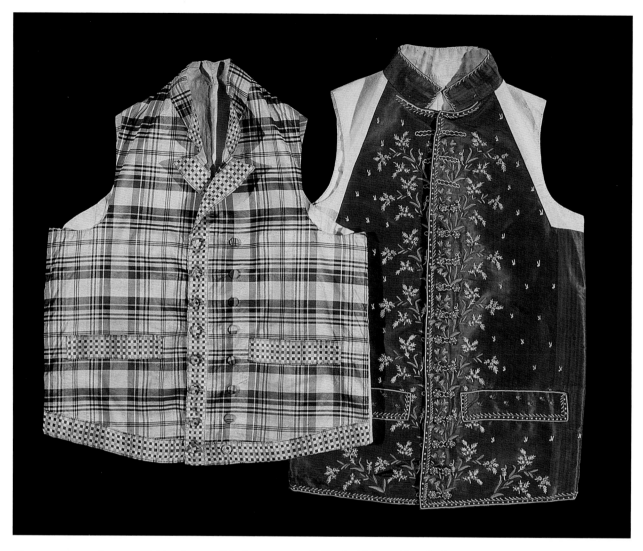

Fig. 279. Two waistcoats, Plaid waistcoat, Britain, ca. 1785, silk lined with linen, linen back, cotton enlargement panels, metal adjustment buckle, G1991-480, gift of Mrs. Cora Ginsburg; Embroidered waistcoat, overall and detail of buttons, Britain, ca. 1790, silk embroidered with silk, lined with linen-cotton, linen-cotton back, G1991-479, gift of Mrs. Cora Ginsburg.

Late in the eighteenth century, fashionable daytime waistcoats were shorter than they had been in the first seventy-five years of the century. Waistcoats came to just below the waist and were cut straight down the fronts and across the hems. Welt pockets, entered from the top, replaced flaps that had the pocket opening underneath. The purple embroidered waistcoat is made of changeable silk, woven with purple threads in one direction and green in the other direction. This placement creates color shifts from purple to green when the textile is moved. The buttons are covered with silk thread.

some tailors did succeed. An embroidered waistcoat underwent drastic revisions to bring it up to date (see sidebar, next page). Waistcoats in other museum collections are remade in a similar manner.[29]

Some alterations completely transformed the original garment. The many yards of fabric in women's gowns could be refashioned into garments for men, too. In 1661,

English diarist Samuel Pepys recorded that he had a waistcoat made from one of his wife's petticoats: "I went home and put on my gray cloth suit and faced white coate, made of one of my wife's pettycoates—the first time that I have had it on."[30] During the eighteenth century, such a transformation was somewhat less likely to occur because men's suiting materials deviated from women's gown textiles in their design (see fig. 263).

UPDATING AN OLD WAISTCOAT

An embroidered waistcoat appears to be a typical example from around 1800, when many waistcoats were short in length with high collars and welt pockets (figs. 280–281). But a second look reveals puzzling anomalies. The embroidered design is somewhat eccentric. Why does the embroidery not extend around the hem? Why does the standing collar have unrelated ornamentation that does not follow its shape? In fact, the waistcoat is like the pieces of a puzzle that have been combined incorrectly. Now altered significantly, the waistcoat was once longer, with pocket flaps that angled off in correspondence to a front cutaway opening (fig. 282). The new standing collar was actually taken from two sides of the front hems, turned upside down, and resewn to the neckline. The new pocket welts were created from the old pocket flaps, similarly turned upside down and repositioned. The remade waistcoat is a clever attempt to make do when fashion rendered the original waistcoat obsolete.

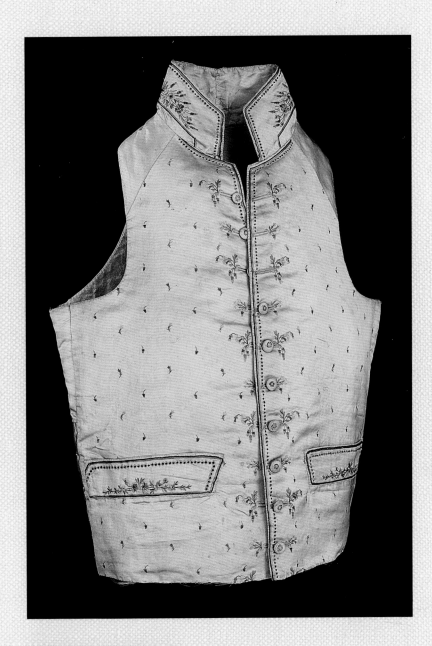

Fig. 282. Line drawing that shows original waistcoat compared with altered garment.

Figs. 280–281. Waistcoat, overall and detail of alteration under the arm, Britain, ca. 1775, remodeled ca. 1800, silk embroidered with silk and paper sequins, faced with silk, lined and enlarged with linen-cotton, linen, and cotton, linen-cotton back, G1971-1562, anonymous gift.

Narrow strips of embroidered satin removed above the pocket flaps were used to enlarge the waistcoat under the arms.

 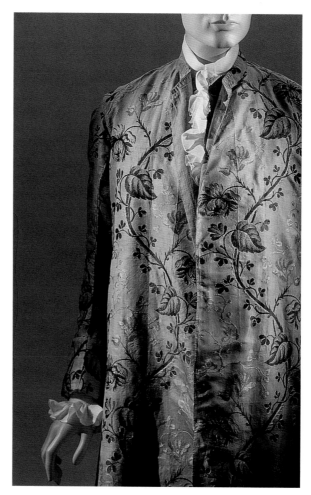

Figs. 283–284. Details of man's banyan, Britain, silk textile ca. 1750, remodeled 1760–1770, silk brocaded with silk, lined with linen and linen-cotton, reproduction shirt ruffles, 1941-208, 1–2.
Old pleats at the front are evidence that this banyan and matching waistcoat were made from a woman's sack-back gown and petticoat. For overall view, see fig. 158.

Nevertheless, some crossover occurred. Men's banyans, or dressing gowns, used large-scale damasks and brocaded textiles similar to those in women's clothing. For instance, a man's dressing gown and matching waistcoat are made from the long lengths of fabric in a woman's sack-back gown and petticoat (figs. 283–284). Vertical fold lines still visible in the floral brocaded silk of the front and sleeves are shadowy reminders of original pleats in the woman's gown used to make the man's ensemble.

Women's clothes were remade at least as often as men's. Martha Washington wanted to have a four-year-old dress transformed into a "sack and coat," that is, a sack-back gown and petticoat. To do so, she needed to purchase additional fabric to match the old. In 1763, George Wash-

ington wrote to his London agent on her behalf: "Mrs. Washington also begs to have 4 yds. of Silk sent according to the Inclosed pattern w'ch was bought in the year 1759 of Palmer & Co. and made into a suit of Cloaths by I Scherberg, but now having occasion to turn it into a Sack and Coat it cannot be effected with't more of the same; this (if to be had) may be sent with my Cloaths."[31]

In September 1760, Washington sent one of his wife's gowns to his English agents for cleaning or redyeing. This process usually required taking the dress apart and remodeling it at the same time (see p. 184). Washington explained to his agents that the garment pieces should be remade into another gown with a sack back, but, if that was not possible, to make it into an informal daytime

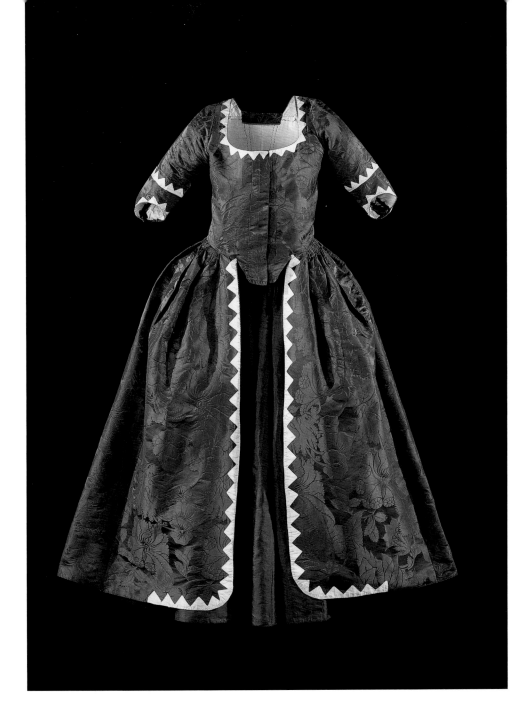

Figs. 285–286. Gown, overall and detail of pieced skirt front, probably Britain, silk textile 1740s, remodeled 1780–1795, silk damask trimmed with appliquéd silk, bodice lined with linen, skirt lined with silk, from the collection of Doris Langley Moore, 1960-713. The large-scale damask in this gown dates to the 1740s, yet the gown was remodeled to wear in the 1780s or early 1790s. Triangular appliqués of white silk at the neckline, sleeves, and skirt front help to disguise the alterations. Typical of gowns in the 1780s, the sleeves are made longer in back to cup over the elbows, and the bodice is pieced so that it meets in the center front.

dress called a night gown. (A night gown was not for sleeping.) He wrote, "Mrs. Washington sends home a Green Sack to get cleaned, or fresh dyed of the same colour; made up into a handsome Sack again woud be her choice, but if the Cloth wont afford that, then to be thrown into a genteel Night Gown."[32] The transformation from a sack-back gown to a night gown is evident in a brocaded silk dress with a Rhode Island history (see figs. 108 and 197).

Another fitted gown from the 1780s or 1790s was made from forty-year-old damask (figs. 285–286). The rich blue old-fashioned damask was brought up to date by restyling the bodice and sleeves and adding white silk appliquéd trimming. The bodice front is pieced to con-

vert it from a stomacher-front fashion to one with a center-front closure. The skirt has large patches, but the white triangular appliqués stitched over their seams help camouflage them (see fig. 286).

Rarely do any substantial fragments survive after clothing alterations because thrifty people remade or reused every available piece of expensive textile. Remarkably, a dress bodice was laid aside and saved after fashion changes and subsequent alterations to the dress around the middle of the eighteenth century made the original bodice obsolete (figs. 287–289). The bodice and the altered gown together tell a story of textile use and reuse over a twenty- or thirty-year period. The shape of the early bodice, the full, cuffed sleeves, and the pattern on

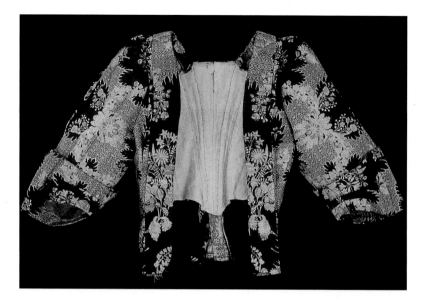

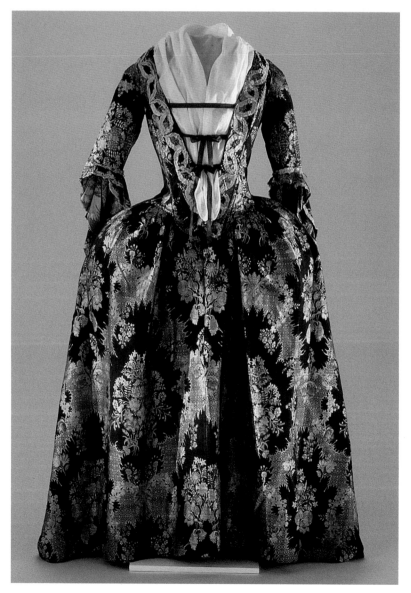

Fig. 287. (LEFT) Gown bodice, Britain, 1730–1745, silk brocaded with silk and lined with linen, G1990-16, 2, gift of Mrs. Cora Ginsburg.

This bodice was left over when the gown was remodeled (see figs. 288–289). The heavy cuffs contrast in style with the slim ruffled sleeves of the later remade gown.

Figs. 288–289. (BELOW) Gown, overall and detail of back, Britain, silk textile ca. 1730, remodeled ca. 1750, silk brocaded with silk, lined with linen and silk, reproduction kerchief and ribbons, G1990-16, 1, gift of Mrs. Cora Ginsburg.

In its remodeled state, the later gown has graduated sleeve ruffles and a fitted bodice that is shaped with pleats down the back. Most gowns of the period had skirts that were open at the front to show off a decorative petticoat. This example is a closed robe style in which the skirt is stitched shut. A drop panel in the skirt front allowed the wearer to step into the gown. The original petticoat was probably used to make the later bodice, thus requiring that the remodeled skirt be closed all the way around to fill in for the missing petticoat.

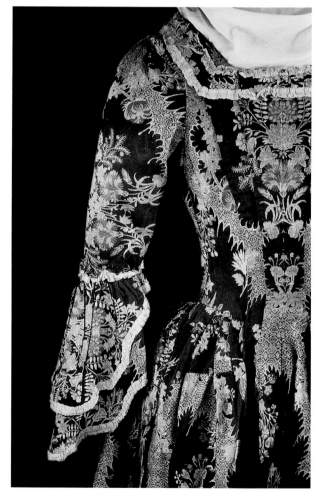

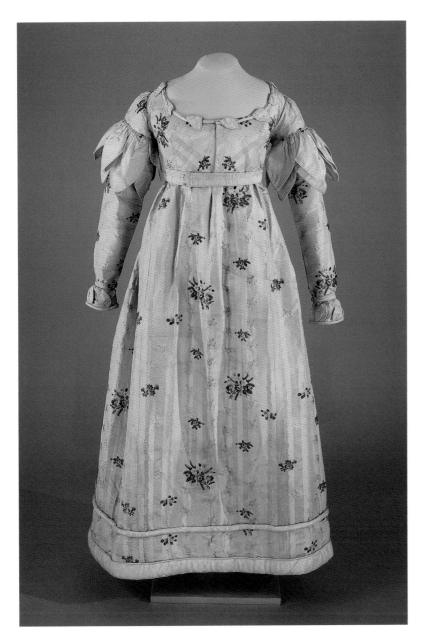

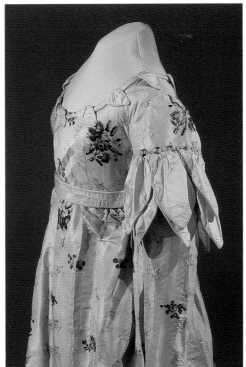

Figs. 290–291. Gown, overall and detail of bodice trimming, Europe or America, silk textile 1770–1780, remodeled 1820s, silk brocaded with silk, trimmed with plain silk flaps and silk fringe, bodice lined with cotton, G1999-248, gift of Tasha Tudor.

The brocaded silk in this charming gown was almost fifty years old when the dress was made. By the late 1820s, skirts had evolved from early nineteenth-century draped silhouettes. Instead, skirts stood away from the body, often aided by padded hems. Crisp eighteenth-century silks could once again be used to good advantage.

the brocaded green silk are typical of 1730s and 1740s styles. The original wearer laced a ribbon or cord through the eyelets in the linen bodice lining, holding the bodice close to the torso, with a kerchief or stomacher to fill in the triangular gap at the front. The bodice back was shaped with pleats sewn in place to the lining. The earlier gown may have had a wide skirt worn with a hoop and a matching petticoat (see fig. 342). The remade gown was brought up to date sometime around 1750 (see figs. 288–289). The new sleeves end in graceful ruffles that had come into fashion around mid century, replacing heavy cuffs. The remodeled gown has a closed skirt with a front drop panel, eliminating the need for a separate petticoat. In all likelihood, the original petticoat was cut up to create the new bodice, sparing the original bodice for posterity.

In the nineteenth century, people continued to take apart and remake clothing into the latest styles, just as they had in previous decades. Heavy, crisp textiles of the eighteenth century were not entirely compatible with draped, neoclassic styles around 1790 to 1820, although a few women continued to reuse old textiles. By the late 1820s and 1830s, however, eighteenth-century textiles were again viable for the new style of gowns with fitted bodices and full skirts (figs. 290–291).

Fig. 292. *"Costumed Participants in Colonial Pageant, Williamsburg, Va., July 4, 1921,"* Courtesy, Swem Library, College of William and Mary.

These residents of Williamsburg, Virginia, dressed up in colonial-style reproduction clothing for an Independence Day celebration. The participants used visual shorthand to suggest the earlier era: large neck kerchiefs, wigs, open-front gown skirts, and suits with knee-length breeches. The women's dresses, however, are only vaguely reminiscent of genuine eighteenth-century styles. Their figures and posture bespeak the 1920s.

Besides the usual alterations for practical daily wear, nineteenth-century people found new uses for old-fashioned clothing at "fancy dress" balls, where they attended parties attired in costumes from cultures or historical periods other than their own. Britain's Queen Victoria and Prince Albert dressed in eighteenth-century style for the queen's 1850 birthday ball. A year later, Queen Victoria dressed in the style of Charles II at the Restoration Ball held at Buckingham Palace.[33] Although the queen could afford to have her "antique" costume made new, many people retrieved their ancestors' clothes from trunks and attics for the popular parties and historical commemorations. In America, the centennial celebration of 1876 gave old clothes new currency. The passion for dressing up in eighteenth-century style continued well into the twentieth century (figs. 292–294).

Even if the size were about right, eighteenth-century clothing did not fit nineteenth-century bodies without alteration. Different styles of corsets and new ideas of personal aesthetics had changed women's posture and the very shape of their bodies (figs. 295–296). While women dressing up may have thought they looked exactly like their ancestors, their costumes had to be restyled with darts and tucks to conform to current corsets and posture. The fashionable nineteenth-century torso was no longer the cone shape it had been in the eighteenth century. In the new century, the body had defined breasts, a small rib cage, constricted waist, and rounder back (see figs. 4, 42, and 95). Even men's bodies changed in favor of squarer, broader shoulders. As people remade old garments, they used current dressmaking and tailoring techniques.

Fig. 293. (RIGHT TOP) "Sarah I'On Loundes Davis,"
Charleston, South Carolina, probably 1920s, G1989-119E, gift
of Alice Davis (Mrs. James) Burke.

Sarah (Mrs. Henry) Davis posed for her photograph wearing an
eighteenth-century gown once owned by her ancestor, Alice
Delancey (Mrs. Ralph) Izard. Areas of machine stitching and
boned darts in the bodice suggest that the gown was first altered in
the mid-nineteenth century. Mrs. Davis added modern lace and
ribbons and further reworked the garment to give it an off-the-
shoulder silhouette. A detail of the gown skirt is in fig. 294.

Fig. 294. (RIGHT BELOW) Detail of gown skirt, British
textile, worn in Charleston, South Carolina, by Alice Delancey
Izard and Sarah I'On Loundes Davis, ca. 1775, altered in
mid-nineteenth century and 1920s, silk brocaded with silk,
bodice lined with linen, trimmed with later net, silk, and lace,
G1989-119A, gift of Alice Davis (Mrs. James) Burke.

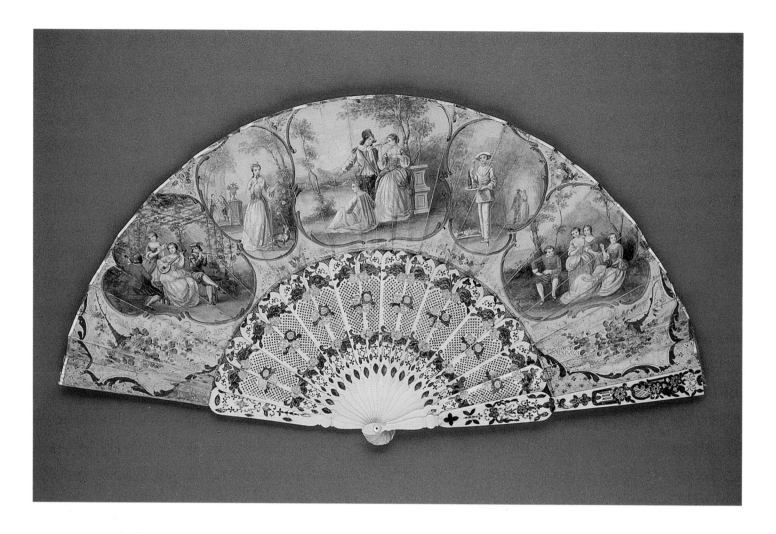

Figs. 295–296. Fan, overall and detail of painted design, Europe, 1850–1870, painted paper, painted and gilded ivory, 1960-165.

Although this fan was designed in an eighteenth-century style, the body shapes and posture depicted indicate a later date. These women have hourglass figures and posture characteristic of the second and third quarters of the nineteenth century.

A woman's gown and petticoat, originally made around 1770, betray their nineteenth-century alterations (figs. 297–300). Machine-sewn darts and new, boned seams create an hourglass bodice shape that was typical of the nineteenth century. The bodice silhouette and the draped, polonaise-style skirt suggest that the gown was remade around 1870 to 1885, a time when draped skirts and variations on the polonaise had returned to fashionable dress. The separate petticoat is also remade and lined with nineteenth-century yellow-white glazed cotton (see figs. 299–300). The pleats in the eighteenth-century petticoat were unpicked, leaving faint fold lines. Whereas the original petticoat was pleated all around, the center front of the remade garment is flat, corresponding to the fashionable shape after 1870. The remaining fullness of the petticoat is gathered at the sides and back in closely spaced gauged pleats of the type used in gowns beginning in the 1830s, but not earlier. A single pocket sewn into one of the seams is characteristic of mid- to late nineteenth-century gowns. Eighteenth-century gowns and petticoats did not have sewn-in pockets; rather, they had slits in the

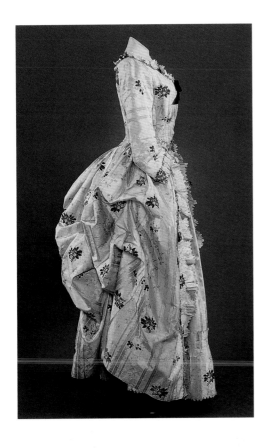

Figs. 297–298. (LEFT AND ABOVE) Gown and petticoat, overall and interior of bodice, Britain, ca. 1770, altered 1870–1885, silk brocaded with silk, trimmed with pinked self-fabric, bodice lined with linen and cotton, later boning and cotton tapes, 1952-459, 1–2.

Boned darts and extra seams in the bodice front accommodate a figure shaped by nineteenth-century corsets. On the reverse of the brocaded silk, visible on the unlined skirt, brocading threads are limited to the pattern area, not carried from selvage to selvage. The petticoat is in figs. 299–300.

Figs. 299–300. (LEFT AND BELOW) Petticoat, overall and detail of waistband, Britain, ca. 1770, altered 1870–1885, silk brocaded with silk, trimmed with pinked self-fabric, lined and backed with cotton, 1952-459, 2.

This petticoat, which matches the gown in figs. 297–298, was remade using nineteenth-century techniques. Creases indicate the original position of the eighteenth-century waistline pleats. New gauged pleats, or folds stitched to the waistband at the edge of each fold, concentrate the fabric at the sides and back. A nineteenth-century pocket is sewn into the right side.

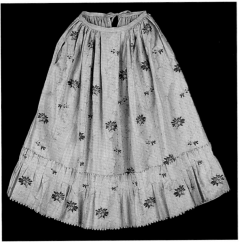

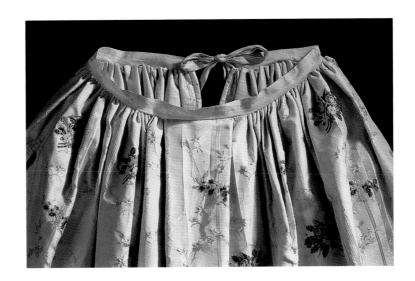

skirts for access to separate pockets tied around the waist (see figs. 47 and 89).

Another gown of eighteenth-century fabric betrays evidence of being altered more than once (fig. 301). It is made of 1760s silk, but is considerably pieced up, with old marks that suggest the bodice fronts once were folded on either side of a stomacher or kerchief (see fig. 70). Judging from faint pleat marks, the gown's back was once a sack. The first alteration must have occurred in the 1780s, when the sack back was converted into a fitted style with a deep point at the waist, a feature especially characteristic of the 1780s (see figs. 49–50). Sometime around 1900, bodice darts were added and the sleeves modified. About that time, contrasting trim matching the petticoat fabric was sewn around the neckline, down the front on either side of the open skirt, and on the sleeves as flounces; the trim was later removed. The square shoulders and the shape of the gathered sleeves are especially characteristic of women's clothing at the end of the nineteenth century. The separate petticoat is an entirely different eighteenth-century patterned silk, woven in colors that complement the gown, but not worn with it until around 1890 to 1910 (see fig. 301). Folds in the fabric of the petticoat indicate that it was cut from a sack-back gown.

Men also wore antique suits for fancy dress and theatrical events. A tall, large man must have appeared out of scale for his diminutive eighteenth-century silk velvet suit that was originally made for a much shorter man (figs. 302–303). To lengthen the coat sleeves, the anonymous tailor who performed the alterations in the nineteenth or early twentieth centuries removed the cuffs and extended the sleeves with pieces of wool cloth lined with cotton. Then he reapplied the cuffs to cover the new sleeve extensions. Moving the cuffs down, however, revealed the cleaner antique textile that had originally been protected from fading and soiling under the cuff. The breeches rise, or torso length, was extended with wool broadcloth and the legs lengthened and enlarged at the inseams using matching material probably taken from the now-missing waistcoat (figs. 304–305). Despite the elongation of the breeches and coat sleeves, the tailor truncated the coat at the waist, probably to conform to nineteenth-century fashions.

What can be learned from altered clothing? Each surviving garment says something about the person who owned it and passed it down over the years. Today, people understand that remaking and wearing antique clothes that are intended for preservation are injurious to the artifacts. Collectors and museums guard fragile artifacts by limiting their handling and exposure to light. When a period style is required for theatrical or interpretive reasons, twenty-first-century people copy the antiques, rather than alter them to fit their bodies. Preservationists decry the alteration or loss of so many genuine documents from the eighteenth century.

Yet perhaps today's generation can forgive their ancestors for altering old clothes. After all, people today still share an impulse to alter the things with which they live. They reupholster old chairs and sofas to use them in traditional living rooms; they add new kitchens and bathrooms to old houses; they repair and restyle christening and wedding dresses to wear at special family events.

The human spirit has long connected with its past through the legacy of surviving material culture by collecting, categorizing, and studying antiques. As modern educators and scholars point out, and as ordinary folks know instinctively, people need the past to help them make sense of the present and the traditions that have come down to them. But, asserts historian David Lowenthal, people constantly change, alter, and "improve" the past, even without conscious knowledge. Sometimes the very attempts to preserve the past cause its alteration: "We also remould the past to our expectations by embellishing its relics. Although revision is seldom the ostensible motive, removing dirt or rust, reconstructing a ruin, restoring an old building to what it might or should have been, and adding to extant remains all in fact aim at improving on what has survived. That improving the past meant changing it long went unrecognized."[34] The same might be said of clothing. The people who altered the clothes now in the Colonial Williamsburg collections probably did so without being aware that their actions would ever be noticed or analyzed by a community of costume historians bent on understanding every thread and stitch.

Viewed in one way, altered eighteenth-century garments are compromised and inferior survivors of their time. Looked at another way, altered clothing can speak eloquently of transformation over time: changes in body shape or size, evolution of fashion, developments in technology or construction, and availability of materials.

This historical information has implications for how altered clothes should be treated. Should they be taken apart (again) to restore them to their original time period, in the process removing several hundred years of stitching, accretions, and ephemera of construction?

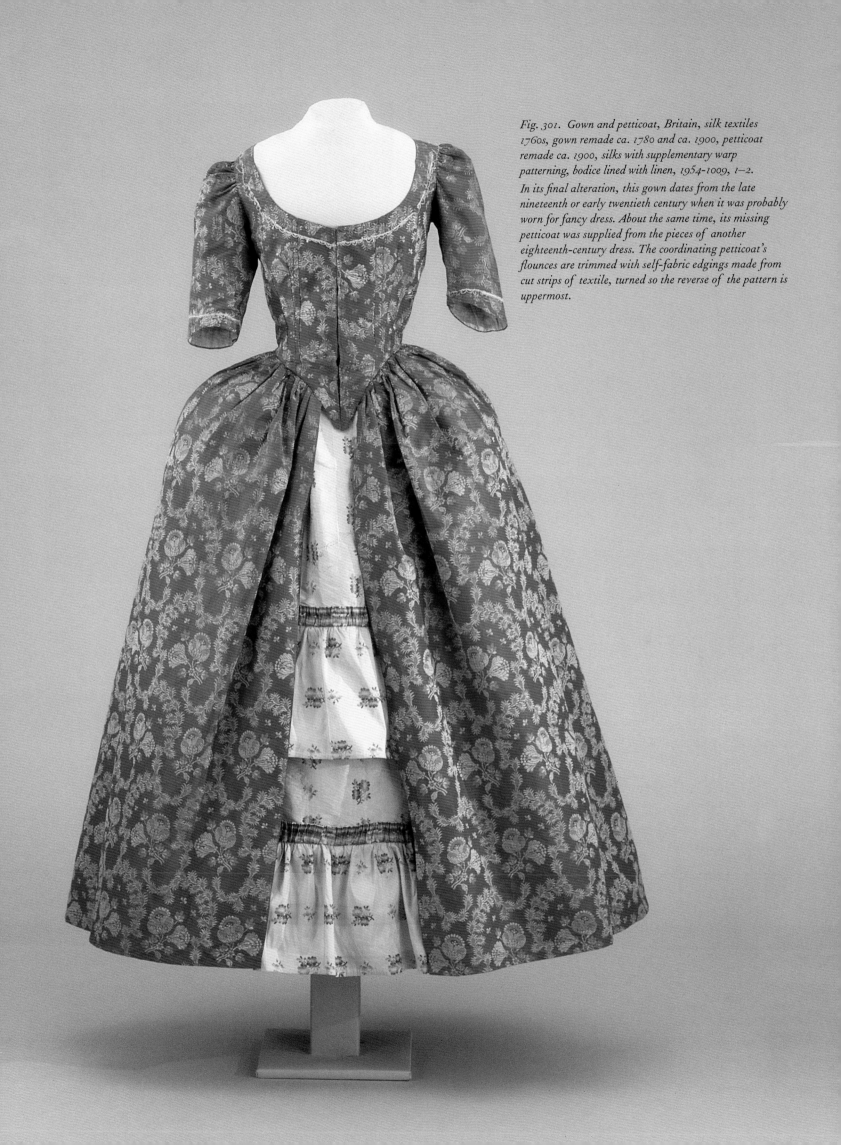

Fig. 301. *Gown and petticoat, Britain, silk textiles 1760s, gown remade ca. 1780 and ca. 1900, petticoat remade ca. 1900, silks with supplementary warp patterning, bodice lined with linen, 1954-1009, 1–2.*
In its final alteration, this gown dates from the late nineteenth or early twentieth century when it was probably worn for fancy dress. About the same time, its missing petticoat was supplied from the pieces of another eighteenth-century dress. The coordinating petticoat's flounces are trimmed with self-fabric edgings made from cut strips of textile, turned so the reverse of the pattern is uppermost.

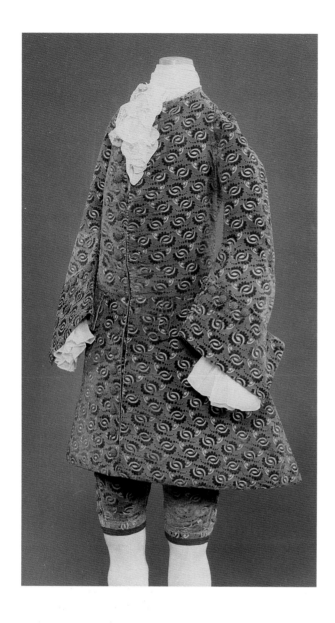

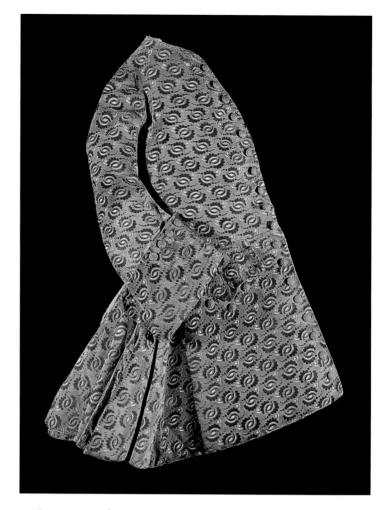

Figs. 302–305. (LEFT, ABOVE, AND OPPOSITE) Suit, overall, coat, and breeches, front and back, Britain, 1725–1750, altered 1850–1920, cut, uncut, and voided silk velvet trimmed with silk thread buttons, lined with later silk, wool alteration fabric, reproduction shirt, 1967-129, 1–2.

This coat was shortened in body length, yet the sleeves were made longer. Unfaded areas of velvet above the cuffs show their original position. Once-functional buttonholes are now sewn shut and the coat closes with a hook and eye. Hidden beneath the coat when worn, the breeches have extensions of tan wool. The suit has an oral tradition of use by Sir William Fleming (1656–1736) of Rydal Hall, Westmorland, England.

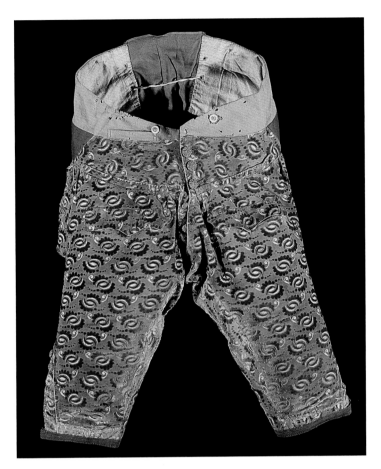
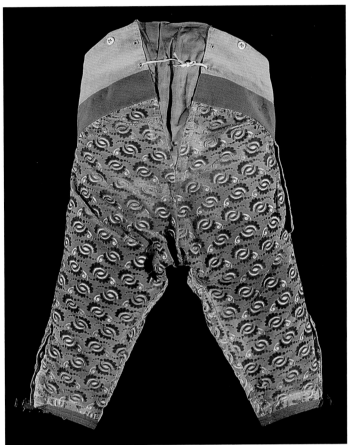

Removing stains from a historical garment, restoring a missing sleeve, or repairing holes may be worthy efforts, but such actions also alter the artifact and, thus, change the historical record. The importance or rarity of a particular original garment may warrant such action, but restoration should not be done without full knowledge and analysis of the consequences.

If the past is always changing and being changed, how does the present generation respond? Lowenthal believes that people respond in one of four ways. They might "remain unaware" of past changes; they may think that alterations are "inconsequential"; they can believe in their ability to "rectify previous changes" and restore relics to an original state; or they accept "alterations as necessary evils," at the same time conserving objects from worse erosion.[35]

Altered clothing confirms and illuminates the written record of how people lived with their clothes. Each garment has a different story contained within the threads and fibers themselves, allowing modern onlookers to peer into the lives of those who wore items over many years and who adapted to constantly changing life situations. Altered clothing shows how people related to their own histories and reveals that continuum in the present, allowing people today to share in the history. If a pristine garment is a valuable snapshot of a person, place, or time, then an altered garment is a motion picture that tells another compelling story worthy of careful preservation.

CONCLUSION
Listening to Clothes

How have so many old garments and accessories survived for hundreds of years? Some clothes, such as court presentation suits or ball gowns, were too beautiful to throw away after the event, while others, such as wedding gowns and babies' clothes, had sentimental meaning. Yet other things were tucked away for eventual remodeling or simply forgotten in an attic or trunk. Many eventually entered museum collections including those of Colonial Williamsburg, which has been collecting and preserving costumes since 1930.

Some garments that were once wearing apparel have become valuable archival documents and museum exhibition pieces. Objects, human beings, landscapes, even abstract concepts of symbolism and beauty change over time. Artifacts seldom retain the same meanings during their entire existence. At various times in its life cycle, the same outfit may have been considered the latest fashion, dowdy or embarrassing, amusingly archaic, raw material for restyling, a costume for a party, a keepsake, an expensive antique, and a priceless icon. Sometimes, an object is the only record remaining of a human life.

What does old clothing reveal? Is there really such a thing as a language of clothing? Strictly speaking, language is a means to communicate thoughts, feelings, and facts through vocal sounds, or human speech. But the concept can refer to less direct messages, such as gestures, signs, and even music. What people wear can be a method of communication, too. Very often (although not always), clothing can tell others the wearer's gender, country of origin, occupation, economic level, activity, and attitude. On a broader scale, textiles and clothing may offer clues to the spirit of the times—the trends in thought that are generally shared by those of a particular culture at a given time, including the place of women, laborers, children, or role models in society (see fig. 306 and sidebar, p. 87).

Unlike written or spoken communication, the language of clothing does not have fixed rules or meanings. What if someone is wearing an odd combination of garments?[1] Without corroborating words and explanations, the meanings of clothing may be misunderstood (see sidebar, p. 213).

Those who want to know the language of eighteenth- and early nineteenth-century clothing need basic knowledge about the artifacts. Although traditional connoisseurs sought to identify the artists and characteristics of the most exceptional works of art, contemporary collectors and

Fig. 306. Close-up of "Apotheosis of Benjamin Franklin and George Washington" furnishing textile, Britain for export to America, ca. 1785, plate-printed linen-cotton, 1959-18.

At the time this textile was designed, Benjamin Franklin and George Washington were greatly admired as heroes of the Revolution and role models for the new nation. In 1783, Franklin had signed the Treaty of Paris, which officially ended the Revolutionary War. Washington was hailed as the victorious commander in chief. He would become president in 1789. See fig. 122.

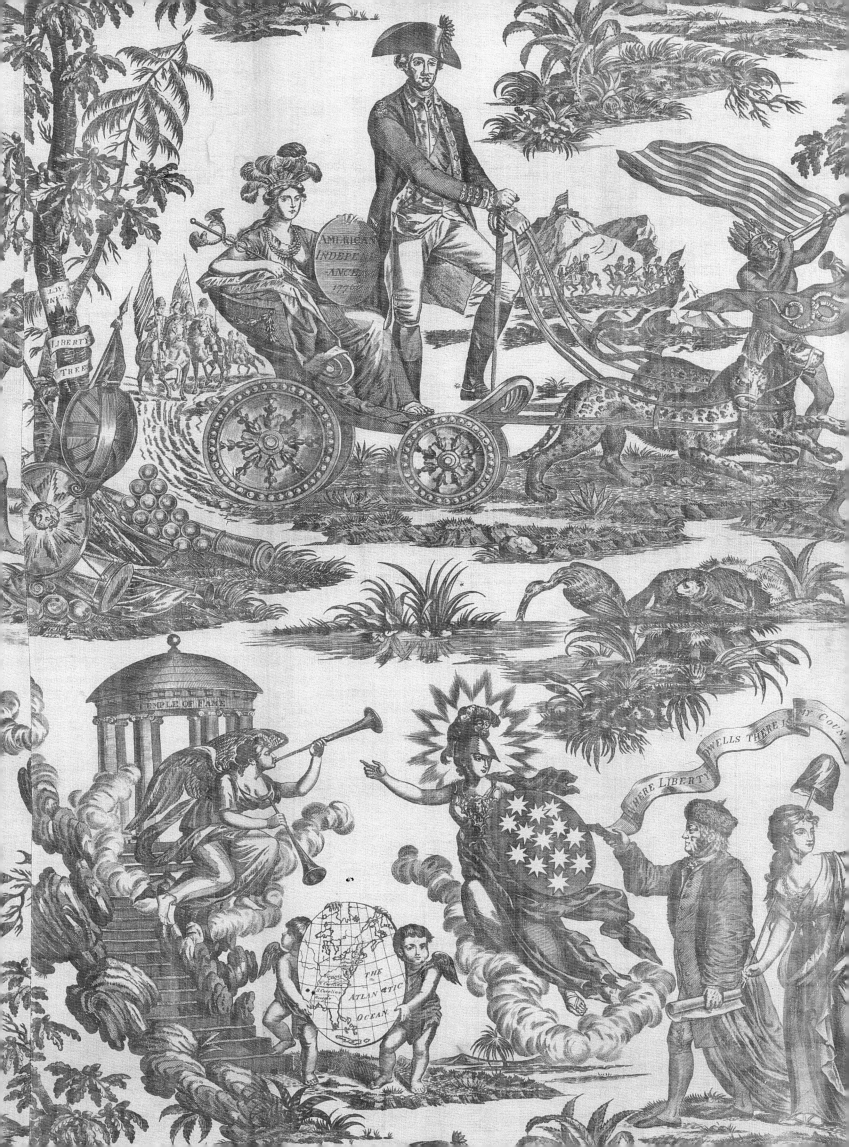

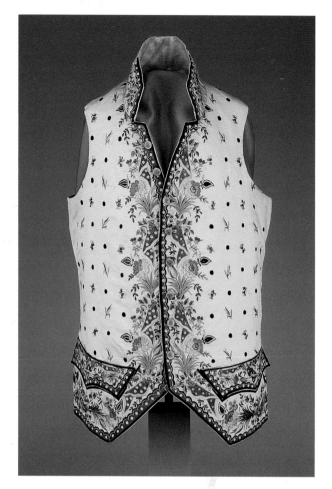
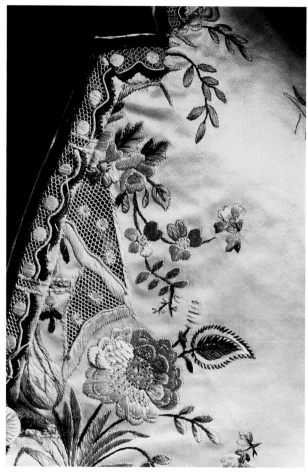

Figs. 307–308. Waistcoat, overall and detail of embroidery, probably Britain, 1780–1800, silk satin embroidered with silk, couched cord, and appliquéd net, lined with cotton and silk, cotton back, G1989-432, gift of Mrs. Cora Ginsburg.

Collectors and museums have always valued the finest artifacts that survived from the past. This waistcoat is an exceptional example in near-perfect condition. Couched cording and embroidery, rendered with the greatest delicacy and skill, surround lacy net appliqués.

scholars have broadened their outlook. They not only continue to study and admire the beauty of historical masterpieces, but also look closely at modest objects such as underwear and workers' garments (figs. 307–310). Examination often includes microscopic and scientific analysis.

Some studies delve into the largely hidden meanings of clothing to explore questions such as the psychological or symbolic basis for a pocket's ornamentation, a skirt's fullness, or a necktie's shape. Sometimes, concealed meanings are made known through artistic or literary sources. By the way they dress their subjects, painters and writers often tap into the meaning of clothing and reveal truth. Writing during a formative period in Amer-

ica's early history, James Fenimore Cooper captured the essence of the frontier through the homespun and leather garments of his fictional character Leatherstocking. Although not literally true, mythological clothing, people, and events say important things about a culture's core beliefs.

Scholars of historic costume try to know the humans who wore the clothes, their locations, genders, ages, and stations in life. Was a particular outfit daily wear, or was it specialized for an occupation or an out-of-the-ordinary occasion? Did many people wear a garment type, or was it the choice of an individual? Does a piece of clothing reach a museum collection because everybody wore one like it, or because almost nobody did? Such questions are challenging

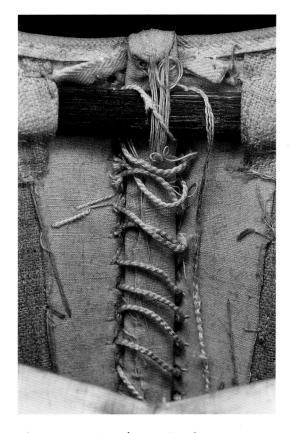

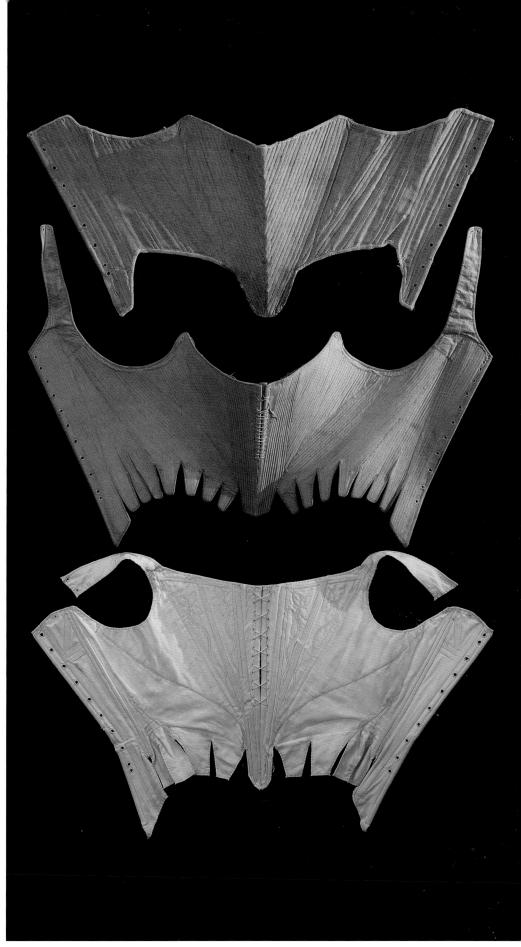

Figs. 309–310. *Women's stays, Strapless stays,
Britain, 1740–1760, linen boned with baleen and
wood, waist tabs removed at a later date, 1935-96;
Beige stays with straps, overall and detail of interior
with boning material, Britain, ca. 1780, cotton lined
with linen, boned with baleen, 1986-45; White stays
with straps, New York, probably worn by Ann Van
Rensselaer, 1780–1790, cotton boned with wood or
cane, G1990-9, gift of Mrs. Cora Ginsburg.*

*These relatively plain stays are nevertheless important
examples for understanding how clothing looked on
eighteenth-century bodies. Stays came in a variety of
styles, some with straps to help maintain the fashionable
flat-back posture. The reason for the removal of waist
tabs on the top stays is not known, although the
alteration may have been for a boy's use; Diderot's
ENCYCLOPÉDIE shows boys' stays without tabs. The
stays in the middle have a horizontal bundle of boning
material that slides in a channel for chest expansion.
This style may have been worn for physical activities
such as riding. Now faded to beige, the stays were
originally pink. The white cotton stays at the bottom are
only partially boned to give a greater degree of comfort.*

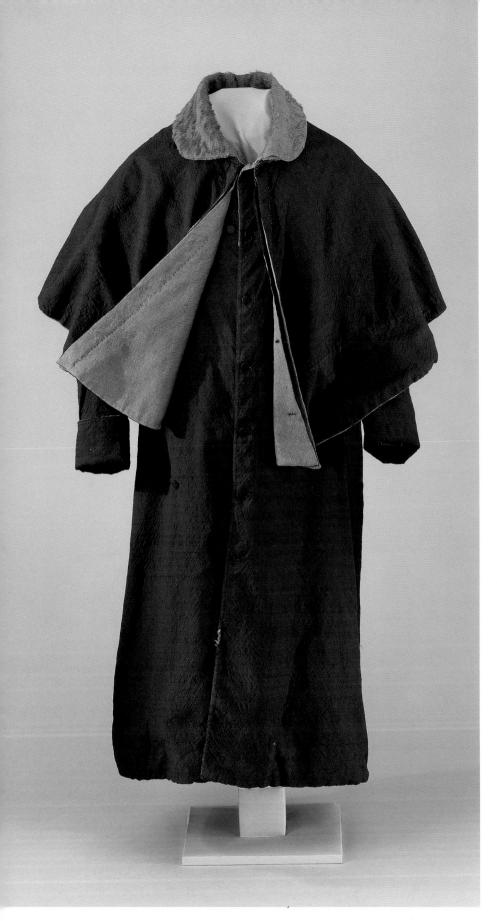

Figs. 311–312. Greatcoat, overall and detail of back with collar turned up, possibly Pennsylvania or Britain, 1780–1800, wool trimmed with wool or mohair shag, body lined with wool, sleeves lined with linen, from the collections of Don Newcomer and James Johnston, 2001-835, partial gift of Tom B. Wilson. This rare man's overcoat was discovered at Hanbury Hall, Britain. Found in storage along with a Pennsylvania rifle from about 1760, the coat may have been used by a Revolutionary War soldier and taken back to Britain following the war's end. Certain stylistic features, especially the quilted stand of the collar, resemble construction techniques on coats from around 1800. Because few eighteenth-century greatcoats survive for comparison, the date of this important artifact is still uncertain. If the Pennsylvania attribution is not correct, the coat may be that of a British coachman. Three widely spaced buttons on the right front are for fastening the coat more closely around the body.

enough when studying present times and people, and even more so when looking back hundreds of years.

Although many common garments did not survive to enter museum collections, prints, paintings, and written sources describe the clothing of daily life. Despite the confining influences of high-style fashions, men and women of the past adapted their clothing for ordinary events. When it was cold, they covered up in functional greatcoats or voluminous cloaks (figs. 311–312 and see fig. 26). When it was hot, people shed clothing items normally considered essential to proper dress. Sailors and some other laborers wore loose trousers instead of restrictive breeches that buckled tightly below the knees. Explorers wore leggings to protect their ankles and calves. Workingwomen wore waist-length fitted jackets

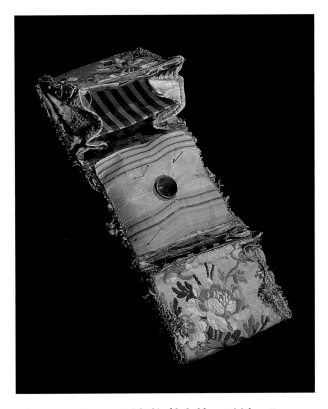

Fig. 313. Sewing case with thimble holder, British or European textiles, made in America, ca. 1800, brocaded, plaid, and striped silks trimmed with silk gimp, from the collection of Mrs. DeWitt Clinton Cohen, G1971-1419, anonymous gift.
A paper label states that this sewing case was made from pieces of Martha Washington's dresses. Although it is difficult to assign an accurate time period to such small fragments, the silks appear to date from about 1760 to 1800.

or loose short gowns. Pregnant women tied their petticoats above their abdomens and filled in the gaps in their gowns with kerchiefs and aprons. Everyone selected textiles and trimmings appropriate to the occasion and particular circumstance.

Too many clothes have lost their histories. People who knew the wearers may have died before passing on the stories to subsequent generations. Some garments and textiles are accompanied by letters or documents that state Aunt Logan, Peter Speer, or Martha Washington wore them, but may fail to say when, where, or for what occasion (fig. 313 and see figs. 32, 147, and 167).

In other instances, physical evidence itself has eroded. Paper labels, such as those inside shoes or hats, may have

CURATOR'S CLOTHES

What conclusions can be made when someone is wearing an odd combination of garments? An onlooker might well be confused to see a woman wearing a dressy skirt and blouse, running shoes and socks, a white smock, and a picture identification tag with bar code.

The odd combination becomes clear only after the wearer explains that she is a museum curator in the process of installing an exhibition on a day that she also has to attend an important meeting. The smock prevents damage to vulnerable antiques from modern buttons, buckles, zippers, and jewelry. The running shoes are for comfort and safety as she carries artifacts and climbs ladders. The bar-coded tag is employee security identification and an access key to costume storage. Before the meeting, the curator will take off the smock, put on a suit jacket, and change into pumps.

Clothing speaks with the clarity of written language only to those initiated into the significance of garments and combinations. For the rest, it suggests meanings, ideas, and beliefs about an individual or a society.

Figs. 314–315. Hat, overall and detail of label, Lancaster, Pennsylvania, made by Philip Heitshu and Son, 1806–1827, felted fur lined and trimmed with silk, paper label, 1992-227.

Although the style of this hat looks eighteenth century, it was made in the nineteenth century. The label glued to the crown lining identifies the maker as Philip Heitshu, son of a German immigrant to Philadelphia. After a period of time spent in Loudoun County, Virginia, Heitshu moved to Lancaster, Pennsylvania, in 1806 and opened a hat manufactory. He retired from the business in 1827.

worn off, causing potential for misidentification. A felt hat, for example, has the wide flat brim and shallow crown typical of women's headwear from 1750 to 1780 (figs. 314–315). Without further documentation and judging by style alone, a collector or curator would assign a date in the eighteenth century. The near miraculous survival of a fragile maker's label, however, indicates that the hat was made in the conservative community of Lancaster, Pennsylvania, sometime after 1806, and perhaps as late as 1827. If a wearer was old-fashioned or thrifty, his or her clothes might date much later than stylistic features would suggest. Further, many clothes had useful lifespans of twenty years or more. One American gown was remade to wear almost fifty years after the textile was first constructed (see figs. 108 and 197). Scholars combine their study of antique clothing itself with knowledge gained through written documents such as labels, orders, diaries, advertisements, and merchants' records. They compare garments with those depicted in paintings and prints. Serious students know that costume dating and identification involve judgment, subjectivity, and humility.

Historic people and their possessions are foreign and familiar. Because ideas of beauty and deportment have changed over the years, styles from more than two hundred years ago seem quite different from today's styles. Then, women dressed in long, full petticoats instead of trousers or short, fitted skirts. For formal occasions, men once sported embroidered flowers on velvet; men today wear plain black wool. Little boys were put into skirts,

not rompers. Middling and gentry children wore boned stays instead of soft, knitted T-shirts.

Yet antique clothing continues to be a part of the present. Historic styles inspire modern fashions. Some years, women will wear dresses with raised waists, a nod to fashions around 1800, or vests inspired by men's waistcoats of the 1770s. Leather jackets and similar western garb remain popular. For ceremonial events, many people select traditional styles, a process called fossilization. Formal tailcoats, for example, are modeled on early nineteenth-century suits (see figs. 144 and 145). Brides might choose a dress with full hoopskirts, triangular insets reminiscent of stomachers, or other time-honored details to underscore the dignity and formality of the occasion.

Familiarity with period clothing styles may help people comprehend historic events. Many reenactors, who re-create scenes from the past as an avocation, nevertheless take their studies seriously, knowing that artifacts give special insight into the period they are trying to understand. Museum interpreters wearing reproduction clothing make history come to life for many visitors who learn what it was like to dress up, work, play, and face death in past times. Those commemorating a centennial or bicentennial of their organization may celebrate by wearing the styles of the original time period. Historical clothing styles continue to live in literature, operas, plays, motion pictures, and everyday life.

Although many wish that artifacts could literally talk about their experiences, clothes are able to reveal many stories to those willing to interpret them. Antique costumes in museum and personal collections are rich with the history of people and their daily lives. Far from being lifeless artifacts in acid-free boxes, antique costumes hold stories in every silhouette, textile, stitch, wrinkle, and stain.

TIME LINE

From the 1690s to the 1830s, basic clothing types evolved slowly. Gentlemen's suits during the late seventeenth century and most of the eighteenth century consisted of three pieces: knee-length breeches, waistcoats with or without sleeves, and coats with long skirts that reached to or slightly above the knees. Following a transitional period from the 1790s to the 1820s, men adopted long pants for fashionable dress, a style that has endured to the present. Before 1790, most women's stylish gowns had close-fitting bodices and long, full skirts. An under-skirt, called a petticoat, often showed through the open front of the gown skirt. Just as men's pants underwent a style transformation between 1790 and 1820, women's gowns also changed dramatically. During the height of the new style, slim skirts fell gracefully from high-waisted bodices. Although men had retained long trousers following this transitional period, women returned to full skirts and fitted bodices with new varia-tions in torso shape and bodice styling. During the one-hundred-forty-five-year period from 1690 to 1835, sleeve and skirt shape, torso length, color and textile choice, and trimmings—details that may appear subtle to modern eyes—nevertheless signaled clearly whether the person was wearing a garment in the latest fashion or an out-of-date outfit. Because styles of trimmings and accessories changed more rapidly than the basic silhouette, women were often able to update old-fashioned gowns by replacing ruffles and lace to create a new look. Men could have their suits retrimmed or recut.

As the eighteenth century began, the three-piece suit was already an established part of a man's formal wardrobe (fig. 317). The suit had developed in the 1660s and has influenced menswear ever since. Around 1700, suit coats had long, flared skirts and full, cuffed sleeves. Men wore their suit coats over long, skirted waistcoats and white shirts. Low-slung knee-length breeches had center-front buttoned openings and were almost obscured by the two upper garments. Fitted stockings covered men's lower legs. Fashionable men wore long wigs.

Around 1700, women wore clothing styles that formed the torso into an elongated cone, pushing the breasts upward. To create this shape, women used stays or had stiff boning built into the gown bodice. Triangular stomachers further emphasized the cone shape. Women's gowns had nar-row shoulders and sleeves that were full and cuffed just above the elbows. Ruffles on the shift worn underneath fell gracefully over the elbows. Long skirts were usually open in front to reveal a petticoat. The most fashionable skirts were narrow at the sides, with the fullness caught

Fig. 316. Detail of "Adam and Eve" apron, England, ca. 1700, linen embroidery on sheer cotton, G1991-525, gift of Mrs. Cora Ginsburg.
The skeletal figures of Adam and Eve and a serpent representing Satan adorn the center of this white embroidered apron. The unknown wearer would have been reminded of temptation's dangers every time she donned the decorative accessory. For overall view, see fig. 326.

Fig. 317. LES DÉTAILS DE L'HABILLEMENT DU COURTISAN, *by Sebastien Le Clerc, France, 1678, hand-colored line engraving on paper, 1961-72.*

A man and woman in stylish seventeenth-century dress stand in a millinery shop stocked with textiles, lace, and other accessories. The man wears a newly fashionable suit with a long, flared coat that effectively hides the waistcoat and breeches he wears underneath. The woman's torso is shaped as an elongated cone, and her skirt is draped back to reveal a petticoat. This style of wearing the skirt open to show a decorative petticoat persisted for more than a century.

back into a bustle effect. Embroidered aprons were fashionable accessories (fig. 316). Women dressed their hair in tall hairstyles, sometimes with starched or wired props.

Although plain textiles were available, both men and women wore patterned fabrics of dark, rich colors. The textiles came in many different patterns, ranging from symmetrical isolated floral and scroll motifs to exotic, abstract designs inspired by Oriental trade, now called Bizarre silks.

By 1710, most women's skirts lost their back fullness and evolved into a dome silhouette. The upper part of the gown changed relatively little, retaining the cone shape and full, cuffed sleeves. This silhouette continued in fashion

through the 1730s. Another fashion option was a tent-shaped gown that fell freely from pleats at the shoulders. Over time, women began to style their gowns with the front bodice fitted closely to the body, retaining the loose pleats at the back. Variations of this sack-back fashion remained in style until the last two decades of the eighteenth century.

During the 1740s, women's sleeves began to narrow slightly. Skirts evolved to great width at the sides, propped up by hoops made of reed, cane, or whalebone that were sewn into petticoats or constructed as separate structures to be tied around the waist under the skirt. Wide skirts served as canvases for displaying bold, realistic floral silks from the 1740s and lighter scatterings of flowers from the 1750s.

At the same time that women's skirts were wide and flared to the sides, men's suit coats echoed the feminine silhouette. Coat skirts stiffened with interlining to stand away from the body were given extra width by pleats at the hip. Full coat sleeves terminated in wide cuffs. Although waistcoats became shorter, they continued to feature lavish, heavy trimmings into the 1750s.

In the 1750s and 1760s, women's skirts began to narrow, becoming bell-shaped by the 1760s. Cuffs gradually went out of fashion. Instead, cascades of double or triple sleeve ruffles echoed the frilly effect of ribbons, lace, and flounces applied elsewhere on gowns, often in serpentine patterns down the fronts of skirts. In the middle years of the eighteenth century, women's hairstyles and caps were small and worn close to the head, giving a decidedly triangular shape to the body silhouette. Headdresses got taller during the 1760s.

Men's suits became slimmer and more closely fitted in the 1760s. Some suit coats were cut away at the center front and not intended to button completely. Shorter waistcoats revealed more of the lower torso and placed greater emphasis on the thighs. In response to these short waistcoats, old-fashioned breeches with center-front buttoned openings went out of style during the third quarter of the century. Newer fall-front breeches had a flap of fabric that covered the opening and gave a smooth, uninterrupted line. The frock, originally a casual workingman's coat with a turndown collar, was adopted for fashionable dress.

During the 1770s and 1780s, the silhouettes of men and women diverged considerably. Men's daytime suits were sober and practical, often made of cotton velvet or solid wool cloth in dark colors. Informal suits that Englishmen had worn in the country now came into fashion in the city. This English style of comfortable, casual clothing began to influence French fashion. Men's suit coats, which continued to become narrower, had high, standing collars, slim sleeves with narrow cuffs, and cut-away fronts that did not always meet over the chest. Waistcoats continued to get shorter, sometimes reaching waist level and often cut straight across. Breeches waistlines rose to avoid a gap from shortened waistcoats. Breeches legs got longer. A notable exception to sober male style was macaroni dress, popularized by young men who returned from the grand tour with a fondness for pasta, hence the nickname macaronis. These young men wore bright, exaggerated styles of clothing.

In contrast to most men's clothes, women's fashions of the 1770s and 1780s were neither sober nor practical. In addition to trimmings and flounces, gown skirts were sometimes drawn up in puffs with drawstrings or tapes, creating a style known as the polonaise. Dress textiles became lighter in color and weight and were woven in small-scale repeat patterns that would not be obscured by lavish trimmings or draped skirts. Tall hairstyles trimmed with pearls, ribbons, and padding emphasized the frivolous appearance of fashionable clothing. Some gowns had sewn-in mock stomachers that buttoned in the front rather than being removable. Other fashionable gowns pinned or laced closed down the center front, dispensing with stomachers altogether. Sleeves got tighter from the 1770s onward; often, the sleeve ruffles were omitted.

From the 1750s through the 1770s, women's bodices often had flat fronts created by long, straight stays. In the 1780s, a new look emphasized a more prominent chest. Puffy kerchiefs rounded and filled in the front décolletage. To balance the larger chest, the fullness of the skirt was pushed back. The fashionable posture became an S-curve, emphasizing the chest and derriere. Some women in the 1780s favored long sleeves that were shaped to curve over the elbows. These long sleeves coexisted with cuffed elbow-length sleeves. Ensembles with wide collars patterned after greatcoats became fashionable for daytime and outdoor activities such as walking. Hats and hairstyles became wide and large, with frizzed softness around the face.

About the same time that the tight, exaggerated S-curve gowns were in style, neoclassic design began to change women's wear. By the mid-1780s, some avant-garde women chose loose chemise dresses of light, gauzy fabrics. Sashes at the waist gave a youthful appearance similar to that of frocks children had been wearing for more than twenty years. During the 1790s, waistlines rose, and by 1800, most fashionable women wore a new style with high waist and natural body shaping. Some women stopped wearing stays.

In the first two decades of the nineteenth century, men's fashionable long pants gradually replaced knee breeches for all but formal occasions and country sporting events (fig. 318). Although workingmen had previously worn practical and comfortable trousers, long pants now became fashionable. At first, pants were tight, retaining the former emphasis on well-shaped legs. Looser trousers soon replaced tight pants. Suit coats evolved into tailcoats cut straight across the front about waist level. In the mid-1820s, men began to wear a new style of frock coat with a narrow waist and full skirt. Although the names were the same, these new coats differed from

Fig. 318. "Four Seasons" handkerchief, Britain, used in New England, 1820s, roller-printed cotton, silk mark-
ing stitches, from the collection of Mrs. DeWitt Clinton Cohen, G1971-1445, anonymous gift.

The borders of this large handkerchief depict activities appropriate to the seasons of spring, summer, autumn,
and winter. During the 1820s, the transition from knee breeches to long trousers was well under way. Some men on
the handkerchief wear the shorter breeches, while others have adopted long pants. According to family history, the
initials S.G. embroidered in the corner are those of a member of the Gardner family.

frocks of the 1770s in that the nineteenth-century version had lapels and waistline seams.

During the 1820s and 1830s, women returned to gowns with fitted bodices, increasingly lower waistlines, and full skirts. Corsets, which had never entirely gone out of fashion, were newly shaped with cups for the breasts, transforming women's torsos from eighteenth-century cones to nineteenth-century hourglasses. Sleeves became very full and gathered at the upper arms.

Clothing styles continued to evolve, sometimes slowly and at other times with dramatic speed. Societal roles and mores, current events, and professional fashion designers all influenced clothing. Knowing the evolution of high fashion does not necessarily tell the scholar how ordinary people dressed for everyday. As in any diverse society, some people maintained their positions in the forefront of new trends, while other individuals followed few, if any, changes in fashion. Even today, many people wear clothing that is five, ten, or even twenty years old. Nevertheless, fashionable styles are a barometer for predicting social evolution and the standing and attitudes of those who wear the clothes.

FASHIONABLE CLOTHING

Men

Three-piece suit, developed in 1660s, still worn

Suit coat reaches to knees, flared below waist, with full, cuffed sleeves

Waistcoat slightly shorter than coat, sometimes with sleeves

Low-slung knee-length breeches hidden by upper garments

Breeches have center-front buttoned opening

Lower legs covered by stockings

Wigs full and long

Women

Gown bodices stiffly boned or worn over boned stays

Bodice silhouette an elongated cone, emphasized by a triangular stomacher

Breasts pushed up high

Sleeves full and cuffed high on arm

Gown skirts long, usually open in front to reveal decorative petticoat

Skirts narrow at sides, sometimes with fullness pulled back into bustle

Hair dressed in tall superstructure

Textiles often richly colored and dark in hue

Textiles patterned with isolated flowers, scrolls, or bizarre abstract designs inspired by Orient

Embroidered aprons fashionable

Men & Women

Fig. 319. Man and woman on sampler

Men's Clothing

Women's Clothing

Fig. 322.
GEOMETRIA

Textiles

Shoes & Accessories

Fig. 325.
"Constantinople" man's pocketbook or comb case

*Fig. 320. Sʀ John
Percivale Barᵀ*

*Fig. 321. Sleeved
waistcoat*

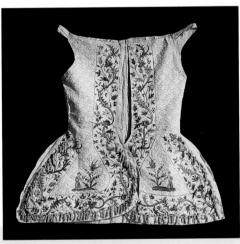

Fig. 323. Waistcoat

Fig. 324. Dress textile

*Fig. 326. "Adam and Eve"
apron*

FASHIONABLE CLOTHING

Men

Suit coat skirts remain full

Waistcoat gradually shortens, still highly decorative

Short breeches worn low on hips

Women

Skirts evolve into dome-shaped silhouette

Bodice retains cone shape, emphasized by stomacher

Sleeves full and cuffed

Sack-back gown developed, at first, a tentlike gown that falls freely from pleats at shoulders; later, fitted at bodice front

Hair styled close to head

Textiles often in dark, rich colors

Textiles have lacy, symmetrical designs or tight scrolls

Decorative short aprons fashionable

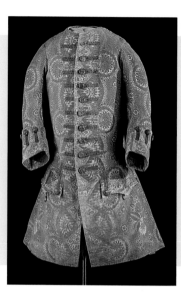

Fig. 329. Coat

Fig. 333. Detail of gown textile

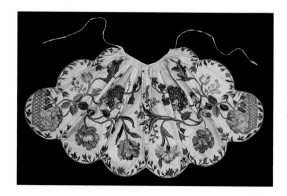

Fig. 335. Apron

Fig. 327. Plate
from FLOOR
DECORATIONS
OF VARIOUS
KINDS

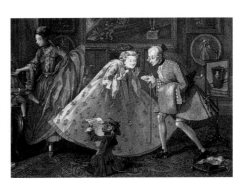

Fig. 328.
TASTE IN
HIGH LIFE

Fig. 330. Breeches

Fig. 331. Detail
of purse

Fig. 332.
DEBORAH
GLEN

Fig. 334. Dress textile

Fig. 336. Purse

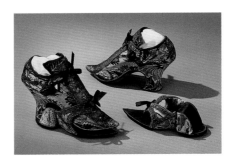

Fig. 337. Shoes
and clogs

FASHIONABLE CLOTHING

Men

Suits still have full skirts, feminine silhouette

Coat skirts stiffened to stand away from body, shaped by pleats at hip

Coat sleeves full; cuffs remain very large

Low-slung knee breeches have center-front buttoned opening

Waistcoats continue to shorten, often heavily trimmed

Women

Bodices retain cone shape and use of stomachers

Sleeves begin to narrow slightly

Skirts become very wide at sides, propped up by hoops

Textiles feature three-dimensional floral designs

Aprons remain fashionable accessories

Fig. 339.
Breeches

Fig. 344.
Dress textile

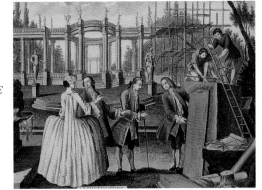

Fig. 338. ARCHITECTURE

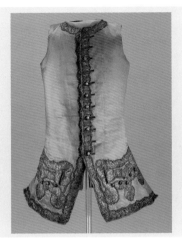

Fig. 340.
Waistcoat

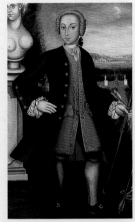

Fig. 341. GEORGE BOOTH

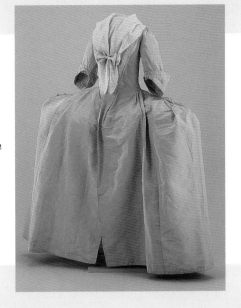

Fig. 342. Gown

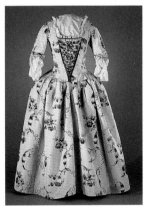

Fig. 343.
Gown

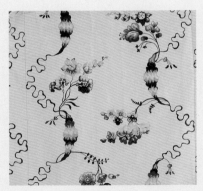

Fig. 345. Detail
of gown textile

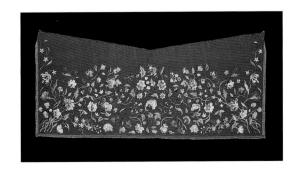

Fig. 346. Apron

FASHIONABLE CLOTHING

Men

Suits gradually become slimmer

By 1770, coats cut away at center front; some do not fully button

Waistcoats continue evolution toward shorter length, reveal more of lower torso and thighs

Fall-front breeches eventually replace center-front buttoned opening

Frock coat with turndown collar gradually adopted for fashionable dress

Suit textiles smaller in scale

Women

Wide skirts become narrower for informal wear; skirts bell-shaped by 1760s

Ribbons, lace, flounces applied to gowns, often in serpentine pattern down front of skirt

Hairstyles and caps small and close to head in 1750s; become taller in 1760s

Textiles feature scattered flowers, serpentine designs

Cascading sleeve ruffles replace cuffs

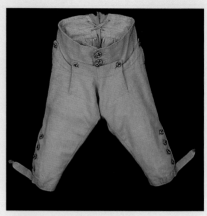

Fig. 348. Breeches from suit

Fig. 352. Panel from gown skirt

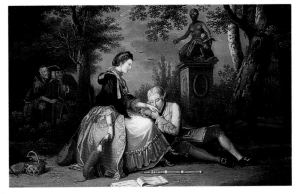

Fig. 347. Modern Love: The Courtship

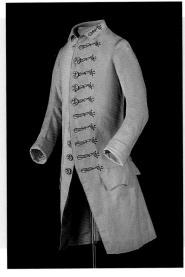

Fig. 349. Frock coat from suit

Fig. 350. Suit

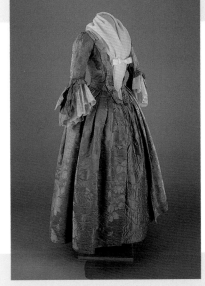

Fig. 351. Gown and accessories

Fig. 353. Dress textile

Fig. 354. Detail of suit textile

Fig. 355. Sleeve ruffles

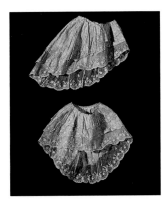

Fig. 356. Shoes

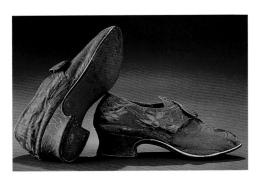

FASHIONABLE CLOTHING

Men

Suit silhouette elongated and slim, less feminine in shape

Formal coats and waistcoats have standing band collars

Coats have slim arms ending in narrow cuffs

Coats often cut away at center fronts; many do not button

Waistcoats shorter, sometimes end at waist level

Breeches elongated up to waist to avoid gap from shortened waistcoat

Breeches legs longer

Daytime suits more sober and practical

Plain frock coat still fashionable for informal fashionable wear

Informal clothing of British country gentleman fashionable for city wear, influences French styles

Macaronis display bright, exaggerated styles

Women

Sack-back gowns remain fashionable for dress occasions

Gowns still trimmed with flounces

Polonaise style features skirts drawn up in puffs with drawstrings or tapes

Sewn-in stomachers with center-front buttons occasionally used

Edge-to-edge center-front bodice closure gradually replaces stomacher

Sleeves tighter after ca. 1770; ruffles sometimes eliminated

Bodices have flat-front appearance prior to ca. 1780; rounded chest emphasized after 1780

Tall caps and elaborate hairstyles fashionable

Textiles lighter in weight and color, with small-scale patterns

Printed textiles fashionable

230

Men & Women

Fig. 357. LADY FASHION'S SECRETARY'S OFFICE, OR PETICOAT RECOMMENDA-TION THE BEST

Men's Clothing

Women's Clothing

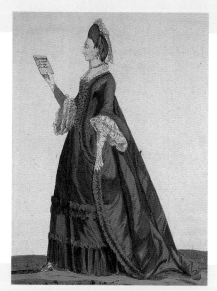

Fig. 360. A PANTHEON NO. REP.

Textiles

Shoes & Accessories

Fig. 365. Man's pocketbook

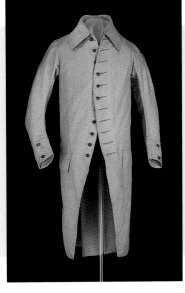

Fig. 358. Frock coat

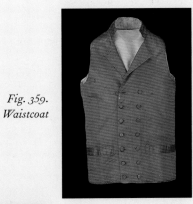

Fig. 359.
Waistcoat

Fig. 361. Sack-back gown

Fig. 362. Polonaise
gown

Fig. 363. Swatches
from silk weaver's
sample book

Fig. 364.
Detail of
gown textile

Fig. 366. Shoe

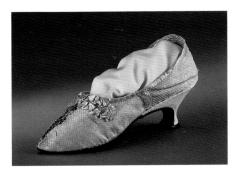

FASHIONABLE CLOTHING

Men

Slender coats with high collars and prominent chests remain fashionable

Some suit coats cut across at front

Nonformal waistcoats reach slightly below waist, cut straight across at hem

Breeches longer and tighter, often made of knitted fabric or leather for stretch

Women

Chest prominent with gowns cut low and worn with puffy kerchiefs that fill chest area

S-curve posture emphasizes chest and derriere

Sashes at waist give youthful appearance

Sleeves sometimes long, shaped to curve over elbows

Cuffs at elbows return to fashion

Greatcoat-style dresses with wide collars worn for daytime and outdoor activities

Jackets fashionable

Chemise dress, with looser fit and light, gauzy textiles, becomes fashionable

Hats and hairstyles wide and large, with frizzed softness around face

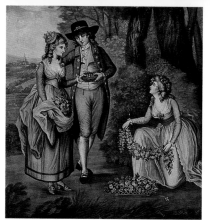

Men & Women

Fig. 367. SPRING

Men's Clothing

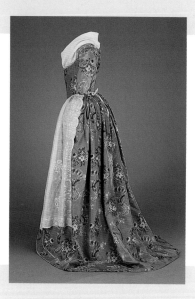

Women's Clothing

Fig. 370. Gown and accessories

Textiles

Shoes & Accessories

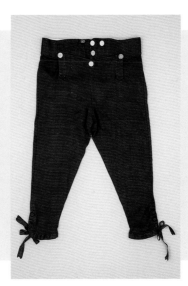

Fig. 368. Waistcoat

Fig. 369. Breeches

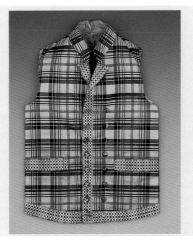

Fig. 371. Unidentified woman

Fig. 372. L'Optique

Fig. 373. Dress textile

Fig. 374. Purse or workbag

FASHIONABLE CLOTHING

Men

Long pants or trousers gradually replace knee breeches

Suit coats and waistcoats develop high standing collars

Tailcoats cut straight across front about waist level

Daytime coats and breeches usually sober in color, except for formal and court wear

Waistcoats still decorative

Women

Neoclassic style influences women's wear

Waistlines rise

By 1800, fashionable women wear new columnar style with natural body shaping

Gowns made of thin fabrics in light colors, prints, or white

Some women eliminate stays altogether

Men & Women

Fig. 375.
COMPLIANCE

Men's Clothing

Women's Clothing

Fig. 378.
DEBORAH
RICHMOND

Textiles

Shoes & Accessories

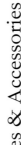

Fig. 381. Shoes

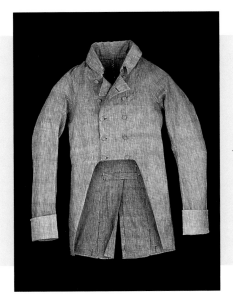

Fig. 376. Coat

Fig. 377. Trousers

Fig. 379. Gown

Fig. 380. Dress or home furnishing textile

Fig. 382. Shoe

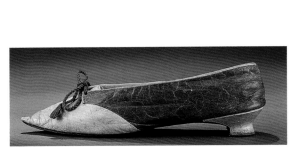

FASHIONABLE CLOTHING

Men

Long pants worn for all but formal occasions and country sporting activities

Tight pantaloons and loose trousers both fashionable

Men's styles have feminine silhouette with raised, narrow waist and full chest

Coat sleeves gathered at top of arm

By mid-1820s, full-skirted frock coats coexist with tailcoats cut across at waist

Women

Brighter colors return to fashion

Waistlines lowered, often with inset waistband between bodice and skirt

Skirts become fuller, often padded or stiffened at hems

Puffed sleeves gradually become huge by 1830

Corsets create hourglass shapes

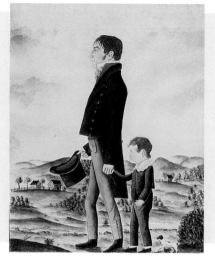

Fig. 385.
JOSEPH
GARDNER
AND HIS SON,
TEMPEST
TUCKER

Fig. 390. Purse

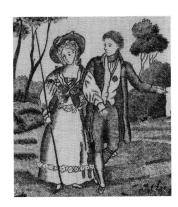

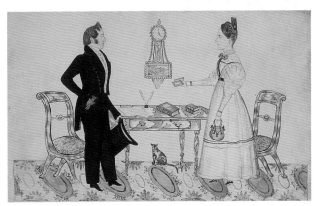

Fig. 383. Detail of
printed handkerchief

Fig. 384. INTERIOR:
MAN FACING WOMAN

Fig. 386. COCK FIGHTING

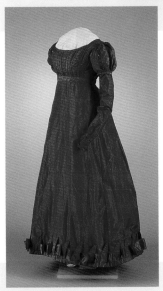

Fig. 387. Dress with
removable long sleeves

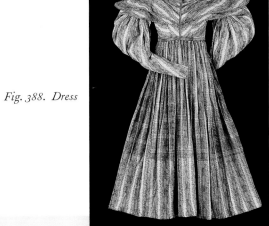

Fig. 388. Dress

Fig. 389. Detail of
gown textile

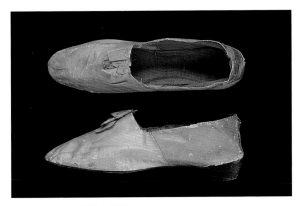

Fig. 391. Shoes

TIME LINE CAPTIONS

1690–1710

Fig. 319. Man and woman on sampler, England, made by Mary Best, 1693, silk raised work embroidery on linen, 1955-45.

Fig. 320. *Sʳ. John Percivale Barᵗ. of Burton in the County of Cork in Ireland*, engraved by John Smith after a painting by Godfrey Kneller, England, 1704, mezzotint engraving on paper, 1996-92.

Fig. 321. Sleeved waistcoat, England, ca. 1710, linen embroidered with silk, lined with cotton, G1991-478, gift of Mrs. Cora Ginsburg.

Fig. 322. *Geometria*, engraved by Jacobus Gole, Amsterdam, Holland, 1693, mezzotint engraving on paper, 1990-168, 2.

Fig. 323. Waistcoat, England, ca. 1700, silk embroidery on linen, linen lining, G1989-435, gift of Mrs. Cora Ginsburg.

Fig. 324. Dress textile, France, 1695–1710, silk brocaded with silk and metallic threads, G1991-539, gift of Mrs. Cora Ginsburg.

Fig. 325. "Constantinople" man's pocketbook or comb case, probably Constantinople, Turkey, for the souvenir market, 1696, silver embroidery on leather, 1960-347.

Fig. 326. "Adam and Eve" apron, England, ca. 1700, linen embroidery on sheer cotton, G1991-525, gift of Mrs. Cora Ginsburg.

1710–1740

Fig. 327. Detail from *Floor Decorations of Various Kinds*, by John Carwitham, London, England, 1739, Special Collections, John D. Rockefeller, Jr. Library.

Fig. 328. *TASTE in HIGH LIFE*, engraved by Samuel Phillips after a painting by William Hogarth, 1742, engraving reprinted 1808, hard-ground etching and engraving on paper, 1950-697.

Fig. 329. Coat, Britain, ca. 1730, uncut voided silk velvet trimmed with metallic braid and buttons, from the collection of James Frere, 1953-836, 1. For detail, see fig. 263.

Fig. 330. Breeches, Britain, ca. 1730, uncut voided silk velvet, waistband lined with linen, from the collection of James Frere, 1953-836, 2.

Fig. 331. Detail of purse, France or Germany, 1730–1745, silk French knots and silver-gilt embroidery on silk, steel frame, 1985-224.

Fig. 332. *Deborah Glen*, Albany, New York, 1739, oil on canvas, from the Glen-Sanders family, 1964.100.1.

Fig. 333. Detail of gown textile, Britain, ca. 1730, silk brocaded with silk, G1990-16, 1, gift of Mrs. Cora Ginsburg. For overall, see figs. 288–289.

Fig. 334. Dress textile, France, 1730–1740, silk brocaded with silk and metallic threads, G1991-527, gift of Mrs. Cora Ginsburg.

Fig. 335. Apron, Britain, 1725–1750, silk, silver, and silver-gilt embroidery on silk, G1991-504, gift of Mrs. Cora Ginsburg.

Fig. 336. Purse, France or Germany, 1730–1745, silk French knots and silver-gilt embroidery on silk, steel frame, 1985-224.

Fig. 337. Shoes and clogs, Britain, 1730–1740, clogs possibly later, made from 1730s textile, brocaded silk, silver tape, lined with linen, leather soles, 1954-1024, 1954-1026.

1740–1750

Fig. 338. Detail from *ARCHITECTURE*, printed for J. Boydell, W. Herbert, and F. Bull after Richard Houston, London, England, ca. 1750, hand-colored line engraving on paper, 1959-430, 1.

Fig. 339. Breeches, Europe or Britain, 1740–1755, uncut and voided velvet trimmed with metallic tape and buttons, waistband lined with linen, 1954-277

Fig. 340. Waistcoat, Britain, 1745–1760, silk satin trimmed with silver galloon, lined with linen-cotton, worsted back, from the collection of Doris Langley Moore, 1960-708.

Fig. 341. *George Booth*, attributed to William Dering, Virginia, 1748–1750, oil on canvas, 1975-242.

Fig. 342. Gown, Britain, 1740–1750, ribbed silk, bodice lined with linen, skirt lined with silk, 1994-87; Kerchief, Britain, 1745–1760, cotton embroidered with linen, 1971-170.

Fig. 343. Gown, Britain, silk textile ca. 1740, remodeled ca. 1750, silk brocaded with silk, bodice lined with linen and silk, G1989-427, gift of Mrs. Cora Ginsburg; Stomacher, Britain, 1730–1750, silk embroidered with silk and metallic threads, backed with linen, G1989-434, gift of Mrs. Cora Ginsburg.

Fig. 344. Dress textile, Britain, worn in America, 1736–1742, silk brocaded with silk, G1992-85A, gift of Mrs. Theodore Dreier.

Fig. 345. Detail of gown textile, Britain, ca. 1740, silk brocaded with silk, G1989-427, gift of Mrs. Cora Ginsburg. For overall, see fig. 343.

Fig. 346. Apron, Britain, 1720–1740, silk embroidery on silk, waistband missing, G1991-502, gift of Mrs. Cora Ginsburg.

1750–1770

Fig. 347. *Modern Love: The Courtship*, John Collet, London, England, probably 1764–1765, oil on canvas, 1969-48, 1.

Fig. 348. Breeches from suit, Britain, ca. 1765, wool broadcloth trimmed with metallic needlework and sequins, lined with linen-cotton and worsted, 1964-32, 2. For matching coat, see fig. 349.

Fig. 349. Frock coat from suit, Britain, ca. 1765, wool broadcloth trimmed with metallic needlework and sequins, 1964-32, 1. For matching breeches, see fig. 348; for detail, see fig. 263.

Fig. 350. Suit, Britain, 1760–1775, compound-weave silk, coat relined with modern silk and linen, breeches waistband lined with eighteenth-century linen-cotton, leather breeches pockets, 1953-838, 1–3. For details, see figs. 263 and 354.

Fig. 351. Gown and accessories, Gown, Britain, 1760–1770, silk damask trimmed with silk ribbon, bodice lined with linen, from the collection of Doris Langley Moore, 1960-714; Petticoat, Britain, 1765–1780, silk quilted to worsted backing and woolen batting, from the collection of Doris Langley Moore, 1960-715; Kerchief, Britain, 1760–1780, cotton embroidered with cotton, reproduction ribbon, 1985-125; Sleeve ruffles, Britain, 1760–1780, cotton embroidered with linen, 1985-127, 1–2.

Fig. 352. Panel from gown skirt, Spitalfields, England, ca. 1755, silk brocaded with silk and metallic threads, supplementary weft secondary patterning, 1973-55.

Fig. 353. Dress textile, Lyons, France, 1760–1770, silk brocaded with floss and chenille silks, from the collection of Paul Grigaut, 1974-652.

Fig. 354. Detail of suit textile, Britain, 1760–1775, compound-weave silk, 1953-838, 1. For overall, see fig. 350.

Fig. 355. Sleeve ruffles, probably Britain, 1750–1775, cotton embroidery on cotton, G1984-60, 1–2, gift of Elizabeth and Miodrag Blagojevich.

Fig. 356. Shoes, probably Britain, 1760–1770, silk damask lined with leather and linen, leather soles, 1985-236, 1–2.

1770–1785

Fig. 357. *LADY FASHION's SECRETARY's OFFICE, or PETICOAT RECOMMENDATION the BEST*, printed for Carington Bowles, London, England, 1772, mezzotint engraving on paper, 1952-151.

Fig. 358. Frock coat, Britain, ca. 1780, silk and worsted trimmed with copper alloy buttons, from the collection of Doris Langley Moore, 1960-695. For detail, see fig. 263.

Fig. 359. Waistcoat, New York, ca. 1785, silk satin lined with cotton, cotton back, from the Glen-Sanders family, 1964-392.

Fig. 360. *A PANTHEON NO. REP.*, published by M. Darly, London, England, 1772, hand-colored etching on paper, 1955-62, II, No. 16.

Fig. 361. Sack-back gown, Britain, 1770–1780, silk brocaded with silk, bodice lined with linen, skirt faced with silk, G1999-247, A–C, gift of Tasha Tudor.

Fig. 362. Polonaise gown, Britain, ca. 1780, block-printed and penciled cotton, bodice lined with linen, reproduction quilted petticoat, 1991-450. For another view, see fig. 78; for detail of textile, see fig. 364.

Fig. 363. Swatches from silk weaver's sample book, J. & J. Jourdain, Spitalfields, England, 1777, silk glued to paper, 1974-47.

Fig. 364. Detail of gown textile, Britain, ca. 1780, block-printed and penciled cotton, 1991-450. For overall views, see figs. 78 and 362.

Fig. 365. Man's pocketbook, America, 1774, wool tent and Irish stitches on linen canvas, glazed wool lining, paper interlining, wool binding tape, 1968-303.

Fig. 366. Shoe, Britain, 1780–1785, silk embroidered with silk and trimmed with later ribbon, lined with linen, leather soles, G1985-262, gift of Mrs. Cora Ginsburg.

1785–1795

Fig. 367. *SPRING*, published by R. Sayer and J. Bennet, London, England, 1785, hand-colored mezzotint engraving on paper, G1974-627, 1, bequest of Grace Hartshorn Westerfield.

Fig. 368. Waistcoat, Britain, ca. 1785, silk lined with linen, linen back, cotton enlargement panels, metal adjustment buckle, G1991-480, gift of Mrs. Cora Ginsburg. For larger view, see fig. 279.

Fig. 369. Breeches, Britain, ca. 1790, frame-knitted silk, waistband lined with cotton, fall lined with linen, 1968-106.

Fig. 370. Gown and accessories, Gown, France, silk textile 1760–1770, remodeled ca. 1785, silk brocaded with silk, trimmed with silk fringe, bodice lined with linen, reproduction kerchief, 1985-144; Apron, Britain, 1760–1780, cotton embroidery on cotton, from the collection of James Frere, 1953-857.

Fig. 371. Unidentified woman, by Edward Edwards, Britain, 1788, watercolor on paper, G1998-207, gift of Mrs. Cora Ginsburg.

Fig. 372. Detail from *L'Optique*, engraved by Fréderic Cazenave after a painting by Louis-Léopold Boilly, France, ca. 1794, stipple engraving with aquatint on paper, 1959-85.

Fig. 373. Dress textile, Britain, ca. 1790, block-printed cotton, blue threads in selvages, 1947-510, 2.

Fig. 374. Purse or workbag, Britain, 1780–1790, silk and metallic thread embroidery on silk, 1985-132.

1795–1815

Fig. 375. *COMPLIANCE*, published by Haines and Son, London, England, 1796, hand-colored mezzotint engraving on paper, 1971-3328.

Fig. 376. Coat, probably Connecticut, 1805–1810, cotton, linen pockets, 1991-442. For larger view, see fig. 144.

Fig. 377. Trousers, possibly United States, 1810–1825, silk satin, waistband lined with cotton, cotton pockets, 1999-215.

Fig. 378. *Deborah Richmond*, artist unidentified, probably Suffield, Connecticut, ca. 1797, oil on canvas, 1974.100.3.

Fig. 379. Gown, possibly America, 1800–1810, cotton, linen bodice lining, 1985-279. For detail view, see fig. 211.

Fig. 380. Dress or home furnishing textile, Britain, 1774–1811, block-printed cotton with pencil blue, blue threads in selvages, quilted to modern fabric, G1984-20, gift of Mr. Ralph E. Carpenter.

Fig. 381. Shoes, Britain, 1790–1810, printed leather trimmed with silk, lined with linen, leather soles, G1989-445, 1–2, gift of Mrs. Cora Ginsburg.

Fig. 382. Shoe, Martin and M'Millan, London, England, 1805–1810, leather lined with linen, leather soles, paper label, 1985-238, 1.

1815–1835

Fig. 383. Detail of printed handkerchief, Britain, used in New England, 1820s, roller-printed cotton, silk marking stitches, G1971-1445, anonymous gift. For overall, see fig. 318.

Fig. 384. *Interior: Man Facing Woman*, attributed to Joseph H. Davis, probably Maine or New Hampshire, ca. 1835, watercolor and pencil on paper, 1958.300.9.

Fig. 385. *Joseph Gardner and His Son, Tempest Tucker*, attributed to Jacob Maentel, Pennsylvania, ca. 1815, watercolor on paper, 1958.300.33.

Fig. 386. *COCK FIGHTING*, Henry Alken, London, England, 1824, hand-colored aquatint engraving on paper, G1989-398, gift of Mr. and Mrs. John O. Sands.

Fig. 387. Dress with removable long sleeves, probably Britain, 1820s, silk trimmed with silk, lined with cotton, G1991-469, A–C, gift of Mrs. Cora Ginsburg.

Fig. 388. Dress, Britain or United States, ca. 1835, printed cotton trimmed with wool and cotton bobbin lace, bodice lined with cotton, G1996-264, gift of Tasha Tudor.

Fig. 389. Detail of gown textile, Britain or United States, ca. 1830, printed cotton, G1996-264, gift of Tasha Tudor. For overall, see fig. 388.

Fig. 390. Purse, France, 1810–1825, printed portrait medallion, silk ribbons, sequins, and metallic threads on silk, lined with silk, G1992-84, gift of Janice D. Reagan.

Fig. 391. Shoes, Massachusetts, worn in Virginia, 1820–1830, leather lined with linen, leather soles, G1950-5, 1–2, gift of Bernard H. Baylor.

NOTES

INTRODUCTION

COLLECTING COSTUMES AT COLONIAL WILLIAMSBURG

1 This gown was assigned the catalog number 745, later changed to a standard museum catalog number that included the year of accession, 1930-367. No history was recorded, although the gown may have been worn in Richmond, Va.

2 I thank Clare Browne and Susan North, Victoria and Albert Museum, London, for helping date the textile of this gown.

3 The gown was in a box of costumes and tools purchased from a Williamsburg, Va., resident in 1935. The dress was apparently thought to date to the eighteenth century. The rest of the clothing was considered too late for the collections and disposed of. Object folder 1935-170, Colonial Williamsburg Foundation.

4 Invoice from Lenygon & Morant, Ltd., London, Aug. 11, 1936. Object folder 1936-666, CWF.

5 Michael Harvard to John Graham, June 25, 1953. Object folder 1953-836, CWF.

6 *The Glen-Sanders Collection from Scotia, New York* (Williamsburg, Va., 1966).

7 For more on the Cora Ginsburg collection, see Linda R. Baumgarten, "Costumes and textiles in the collection of Cora Ginsburg," *The Magazine Antiques*, CXXXIV (August 1988), pp. 260–277.

8 Linda Baumgarten and Jan K. Gilliam, "Nineteenth-century children's costumes in Tasha Tudor's collection," *The Magazine Antiques*, CLIII (April 1998), pp. 564–571.

CHAPTER I

COSTUME: OLD AND NEW CONNOISSEURSHIP

1 *Merriam-Webster's Collegiate Dictionary*, 10th ed., s.v. "connoisseur."

2 Thomas Wolsey (ca. 1475–1530) dominated Henry VIII's government; James I was the king of England from 1603 to 1625. William Hadley, comp., *Horace Walpole, Selected Letters*, 1926, reprint (London, 1967), pp. 106, 139, 157; see also Aileen Ribeiro, "Antiquarian Attitudes—Some Early Studies in the History of Dress," *Costume*, XXVIII (1994), pp. 60–70.

3 Horace Walpole to the Earl of Harcourt, Oct. 8, 1777, in Hadley, comp., *Horace Walpole*, p. 135.

4 *Ibid.*, p. 157.

5 Ribeiro, "Antiquarian Attitudes," p. 61.

6 Virginia Historical Society, Richmond, Va., Por 973.17. I thank William Rasmussen for information about Hudson's portrait of Robert Carter.

7 Claudia Brush Kidwell, "Are Those Clothes Real? Transforming the Way Eighteenth-Century Portraits are Studied," *Dress*, XXIV (1997), pp. 3–15.

8 Benjamin West to Charles Willson Peale, June 15, 1783, in Jules David Prown, "John Trumbull as History Painter," in *John Trumbull, The Hand and Spirit of a Painter*, ed. Helen A. Cooper (New Haven, Conn., 1982), p. 29.

9 Peale to West, Aug. 25, 1783, in Lillian B. Miller, ed., *The Selected Papers of Charles Willson Peale and His Family*, I (New Haven, Conn., 1983), pp. 394–395.

10 I am indebted to the work of Jules Prown, who first suggested Trumbull's use of the clothing Peale had sent to London. Prown, "Trumbull as History Painter," p. 30.

11 Jean-Louis-Ernest Meissonier (1815–1891) specialized in military and genre scenes. Kay Staniland to Linda Baumgarten, Nov. 29, 1993. Object folder 1954-1030, 1, CWF. I thank Ms. Staniland, curator (clothing and textiles), Later London History & Collections, Museum of London, for her helpful comments about the Bennett collection.

12 Some garments from the Bennett collection went to the Museum of London and to the Gallery of English Costume; the rest were sold to theatrical costumers.

13 Joseph Strutt, *A Complete View of the Dress and Habits of the People of England, from the Establishment of the Saxons in Britain to the Present Time* (1796), I, 1842, reprint, with an introduction and notes by J. R. Planché (London, 1970), p. 4.

14 James Robinson Planché, *A Cyclopaedia of Costume or Dictionary of Dress, Including Notices of Contemporaneous Fashions on the Continent*, 2 vols. (London, 1876–1879), II, p. 1.

15 For more on the study of costume in paintings, see Kidwell, "Are Those Clothes Real?"; Anne Buck, *Dress in Eighteenth-Century England* (New York, 1979), pp. 10–11; Aileen Ribeiro, *The Dress Worn at Masquerades in England, 1730–1790, and Its Relation to Fancy Dress in Portraiture* (New York, 1984), esp. chap. 3; Aileen Ribeiro, "Fashion and Fantasy: The Use of Costume in Eighteenth-Century British Portraiture," in *The British Face, A View of Portraiture, 1625–1850*, ed. Donald Garstang (London, 1986), pp. 20–22; Anne Hollander, *Seeing Through Clothes*, 2nd printing (New York, 1978); Naomi E. A. Tarrant, "The Portrait, the Artist and the Costume Historian," *Dress*, XXII (1995), pp. 69–77; and T. H. Breen, "The Meaning of 'Likeness': Portrait-Painting in an Eighteenth-Century Consumer Society," in *The Portrait in Eighteenth-Century America*, ed. Ellen G. Miles (Newark, Del., 1993), pp. 37–60.

16 David Lowenthal, *The Past Is a Foreign Country* (Cambridge, 1985), pp. 36, xxiii.

17 Nicholas Stanley Price, M. Kirby Talley, Jr., and Alessandra Melucco Vaccaro, eds., *Historical and Philosophical Issues in the Conservation of Cultural Heritage* (Los Angeles, Calif., 1996), pp. 28–30.

18 Jonathan Richardson, *The Works of Jonathan Richardson. Containing I. The Theory of Painting. II. Essay on the Art of Criticism, (So far as it relates to Painting). III. The Science of a Connoisseur* ([London], 1792), pp. 19–73, 120. This volume, in the rare book collection in Earl Gregg Swem Library, College of William and Mary, Williamsburg, Va., was a new edition of Richardson's 1719 *Discourses*.

19 Charles F. Montgomery, "The Connoisseurship of Artifacts," in *Material Culture Studies in America*, ed. Thomas J. Schlereth (Nashville, Tenn., 1982), pp. 143–152.

20 Heckscher describes the four categories as follows: "1. *Attribution*. What is it? Where was it made? Who made it? 2. *Authenticity*. Is it really what it purports to be? 3. *Condition*. Has it changed since it was originally made? 4. *Quality*. How good an example is it of its kind?" Morrison H. Heckscher, "American furniture and the art of connoisseurship," *The Magazine Antiques*, CLIII (May 1998), p. 722.

21 See, for example, Beverly Lemire, "Developing Consumerism and the Ready-made Clothing Trade in Britain, 1750–1800," *Textile History*, XV (spring 1984), pp. 21–44; Natalie Rothstein, "Silks for the American market," *Connoisseur*, CLXVI (October 1967), pp. 90–94; Madeleine Ginsburg, "The Tailoring and Dressmaking Trades, 1700–1850," *Costume*, VI (1972), pp. 64–69. For more general studies of consumerism, see Grant McCracken, *Culture and Consumption, New Approaches to the Symbolic Character of Consumer Goods and Activities* (Bloomington, Ind., 1990); John Brewer and Roy Porter, eds., *Consumption and the World of Goods* (London, 1993); Neil McKendrick, John Brewer, and J. H. Plumb, *The Birth of a Consumer Society, The Commercialization of Eighteenth-century England* (London, 1982); and Cary Carson, "The Consumer Revolution in Colonial British America: Why Demand?" in *Of Consuming Interests, The Style of Life in the Eighteenth Century*, ed. Cary Carson, Ronald Hoffman, and Peter J. Albert (Charlottesville, Va., 1994), pp. 483–697.

22 Ginsburg, "Tailoring and Dressmaking Trades," pp. 64, 65, 69.

23 William K. Bottorff and Roy C. Flannagan, eds., "The Diary of Frances Baylor Hill of 'Hillsborough' King and Queen County Virginia (1797)," *Early American Literature Newsletter*, II (winter 1967), pp. 27–30.

24 Many published sources discuss clothing style progression. See esp. Naomi Tarrant, *The Development of Costume* (Edinburgh, Scot., 1994); Claudia Brush Kidwell and Valerie Steele, eds., *Men and Women, Dressing the Part* (Washington, D. C., 1989); Janet Arnold, *Patterns of Fashion, Englishwomen's dresses & their construction c. 1660–1860* (New York, 1972); and David M. Kuchta, "'Graceful, Virile, and Useful': The origins of the three-piece suit," *Dress*, XVII (1990), pp. 118–126.

25 Rosalie Calvert to Mme H. J. Stier, Mar. 2, 1804, in Margaret Law Callcott, ed., *Mistress of Riversdale, The Plantation Letters of Rosalie Stier Calvert, 1795–1821* (Baltimore, Md., 1991), p. 77.

26 See Linda Baumgarten, "Under Waistcoats and Drawers," *Dress*, XIX (1992), pp. 4–16.

27 Edward Dumbauld, "Thomas Jefferson as a Traveler," in *Jefferson Reader: A Treasury of Writings about Thomas Jefferson*, ed. Francis Coleman Rosenberger (New York, 1953), p. 174.

28 On May 25, 1797, Thomas Jefferson wrote to Mary Jefferson from Philadelphia that he was slowly recovering from his rheumatism. Sarah N. Randolph, comp., *The Domestic Life of Thomas Jefferson* 1871, reprint (Charlottesville, Va., 1978), p. 244.

29 Thomas Jefferson to John Adams, June 1, 1822, *ibid.*, p. 379.

30 Jefferson to Adams, Oct. 12, 1823, *ibid.*, p. 388.

31 Philip Vickers Fithian tutored the young children of plantation owner Robert Carter of Nomini Hall. Five days after the abnormally cold temperature, the weather was more typical of a Virginia summer; Fithian wrote, "O! it is very hot—The wind itself seems to be heated! . . . I dress in a thin Waist-Coat, & a loose, light linen Gown." Hunter Dickinson Farish, ed., *Journal & Letters of Philip Vickers Fithian, 1773–1774: A Plantation Tutor of the Old Dominion* (Williamsburg, Va., 1965), pp. 148, 150.

32 George Washington to Charles Lawrence, Sept. 28, 1760, in which Washington noted that the enclosed measurement was the exact size, "because it was taken over a thin, close pair of drawers, and no allowance made." Anne Wood Murray, "George Washington's apparel," *The Magazine Antiques*, CXVIII (July 1980), p. 121. Washington to Thomas Gibson, July 1772, in which Washington ordered two suits and a pair of black silk net [stockinet] breeches, noting that "all the Breeches to be worn w'Drawers." *Ibid.*, p. 123.

33 Lord Botetourt's breeches are listed as being leather, black silk, black velvet, white cloth, white velvet, and buff, clearly fabrics for outerwear. In contrast, the drawers were described as "2 P' of Flannel Drawers . . . 3 P' Linnen Drawers, 11 P' of Cotton D°. . . 6 P' of Cotton Drawers." The under waistcoats were described as "1 White Sattin Under Waistcoat, 1 Crimson Silk Under Waistcoat . . . 1 [flannel] Under Waistcoat, 2 Cotton Under Waistcoats, 5 Linnen D°." Graham Hood, *Inventories of Four Eighteenth-Century Houses in the Historic Area of Williamsburg* (Williamsburg, Va., 1974), p. 19.

34 Nigel Arch and Joanna Marschner, *Splendour at Court, Dressing for Royal Occasions since 1700* (London, 1987), pp. 70–71. The suit is of mulberry-colored wool cloth with an embroidered silk waistcoat; it was worn by an official of the Chinese Customs House at the British court in 1866.

35 Albert Sack, *The New Fine Points of Furniture, Early American* (New York, 1993), p. 13.

36 David Pye, *The nature of design* (New York, 1964), pp. 36, 83.

37 *Ibid.*, p. 87.

38 Deborah E. Kraak, "Art in the Details, Defining textile and embroidery masterworks," *Winterthur Magazine*, XL (summer 1994), pp. 7, 13.

39 *Merriam-Webster's Collegiate Dictionary*, 10th ed., s.v. "master."

40 Janet Arnold pointed out that dressmaking techniques improved between 1770 and 1790, and that interior construction became much neater. Janet Arnold, informal lecture to employees at the Costume Design Center, Oct. 21, 1993, Colonial Williamsburg Foundation, Williamsburg, Va.

41 Petroleum dry cleaning solvents were not used in the eighteenth century. For more information on cleaning methods, see G. Schaefer, "Some Old-Fashioned Ways of Cleaning Textiles," *Ciba Review*, LVI (April 1947), pp. 2034–2038; Alan Mansfield, "Dyeing and Cleaning Clothes in the Late Eighteenth and Early Nineteenth Centuries," *Costume*, I–II (1970), pp. 38–43; and Richard L. Bushman and Claudia L. Bushman, "The Early History of Cleanliness in America," *Journal of American History*, LXXIV (March 1988), pp. 1213–1283.

42 John Watson and I examined the stockings at Monticello with the aid of an infrared scanner in 1994. Hans Lorenz photographed the stockings using infrared film. Stanley Chapman to L. Baumgarten, July 4, 1994.

43 The European China-blue technique involved printing ground indigo with the addition of iron-sulphate and a thickener; the printed textile was then immersed in chemical baths, first to dissolve the ground indigo, then to reduce it. In India, blue was achieved through a labor-intensive process of waxing the entire surface, except parts intended to be blue, then dipping the fabric in an indigo vat. Pencil blue could be achieved more quickly than the Indian resist method. See Florence M. Montgomery, *Printed Textiles, English and American Cottons and Linens, 1700–1850* (New York, 1970), pp. 194–200, 112–113.

44 *Ibid.*, p. 111.

45 Leanna Lee-Whitman, "The Silk Trade: Chinese Silks and the British East India Company," *Winterthur Portfolio*, XVII (spring

1982), pp. 21–42. See also Leanna Lee-Whitman and Marina Skelton, "Where Did All the Silver Go? Identifying Eighteenth-Century Chinese Painted and Printed Silks," *Textile Museum Journal*, XXII (1983), pp. 33–52.

CHAPTER 2
THE MYTHS AND MEANINGS OF CLOTHING

1 Jules David Prown, "Style as Evidence," *Winterthur Portfolio*, XV (autumn 1980), p. 208.

2 R[obert] Campbell, *The London Tradesman*, 1747, reprint (New York, 1969), p. 191.

3 William Hogarth, *The Analysis of beauty: written with a view of fixing the fluctuating ideas of taste* (London, [1753]), in Ribeiro, "Fashion and Fantasy," p. 22.

4 See Mary Ellen Roach and Joanne B. Eicher, *The Visible Self: Perspectives on Dress* (Englewood Cliffs, N. J., 1973).

5 Linda Baumgarten, *Eighteenth-Century Clothing at Williamsburg* (Williamsburg, Va., 2002), pp. 12–13.

6 Rhys Isaac, *The Transformation of Virginia, 1740–1790* (Chapel Hill, N. C., 1982), p. 44.

7 For discussions about clothing or material objects as language, see Alison Lurie, *The Language of Clothes* (New York, 2000); Fred Davis, *Fashion, Culture, and Identity* (Chicago, 1992), pp. 24–25, esp. chaps. 1 and 2; McCracken, *Culture and Consumption*, chap. 4; Mary Ellen Roach and Joanne Bubolz Eicher, "The Language of Personal Adornment," in *The Fabrics of Culture, The Anthropology of Clothing and Adornment*, ed. Justine M. Cordwell and Ronald A. Schwarz (The Hague, Netherlands, 1979); and Patricia A. Cunningham and Susan Voso Lab, eds., *Dress and Popular Culture* (Bowling Green, Ohio, 1991).

8 For more on the "cooperative game" of language, see Ronald B. Adler and Neil Towne, *Looking Out/Looking In, Interpersonal Communication* (Fort Worth, Tex., 1996), pp. 172–223.

9 McCracken, *Culture and Consumption*, p. 65.

10 Jules David Prown, "The Truth of Material Culture: History or Fiction," in *History from Things, Essays on Material Culture*, ed. Steven Lubar and W. David Kingery (Washington, D. C., 1993), p. 3.

11 Prown, "Truth of Material Culture," p. 5; Jules David Prown, "Mind in Matter, An Introduction to Material Culture Theory and Method," *Winterthur Portfolio*, XVII "(spring, 1982)," pp. 1–19. See also Prown, "Style as Evidence," pp. 197–210.

12 Yolanda Van de Krol, "'Ty'ed about My Middle, Next to My Smock': The Cultural Context of Women's Pockets" (master's thesis, University of Delaware, 1994). In a similar study, Karen Northrop studied the use and symbolism of gloves; see Karen E. Northrop, "'To Go with an Ungloved Hand Was Impossible': A History of Gloves, Hands, Sex, Wealth, and Power" (master's thesis, College of William and Mary, 1998).

13 Hollander, *Seeing Through Clothes*; Anne Hollander, *Sex and Suits* (New York, 1994); Joanne Finkelstein, *The Fashioned Self* (Philadelphia, Pa., 1991).

14 Kidwell and Steele, eds., *Men and Women*, pp. 16–17.

15 Finkelstein, *Fashioned Self*, pp. 120–122.

16 Prown, "Truth of Material Culture," p. 3.

17 Jane Richardson and A. L. Kroeber, "Three Centuries of Women's Dress Fashions: A Quantitative Analysis," in *The Nature of Culture*, ed. A. L. Kroeber (Chicago, 1952), pp. 358–372. Richardson and Kroeber studied women's formal clothing for a period of about 300 years to track the proportion of skirt to bodice, skirt length and width, the position and width of the waist, and the amount of décolletage. When considering overall silhouette, as opposed to smaller details, the authors discovered a remarkably consistent pattern that evolved slowly. Writing in the early 1950s, Richardson and Kroeber considered the clothing of the 1920s as exceptions to the general pattern. The authors apparently thought that the prevailing New Look fashions, which had full skirts and defined bodices, were a return to the basic or ideal pattern of women's clothing. Costume scholars now believe that the modern era of clothing began about 1920. Colleen Callahan points out that the New Look of the late 1940s and 1950s might be considered a revival, rather than part of Richardson and Kroeber's "ideal pattern." Colleen Callahan, memo to L. Baumgarten, Apr. 22, 2002, and Colleen Callahan, telephone conversation with L. Baumgarten, Apr. 25, 2002. I thank Colleen for her insightful comments. For recent analysis of hoop petticoats, see Kimberly Chrisman, "Unhoop the Fair Sex: The Campaign against the Hoop Petticoat in Eighteenth-Century England," *Eighteenth-Century Studies*, XXX (1996), pp. 5–23.

18 Disposable menstrual products were not widely available until the 1880s. Before that time, women used rags or towels. Penelope Byrde, *Nineteenth Century Fashion* (London, 1992), p. 177, n. 25; Sarah Levitt, *Victorians Unbuttoned: Registered Designs for Clothing, Their Makers and Wearers, 1839–1900* (London, 1986); Laura K. Kidd and Jane Farrell-Beck, "Menstrual Products Patented in the United States, 1854–1921," *Dress*, XXIV (1997), pp. 27–42.

19 Campbell, *London Tradesman*, p. 212.

20 A few Anglo-American women wore trousers under special circumstances or for symbolic reasons. The bloomer fashions and the dress reform movement of the nineteenth century were important, yet the styles did not enter the mainstream or gain widespread acceptance.

21 Prown, "Truth of Material Culture," p. 6.

22 *Ibid.*

23 Henry Nash Smith said, "The character of Leatherstocking is by far the most important symbol of the national experience of adventure across the continent." Henry Nash Smith, *Virgin Land, The American West as Symbol and Myth* (Cambridge, Mass., 1982), p. 61. See also Richard Brookhiser, "Deerslayer Helped Define Us All," *Time* (Nov. 9, 1992), p. 92.

24 For more detail about the costume in James Fenimore Cooper's novels, see Linda R. Baumgarten, "Leather Stockings and Hunting Shirts," in *American Material Culture, The Shape of the Field*, ed. Ann Smart Martin and J. Ritchie Garrison (Winterthur, Del., 1997), pp. 251–276. I thank the Winterthur Museum for permission to publish portions of this article and acknowledge with gratitude the comments of Rick Guthrie, specialist in early Indian and frontier artifacts, who read the manuscript.

25 James Fenimore Cooper, *The Last of the Mohicans*, 1826, reprint (New York, 1980), chap. 3, p. 33, n. 1.

26 James Fenimore Cooper's life is discussed in Robert Emmet Long, *James Fenimore Cooper* (New York, 1990).

27 James Fenimore Cooper, *The Deerslayer*, 1841, reprint (New York, 1982), chap. 12, p. 186.

28 George Washington to John Blair, May 28, 1758, in John C. Fitzpatrick, ed., *The Writings of George Washington*, 39 vols. (Washington, D. C., 1931–1944), II, p. 207.

29 General Orders from Washington's Headquarters at Cambridge, Aug. 7, 1775, in Fitzpatrick, ed., *Writings of Washington*, III, p. 404.

30 J[ohn] F[erdinand] D[alziel] Smyth, *A Tour in the United States of*

America . . . (Dublin, Ireland, 1784), I, p. 115. I thank Al Saguto for bringing this reference to my attention.

31 Apr. 4, 1775, in *The Journal of Nicholas Cresswell, 1774–1777* (Port Washington, N. Y., 1968), p. 61.

32 Aug. 19, 1775, *ibid.*, p. 102.

33 Washington to Col. Henry Bouquet, July 3, 1758, in Fitzpatrick, ed., *Writings of Washington*, II, p. 229.

34 Washington to Bouquet, July 13, 1758, *ibid.*, p. 235. Rick Guthrie pointed out that the men wearing Indian dress in this particular situation were scouts.

35 In a letter to Lt. Col. Adam Stephen, Washington ordered "stuff . . . for Breech Clouts" to be charged to the "Publick" in 1758. Washington to Lt. Col. Stephen, July 16, 1758, *ibid.*, p. 240.

36 Washington to governor Jonathan Trumbull, Aug. 4, 1775, in Fitzpatrick, ed., *Writings of Washington*, III, p. 389.

37 Washington to governor Nicholas Cooke, Aug. 14, 1775, *ibid.*, p. 422.

38 Washington to the Committee of the Massachusetts Legislature, Aug. 11, 1775, *ibid.*, p. 415.

39 Silas Deane to his wife, in John R. Elting, ed., *Military Uniforms in America.* I: *The Era of the American Revolution, 1755–1795* (San Rafael, Calif., 1974), p. 104.

40 Charles Campbell, ed., *The Orderly Book of That Portion of the American Army Stationed at or Near Williamsburg, Va., Under the Command of General Andrew Lewis* (Richmond, Va., 1860), pp. 13–14; *ibid.*, p. 90.

41 The shirt is thought to have been worn by Abraham Duryea, militiaman from Dutchess Co., N. Y.

42 *South-Carolina and American General Gazette* (Charleston), Feb. 25, 1779, in Lathan A. Windley, comp., *Runaway Slave Advertisements, A Documentary History from the 1730s to 1790.* III: *South Carolina* (Westport, Conn., 1983), pp. 550–551.

43 Cooper, *Last of the Mohicans*, chap. 4, pp. 47–48.

44 William Cronon, *Changes in the Land, Indians, Colonists, and the Ecology of New England* (New York, 1983), p. 102.

45 Michael N. McConnell, *A Country Between, The Upper Ohio Valley and Its Peoples, 1724–1774* (Lincoln, Nebr., 1992), p. 37. See also James A. Hanson, "Laced Coats and Leather Jackets: The Great Plains Intercultural Clothing Exchange," in *Plains Indian Studies, A Collection of Essays in Honor of John C. Ewers and Waldo R. Wedel*, ed. Douglas H. Ubelaker and Herman J. Viola (Washington, D. C., 1982), pp. 105–117.

46 Daniel K. Richter, *The Ordeal of the Longhouse, The Peoples of the Iroquois League in the Era of European Colonization* (Chapel Hill, N. C., 1992), p. 80. See also Laurel Thatcher Ulrich, "Cloth, Clothing, and Early American Social History," *Dress*, XVIII (1991), pp. 39–48.

47 John Filson, *The Discovery, Settlement and present State of Kentucke, 1784*, reprint (New York, 1962), p. 99.

48 Oct. 1, 1775, in *Journal of Cresswell*, pp. 120–121.

49 Dec. 7, 1774, *ibid.*, pp. 49–50.

50 Richter, *Ordeal of the Longhouse*, p. 80.

51 For more information on English smock frocks, see Anne Buck, "The Countryman's Smock," *Folk Life*, I (1963), pp. 16–34; Buck, *Dress in Eighteenth-Century England*, pp. 140–142; and Alma Oakes and Margot Hamilton Hill, *Rural Costume, Its Origin and Development in Western Europe and the British Isles* (London, 1970), chap. 4.

52 Mary Morgan to her sister, in Elting, ed., *Military Uniforms in America*, p. 104.

53 John Joseph Henry, *Account of Arnold's Campaign Against Quebec*

. . ., 1877, reprint (New York, 1968), p. 11. The account was first published in 1812.

54 June 6, 1775, in Robert Greenhalgh Albion and Leonidas Dodson, eds., *Philip Vickers Fithian: Journal, 1775–1776* (Princeton, N. J., 1934), p. 24.

55 See Sally Helvenston, "Fashion on the Frontier," *Dress*, XVII (1990), pp. 141–155; Carolyn R. Shine, "Scalping Knives and Silk Stockings: Clothing the Frontier, 1780–1795," *Dress*, XIV (1988), pp. 39–47; Ulrich, "Cloth, Clothing, and Social History," pp. 39–48; Adrienne Dora Hood, "Organization and Extent of Textile Manufacture in Eighteenth-Century, Rural Pennsylvania: A Case Study of Chester County" (Ph.D. diss., University of California, San Diego, 1988); Carole Shammas, *The Pre-industrial Consumer in England and America* (Oxford, 1990); and Carole Shammas, "How Self-Sufficient Was Early America?" *Journal of Interdisciplinary History*, XIII (1982) pp. 247–272.

CHAPTER 3
HOMESPUN AND SILK: AMERICAN CLOTHING

1 Bernard Bailyn, *The New England Merchants in the Seventeenth Century* (Cambridge, Mass., 1955), p. 74. For a discussion of seventeenth-century textile importation, see Linda R. Baumgarten, "The Textile Trade in Boston, 1650–1700," in *Arts of the Anglo-American Community in the Seventeenth Century*, ed. Ian M. G. Quimby (Charlottesville, Va., 1975), pp. 219–274.

2 Charles M. Andrews, *The Colonial Period of American History* (New Haven, Conn., 1938), pp. 61–65, 118–121.

3 Oliver M. Dickerson, *The Navigation Acts and the American Revolution* (Philadelphia, Pa., 1951), pp. 46, 70–72.

4 "A Comparison drawn between Manufacturing & Importing, the Goods on the other side," in Patricia A. Gibbs, "Cloth Production in Virginia to 1800," Colonial Williamsburg Research Report, Mar. 1978, pp. 88–89, 128.

5 N. B. Harte, "The British Linen Trade with the United States in the Eighteenth and Nineteenth Centuries," in *Textiles in Trade, Proceedings of the Textile Society of America Biennial Symposium, September 14–16, 1990, Washington, D. C.* (Los Angeles, Calif., 1990), p. 20, fig. 8.

6 John Horner, *The Linen Trade of Europe during the Spinning-Wheel Period* (Belfast, Ireland, 1920), p. 421.

7 For more about Yorkshire woolen production, see Herbert Heaton, *The Yorkshire Woollen and Worsted Industries from the Earliest Times up to the Industrial Revolution* (Oxford, 1965).

8 See Linda Baumgarten, "Plains, Plaid and Cotton: Woolens for Slave Clothing," *Ars Textrina*, XV (July 1991), pp. 203–222.

9 See Beverly Lemire, *Fashion's Favourite: The Cotton Trade and the Consumer in Britain, 1660–1800* (Oxford, 1991).

10 For a discussion of textiles imported by the East India Company and attempts at prohibition, see John Irwin and Katharine B. Brett, *Origins of Chintz* (London, 1970), and Rothstein, "Silks for the American market," pp. 90–94.

11 Christopher Gilbert, *The Life and Work of Thomas Chippendale* (London, 1978), pp. 36–37, 240.

12 See advertisements in the *Virginia Gazette* (Purdie and Dixon), Apr. 13, 1769, Apr. 19, 1770, Oct. 17, 1771, Jan. 30, 1772; *Va. Gaz.* (Rind), Apr. 13, 1769, Apr. 19, 1770, Nov. 8, 1770, Feb. 6, 1772, May 12, 1774.

13 For a discussion of silks exported to the colonies, see Rothstein, "Silks for the American market," pp. 92–93, and Natalie Rothstein, "Silks for the American market: 2," *Connoisseur*, CLXVI

(November 1967), pp. 150–156. See also Lee-Whitman, "Silk Trade," pp. 21–42.

14 Daughters of American Revolution Museum, Washington, D. C., acc. no. 3763. The gown was worn by Mrs. Christiana Beatty (1700–1776) of Little Britain, Ulster Co., N. Y. I am indebted to Alden O'Brien for assisting with this information.

15 French silks were prohibited from 1766 to 1826. See Natalie Rothstein, *Silk Designs of the Eighteenth Century in the Collection of the Victoria and Albert Museum, London, with a Complete Catalogue* (Boston, Mass., 1990), pp. 23–26.

16 *Spitalfields Silks of the 18th and 19th Centuries*, with an introduction by J. F. Flanagan (Leigh-on-Sea, Eng., 1954), p. 5.

17 Rothstein, *Silk Designs*, pp. 170–172.

18 *Ibid.*, p. 46; Natalie Rothstein, "Silk in European and American Trade before 1783, A commodity of commerce or a frivolous luxury?" in *Textiles in Trade*, p. 7.

19 *Va. Gaz.* (Dixon and Nicolson), Oct. 9, 1779.

20 Frances Norton Mason, ed., *John Norton & Sons, Merchants of London and Virginia* (Richmond, Va., 1937), pp. 499–500.

21 *Ibid.*, pp. 217, 518.

22 *Ibid.*, pp. 206, 257. The "tupees" were probably curls or hairpieces.

23 *Ibid.*, p. 258. A hand-netted linen cap, which I examined at Mount Vernon in 1993, may be a rare survival of an eighteenth-century hairnet for sleeping. The plain cap was too large to be a child's head covering.

24 *Ibid.*, pp. 205–206, 210–212, 214–215, 217–219, 225, 256–259.

25 The analysis of the tooth powder was performed at laboratories at the College of William and Mary.

26 Order from Robert Carter Nicholas to John Norton, Sept. 6, 1768, in Mason, ed., *John Norton & Sons*, pp. 72–73.

27 Robert Carter to Robert Cornthwaite, Mar. 25, 1765, in Susan Briggs Eley, "Robert Carter Letterbook, 1764–1768" (master's thesis, College of William and Mary, 1962), p. 9.

28 George Washington to Richard Washington, Oct. 30, 1761, in Murray, "George Washington's apparel," p. 122; George Washington to Charles Lawrence, Apr. 26, 1763, *ibid.*, p. 122.

29 Francis Jerdone to Alexander Speirs, July 25, 1757, in Letter copy book of Francis Jerdone, 1756–1763, Jerdone Family Papers, Group 1, Manuscripts and Rare Books Department, Swem Lib., CWF microfilm M-152.2.

30 Rawleigh Downman to Clay and Midgley, Aug. 18, 1767, in Rawleigh Downman Letterbook, 1760–1780, typescript TR 93, research files, Rockefeller Library, CWF, p. 19, original in Library of Congress.

31 Jerdone to Joseph Carpue, Sept. 20, 1762, in Letter copy book of Jerdone.

32 Robert Carter III to James Buchanan & Company, Sept. 8, 1761, in A Letterbook of Robert Carter III, of Nomony Hall, for the Years 1760 to 1764, typescript TR 7.1, p. 9, Rockefeller Lib.; Jeffrey L. Scheib, "The Richard Corbin Letterbook, 1758–1760" (master's thesis, College of William and Mary, 1982), p. 105; Washington to Robert Cary and Company, Sept. 20, 1759, in Fitzpatrick, ed., *Writings of Washington*, II, p. 331.

33 R. Carter to Mrs. Jane Hyde, June 26, 1729, in Robert Carter letter book, 1728 August–1731 July, Robert Carter Papers (# 3807), The Albert and Shirley Small Special Collections Library, University of Virginia Library. Typescript courtesy Edmund Berkeley, Jr.

34 Mann Page to J. Norton, Feb. 22, 1770, in Mason, ed., *John Norton & Sons*, p. 124.

35 R. Carter III to James Buchanan & Co, Sept. 8, 1761, in Letterbook of Robert Carter III, p. 9.

36 John Pory to Sir Dudley Carleton, Sept. 30, 1619, in William S. Powell, *John Pory, 1572–1636, The Life and Letters of a Man of Many Parts* (Chapel Hill, N. C., 1977), microfiche supplement, p. 74.

37 Hugh Jones, *The Present State of Virginia from Whence Is Inferred a Short View of Maryland and North Carolina*, 1724, ed. with an introduction by Richard L. Morton, reprint (Chapel Hill, N. C., 1956), p. 71.

38 Alice Morse Earle, *Costume of Colonial Times*, 1894, reprint (New York, 1924), p. 24.

39 Monday, June 6, 1774, in *Journal of Cresswell*, p. 21.

40 William Eddis, quoted in Julia Cherry Spruill, *Women's Life and Work in the Southern Colonies*, 1938, reprint (New York, 1972), p. 92.

41 Rothstein, "Silks for American market: 2," p. 155.

42 Peter H. Wood, *Black Majority, Negroes in Colonial South Carolina, From 1670 through the Stono Rebellion* (New York, 1974), p. 36.

43 William J. Van Schreeven, comp., Robert L. Scribner, ed., *Revolutionary Virginia, The Road to Independence. I: Forming Thunderclouds and the First Convention, 1763–1774* (Charlottesville, Va., 1973), pp. 72–77.

44 *Va. Gaz.* (Purdie and Dixon), Dec. 14, 1769.

45 Martha Goosley to J. Norton, Aug. 8, 1770, in Mason, ed., *John Norton & Sons*, p. 143; William Nelson to J. Norton, Jan. 24, 1770, *ibid.*, p. 122.

46 Van Schreeven and Scribner, eds., *Revolutionary Virginia*, p. 232.

47 See Baumgarten, "Plains, Plaid and Cotton."

48 R. C. Nicholas to J. Norton, May 31, 1769, in Mason, ed., *John Norton & Sons*, pp. 96–97. For a discussion of New England homespun textile production, see Laurel Thatcher Ulrich, *The Age of Homespun, Objects and Stories in the Creation of an American Myth* (New York, 2001).

49 Matthew Pope to John Jacob, Aug. 25, 1775, microfilm M-283, Rockefeller Lib., original in British Museum, Additional Manuscripts, 34813, ff. 88-90 R., S. R. 344; Gibbs, "Cloth Production in Virginia," p. 111. I am indebted to Martha Katz-Hyman for pointing out that the swatches of linen still survive.

50 R. A. Brock, ed., *The Official Letters of Alexander Spotswood . . .* 1882, reprint (New York, 1973), I, p. 72.

51 Advertisement of Elisha and Robert White, Hanover Co., Va., in *Va. Gaz.* (Pinkney), Dec. 20, 1775.

52 George Washington to governor Jonathan Trumbull, Aug. 4, 1775, in Fitzpatrick, ed., *Writings of Washington*, III, p. 389.

53 Benjamin Franklin to Deborah Franklin, Apr. 6, 1766, in Leonard W. Labaree et al., eds., *The Papers of Benjamin Franklin* (New Haven, Conn., 1969), XIII, p. 233.

54 Jefferson wrote, "Observe that one of the strings is to be drawn tight round the root of the crown of the hat; and the vail then falling over the brim of the hat is drawn by the lower string as tight or loose as you please round the neck. When the vail is not chosen to be down, the lower string also is tied round the root of the crown so as to give it the appearance of a puffed bandage for the hat." Thomas Jefferson to Mary Jefferson, Apr. 24, 1791, in Edwin Morris Betts and James Adam Bear, Jr., eds., *The Family Letters of Thomas Jefferson* (Columbia, Mo., 1966), p. 79.

55 *Benjamin Franklin, Autobiography and Other Writings*, ed. with an introduction and notes by Ormond Seavey (Oxford, 1993), p. 68.

56 B. Franklin to Mary Stevenson, Sept. 14, 1767, in Ronald W. Clark, *Benjamin Franklin, A Biography* (New York, 1983), p. 209.

57 Franklin was described by Bancroft, *ibid.*, p. 242. Clark gives a complete history of Franklin's appearance before the Privy Council.

58 Benjamin Franklin, *Poor Richard: The Almanacks for the Years 1733–1758* (New York, 1976), p. 47.

59 B. Franklin to Emma Thompson, in Charles Coleman Sellers, *Benjamin Franklin in Portraiture* (New Haven, Conn., 1962), p. 99.

60 Mme. Vigée-Le Brun, *Memoirs of Mme. Elisabeth Louise Vigée-Le Brun*, Mar. 23, 1779, in Clark, *Benjamin Franklin*, p. 341.

61 Thomas Lee Shippen to William Shippen, Feb. 20, 1788, in Julian P. Boyd et al., eds., *The Papers of Thomas Jefferson*, 29 vols. (Princeton, N. J., 1950–), XII, p. 504.

62 Fragments of Jefferson's waistcoats are in the collections at Monticello, acc. nos. 27-65 a–c. Jefferson selected the July 1790 issue of *Magasin des Modes* for Martha Jefferson, see Boyd et al., eds., *Papers of Jefferson*, XVIII, p. 111.

63 *Memoirs of a Monticello Slave as Dictated to Charles Campbell in the 1840's by Isaac, one of Thomas Jefferson's Slaves*, ed. Rayford W. Logan (Charlottesville, Va., 1951), pp. 19–20.

64 Thomas Jefferson Randolph to Henry S. Randall, 1858, in *Jefferson Reader: A Treasury of Writings about Thomas Jefferson*, ed. with an introduction by Francis Coleman Rosenberger (New York, 1953), pp. 64–65.

65 Richard Beale Davis, ed., *Jeffersonian America, Notes on the United States of America Collected in the Years 1805–6–7 and 11–12 by Sir Augustus John Foster, Bart.* (San Marino, Calif., 1954), pp. 9–10, 15, 23, 49–50, 52, 54–55, 155.

66 Sen. William Plumer described Jefferson, "He was drest, or rather *undrest*, with an old brown coat, red waistcoat, old corduroy small clothes, much soiled—woolen hose—and slippers without heels," in Noble E. Cunningham, Jr., *The Image of Thomas Jefferson in the Public Eye* (Charlottesville, Va., 1981), p. 2.

67 For more on the Jeffersonian embargo, see Forrest McDonald, *The Presidency of Thomas Jefferson* (Lawrence, Kans., 1976), and Burton Spivak, *Jefferson's English Crisis, Commerce, Embargo, and the Republican Revolution* (Charlottesville, Va., 1979).

68 John Smilie, quoted in Spivak, *Jefferson's English Crisis*, p. 38.

69 T. Jefferson to Ellen Wayles Randolph, Feb. 23, 1808, in Betts and Bear, eds., *Family Letters of Thomas Jefferson*, p. 329.

70 Ann Cary Randolph to T. Jefferson, Mar. 18, 1808, *ibid.*, p. 334.

71 T. Jefferson to T. J. Randolph, Dec. 19, 1808, *ibid.*, p. 372.

72 Rosalie Calvert to her father, H. J. Stier, Nov. 13, 1808, in Callcott, ed., *Mistress of Riversdale*, p. 192.

73 R. Calvert to H. J. Stier, June 9, 1809, *ibid.*, p. 206.

74 R. Calvert to Isabelle van Havre, Dec. 3, 1808, *ibid.*, pp. 194–195. I thank Philip D. Morgan for pointing out that Rosalie's continental roots may have influenced her view of having a king.

75 David John Jeremy, ed., *Henry Wansey and his American Journal, 1794* (Philadelphia, Pa., 1970), pp. 40, 58, 99, 122.

76 Henry J. Hassey, No. 72 Wall-street, *New-York Gazette and General Advertiser*, Oct. 10, 1801, in Rita Susswein Gottesman, comp., *The Arts and Crafts in New York, 1800-1804* (New York, 1965), p. 367.

77 Michele Majer, "American Women and French Fashion," in *The Age of Napoleon, Costume from Revolution to Empire, 1789–1815*, ed. Katell le Bourhis (New York, 1989), pp. 217–237.

78 Devereux Jarratt, *The Life of the Reverend Devereux Jarratt . . .*, 1806, reprint (New York, 1969), p. 14.

CHAPTER 4

COMMON DRESS: CLOTHING FOR DAILY LIFE

1 Gregory A. Stiverson and Patrick H. Butler III, eds., "Virginia in 1732: The Travel Journal of William Hugh Grove," *Virginia Magazine of History and Biography*, LXXXV (January 1977), p. 29.

2 Mason, ed., *John Norton & Sons*, pp. 71–73.

3 July 29, 1774, in Farish, ed., *Journal & Letters of Fithian*, p. 150.

4 Collinson to Bartram, Feb. 17, 1737, in *William and Mary Quarterly*, 2nd Ser., VI (October 1926), p. 304.

5 Caution should be observed in interpreting period references; sometimes the word stuff refers to textile fabrics in general, not to the worsted textiles known as stuff.

6 Frederic Morton Eden, *The State of the Poor . . .*, III, 1797, reprint (London, 1966), p. cccxliii. The complete list of a woman's clothing for one year is:

Woman.	One Year's Expences.		
	£.	s.	d.
A common stuff gown	0	6	6
Petticoat	0	4	6
Two shifts, 3s. 8d. each, i[f] made at home will cost	0	6	0
Two pair of shoes, at 3s. 9d.	0	7	6
Coarse apron, 1s. Check ditto, 2s.	0	3	2
2 pair of stockings, 3s. if knit at home	0	2	6
Hat, (one in two years,) 1s. 8d.	0	0	10
Pair of stays, (once in 6 years,) 6s.	0	1	0
Coloured neck-handkerchief	0	1	0
Two common caps	0	1	8
Cheapest cloak, 2 years, 4s. 6d.	0	2	3
	£. 1	16	11

7 The largest girl's gown required seven yards of stuff, while the woman's gown required six yards of the wider grogram. *INSTRUCTIONS for Cutting out Apparel for the Poor. . . .* (London, 1789), pp. 16–17, 66, 68.

8 For a definition of grogram, see Florence M. Montgomery, *Textiles in America, 1650–1870* (New York, 1984), p. 250.

9 *Va. Gaz.* (Hunter), July 3, 1752.

10 *Maryland Gazette*, Dec. 2, 1746; *Va. Gaz.* (Purdie), Apr. 25, 1766. I am indebted to Joan Winder for recording clothing references from the *Md. Gaz.* newspapers.

11 *South-Carolina and American General Gazette* (Charleston), Dec. 15–22, 1775, in Windley, comp., *Runaway Slave Advertisements*, III, p. 479.

12 Baumgarten, "Plains, Plaid and Cotton," pp. 203–222.

13 Almost all eighteenth-century osnaburg was of linen fiber content. In the nineteenth century, osnaburg began to be made from cotton, not linen.

14 Lemire, *Fashion's Favourite*.

15 *Va. Gaz.* (Rind), July 20, 1769. Elizabeth Berry also had a blue cloth cloak with a hood, an old red cloak, a striped linsey short gown, and several petticoats.

16 Planché, *Cyclopaedia of Costume*, I, p. 230.

17 Eden, *State of the Poor*, II, pp. 556–557.

18 Sarah Benfield, an English servant, was advertised as a runaway in the *Va. Gaz.* (Hunter), Sept. 29, 1752.

19 *Md. Gaz.*, Aug. 28, 1760, Sept. 14, 1769.

20 Advertisement for Margaret Sliter, May 21, 1761, in Billy G. Smith

and Richard Wojtowicz, *Blacks Who Stole Themselves, Advertise-ments for Runaways in the* Pennsylvania Gazette, *1728–1790* (Philadelphia, Pa., 1989), p. 50.

21 Sept. 1, 1763, *ibid.*, p. 63.

22 Scholars continue to research what the phrases short gown and bed gown meant. I believe that short gowns may have differed from bedgowns in that the former had shaping pleats or draw-strings to give a closer fit, distinguishing them from unfitted, loose bedgowns. See Claudia Kidwell, "Short Gowns," *Dress*, IV (1978), pp. 30–65. Kidwell describes a group of 28 related gar-ments that probably were called short gowns. CWF has a printed cotton garment (1985-242) that may be a short gown. See Linda Baumgarten and John Watson with Florine Carr, *Costume Close-Up, Clothing Construction and Pattern, 1750–1790* (Williamsburg, Va., 1999), pp. 43–46.

23 *Pa. Gaz.*, Feb. 7, 1763, in Smith and Wojtowicz, *Blacks Who Stole Themselves*, pp. 61–62.

24 *Pa. Gaz.*, July 7, 1784, *ibid.*, p. 171.

25 Memorandum of articles purchased by Abigail Adams in London for "Miss Jefferson & Maid," July 10, 1787, prior to Mary Jeffer-son joining her father in Paris. Boyd et al., eds., *Papers of Jeffer-son*, XI, p. 574.

26 Randle Holme, *The Third Book of the Academy of Armory and Blazon*, 1688, reprint (Menston, Eng., 1972), p. 95.

27 *Va. Gaz.* (Purdie and Dixon), Feb. 5, 1767.

28 Robert Carter to Joshua Lefavor, Dec. 19, 1774, in Robert Carter Day Book, XIII (1773–1776), typescript TR 07.2, Rockefeller Lib., original in Duke University Library.

29 Landon Carter recorded that "my housewenches rec[eived] 4 yards [for] each [petticoat] and 2 yards each waistcoat." May 15, 1776, in Jack P. Greene, ed., *The Diary of Colonel Landon Carter of Sabine Hall, 1752–1778*, II (Charlottesville, Va., 1965), p. 1040.

30 In addition to her jacket, Hannah had "Petticoats of striped Cot-ton and Yarn, white Cotton Shift, Linen Handkerchief, a black Chip Hat, and Shoes and Stockings." During the eighteenth cen-tury, Virginians referred to any textile produced in the colony as "Virginia cloth," whether made of cotton, linen, wool, or a com-bination of fibers. *Va. Gaz.* (Dixon and Hunter), Oct. 17, 1777.

31 Beck, a mulatto slave who ran away from Frederick Co., also had "an old Osnabrig ditto [petticoat], and a white Apron, with One Breadth and a Half in it." *Md. Gaz.*, Sept. 6, 1770.

32 *South-Carolina Gazette*, Oct. 20–27, 1758, in Windley, comp., *Run-away Slave Advertisements*, III, p. 166.

33 Eden, *State of the Poor*, III, p. cccxliii.

34 Farish, ed., *Journal & Letters of Fithian*, p. 207.

35 July 8, 1781, in Diary of Mrs. Sarah Fouace Nourse, wife of James Nourse, of Piedmont, Berkeley Co., Va., p. 12, typescript TR 43, research files, Rockefeller Lib., original in private collection.

36 *Md. Gaz.*, Jan. 13, 1747, *Va. Gaz.* (Rind), Mar. 3, 1768.

37 *Va. Gaz.* (Purdie and Dixon), May 16, 1766, in Windley, comp., *Runaway Slave Advertisements*. I: *Virginia and North Carolina*, p. 43. Jemmy also wore "osnabrugs trousers, cotton jacket, waistcoat and breeches, [and] a hat, or Dutch cap."

38 Eighteenth-century newspapers confirm that workingmen wore a variety of sturdy cotton textiles. Nankeen breeches were worn by runaway men described in the *Va. Gaz.* (Rind), Sept. 22, 1768, June 7, 1770, and the *Virginia Independent Chronicle and General Advertiser* (Davis) (Richmond), July 7, 1790. A black Manchester velvet waistcoat appeared in the *Va. Gaz.* (Rind), Feb. 8, 1770. Black Manchester velvet breeches were worn by a runaway

described in the *Md. Gaz.*, Mar. 29, 1770. A white dimity jacket appeared in the *Virginia Gazette. or American Advertiser* (Hayes), July 9, 1785. White corded dimity breeches and jacket were taken by a runaway convict sought in the *Md. Gaz.*, July 15, 1746.

39 Harold Gill, formerly of the Research Dept., CWF, first com-pared leather breeches to blue jeans in the 1980s. Old Sturbridge Village, Sturbridge, Mass., has a pair of leather breeches that were worn by a free black man, acc. no. 26.40.21; the breeches are illus-trated in Linda Baumgarten, "'Clothes for the People,' Slave Clothing in Early Virginia," *Journal of Early Southern Decorative Arts*, XIV (November 1988), pp. 53–55.

40 *Va. Gaz.* (Purdie and Dixon), Mar. 28, 1766.

41 *Va. Gaz.* (Hunter), Apr. 11, 1755. The man also wore a "grey plain Frock with Metal Buttons," probably a loose coat with a collar.

42 *Va. Gaz.* (Purdie and Dixon), Oct. 27, 1768, July 25, 1766.

43 *Pa. Gaz.*, May 17, 1775, in Smith and Wojtowicz, *Blacks Who Stole Themselves*, p. 123. Leather breeches in the collection of the Museum of Fine Arts, Boston, are made in a similar manner with-out seams between the legs. Acc. no. 43.650. "Boursier," in Denis Diderot, *Recueil de planches, sur les sciences, les arts libéraux, et les arts mécaniques* (Paris, 1762–1777), II, plate 3.

44 *Va. Gaz.* (Hunter), Feb. 28, 1750/1.

45 During most of the eighteenth century, nonmilitary working-men's long pants were called trousers. Runaway advertisements reveal that the term overalls began to be used in the 1780s.

46 *Va. Gaz.* (Hunter), May 2, 1755; *Va. Gaz.* (Rind), Dec. 24, 1767.

47 *Va. Gaz.* (Rind), July 12, 1770; *Va. Gaz.* (Purdie), Nov. 28, 1777; *Va. Gaz.* (Dixon and Hunter), Aug. 26, 1775.

48 Copley painted three versions of *Watson and the Shark*. The paint-ings are in the National Gallery of Art, the Museum of Fine Arts, Boston, and the Detroit Institute of Arts.

49 Robert Pringle to David Glen, Jan. 22, 1738/9, in Walter B. Edgar, ed., *The Letterbook of Robert Pringle*, I: *April 2, 1737–September 25, 1742* (Columbia, S. C., 1972), p. 63.

50 *Va. Gaz.* (Rind), Sept. 22, 1768.

51 *Md. Gaz.*, Sept. 13, 1770.

52 *Va. Gaz.* (Hunter), Apr. 10, 1752.

53 *Md. Gaz.*, May 24, 1770.

54 *S.-C. Gaz.*, Dec. 8–15, 1759, in Windley, comp., *Runaway Slave Advertisements*, III, p. 178. The term robbin was used in Charleston; I have not found it in use in other colonies.

55 *South-Carolina Gazette and General Advertiser* (Charleston), May 20, 1783, *ibid.*, p. 715.

56 Fitzpatrick, ed., *Writings of Washington*, I, p. 254.

57 Fitzpatrick, ed., *Writings of Washington*, II, p. 420. See also "Wash-ington's Invoices and Letters, 1755–66," p. 94, typescript notebook at Mount Vernon Ladies Association, original in Lib. Cong.

58 Fitzpatrick, ed., *Writings of Washington*, XXVII, p. 296.

59 Thomas Jefferson's accounts with Thomas Carpenter and James Melvin, typescripts in Monticello, Carpenter accounts for May 1, 1801, Apr. 26, 1802, June 14, 1802, originals in University of Vir-ginia; Carpenter accounts for Dec. 1, 1802, Dec. 1805, March 8, 1806, and Melvin account for Oct. 10, 1807, originals in Massachu-setts Historical Society, Boston; Carpenter account for Dec. 1, 1803, original in Huntington Library. I thank the staff at Monti-cello for sharing research information, especially Lucinda Stan-ton, Susan Stein, and Ann M. Lucas.

60 Jack Ayres, ed., *Paupers and Pig Killers, The Diary of William Holland, A Somerset Parson, 1799–1818* (Gloucester, Eng., 1986), p. 74.

61 *Md. Gaz.*, Dec. 2, 1746.

62 *S.-C. Gaz.*, June 11–18, 1763, in Windley, comp., *Runaway Slave Advertisements*, III, p. 231, Aug. 30–Sept. 6, 1760, *ibid.*, p. 186.

63 *Va. Gaz.*, Oct. 22, 1736.

64 Charles Ball, *Fifty Years in Chains; or, the Life of an American Slave*, 1858, reprint (Miami, Fla., 1969), pp. 200, 288. Ball's oral narrative was originally told to a Mr. Fisher and first published in 1836, probably as an antislavery tract. It went through subsequent printings, some of which left out portions of the earlier edition. A copy of the 1836 edition, titled *Slavery in the United States; A Narrative of the Life and Adventures of Charles Ball, A Black Man* (Lewistown, Pa., 1836) is in Swem Lib.

65 Stiverson and Butler, eds., "Virginia in 1732," pp. 31–32.

66 Allan Kulikoff, *Tobacco and Slaves, The Development of Southern Culture in the Chesapeake, 1680–1800* (Chapel Hill, N. C., 1986).

67 Edmund S. Morgan, *American Slavery, American Freedom: The Ordeal of Colonial Virginia* (New York, 1975), p. 331.

68 *S.-C. Gaz.*, June 11–18, 1750, July 30–Aug. 6, 1750, in Windley, comp., *Runaway Slave Advertisements*, III, pp. 99–100.

69 Jefferson added that the rest of the workers were clothed in "Colored plains" or "cotton." James A. Baer, Jr., ed., *Jefferson at Monticello* (Charlottesville, Va., 1967), pp. 53–54.

70 Stephen Decatur, Jr., *Private Affairs of George Washington, From the Records and Accounts of Tobias Lear, Esquire, his Secretary* (Boston, 1933), p. 32.

71 Joseph Ball to his nephew, Joseph Chinn, who was managing his Virginia plantations, June 30, 1749, Oct. 7, 1758. Joseph Ball Letter Book, typescript TR 92, research files, Rockefeller Lib., original in Lib. Cong.

72 "The Will of Mrs. Mary Willing Byrd of Westover, 1813, with a List of the Westover Portraits," *VMHB*, VI (April 1899), p. 353.

73 *Va. Gaz.* (Purdie and Dixon), May 4, 1769, Dec. 13, 1770.

74 *South-Carolina Gazette and Country Journal* (Charleston), Nov. 12, 1771, in Windley, comp., *Runaway Slave Advertisements*, III, p. 669. During this period, negro cloth was the name given to the wool fabric also known as plains; in the nineteenth century, negro cloth and negro cotton were usually made of true cotton fiber. For an example of negro cotton around 1834, see Rita Adrosko, "A 'Little Book of Samples': Evidence of Textiles Traded to the American Indians," in *Textiles in Trade*, pp. 68, 73. See also *"Negro Cloth," Northern Industry & Southern Slavery* (Boston, 1981).

75 *South-Carolina Gazette and Country Journal* (Charleston), Feb. 25, 1772, in Windley, comp., *Runaway Slave Advertisements*, III, p. 673.

76 *Va. Gaz.* (Purdie and Dixon), Nov. 29, 1770.

77 Robert Beverley to John Backhouse, probably 1768, in Robert Beverley Letterbook, typescript in slave clothing files, Dept. of Collections, CWF, original in Lib. Cong.

78 For more on slave and plantation clothing, see Baumgarten, "'Clothes for the People.'"

79 Dec. 20, 1784, in Nathaniel Burwell Day Book, typescript TR 06, research files, Rockefeller Lib.

80 Entries for Jan. 4, 20, 29, Mar. 24, May 21, June 16, Oct. 1, 6, 1781; Oct. 14, 15, 17, 18, 19, 22, Dec. 3, 16, 21, 1782, in Diary of Nourse, pp. 1, 2, 6, 9, 10, 18, 44, 45.

81 Fitzpatrick, ed., *Writings of Washington*, XXXII, pp. 277, 348.

82 Feb. 18, 1743/4, in Joseph Ball Letter Book.

83 Edward Ambler, Dec. 7, 1767, in Charles W. Dabney Papers, microfilm M-24.1, Rockefeller Lib., original in Charles W. Dabney Papers, University of North Carolina Library, Southern Historical Collection.

84 List of coarse goods desirable for slaves, in Boyd et al., eds., *Papers of Jefferson*, XIII, pp. 392–393.

85 Wood, *Black Majority*, p. 232.

86 *S.-C. Gaz.* (Powell & Co.), May 10, 1773, in Windley, comp., *Runaway Slave Advertisements*, III, p. 324.

87 *South-Carolina and American General Gazette* (Charleston), Dec. 5–11, 1770, *ibid.*, pp. 435–436.

88 Gladys-Marie Fry, *Stitched from the Soul, Slave Quilts from the Ante-Bellum South* (New York, 1990), pp. 7, 53.

89 *S.-C. Gaz.*, Nov. 5, 1744.

90 *Va. Gaz.* (Pinkney), June 15, 1775, in Windley, comp., *Runaway Slave Advertisements*, I, pp. 331–332; *South-Carolina and American General Gazette* (Charleston), Nov. 4, 1780, *ibid.*, III, p. 572.

91 *Va. Gaz.* (Rind), Sept. 22, 1768, *ibid.*, I, pp. 289–290.

92 At least as early as the 1730s, Charleston slaves were generally given liberty during the Christmas holiday. Wood, *Black Majority*, p. 320, n. 48.

93 A. G. Roeber, ed., "A New England Woman's Perspective on Norfolk, Virginia, 1801–1802: Excerpts from the Diary of Ruth Henshaw Bascom," *Proceedings of the American Antiquarian Society*, LXXXVIII (1978), p. 289.

94 *Va. Gaz.* (Purdie), Apr. 25, 1766, in Windley, comp., *Runaway Slave Advertisements*, I, p. 40; *S.-C. Gaz.*, Oct. 13, 1757, *ibid.*, III, p. 158. For other references to slaves in earrings, see *Royal South-Carolina Gazette* (Charleston), Dec. 21, 1780, and *South-Carolina Gazette and General Advertiser* (Charleston), May 2, 1783, *ibid.*, pp. 708, 713.

95 *S.-C. Gaz.*, Jan. 12–19, 1738, Feb. 12–19, 1741, *ibid.*, pp. 30, 44.

96 *S.-C. Gaz.*, June 10–14, 1760, *ibid.*, p. 184.

97 Gerald W. Mullin, *Flight and Rebellion, Slave Resistance in Eighteenth-Century Virginia* (New York, 1972), p. 41. See also Philip David Morgan, "The Development of Slave Culture in Eighteenth Century Plantation America" (Ph.D. diss., University College London, 1977), p. 382.

98 Herbert M. Cole, *Icons, Ideals and Power in the Art of Africa* (Washington, D. C., 1989), p. 46, fig. 51, p. 90, fig. 100. For descriptions of scarification and teeth filing in early Africa, see Philip D. Curtin, ed., *Africa Remembered, Narratives by West Africans from the Era of the Slave Trade* (Madison, Wisc., 1968), pp. 91, 255–257.

99 *S.-C. Gaz.*, June 21–28, 1735, *South-Carolina and American General Gazette* (Charleston), Dec. 24, 1778, in Windley, comp., *Runaway Slave Advertisements*, III, pp. 16, 548. For other runaways with ritual scarring and filed teeth, see *ibid.*, I, p. 15 and *ibid.*, III, pp. 14, 17, 108, 117, 125, 134, 140, 151, 156, 161, 165, 167, 170, 171, 173, 176, 178, 179, 187, 191, 202, 204, 208, 227, 241, 242, 246, 253, 254, 269, 277, 279, 280, 282, 283, 297, 313, 314, 316, 319, 321, 325, 329, 332, 342, 346, 349, 466, 472, 478, 479, 573.

100 *Va. Gaz.*, Oct. 3–10, 1745, in Windley, comp., *ibid.*, I, p. 15

101 For more about the use of head wraps among African-Americans, see Helen Bradley Foster, *"New Raiments of Self," African American Clothing in the Antebellum South* (New York, 1997), esp. chap. 6.

102 *South-Carolina Gazette and Country Journal* (Charleston), Aug. 30, 1774, in Windley, comp., *Runaway Slave Advertisements*, III, p. 696. For more references to head kerchiefs, see pp. 13, 14, 44, 62, 66, 122, 126, 135, 183, 255, 324, 330, 355, 356, 405, 422, 459, 467, 553.

103 *South-Carolina Gazette and Country Journal* (Charleston), July 11, 1775, *ibid.*, p. 702; *Va. Gaz.* (Hunter), Mar. 12, 1752.

104 Basil Hall, *Travels in North America, in the Years 1827 and 1828*, II (Philadelphia, Pa., 1829), p. 233.

105 *Va. Gaz.* (Rind), Oct. 26, 1769.

CHAPTER 5
CRADLE TO COFFIN:
LIFE PASSAGES REFLECTED IN CLOTHING

1 Aug. 12, 1755, in Carol F. Karlsen and Laurie Crumpacker, eds., *The Journal of Esther Edwards Burr, 1754–1757* (New Haven, Conn., 1984), p. 143.

2 *Ibid.*, p. 292.

3 June 3, 1770, Aug. 3, 1788, in Thomas Eliot Andrews, ed., "The Diary of Elizabeth (Porter) Phelps," *New England Historical and Genealogical Register*, CXVIII (April 1964), pp. 109, CXIX (October 1965), p. 298.

4 A note that accompanied the dress gave Sarah Greene Hill's dates as 1700–1760; her wedding date is unknown, Object folder 1951-150, 1, CWF. Natalie Rothstein dated the silk and identified it as Spitalfields production. Rothstein, *Silk Designs of the Eighteenth Century*, p. 118. The alterations to the gown were extensive. The back bodice has old folds from the pleats of a former sack-back gown. Piecing and faint impressions of folds indicate that the bodice was altered from a stomacher-front style to one with a center-front, edge-to-edge closure. The sleeves were slimmed and elongated with pieces set in above the elbows.

5 Wedding dress of Mrs. Joseph Nollekens, 1772, described in Phillis Cunnington and Catherine Lucas, *Costume for Births, Marriages & Deaths* (New York, 1972), p. 84.

6 A white satin gown at Colonial Williamsburg is trimmed with pinked and punched self-fabric ribbons. The stylistic features of a decorative stomacher, punched self-fabric trim, sleeve flounces, and open skirt accord with the traditional date of 1756, when Ursula Westoff of Leicester, Eng., is said to have worn it for her wedding. The gown bears evidence, however, of remodeling from an earlier period, perhaps as early as 1740. If the oral tradition is correct, the bride wore an altered gown at her wedding. See Baumgarten and Watson, *Costume Close-Up*, pp. 11–15.

7 *London Magazine or Gentleman's Monthly Intelligencer*, in Cunnington and Lucas, *Costume for Births, Marriages & Deaths*, pp. 99–100.

8 The eight female attendants who carried Princess Anne's heavy train wore "the same sort of dress—all white and silver, with great quantities of jewels in their hair." Lady Llanover, ed., *The Autobiography and Correspondence of Mary Granville, Mrs. Delany; with Interesting Reminiscences of King George the Third and Queen Charlotte*, 1st Ser., I (London, 1861), p. 436. A stiff-bodied gown was considered formal dress, not worn for daily occasions.

9 From the diary of the Duchess of Northumberland, in Cunnington and Lucas, *Costume for Births, Marriages & Deaths*, p. 100.

10 *Va. Gaz.* (Rind), Apr. 13, 1769; *Va. Gaz.* (Purdie and Dixon), Nov. 29, 1770.

11 Mason, ed., *John Norton & Sons*, p. 218.

12 A handwritten paper that came with the fan stated that it belonged to Nancy or Ann Bland (b. Aug. 15, 1735), the daughter of Anne Poythress and Richard Bland, member of the Virginia House of Burgesses. Ann married John Pryor at an unknown date; her first child, Richard, was born about 1760. Richard married a woman with the same name as his mother, Ann Poythress Bland, and the fan may be the wedding fan of this later Ann. Object folder 1992-172, 1, CWF.

13 Technical analysis reveals that no actual silver is present on the fan; watercolor, lead white paint, and tin-plating on copper sequins give the impression of silver at less expense. For technical analysis, I thank colleagues in the Conservation Department, CWF, esp. Valinda Carroll, Pamela Young, David Blanchfield, and Patricia Silence. Valinda Carroll performed extensive testing and did research on the fan.

14 Andrews, ed., "Diary of Phelps," *New Eng. Hist. Gen. Reg.*, CXVIII (April 1964), p. 117.

15 Ethel Armes, comp. and ed., *Nancy Shippen, Her Journal Book, The International Romance of a Young Lady of Fashion of Colonial Philadelphia with Letters to Her and about Her*, 1935, reprint (New York, 1968), p. 219.

16 Karlsen and Crumpacker, eds., *Journal of Burr*, p. 268.

17 *Ibid.*, p. 265.

18 Jefferson to Mary Jefferson Eppes, Jan. 7, 1798, in Randolph, comp., *Domestic Life of Thomas Jefferson*, p. 247. Mary had been married for about three months when her father wrote this letter.

19 Elaine Forman Crane et al., eds., *The Diary of Elizabeth Drinker*, 3 vols. (Boston, 1991), I, p. 415.

20 *Ibid.*, pp. 88–420.

21 Apr. 13, 1756, in Karlsen and Crumpacker, eds., *Journal of Burr*, p. 192.

22 Isabelle van Havre to Rosalie Calvert, spring 1812, translated from the French, in Callcott, ed., *Mistress of Riversdale*, p. 233, n. 3.

23 Calvert to van Havre, June 2, 1816, *ibid.*, p. 299. For more on women's experience with pregnancy, see Mary Beth Norton, *Liberty's Daughters, The Revolutionary Experience of American Women, 1750–1800* (Boston, 1980), pp. 71–94.

24 Other students of women's lives confirm that pregnant women continued to be active. See Sally G. McMillen, *Motherhood in the Old South, Pregnancy, Childbirth, and Infant Rearing* (Baton Rouge, La., 1990); Jane C. Nylander, *Our Own Snug Fireside, Images of the New England Home, 1760–1860* (New York, 1993); and Laurel Thatcher Ulrich, *Good Wives, Image and Reality in the Lives of Women in Northern New England, 1650–1750* (New York, 1982).

25 Karlsen and Crumpacker, eds., *Journal of Burr*, pp. 126–188.

26 Entries for winter 1769/70, Mrs. Mary (Vial) Holyoke, in *The Holyoke Diaries, 1709–1856*, introduction and annotations by George Francis Dow (Salem, Mass., 1911), pp. 71–73.

27 Andrews, ed., "Diary of Phelps," *New Eng. Hist. Gen. Reg.*, CXVIII (April 1964), p. 121.

28 Natalie Rothstein, ed., *A Lady of Fashion, Barbara Johnson's Album of Styles and Fabrics* (London, 1987), p. 9. The event occurred on Sept. 24, 1743.

29 Bottorff and Flannagan, eds., "Diary of Hill," pp. 27–28, 30.

30 William Buchan, *Advice to Mothers. . . .* (Charleston, S. C., 1807), pp. 21–23.

31 Cunnington and Lucas, *Costume for Births, Marriages & Deaths*, p. 15.

32 "Tailleur de Corps," in Diderot, *Recueil de planches*, IX, plate 24, figs. 2–7.

33 "Corps pour les femmes enceintes se laçent par les deux côtés en A," *ibid.*, plate 23, fig. 3.

34 I am indebted to Janet Arnold for first suggesting that this pair of stays was probably intended for pregnancy.

35 Buchan, *Advice to Mothers*, p. 10.

36 "Sister Polly" Hill died soon after childbirth in Sept. 1797; see entries for Sept. 8–11, 1797, in Bottorff and Flannagan, eds., "Diary of Hill," p. 42.

37 Samuel Pepys, in Cunnington and Lucas, *Costume for Births, Marriages & Deaths*, pp. 14–15.

38 Farish, ed., *Journal & Letters of Fithian*, p. 193.

39 Several early maternity gowns have been published or have been brought to my attention. Judy Wentworth provided photographs of an example in the Ulster Museum, Belfast. The striped silk gown has a generous overlap on the front bodice; beneath the overlapping flaps is an adjustable laced inner bodice. This gown was not designed for a stomacher. The bodice back is sewn to the gown overskirt, while the bodice front has extended tabs that overlay a separate matching petticoat. Another maternity gown is in the collections of Old Sturbridge Village, Mass. It has a history of having been worn in Maine by Betsey Rogers Barker in the 1790s. See Jane Nylander, "Textiles at Old Sturbridge Village," *The Magazine Antiques*, CXVI (September 1979), p. 603. A linen maternity dress from Chester Co., Pa., is in the collections of the Philadelphia Museum of Art. See Linda Grant De Pauw and Conover Hunt, *Remember the Ladies, Women in America, 1750–1815* (New York, 1976), p. 22. Nancy Bradfield has published a 1770s jacket from the Snowshill Collection, Berrington Hall, Leominster, Eng. Apparently designed for pregnancy, the jacket has an inner bodice of linen with eyelets for lacing and a generous front overlap with a series of hooks and thread bars for expansion. Nancy Bradfield, *Costume in Detail, 1730–1930* (New York, 1997), p. 46.

40 Some statistical studies suggest that fewer women died in childbirth than was generally believed. Nevertheless, most people had known someone who had died in childbirth, and the perception of danger was widely prevalent. Norton, *Liberty's Daughters*, pp. 75–79.

41 For a discussion of childbirth, see Ulrich, *Good Wives*, chap. 7.

42 Josiah Wedgwood to Mr. Bentley, Nov. 30, 1774, in Ann Finer and George Savage, eds., *The Selected Letters of Josiah Wedgwood* (London, 1965), p. 168.

43 *Holyoke Diaries*, pp. 73, 77, 107.

44 Mar. 8, 1757, in Karlsen and Crumpacker, eds., *Journal of Burr*, pp. 252–253.

45 Nylander, *Our Own Snug Fireside*, p. 28.

46 *INSTRUCTIONS for Cutting out Apparel*, pp. 73–85; and A Lady, *The Lady's ECONOMICAL ASSISTANT, or THE ART OF CUTTING OUT, AND MAKING, The most useful Articles of Wearing Apparel...*, 1808, reprint (Springfield, Ohio, 1998), pp. 25–33.

47 *INSTRUCTIONS for Cutting out Apparel*, p. 84; Thomas Bull, *Hints to Mothers*, 1841, in Cunnington and Lucas, *Costume for Births, Marriages & Deaths*, p. 17.

48 Trade card of Sibbella Lloyd, Martha Williams, and Elizabeth Storey, London haberdashers, in Clare Rose, "A Group of Embroidered Eighteenth-Century Bedgowns," *Costume*, XXX (1996), p. 80.

49 A second short shift used by Van Rensselaer is similar to the example illustrated, except the sleeves have been cut off. CWF, G1990-5, gift of Mrs. Cora Ginsburg. Van Rensselaer's 1854 will divided her personal effects that were not otherwise specifically enumerated between two women. The clothing descended to a grand niece, Ann Van Rensselaer Van Wyck Wells (1822–1919). Mary Ann Cappiello, Research on Ann De Peyster Van Cortlandt Van Rensselaer, Philip Schuyler Van Rensselaer, and the Van Cortlandt and Van Rensselaer Families, unpublished research report, July 18, 2000. Object folder G1990-5, CWF.

50 A similar bed gown is in the collections at Platt Hall, Manchester, Eng. See Jane Tozer and Sarah Levitt, *Fabric of Society, A Century of People and their Clothes 1770–1870* (Cambridge, 1983), pp. 51–52.

51 See the examples described by Rose, "Embroidered Eighteenth-Century Bedgowns."

52 Advertisements by Jane Charlton and Margaret Hunter, milliners in Williamsburg, Va., *Va. Gaz.* (Purdie and Dixon), May 7, 1772; *Va. Gaz.* (Purdie and Dixon), Apr. 29, 1773.

53 Rosalind K. Marshall, *Virgins and Viragos, A History of Women in Scotland from 1080 to 1980* (London, 1983), p. 229.

54 July 29, 1756, in Karlsen and Crumpacker, eds., *Journal of Burr*, p. 214.

55 Esther Burr weaned Aaron when he was about 14 months old. Apr. 18, 1757, *ibid.*, p. 258.

56 Ulrich, *Good Wives*, pp. 141–143.

57 Bottorff and Flannagan, eds., "Diary of Hill," pp. 8–10.

58 John Locke, *Some Thoughts Concerning Education*, 1699, ed. John W. Yolton and Jean S. Yolton (Oxford, 1989).

59 Buchan, *Advice to Mothers*, p. 41. For a description of swaddling, see Clare Rose, *Children's Clothes Since 1750* (London, 1989), pp. 15–18, and Phillis Cunnington and Anne Buck, *Children's Costume in England, From the Fourteenth to the end of the Nineteenth Century* (London, 1965), p. 103.

60 "Diaper for Clouting" was advertised for sale in the *Va. Gaz.* (Purdie and Dixon), Apr. 29, 1773.

61 Kathleen Epstein, *British Embroidery, Curious Works from the Seventeenth Century* (Williamsburg, Va., 1998), p. 70; Gillian Clark, "Infant Clothing in the Eighteenth Century: A New Insight," *Costume*, XXVIII (1994), pp. 52–53; Jill Draper, "Oliver Cromwell's Baby Clothes?" *Antique Collector* (June 1986), pp. 125–126. Epstein believes that the cotton yarn suitable for knitting arrived in English towns in the early 1690s; Draper assigns a date of the 1730s.

62 In the seventeenth century, some babies were christened in colored gowns. The Countess of Derby wrote in 1628 that the French fashion was for white christening gowns, while "here [in England] they dress them in colours." Cunnington and Lucas, *Costume for Births, Marriages & Deaths*, p. 54.

63 Poor children may have escaped the rigors of wearing stays. No stays are listed among the extant orders for clothing for Virginia slave children.

64 *Va. Gaz.* (Purdie and Dixon), Oct. 10, 1771.

65 As late as the 1930s, pink and blue were interchangeable for infants. See Jo B. Paoletti, "The Gendering of Infants' and Toddlers' Clothing in America," in *The Material Culture of Gender, The Gender of Material Culture*, ed. Katharine Martinez and Kenneth L. Ames (Winterthur, Del., 1997), pp. 27–35.

66 Clark, "Infant Clothing," pp. 47–59, esp. pp. 50, 51, 55, 56.

67 A Lady, *The Workwoman's Guide*, 1838, reprint (Owston Ferry, Eng., 1975), p. 41.

68 Abigail Adams to Mary Smith Cranch, Oct. 13, 1766, in Lyman H. Butterfield, ed., *Adams Family Correspondence* (Cambridge, Mass., 1963), I, pp. 56–57.

69 *Va. Gaz.* (Purdie and Dixon), Jan. 30, Apr. 23, Oct. 14, 1773.

70 Esther reported proudly that Sally had begun to walk at 14 months old, and was running by 15 months, July 7, 1755, in Karlsen and Crumpacker, eds., *Journal of Burr*, p. 132.

71 Crane et al., *Diary of Drinker*, I, p. 175.

72 Farish, ed., *Journal & Letters of Fithian*, p. 148.

73 Andrews, ed., "Diary of Phelps," *New Eng. Hist. Gen. Reg.*, CXVIII (April 1964), p. 114; CXIX (April 1965), p. 133 (October 1965), p. 300; CXX (January 1966), p. 63 (October 1966), p. 295; CXXII (October 1968), p. 307.

74 Crane et al., eds., *Diary of Drinker*, II, p. 893.

75 Mason, ed., *John Norton & Sons*, p. 331.

76 Barbara Johnson chose "grey [worsted] stuff "and "white [silk] lutestring" as second mourning for her father in 1756. Rothstein, ed., *Lady of Fashion*, p. 3. A woman from Westmoreland Co., Va., ordered for her second mourning in 1766, "dark Ravenly Ray ducape," black India persian with matching ribbon, calico in a black and white shell pattern, and a black quilted petticoat in 1766. Order from Mrs. William Landhorn to John Norton and Company, Dec. 1766, Nancy Oberseider, "The Wearing Apparel of the Women of Westmoreland County, Virginia, 1700–1775" (master's thesis, College of William and Mary, 1966), p. 64.

77 Bottorff and Flannagan, eds., "Diary of Hill," p. 43.

78 Rothstein, ed., *Lady of Fashion*, pp. 4, 77.

79 "BOmbazeens, Crapes, and other Sorts of Mourning, for Ladies" were offered by Sarah Packe, *Va. Gaz.*, Feb. 24–Mar. 1, 1737/8. Other advertisements for bombazeen and crape are listed in the *Va. Gaz.* (Purdie and Dixon) July 25, 1766, Feb. 25, 1768, Nov. 12, 1772; *Va. Gaz.* (Dixon and Hunter) June 27, 1777.

80 *Va. Gaz.* (Parks), Feb. 24–Mar. 1, 1737/8.

81 Lord Botetourt's Estate for Mourning, Oct. 17, 1770, in Robert Carter Nicholas Accounts, Accounts of the Botetourt Estate, 1768–1771, microfilm M-22-3, Rockefeller Lib., original in Lib. Cong.

82 Supplement to the *Va. Gaz.* (Purdie and Dixon), Oct. 18, 1770.

83 "The Estate of Mrs. Martha Winkfield [sic], To funerall Charges & other Acco^bl" July 22–23, 1709, photocopy and information courtesy Mr. Henry G. Taliaferro, Aug. 13, 1995, original in Suffolk Co., Mass., records.

84 *South-Carolina and American General Gazette* (Charleston), Nov. 4, 1780, in Windley, comp., *Runaway Slave Advertisements*, III, p. 572.

85 Abigail Adams to her sister, Dec. 30, 1799, in "New Letters of Abigail Adams," *Proceedings of the American Antiquarian Society*, LV (October 1945), p. 403.

86 *Va. Gaz.* (Purdie & Dixon), May 11, 1769, Oct. 31, 1771, Nov. 5, 1772; Mason, ed., *Norton & Sons*, pp. 218–219.

87 Anne Sue Hirshorn, "Mourning fans," *The Magazine Antiques*, CIII (April 1973), pp. 801–804.

88 Almost 60 pairs of gloves, 9 hatbands, and 12 "favours" were given out at the 1757 funeral of an English spinster. David Vaisey, ed., *The Diary of Thomas Turner, 1754–1765* (Oxford, 1985), pp. 78–79.

89 M. Halsey Thomas, ed., *The Diary of Samuel Sewall, 1674–1729*. II, *1709–1729* (New York, 1973), p. 1056.

90 *Va. Gaz.* (Purdie and Dixon), June 4, 1772, June 20, 1771, July 29, 1773.

91 Crane et al., eds., *Diary of Drinker*, III, pp. 2080, 2090.

CHAPTER 6

TAILORING MEANING: ALTERATIONS
IN EIGHTEENTH-CENTURY CLOTHING

1 I am indebted to John Watson for his creative thoughts on the life cycle of artifacts and the concept of limbo. John Watson, "The Conservation of Working Objects," lecture, Nov. 9, 2001, Williamsburg, Va., in author's files.

2 Will of John Johnson, alias Weston, Jan. 28, 1763, Norfolk Co., Va., Wills, microfilm M-1365-21, pp. 103–105, Rockefeller Lib., original in Norfolk Co. Courthouse, Portsmouth, Va.

3 Buck, *Dress in Eighteenth-Century England*, pp. 79–80.

4 Invoice, July 15, 1771, in Gilbert, *Life and Work of Chippendale*, p. 192.

5 Colin MacKenzie, *Mackenzie's Five Thousand Receipts in All the Useful and Domestic Arts. . . .* (Philadelphia, Pa., 1830), p. 97.

6 *Va. Gaz.* (Purdie and Dixon), June 23, 1768.

7 *Ibid.* (Hunter), Oct. 20, 1752.

8 Edward Ambler, Dec. 7, 1767, microfilm M-24.1, Rockefeller Lib., original in Dabney Papers.

9 Joseph Ball to Joseph Chinn, Feb. 18, 1743/4, in Joseph Ball Letter Book.

10 *Va. Gaz.* (Purdie and Dixon), Dec. 10, 1767.

11 Windley, comp., *Runaway Slave Advertisements*, III, p. 44.

12 The clothing is in the collections at Monticello, Charlottesville, Va. Linda R. Baumgarten, "Jefferson's clothing," *The Magazine Antiques*, CXLIV (July 1993), pp. 100–105; Baumgarten, "Under Waistcoats and Drawers," pp. 4–16.

13 Janet Arnold, ed., *Queen Elizabeth's Wardrobe Unlock'd, The Inventories of the Wardrobe of Robes prepared in July 1600* (Leeds, Eng., 1988), pp. 206–207; Jeremy Farrell, *Socks and Stockings* (London, 1992), p. 10.

14 Advertisements of Sept. 26, 1748, Apr. 1, 1751, *New-York Gazette Revived in the Weekly Post-Boy*, in Gottesman, comp., *Arts and Crafts in New York*, pp. 275, 325–326.

15 See Baumgarten and Watson, *Costume Close-Up*, pp. 75–79.

16 Henry Purefoy to his tailor, July 7, 1751, in Cunnington and Lucas, *Costume for Births, Marriages & Deaths*, p. 247.

17 July 20, 1767, in Fitzpatrick, ed., *Writings of Washington*, II, p. 463.

18 Rosalie Calvert to Isabelle Van Havre, Dec. 30, 1817, Mar. 25, 1819, in Callcott, ed., *Mistress of Riversdale*, pp. 329, 347.

19 Thomas Anburey, *Travels Through the Interior Parts of America*, 1789, reprint (New York, 1969), I, p. 197.

20 General Orders from Newburgh, N. Y., Feb. 24, 1783, in Fitzpatrick, ed., *Writings of Washington*, XXVI, pp. 158–159.

21 Nylander, *Our Own Snug Fireside*, p. 165.

22 Stuart Maxwell, *Two Eighteenth-Century Tailors*, Hawick Archaeological Society Transactions, 1972, reprint (Hawick, Eng., 1973), p. 13.

23 July 14, 1775, June 10, 1774, in Edward Miles Riley, ed., *The Journal of John Harrower, An Indentured Servant in the Colony of Virginia 1773–1776* (Williamsburg, Va., 1963), pp. 102–103, 45.

24 June 30, 1792, in Colonel Francis Taylor's Diary 1786–1799, p. 65, typescript in Department of Collections files, CWF, original in Virginia State Library, reference courtesy of Jan K. Gilliam.

25 Peter Hayden, "Records of Clothing Expenditure for the Years 1746–79 Kept by Elizabeth Jervis of Meaford in Staffordshire," *Costume*, XXII (1988), p. 38.

26 A Lady, *Workwoman's Guide*, p. 109.

27 Mar. 7, 1791, July 17, 1797, in Colonel Taylor's Diary, pp. 52, 104.

28 For more information about the shirt, see Baumgarten and Watson, *Costume Close-Up*, pp. 105–108.

29 A waistcoat at the Montreal Museum of Fine Arts, acc. no. 1975.DT. 3, is pale green silk, embroidered to form with silk, metal threads, and sequins. The embroidered stand-up collar was taken from the embroidered reserve just beneath the pocket flaps. The shaped pocket flaps were turned upside-down and moved up on the body to become welt pockets. The original hems were cut and repieced into position to become the new hems. The waistcoat probably dates from the 1770s and was remodeled around 1800. I thank the staff at the Montreal Museum of Fine Arts for allowing

access to examine the waistcoat in 1994. The Wisconsin Historical Society, Madison, has a similarly altered waistcoat, acc. no. 1956-4234. The garment is cream-color silk satin embroidered with silk. The pocket flaps were raised, with sections taken out above the hem's embroidery to shorten the garment. The removed fabric probably formed the new standing collar. I thank Joan Severa and Leslie Bellais.

30 June 13, 1661, in Robert Latham and William Matthews, eds., *The Diary of Samuel Pepys: A New and Complete Transcription* (London, 1970), II, p. 120. I thank Betty Leviner for drawing attention to this reference.

31 George Washington to Robert Cary & Company, Apr. 26, 1763, in Fitzpatrick, ed., *Writings of Washington*, II, p. 395.

32 Washington to Cary & Co., Sept. 28, 1760, *ibid.*, p. 351.

33 Kay Staniland, *In Royal Fashion, The Clothes of Princess Charlotte of Wales & Queen Victoria 1796–1901* (London, 1997), pp. 132, 134, 144, 146, 148. Franz Xaver Winterhalter painted the queen and her family in historical costume on several occasions.

34 Lowenthal, *Past Is a Foreign Country*, pp. 263, 278.

35 *Ibid.*, p. 263.

CONCLUSION

1 Grant McCracken points out that when people combine clothing in a novel way, exercising the "combinatorial freedom" that is inherent in language, the message becomes more, rather than less, confusing to the viewer. McCracken, *Culture and Consumption*, p. 66.

SELECTED BIBLIOGRAPHY

Adler, Ronald B., and Neil Towne. *Looking Out/Looking In, Interpersonal Communication.* Fort Worth, Tex.: Harcourt Brace College Publishers, 1996.

Adrosko, Rita. "A 'Little Book of Samples': Evidence of Textiles Traded to the American Indians." In *Textiles in Trade, Proceedings of the Textile Society of America Biennial Symposium, September 14–16, 1990, Washington, D. C.* Los Angeles, Calif.: Textile Society of America, 1990.

Albion, Robert Greenhalgh, and Leonidas Dodson, eds. *Philip Vickers Fithian: Journal, 1775–1776.* Princeton, N. J.: Princeton University Press, 1934.

Anburey, Thomas. *Travels Through the Interior Parts of America.* 1789. Reprint. New York: Arno Press, 1969.

Andrews, Charles M. *The Colonial Period of American History.* New Haven, Conn.: Yale University Press, 1938.

Andrews, Thomas Eliot, ed. "The Diary of Elizabeth (Porter) Phelps." *New England Historical and Genealogical Register*, CXVIII (April 1964); CXIX (April 1965); CXIX (October 1965); CXX (January 1966); CXX (October 1966); CXXII (October 1968).

Arch, Nigel, and Joanna Marschner. *Splendour at Court, Dressing for Royal Occasions since 1700.* London: Unwin Hyman, 1987.

Armes, Ethel, comp. and ed. *Nancy Shippen, Her Journal Book, The International Romance of a Young Lady of Fashion of Colonial Philadelphia with Letters to Her and about Her.* 1935. Reprint. New York: Benjamin Blom, 1968.

Arnold, Janet, ed. *Queen Elizabeth's Wardrobe Unlock'd, The Inventories of the Wardrobe of Robes prepared in July 1600.* Leeds, Eng.: Maney, 1988.

Arnold, Janet. *Patterns of Fashion, Englishwomen's dresses & their construction c. 1660–1860.* New York: Drama Book Publishers, 1972.

Ashelford, Jane. *The Art of Dress: Clothes and Society, 1500–1914.* London: National Trust Enterprises, 1996.

Ayres, Jack, ed. *Paupers and Pig Killers, The Diary of William Holland, A Somerset Parson, 1799–1818.* Gloucester, Eng.: Alan Sutton, 1986.

Baer, James A., Jr., ed. *Jefferson at Monticello.* Charlottesville, Va.: University Press of Virginia, 1967.

Bailyn, Bernard. *The New England Merchants in the Seventeenth Century.* Cambridge, Mass.: Harvard University Press, 1955.

Ball, Charles. *Fifty Years in Chains; or, the Life of an American Slave.* 1858. Reprint. Miami, Fla.: Mnemosyne Publishing Co., 1969.

Basedow, Johann Bernhard. *Elementarwerke für die Jugend und ihre Freunde.* Berlin, 1774.

Baumgarten, Linda. "'Clothes for the People,' Slave Clothing in Early Virginia." *Journal of Early Southern Decorative Arts*, XIV (November 1988).

———. "Dolls and doll clothing at Colonial Williamsburg." *The Magazine Antiques*, CXL (July 1991).

———. *Eighteenth-Century Clothing at Williamsburg.* 1986. Reprint. Williamsburg, Va.: Colonial Williamsburg Foundation, 2002.

———. "Plains, Plaid and Cotton: Woolens for Slave Clothing." *Ars Textrina*, XV (July 1991).

———. "Under Waistcoats and Drawers." *Dress*, XIX (1992).

Baumgarten, Linda R. "Costumes and textiles in the collection of Cora Ginsburg." *The Magazine Antiques*, CXXXIV (August 1988).

———. "Jefferson's clothing." *The Magazine Antiques*, CXLIV (July 1993).

———. "Leather Stockings and Hunting Shirts." In *American Material Culture, The Shape of the Field.* Edited by Ann Smart Martin and J. Ritchie Garrison. Winterthur, Del.: Henry Francis du Pont Winterthur Museum, 1997.

———. "The Textile Trade in Boston, 1650–1700." In *Arts of the Anglo-American Community in the Seventeenth Century.* Edited by Ian M. G. Quimby. Charlottesville, Va.: University Press of Virginia, 1975.

Baumgarten, Linda, and Jan K. Gilliam. "Nineteenth-century children's costumes in Tasha Tudor's collection." *The Magazine Antiques*, CLIII (April 1998).

Baumgarten, Linda, and John Watson with Florine Carr. *Costume Close-Up, Clothing Construction and Pattern, 1750–1790.* Williamsburg, Va.: Colonial Williamsburg Foundation, 1999.

Benjamin Franklin, Autobiography and Other Writings. Edited with an introduction and notes by Ormond Seavey. Oxford: Oxford University Press, 1993.

Betts, Edwin Morris, and James Adam Bear, Jr., eds. *The Family Letters of Thomas Jefferson.* Columbia, Mo.: University of Missouri Press, 1966.

Bottorff, William K., and Roy C. Flannagan, eds. "The Diary of Frances Baylor Hill of 'Hillsborough' King and Queen County Virginia (1797)." *Early American Literature Newsletter*, II (winter 1967).

Boyd, Julian P., et al., eds. *The Papers of Thomas Jefferson.* 29 vols. Princeton, N. J.: Princeton University Press, 1950–.

Bradfield, Nancy. *Costume in Detail, 1730–1930.* New York: Costume & Fashion Press, 1997.

Breen, T. H. "The Meaning of 'Likeness': Portrait-Painting in an Eighteenth-Century Consumer Society." In *The Portrait in Eighteenth-Century America.* Edited by Ellen G. Miles. Newark, Del.: University of Delaware Press, 1993.

Brewer, John, and Roy Porter, eds. *Consumption and the World of Goods.* London: Routledge, 1993.

Brock, R. A., ed. *The Official Letters of Alexander Spotswood* 1882. Reprint. New York: AMS Press, 1973.

Brookhiser, Richard. "Deerslayer Helped Define Us All." *Time*, Nov. 9, 1992.

Buchan, William. *Advice to Mothers* Charleston, S. C.: John Hoff, 1807.

Buck, Anne. *Clothes and the Child, A Handbook of Children's Dress in England 1500–1900.* Carlton, Eng.: Ruth Bean, 1996.

———. "The Countryman's Smock." *Folk Life*, I (1963).

———. *Dress in Eighteenth-Century England.* New York: Holmes & Meier Publishers, 1979.

———. "Pamela's Clothes." *Costume*, XXVI (1992).

Bushman, Richard L., and Claudia L. Bushman. "The Early History of Cleanliness in America." *Journal of American History*, LXXIV (March 1988).

Butterfield, Lyman H., ed. *Adams Family Correspondence*. Cambridge, Mass.: Belknap Press, 1963.

Byrde, Penelope. *Nineteenth Century Fashion*. London: B. T. Batsford, 1992.

Callcott, Margaret Law, ed. *Mistress of Riversdale, The Plantation Letters of Rosalie Stier Calvert, 1795–1821*. Baltimore, Md.: Johns Hopkins University Press, 1991.

Campbell, Charles, ed. *The Orderly Book of That Portion of the American Army Stationed at or Near Williamsburg, Va., Under the Command of General Andrew Lewis*. Richmond, Va.: Privately printed, 1860.

Campbell, R[obert]. *The London Tradesman*. 1747. Reprint. New York: August M. Kelley, Publishers, 1969.

Carson, Cary. "The Consumer Revolution in Colonial British America: Why Demand?" In *Of Consuming Interests, The Style of Life in the Eighteenth Century*. Edited by Cary Carson, Ronald Hoffman, and Peter J. Albert. Charlottesville, Va.: University Press of Virginia, 1994.

Chrisman, Kimberly. "Unhoop the Fair Sex: The Campaign against the Hoop Petticoat in Eighteenth-Century England." *Eighteenth-Century Studies*, XXX (1996).

Clark, Gillian. "Infant Clothing in the Eighteenth Century: A New Insight." *Costume*, XXVIII (1994).

Clark, Ronald W. *Benjamin Franklin, A Biography*. New York: Random House, 1983.

Cole, Herbert M. *Icons, Ideals and Power in the Art of Africa*. Washington, D. C.: Smithsonian Institution Press, 1989.

Cooper, James Fenimore. *The Deerslayer*. 1841. Reprint. New York: Bantam Books, 1982.

———. *The Last of the Mohicans*. 1826. Reprint. New York: Signet Classic, 1980.

———. *The Pioneers*. 1823. Reprint. New York: Signet Classic, 1980.

Crane, Elaine Forman, et al., eds. *The Diary of Elizabeth Drinker*. 3 vols. Boston: Northeastern University Press, 1991.

Cronon, William. *Changes in the Land, Indians, Colonists, and the Ecology of New England*. New York: Hill and Wang, 1983.

Cumming, Valerie. *A Visual History of Costume, The Seventeenth Century*. London: B. T. Batsford, 1984.

———. *The Visual History of Costume Accessories*. New York: Costume & Fashion Press, 1998.

Cunningham, Noble E., Jr. *The Image of Thomas Jefferson in the Public Eye*. Charlottesville, Va.: University Press of Virginia, 1981.

Cunningham, Patricia A., and Susan Voso Lab, eds. *Dress and Popular Culture*. Bowling Green, Ohio: Bowling Green State University Popular Press, 1991.

Cunnington, Phillis, and Anne Buck. *Children's Costume in England, From the Fourteenth to the end of the Nineteenth Century*. London: Adam & Charles Black, 1965.

Cunnington, Phillis, and Catherine Lucas. *Costume for Births, Marriages & Deaths*. New York: Barnes & Noble Books, 1972.

Curtin, Philip D., ed. *Africa Remembered, Narratives by West Africans from the Era of the Slave Trade*. Madison, Wis.: University of Wisconsin Press, 1968.

Davis, Curtis Carroll. "A Legend at Full-Length, Mr. Chapman Paints Colonel Crockett—and Tells About It." *Proceedings of the American Antiquarian Society*, LXIX (October 1959).

Davis, Fred. *Fashion, Culture, and Identity*. Chicago: University of Chicago Press, 1992.

Davis, Richard Beale, ed. *Jeffersonian America, Notes on the United States of America Collected in the Years 1805–6–7 and 11–12 by Sir Augustus John Foster, Bart*. San Marino, Calif.: Huntington Library, 1954.

De Pauw, Linda Grant, and Conover Hunt. *Remember the Ladies, Women in America, 1750–1815*. New York: Viking Press, 1976.

Decatur, Stephen, Jr. *Private Affairs of George Washington, From the Records and Accounts of Tobias Lear, Esquire, his Secretary*. Boston: Riverside Press, 1933.

Dickerson, Oliver M. *The Navigation Acts and the American Revolution*. Philadelphia, Pa.: University of Pennsylvania Press, 1951.

Diderot, Denis, and Jean Le Rond d'Alembert. *Encyclopédie, ou dictionnaire raisonné des sciences, des arts et des métiers*. Paris, 1751–1765.

———. *Recueil de planches, sur les sciences, les arts libéraux, et les arts méchaniques*. Paris, 1762–1772.

———. *Suite du recueil de planches, sur les sciences, les arts liberaux, et les arts méchaniques*. Paris, 1777.

Draper, Jill. "Oliver Cromwell's Baby Clothes?" *Antique Collector* (June 1986).

Dumbauld, Edward. "Thomas Jefferson as a Traveler." In *Jefferson Reader: A Treasury of Writings about Thomas Jefferson*. Edited by Francis Coleman Rosenberger. New York: E. P. Dutton & Co., 1953.

Earle, Alice Morse. *Costume of Colonial Times*. 1894. Reprint. New York: Empire State Book, 1924.

Eden, Frederic Morton. *The State of the Poor* III. 1797. Reprint. London: Frank Cass & Co., 1966.

Edgar, Walter B., ed. *The Letterbook of Robert Pringle*, I: *April 2, 1737–September 25, 1742*. Columbia, S. C.: University of South Carolina Press, 1972.

Eley, Susan Briggs. "Robert Carter Letterbook, 1764–1768." Master's thesis, College of William and Mary, 1962.

Elting, John R., ed. *Military Uniforms in America, The Era of the American Revolution, 1755–1795*. San Rafael, Calif.: Presidio Press, 1974.

Epstein, Kathleen. *British Embroidery, Curious Works from the Seventeenth Century*. Williamsburg, Va.: Colonial Williamsburg Foundation, 1998.

Farish, Hunter Dickinson, ed. *Journal & Letters of Philip Vickers Fithian, 1773–1774: A Plantation Tutor of the Old Dominion*. Williamsburg, Va.: Colonial Williamsburg, 1965.

Farrell, Jeremy. *Socks and Stockings*. London: B. T. Batsford, 1992.

Filson, John. *The Discovery, Settlement and present State of Kentucke*. 1784. Reprint. New York: Corinth Books, 1962.

Finer, Ann, and George Savage, eds. *The Selected Letters of Josiah Wedgwood*. London: Cory, Adams & Mackay, 1965.

Finkelstein, Joanne. *The Fashioned Self*. Philadelphia, Pa.: Temple University Press, 1991.

Fitzpatrick, John C., ed. *The Writings of George Washington*. 39 vols. Washington, D. C.: U. S. Government Printing Office, 1931–1944.

Foster, Helen Bradley. *"New Raiments of Self," African American Clothing in the Antebellum South*. New York: Berg, 1997.

Foster, Vanda. *A Visual History of Costume, The Nineteenth Century*. London: B. T. Batsford, 1989.

Franklin, Benjamin. *Poor Richard: The Almanacks for the Years 1733–1758*. New York: Paddington Press, 1976.

Fry, Gladys-Marie. *Stitched from the Soul, Slave Quilts from the Ante-Bellum South*. New York: Dutton Studio Books, 1990.

Gilbert, Christopher. *The Life and Work of Thomas Chippendale*. London: Studio Vista, 1978.

Ginsburg, Madeleine. "The Tailoring and Dressmaking Trades, 1700–1850." *Costume*, VI (1972).

The Glen-Sanders Collection from Scotia, New York. Williamsburg, Va.: Colonial Williamburg, 1966.

Gottesman, Rita Susswein, comp. *The Arts and Crafts in New York, 1800–1804*. New York: New-York Historical Society, 1965.

Greene, Jack P., ed. *The Diary of Colonel Landon Carter of Sabine Hall, 1752–1778*. II. Charlottesville, Va.: University Press of Virginia, 1965.

Hadley, William, comp. *Horace Walpole, Selected Letters*. 1926. Reprint. London: Everyman's Library, 1967.

Hall, Basil. *Travels in North America, in the Years 1827 and 1828*. II. Philadelphia, Pa.: Carey, Lee & Carey, 1829.

Hanson, James A. "Laced Coats and Leather Jackets: The Great Plains Intercultural Clothing Exchange." In *Plains Indian Studies, A Collection of Essays in Honor of John C. Ewers and Waldo R. Wedel*. Edited by Douglas H. Ubelaker and Herman J. Viola. Washington, D. C.: Smithsonian Institution Press, 1982.

Harte, N. B. "The British Linen Trade with the United States in the Eighteenth and Nineteenth Centuries." In *Textiles in Trade, Proceedings of the Textile Society of America Biennial Symposium, September 14–16, 1990, Washington, D. C.* Los Angeles, Calif.: Textile Society of America, 1990.

Hauck, Richard Boyd. "The Man in the Buckskin Hunting Shirt." In *Davy Crockett, The Man, the Legend, the Legacy, 1786–1986*. Edited by Michael A. Lofaro. Knoxville, Tenn.: University of Tennessee Press, 1985.

Hayden, Peter. "Records of Clothing Expenditure for the Years 1746–79 Kept by Elizabeth Jervis of Meaford in Staffordshire." *Costume*, XXII (1988).

Heaton, Herbert. *The Yorkshire Woollen and Worsted Industries from the Earliest Times up to the Industrial Revolution*. Oxford: Clarendon Press, 1965.

Heckscher, Morrison H. "American furniture and the art of connoisseurship." *The Magazine Antiques*, CLIII (May 1998).

Helvenston, Sally. "Fashion on the Frontier." *Dress*, XVII (1990).

Henry, John Joseph. *Account of Arnold's Campaign Against Quebec* 1877. Reprint. New York: Arno Press, 1968.

Hirshorn, Anne Sue. "Mourning fans." *The Magazine Antiques*, CIII (April 1973).

Hogarth, William. *The Analysis of beauty: written with a view of fixing the fluctuating ideas of taste*. London: J. Reeves, 1753.

Hollander, Anne. *Seeing Through Clothes*. New York: Viking Press, 1978.
———. *Sex and Suits*. New York: Alfred A. Knopf, 1994.

Holme, Randle. *The Third Book of the Academy of Armory and Blazon*. 1688. Reprint. Menston, Eng.: Scolar Press, 1972.

The Holyoke Diaries, 1709–1856. Introduction and annotations by George Francis Dow. Salem, Mass.: Essex Institute, 1911.

Horner, John. *The Linen Trade of Europe during the Spinning-Wheel Period*. Belfast, Ireland: M'Caw, Stevenson & Orr, 1920.

Hood, Adrienne Dora. "Organization and Extent of Textile Manufacture in Eighteenth-Century, Rural Pennsylvania: A Case Study of Chester County." Ph.D. diss., University of California, San Diego, 1988.

Hood, Graham. *Inventories of Four Eighteenth-Century Houses in the Historic Area of Williamsburg*. Williamsburg, Va.: Colonial Williamsburg Foundation, 1974.

Hunt-Hurst, Patricia. "'Round Homespun Coat and Pantaloons of the Same': Slave Clothing as Reflected in Fugitive Slave Advertisements in Antebellum Georgia." *Georgia Historical Quarterly*, LXXXIII (winter 1999).

INSTRUCTIONS for Cutting out Apparel for the Poor; Principally intended for the Assistance of the PATRONESSES of SUNDAY SCHOOLS, And other Charitable Institutions, But USEFUL in all FAMILIES. London: J. Walter, 1789.

Irwin, John, and Katharine B. Brett, *Origins of Chintz*. London: Her Majesty's Stationery Office, 1970.

Isaac, Rhys. *The Transformation of Virginia, 1740–1790*. Chapel Hill, N. C.: University of North Carolina Press, 1982.

Jarratt, Devereux. *The Life of the Reverend Devereux Jarratt* 1806. Reprint. New York: Arno Press, 1969.

Jefferson Reader: A Treasury of Writings about Thomas Jefferson. Edited with an introduction by Francis Coleman Rosenberger. New York: E. P. Dutton & Co., 1953.

Jeremy, David John, ed. *Henry Wansey and his American Journal, 1794*. Philadelphia, Pa.: American Philosophical Society, 1970.

Jones, Hugh. *The Present State of Virginia from Whence Is Inferred a Short View of Maryland and North Carolina*. 1724. Edited with an introduction by Richard L. Morton. Reprint. Chapel Hill, N. C.: University of North Carolina Press, 1956.

The Journal of Nicholas Cresswell, 1774–1777. Port Washington, N. Y.: Kennikat Press, 1968.

Karlsen, Carol F., and Laurie Crumpacker, eds. *The Journal of Esther Edwards Burr, 1754–1757*. New Haven, Conn.: Yale University Press, 1984.

Kidd, Laura K., and Jane Farrell-Beck. "Menstrual Products Patented in the United States, 1854–1921." *Dress*, XXIV (1997).

Kidwell, Claudia. "Short Gowns." *Dress*, IV (1978).

Kidwell, Claudia Brush. "Are Those Clothes Real? Transforming the Way Eighteenth-Century Portraits are Studied." *Dress*, XXIV (1997).

Kidwell, Claudia Brush, and Valerie Steele, eds. *Men and Women, Dressing the Part*. Washington, D. C.: Smithsonian Institution Press, 1989.

Kraak, Deborah E. "Art in the Details, Defining textile and embroidery masterworks." *Winterthur Magazine*, XL (summer 1994).

Kuchta, David M. "'Graceful, Virile, and Useful': The origins of the three-piece suit." *Dress*, XVII (1990).

Kulikoff, Allan. *Tobacco and Slaves, The Development of Southern Culture in the Chesapeake, 1680–1800*. Chapel Hill, N. C.: University of North Carolina Press, 1986.

Labaree, Leonard W., et al., eds. *The Papers of Benjamin Franklin*. XIII. New Haven, Conn.: Yale University Press, 1969.

The Lady's ECONOMICAL ASSISTANT, or THE ART OF CUTTING OUT, AND MAKING, The most useful Articles of Wearing Apparel. . . . 1808. Reprint. Springfield, Ohio: Kannik's Korner, 1998.

Latham, Robert, and William Matthews, eds. *The Diary of Samuel Pepys: A New and Complete Transcription*. II. London: G. Bell and Sons, 1970.

Lee-Whitman, Leanna. "The Silk Trade: Chinese Silks and the British East India Company." *Winterthur Portfolio*, XVII (spring 1982).

Lee-Whitman, Leanna, and Maruta Skelton, "Where Did All the Silver Go? Identifying Eighteenth-Century Chinese Painted and Printed Silks." *Textile Museum Journal*, XXII (1983).

Lemire, Beverly. "Developing Consumerism and the Ready-made Clothing Trade in Britain, 1750–1800." *Textile History*, XV (spring 1984).
———. *Fashion's Favourite: The Cotton Trade and the Consumer in Britain, 1660–1800*. Oxford: Oxford University Press, 1991.

Levitt, Sarah. *Victorians Unbuttoned: Registered Designs for Clothing,*

Their Makers and Wearers, 1839–1900. London: Allen & Unwin, 1986.

Llanover, Lady, ed. *The Autobiography and Correspondence of Mary Granville, Mrs. Delany; with Interesting Reminiscences of King George the Third and Queen Charlotte*. 1st Ser., I. London: R. Bentley, 1861.

Locke, John. *Some Thoughts Concerning Education*. 1699. Edited by John W. Yolton and Jean S. Yolton. Oxford: Clarendon Press, 1989.

Lofaro, Michael A., ed. *Davy Crockett: The Man, the Legend, the Legacy, 1786–1986*. Knoxville, Tenn.: University of Tennessee Press, 1985.

Long, Robert Emmet. *James Fenimore Cooper*. New York: Continuum, 1990.

Lowenthal, David. *The Past Is a Foreign Country*. Cambridge: Cambridge University Press, 1985.

Lurie, Alison. *The Language of Clothes*. New York: Henry Holt and Co., 2000.

MacKenzie, Colin. *Mackenzie's Five Thousand Receipts in All the Useful and Domestic Arts* Philadelphia, Pa.: James Kay, Jun., 1830.

Majer, Michele. "American Women and French Fashion." In *The Age of Napoleon, Costume from Revolution to Empire, 1789–1815*. Edited by Katell le Bourhis. New York: Metropolitan Museum of Art, 1989.

Mansfield, Alan. "Dyeing and Cleaning Clothes in the Late Eighteenth and Early Nineteenth Centuries." *Costume*, I–II (1970).

Marshall, Rosalind K. *Virgins and Viragos, A History of Women in Scotland from 1080 to 1980*. London: Collins, 1983.

Mason, Frances Norton, ed. *John Norton & Sons, Merchants of London and Virginia*. Richmond, Va.: Dietz Press, 1937.

Maxwell, Stuart. *Two Eighteenth-Century Tailors*. Hawick Archaeological Society Transactions, 1972. Reprint. Hawick, Eng., 1973.

McConnell, Michael N. *A Country Between, The Upper Ohio Valley and Its Peoples, 1724–1774*. Lincoln, Nebr.: University of Nebraska Press, 1992.

McCracken, Grant. *Culture and Consumption, New Approaches to the Symbolic Character of Consumer Goods and Activities*. Bloomington, Ind.: Indiana University Press, 1990.

McDonald, Forrest. *The Presidency of Thomas Jefferson*. Lawrence, Kans.: University Press of Kansas, 1976.

McKendrick, Neil, John Brewer, and J. H. Plumb. *The Birth of a Consumer Society, The Commercialization of Eighteenth-century England*. London: Europa Publications, 1982.

McMillen, Sally G. *Motherhood in the Old South, Pregnancy, Childbirth, and Infant Rearing*. Baton Rouge, La.: Louisiana State University Press, 1990.

Memoirs of a Monticello Slave as Dictated to Charles Campbell in the 1840's by Isaac, one of Thomas Jefferson's Slaves. Edited by Rayford W. Logan. Charlottesville, Va.: University of Virginia Press, 1951.

Miller, Lillian B., ed. *The Selected Papers of Charles Willson Peale and His Family*. I. New Haven, Conn.: Yale University Press, 1983.

Mitchell, Margaret. *Gone With the Wind*. 1936. Reprint. New York: Macmillan Publishing Company, 1964.

Montgomery, Charles F., "The Connoisseurship of Artifacts." In *Material Culture Studies in America*. Edited by Thomas J. Schlereth. Nashville, Tenn.: American Association for State and Local History, 1982.

Montgomery, Florence M. *Printed Textiles, English and American Cottons and Linens, 1700–1850*. New York: Viking Press, 1970.

———. *Textiles in America, 1650–1870*. New York: W. W. Norton & Company, 1984.

Morgan, Edmund S. *American Slavery, American Freedom: The Ordeal of Colonial Virginia*. New York: W. W. Norton & Company, 1975.

Morgan, Philip David. "The Development of Slave Culture in Eighteenth Century Plantation America." Ph.D. diss., University College London, 1977.

Mullin, Gerald W. *Flight and Rebellion, Slave Resistance in Eighteenth-Century Virginia*. New York: Oxford University Press, 1972.

Murray, Anne Wood. "George Washington's apparel." *The Magazine Antiques*, CXVIII (July 1980).

"Negro Cloth," Northern Industry & Southern Slavery. Boston: Merrimack Textile Museum, 1981.

"New Letters of Abigail Adams." *Proceedings of the American Antiquarian Society*, LV (October 1945).

Northrop, Karen E. "'To Go with an Ungloved Hand Was Impossible': A History of Gloves, Hands, Sex, Wealth, and Power." Master's thesis, College of William and Mary, 1998.

Norton, Mary Beth. *Liberty's Daughters, The Revolutionary Experience of American Women, 1750–1800*. Boston: Little, Brown and Company, 1980.

Nylander, Jane. "Textiles at Old Sturbridge Village." *The Magazine Antiques*, CXVI (September 1979).

Nylander, Jane C. *Our Own Snug Fireside, Images of the New England Home, 1760–1860*. New York: Alfred A. Knopf, 1993.

Oakes, Alma, and Margot Hamilton Hill. *Rural Costume, Its Origin and Development in Western Europe and the British Isles*. London: B. T. Batsford, 1970.

Oberseider, Nancy. "The Wearing Apparel of the Women of Westmoreland County, Virginia, 1700–1775." Master's thesis, College of William and Mary, 1966.

The Official Records of Robert Dinwiddie, Lieutenant Governor of the Colony of Virginia, 1751–1758. I. Richmond, Va.: Virginia Historical Society, 1883.

Paoletti, Jo B. "The Gendering of Infants' and Toddlers' Clothing in America." In *The Material Culture of Gender, The Gender of Material Culture*. Edited by Katharine Martinez and Kenneth L. Ames. Winterthur, Del.: Henry Francis du Pont Winterthur Museum, 1997.

Planché, James Robinson. *A Cyclopaedia of Costume or Dictionary of Dress, Including Notices of Contemporaneous Fashions on the Continent*. 2 vols. London: Chatto and Windus, 1876–1879.

Powell, William S. *John Pory, 1572–1636, The Life and Letters of a Man of Many Parts*. Chapel Hill, N. C.: University of North Carolina Press, 1977.

Price, Nicholas Stanley, M. Kirby Talley, Jr., and Alessandra Melucco Vaccaro, eds. *Historical and Philosophical Issues in the Conservation of Cultural Heritage*. Los Angeles, Calif.: Getty Conservation Institute, 1996.

Prown, Jules David. "John Trumbull as History Painter." In *John Trumbull, The Hand and Spirit of a Painter*. Edited by Helen A. Cooper. New Haven, Conn.: Yale University Art Gallery, 1982.

———. "Mind in Matter, An Introduction to Material Culture Theory and Method." *Winterthur Portfolio*, XVII (spring 1982).

———. "Style as Evidence." *Winterthur Portfolio*, XV (autumn 1980).

———. "The Truth of Material Culture: History or Fiction." In *History from Things, Essays on Material Culture*. Edited by Steven Lubar and W. David Kingery. Washington, D. C.: Smithsonian Institution Press, 1993.

Pye, David. *The nature of design*. New York: Reinhold Publishing Corporation, 1964.

Randolph, Sarah N., comp. *The Domestic Life of Thomas Jefferson*. 1871. Reprint. Charlottesville, Va.: University Press of Virginia, 1978.

Ribeiro, Aileen. "Antiquarian Attitudes—Some Early Studies in the History of Dress." *Costume*, XXVIII (1994).

———. *The Art of Dress: Fashion in England and France 1750–1820*. New Haven, Conn.: Yale University Press, 1995.

———. *The Dress Worn at Masquerades in England, 1730–1790, and Its Relation to Fancy Dress in Portraiture*. New York: Garland Publishing, 1984.

———. "Fashion and Fantasy: The Use of Costume in Eighteenth-Century British Portraiture." In *The British Face, A View of Portraiture, 1625–1850*. Edited by Donald Garstang. London: P & D Colnaghi & Co., 1986.

———. *A Visual History of Costume, The Eighteenth Century*. London: B. T. Batsford, 1983.

Richardson, Jane, and A. L. Kroeber. "Three Centuries of Women's Dress Fashions: A Quantitative Analysis." In *The Nature of Culture*. Edited by A. L. Kroeber. Chicago: University of Chicago Press, 1952.

Richardson, Jonathan, *The Works of Jonathan Richardson. Containing I. The Theory of Painting. II. Essay on the Art of Criticism, (So far as it relates to Painting). III. The Science of a Connoisseur*. [London,] 1792.

Richter, Daniel K. *The Ordeal of the Longhouse, The Peoples of the Iroquois League in the Era of European Colonization*. Chapel Hill, N. C.: University of North Carolina Press, 1992.

Riley, Edward Miles, ed. *The Journal of John Harrower, An Indentured Servant in the Colony of Virginia 1773–1776*. Williamsburg, Va.: Colonial Williamsburg, 1963.

Roach, Mary Ellen, and Joanne B. Eicher. *The Visible Self: Perspectives on Dress*. Englewood Cliffs, N. J.: Prentice-Hall, 1973.

Roach, Mary Ellen, and Joanne Bubolz Eicher. "The Language of Personal Adornment." In *The Fabrics of Culture, The Anthropology of Clothing and Adornment*. Edited by Justine M. Cordwell and Ronald A. Schwarz. The Hague, Netherlands: Mouton Publishers, 1979.

Roeber, A. G., ed. "A New England Woman's Perspective on Norfolk, Virginia, 1801–1802: Excerpts from the Diary of Ruth Henshaw Bascom." *Proceedings of the American Antiquarian Society*, LXXXVIII (1978).

Rose, Clare. *Children's Clothes Since 1750*. London: B. T. Batsford, 1989.

———. "A Group of Embroidered Eighteenth-Century Bedgowns." *Costume*, XXX (1996).

Rosenberger, Francis Coleman, ed. *Jefferson Reader, A Treasury of Writings about Thomas Jefferson*. New York: E. P. Dutton & Company, 1953.

Rothstein, Natalie, ed. *A Lady of Fashion, Barbara Johnson's Album of Styles and Fabrics*. London: Thames and Hudson, 1987.

Rothstein, Natalie. *Silk Designs of the Eighteenth Century in the Collection of the Victoria and Albert Museum, London, with a Complete Catalogue*. Boston, Mass.: Bulfinch Press Book, 1990.

———. "Silk in European and American Trade before 1783, A commodity of commerce or a frivolous luxury?" In *Textiles in Trade, Proceedings of the Textile Society of America Biennial Symposium, September 14–16, 1990, Washington, D. C.* Los Angeles, Calif.: Textile Society of America, 1990.

———. "Silks for the American market." *Connoisseur*, CLXVI (October 1967).

———. "Silks for the American market: 2." *Connoisseur*, CLXVI (November 1967).

Sack, Albert. *The New Fine Points of Furniture, Early American*. New York: Crown Publishers, 1993.

Schaefer, G. "Some Old-Fashioned Ways of Cleaning Textiles." *Ciba Review*, LVI (April 1947).

Scheib, Jeffrey L. "The Richard Corbin Letterbook, 1758–1760." Master's thesis, College of William and Mary, 1982.

Sellers, Charles Coleman, *Benjamin Franklin in Portraiture*. New Haven, Conn.: Yale University Press, 1962.

Shackford, James Atkins. *David Crockett, The Man and the Legend*. Chapel Hill, N. C.: University of North Carolina Press, 1987.

Shammas, Carole. "How Self-Sufficient Was Early America?" *Journal of Interdisciplinary History*, XIII (1982).

———. *The Pre-industrial Consumer in England and America*. Oxford: Clarendon Press, 1990.

Shine, Carolyn R. "Scalping Knives and Silk Stockings: Clothing the Frontier, 1780–1795." *Dress*, XIV (1988).

Smith, Billy G., and Richard Wojtowicz. *Blacks Who Stole Themselves, Advertisements for Runaways in the* Pennsylvania Gazette, *1728–1790*. Philadelphia, Pa.: University of Pennsylvania Press, 1989.

Smith, Henry Nash. *Virgin Land, The American West as Symbol and Myth*. Cambridge, Mass.: Harvard University Press, 1982.

Smyth, J[ohn] F[erdinand] D[alziel]. *A Tour in the United States of America* Dublin, Ireland: G. Perrin, 1784.

Spitalfields Silks of the 18th and 19th Centuries. With an introduction by J. F. Flanagan. Leigh-on-Sea, Eng.: F. Lewis, Publishers, 1954.

Spivak, Burton. *Jefferson's English Crisis, Commerce, Embargo, and the Republican Revolution*. Charlottesville, Va.: University Press of Virginia, 1979.

Spruill, Julia Cherry. *Women's Life and Work in the Southern Colonies*. 1938. Reprint. New York: Norton Library, 1972.

Staniland, Kay. *In Royal Fashion, The Clothes of Princess Charlotte of Wales & Queen Victoria 1796–1901*. London: Museum of London, 1997.

Stiverson, Gregory A., and Patrick H. Butler III, eds. "Virginia in 1732: The Travel Journal of William Hugh Grove." *Virginia Magazine of History and Biography*, LXXXV (January 1977).

Strutt, Joseph. *A Complete View of the Dress and Habits of the People of England, from the Establishment of the Saxons in Britain to the Present Time*. (1796) I. 1842. Reprint, with an introduction and notes by J. R. Planché. London: Tabard Press, 1970.

Tarrant, Naomi. *The Development of Costume*. Edinburgh, Scot.: National Museums of Scotland, 1994.

Tarrant, Naomi E. A. "The Portrait, the Artist and the Costume Historian." *Dress*, XXII (1995).

Thomas, M. Halsey, ed. *The Diary of Samuel Sewall, 1674–1729*. II: *1709–1729*. New York: Farrar, Straus and Giroux, 1973.

Tozer, Jane, and Sarah Levitt. *Fabric of Society, A Century of People and their Clothes 1770–1870*. Cambridge: Laura Ashley Publications, 1983.

Ulrich, Laurel Thatcher. *The Age of Homespun, Objects and Stories in the Creation of an American Myth*. New York: Alfred A. Knopf, 2001.

———. "Cloth, Clothing, and Early American Social History." *Dress*, XVIII (1991).

———. *Good Wives, Image and Reality in the Lives of Women in Northern New England, 1650–1750*. New York: Alfred A. Knopf, 1982.

Vaisey, David, ed. *The Diary of Thomas Turner, 1754–1765*. Oxford: Oxford University Press, 1985.

Van de Krol, Yolanda. "'Ty'ed about My Middle, Next to My Smock': The Cultural Context of Women's Pockets." Master's thesis, University of Delaware, 1994.

Van Schreeven, William J., comp., Robert L. Scribner, ed. *Revolutionary Virginia, The Road to Independence*. I: *Forming Thunderclouds and the First Convention, 1763–1774*. Charlottesville, Va.: University Press of Virginia, 1973.

"The Will of Mrs. Mary Willing Byrd of Westover, 1813, with a List of the Westover Portraits." *Virginia Magazine of History and Biography*, VI (April 1899).

Willett, C., and Phillis Cunnington. *The History of Underclothes*. With revisions by A. D. Mansfield and Valerie Mansfield. London: Faber and Faber, 1981.

Windley, Lathan A., comp. *Runaway Slave Advertisements, A Documentary History from the 1730s to 1790*. I: *Virginia and North Carolina*. II: *Maryland*. III: *South Carolina*. IV: *Georgia*. Westport, Conn.: Greenwood Press, 1983.

Wood, Peter H. *Black Majority, Negroes in Colonial South Carolina, From 1670 through the Stono Rebellion*. New York: Alfred A. Knopf, 1974.

The Workwoman's Guide. 1838. Reprint. Owston Ferry, Eng.: Bloomfield Books & Publications, 1975.

INDEX

Buttons, *32–33*, *59*, *99*, 100, 101, *130*, 135; on infant clothes, 158, *159*
Byrd, Mary Willing, 134, 135

Calvert, Rosalie Stier, 26, 102, 104, 147, 187
Campbell, Robert, 52, 64
Canes: sword, 90
Caps, 66, *140–141*, 154, 219, 228, 230, 245; children's, *13*, *156*, 158, *160*, 166, *166*; construction of, 110; and elderly, 176; fur, *87*, 99, *99*, 100; and gender, 166; lappet, *97*, *97*, *169*, *176*; men's, 108, 110, *110*, *111*, 112; Monmouth, 136
Carey, Mr. and Mrs. Charles D.: gift of, 92, 159, 174
Caroline, Queen, 156, 177, 178
Caroline (slave), 135, 136
Carpenter, Ralph E.: gift of, 235, 239
Carpue, Joseph, 94
Carter, Col. Landon, 120, 128
Carter, Robert, 18, 19, 93, 128, 187; portrait of, *19*
Carter, Mrs. Robert, 95, 122
Carter, Robert "King," 94
Catheal, David, 129
Chadwick Shoe Store, T. A., 92
Chapman, John Gadsby, 73
Charlestown Bleachery and Dye Works, Mass., 104
Charlotte, Princess, 144, *145*
Charol, Ed: collection of, *54*, *75*
Childbed linens. *See* Linens (personal)
Childbirth, 154–155; "drinking cordial," 154; nursing, 156; weaning, 156, 158; women's clothing for, 116, 123, *152*, 154–155, *155–157*
Children's clothing, 13, 14, 162, *167*, 173, 175; alterations of, 189, *189*; attitude toward, 168, 170; bed gowns, 123, *123*, 160, 164; caps, *13*, 158, 166; frocks, *123*, 160, *161*, 163, *163*, 164, *164*, 165, 168, *170*, 171, 173, *173*, 219; and gender, 164, 166, 249; gown, *164*; leading strings on, *142*, 166, *167*, *175*; made from adult clothing, 189, *190*, 191, 192; pudding caps, *156*, 166, *166*; shifts, 189, *189*; shirts, 164; skirts, 164, *169*; stays, 38, 40, 121, 122, *122*, 162–163, *163*, 211, 249; textiles for, 114, 171. *See also* Boys' clothing; Infants' clothing.
China: cotton from, 124, *124*; fans from, *91*
Chinese silk, 36, *37*, 49, *50–51*, *82–83*; characteristics of, 49–50, 51, 82, 83; comparison with British silk, 50, 51, 84; gowns of, with American history, 82, *82–83*; laws related to, 82; weaving process of, 49–50
Chippendale, Thomas, 82, 184
Christening. *See* Infants' clothing
Clark, Mark A.: gift of, 4, 190
Clifford, Anna, 91
Cloaks, *14*, 89, 118, 212, 245
Cloe (slave), 135
Clothing: adapted to cold weather, 27–28, 30; adapted to frontier, 66, 68–69, 72, 73, 74; adapted to tasks, 26, 54, 68, 114, 116, 122; adapted to warm weather, 54, 101, 110, 112, 122, 132, 135, 241; and American mythology, 65, 74–75, 76, 100, 102, 105, 210; artists' use of, 15, 18, *19*, 20, *20*, 21, 22; as costume dress, 16, 18, *19*, 23, 200, *200*, 204; as documents, 2, 16, 22, 52, 56, 106, 182, 184, 186, 204, 207, 208, 215; early research on, 20, 22; in fiction, 64–66, 68, 69, 74; and gender, 64, 164, 166, 168; as indicators of age, *52–53*, 100, *140–141*, *169*, *175–176*; as indicators of occupation, 139, 146; as indicators of status, *52–53*, 64, 75, 106, 112, 133, 134, 139; as indicators of wealth, *52–53*, 56, 60, 64, 112; language of, 52, 54, 56, 60, 64, 72, 74–75, 114, 139, 208, 210, 213–215; as political statements, 95–96, 97–100, 102; researching, 23, 42–43, 106, 123, 182, 184, 210, 213–214; and shaping of men's bodies, 25, 33, 35, 121–122, 163, 200, 236; and shaping of women's bodies, 25–27, 60, 62, 63, 118, 121–122, 163, 200, 202, *203*, 216, 218–219, 232, 242; and symbolism, 52, 112, 128, 132, 133, 164, 168, 169, 210; terminology, 69, 106, 108, 116, 120, 127, 132

Coats, 20, *21*, 35, 103, *182–183*, *192*, *224*; American-made, 12, *76–77*, *79*, 101, *101*, *103*, *235*; fit of, 47; frock, 108, *109*, 219, 221, 229, *229*, 230, *231*, 236, 246; greatcoat, 212, *212*; style evolution of, 25, 216, 219, 221, 224–236; tailcoats, 47, 103, 234, 236; turning of, 133, 187. *See also* Court suits; Livery; Suits
COCK FIGHTING (Alken), *237*
Cogar, James, 7
Cohen, Mrs. DeWitt Clinton: collection of, *13*, *57*, *110*, *111*, *159*, *166*, *186*, *191*, *213*, *220*
Collecting, 2, 4, 7–9, 11–15, 18, 20, 22, 23; motivation for, 16, 23, 106; by museums, 2, 5, 182, 208. *See also* Colonial Williamsburg collections
Collinson, Peter, 112
Colonial Revival, 6, 200
Colonial Williamsburg collections, 2, 6, 116, 184; growth of, 2, 5, 7–8, 11–15, 20, 208
COMPLIANCE, *234*
Compton, Mary, 189
Connecticut: clothing made in, *89*, *93*, *103*, *235*, 239; clothing with history of being worn in, *128*
Connoisseurship, 16, 22, 23, 25–27, 31, 33, 36, 50, 208, 241; and masterpieces, 2, 12, 33, 38, 40, 42, 210; and quality, 33, 45; and science, 42, 45
Construction, 7, 8, 10, 246; of bed gowns, 116, 123; of breeches, *131*, 246; of caps, *110*; clues to date, 26, 31; of gloves, 117; of gowns, 25, 40, *41*, 89, 154, 177, 241, 245; of infant wear, 159, 160; of nineteenth-century clothing, 26, 202, *203*; of petticoat, 119; of shifts, 40, *41*; of skirts, 154; of slave clothing, 135–136; of stays, 38, 40, *211*; of stockings, 136; time of, 25, 40
Continental Congress, 69, 97
Cooke, Gov. Nicholas, 69
Cooper, James Fenimore, 65, 66, 68, 73, 210
Copley, John Singleton, 126
Cornthwaite, Robert, 93
Corsets, 23, 26, *26*, 63; effect of, on body shape, 26, 27, 121, 200, 221, 236; in *Encyclopédie*, 149, *150*. *See also* Stays
Cotton, 96, 101, 113, *124*, *182–183*, *237*; block-printed, 45, *46*, 49, *49*, 76, 115, *115*, *231*, *233*, *235*, 241; blue threads in selvages of, 49, *161*; characteristics of, 42, *43*, 101; from China, *124*; dimity, *124*, 125, 178, 246; imitating Indian chintz, *9*, 115; imitating silk, *48–49*; from Lancashire, 79, *132*; laws related to, 49, 79; Manchester velvet, 98, *124*, 125, 246; nankeen, *124*, 125, 246; negro cotton, 247; produced in America, 96; velvet, *98–99*. *See also* Indian cotton; Kendal cotton
Cotton, Dudley, 13, 18, 19
Court suits, 4, 32, 33, *35*, 103; coats of, *4*, *11*, *16–17*, 32, *32*, 33, *33–34*, 35, 47, *47*; French, *4*, *16–17*
Craig, Robert, 185
Cresswell, Nicholas, 68, 71–72, 95
Crockett, David "Davy," 73
Cromwell, Oliver, 159
Custis, Patsy, 175

Dandridge, Elizabeth, 84, 86
Dating: by blue threads, 49; by features, 20, 25, 31, *31*, 32, *55*, 63; by textile design, *7*, *15*, 31, 84, *182–183*
Davenport, Mary, 94
Davis, Sarah I'On Loundes, *201*
Dean, Silas, 69
Death of General Montgomery in the Attack on Quebec, The (Trumbull), *20*
Delaware: clothing with history of being worn in, *50–51*, 82, *82–83*
Diaper, 118, 158
Dibdin, Charles, 132
Dickerson, Oliver, M., 78

Livery, 20, 21, 42, 128, *128*, *130*, 130–132, 134; doll dressed in, *129;* symbolic meaning of, 132
Livingston, Peggy, 175
Locke, John, 158, 168
Logan, Aunt, 119, 213
LoNano, Ernest: gift of, 58–59
London, Eng., 23, 93, 94, 95, 175; Native Americans' visit to, *71;* orders to, from America, 90, *90,* 93, 94–95, 97, 144
L'Optique (Cazenave), *233*
Lowenthal, David, 23, 204, 207

Magasin des Modes Nouvelles, 100, *100*
Magazines: fashion, 25, 100, *100,* 175
Mall (slave), 178
Manchester velvet. *See* Cotton
Mantua-makers, 88, 95
Man of Business, The (Darly), *147,* 149
Mantua-makers, 88, 95, 175, 184
Maryland: clothing in, 121, 122, 127, 132; comments on dress in, 95
Massachusetts, 142, 147, 178; cloth production in, 76; clothing made in, *79, 92, 104, 237,* 239; clothing with history of being worn in, 13, 18, *19;* comments on dress in, 95
Maternity. *See* Gowns; Pregnancy
Matthews, Frances: gift of, 117
McCracken, Grant, 56
McKinly, Jane Richardson, 51, 82
Meade, David, Jr., *169*
Measurements, 25, 66; of bedsteads, 66; of children's clothing, 19, 161, 168, 189, 192; of coat, 21; ellwand, *8;* of gowns, 62, 63, 66, 153; nail, 185, 187; of shirts, 69, 88, 189; of shoes, 93–94, *94;* of stays, 38, 40, 66, 122, 149, 163; used by tailor, 93; of worsteds, 114, 177
Meissonier, Jean-Louis-Ernest, 20, 240
Men's clothing: everyday, 106, 108, *124, 132,* 139; leisure, 108, 110, 112, 139; and life cycle, 140, *142;* macaroni, 219, 230; for mourning, 178; style evolution of, 216, 219, 222–237; for work, 108, 122, 125–128, *126, 127, 131,* 132, 133, 246; for work becomes fashionable, 109, 125, 219
Menstruation, 64, 242
Merchants, 25, 49, 78, 94, 125, 175, 178
Milliners: and custom-made clothing, 88; import from London, 90, *90,* 94; inventory of, 90; measuring customer, *8;* prints of, *8, 218;* as retailers, 25, 88, 89, 90, 93, 144, 155, 166, 177, 180
Millinery Shop, Margaret Hunter, 8
Mitts, *117,* 118, 176, 185
Moccasins. *See* Shoes
Modern Love: The Courtship (Collet), *229*
Modern Love: The Elopement (Collet), *118*
Monroe, James, 179
Monticello, 28, 30, 45, 102
Montgomery, Charles, 23, 33, 36
Moore, Doris Langley, 66; collection of, *2–3, 38–39,* 40, 109, *182–183, 191, 192, 197,* 227, 229, *231,* 238, 239
Mourning. *See* Fans; Gloves; Gowns; Men's clothing; Rings; Servants'; Textiles; Washington, George; Women's clothing
Mungo (slave), 130
Museum of London, 32

Native Americans: influence American dress, 18, 66, 72, 243; influenced by European contact, *67,* 69, *71,* 71–72; loincloths worn by, 69, 71, 72; clothing of, symbolic, 74; and uniforms, 68–69
Navigation Acts, 76, 82, 84
Neckwear: marked, 60; neck kerchief, *72;* neckcloths, 122; neckties, 60; stocks, 56, 60, *60;* symbolism of, 60

Negro cloth. *See* Wool
Negro cotton. *See* Cotton; Wool
Nelson, William, 96
Neoclassic style, 26, 45–46, 105, 199, 219, 234
New England: clothing made in, *58,* 59, *119, 168, 174;* clothing with history of being worn in, 12, 18, *18, 237,* 239; textiles made in, 69, *119. See also* individual colonies and states
New Jersey, 146; clothing made in, *62, 78,* 189
New York, 187; clothing made in, *46, 58,* 59, *70,* 89, 154–155, *156,* 160, *211;* clothing with history of being worn in, 12, *14, 80–81, 82–83, 91, 92, 119, 144, 163, 163, 177*
Newcomer, Don: collection of, *212*
Nice Prussian Matches New pinched pointed Matches (Sandby), *108*
Nicholas, Robert Carter, 93, 96, 110
Nichols, Jane Hodge, 92
Nonimportation, 95–96
Norton, Courtney, 88–89
Norton, Frances, 8
Norton, John, 84, 88, 96, 144
Norton, John & Sons, 90, 94
Norton, John Hatley, 88
Norwich, Eng., 43, 44, 114, 184
Norwich stuff. *See* Stuff
Nourse, Sarah Fouace, 122, 134, 135
Nursing, 156, *156. See also* Childbirth; Gowns; Stays

O'Hara, Scarlett, 148
Old Plantation, The, 138
Osborne, Mabel C.: collection of, *19*
Osnaburg, 78, 82, 96, 113, 115, 125, 126, 132, 134, 135, 245

Page, Mrs. Mann, 94
Pagets, Warner & Allsopp, 45, *45*
Paintings: of children, *52–53, 140–141,* 155, *164, 169,* 227, *236;* as documents of style, 22, 23, 73, 84, 115; of men, *19,* 20, 42, *52–53,* 67, *126, 155,* 229, 236, *237;* of slaves, *138;* of women, 42, *52–53,* 85, 108, *118, 140–141,* 155, *176, 181,* 225, 229, 234, *237*
Pantheon No. Rep., A, 230
Pants. *See* Trousers
Peale, Charles Willson, 18, 67
Pencil blue, *9, 46,* 49, 241
Pennsylvania: clothing made in, 58, 59, *173, 214, 214;* clothing with history of being worn in, *91, 124;* servant clothing in, 118, 125; textiles in, 84, *85*
Pepys, Samuel, 151, 194
Percival, Sir John: portrait of, *223*
Peterson's Magazine, 25
Petticoats, *12,* 56, 112, 114, *119,* 120, 202, 216, 218; adapted to pregnancy, 151, *152,* 153, *153,* 213; from bed quilt, 185; made in America, *76–77,* 89, *119, 143;* pleated, *80–81;* quilted, *7,* 24, 25, 44, 57, *76–77,* 88, 89, 114, 116, *153;* remade, 202, *203, 205;* with short gowns, 118, *119,* 151; under, 29, *29,* 40; used in alterations, *198,* 199, 204, *205;* worn by slaves, 116, 118, 120, 121, 134, 135. *See also* Gowns
Phebe (slave), 118
Phelps, Charles, 142
Phelps, Elizabeth Porter, 142, 146, 147, 173, 176
Pinking, *8, 143*
Pioneers, The (Cooper), 65
Plaid. *See* Hose; Wool
Planché, James Robinson, 22, 116
Pocketbooks, 7, 90, *222, 230*
Pockets, 29, *29,* 56, *58,* 59, 88, 202, *203,* 204

What Clothes Reveal:
The Language of Clothing in Colonial and Federal America

Designed by Greer Allen and Jo Ellen Ackerman

Composed in Monotype Fournier

Printed and bound in Singapore by CS Graphics Pte, Ltd.